Nature and Culture

Nature and Culture

AMERICAN LANDSCAPE AND PAINTING
1825–1875

BARBARA NOVAK

New York
OXFORD UNIVERSITY PRESS
1980

Copyright © 1980 by Oxford University Press, Inc.
Library of Congress Cataloging in Publication Data
Novak, Barbara.
Nature and culture.
Bibliography: p. Includes index.
1. Landscape painting, American. 2. Landscape painting—
19th century—United States. I. Title.
ND1351.5.N68 758'.1'0973 79-10131 ISBN 0-19-502606-3

Second printing, 1981
Printed in the United States of America

For Brian O'Doherty

Preface

This book's main intention is to place American landscape painting of the great era from 1825 to 1875 in its own cultural context—and to examine that context—philosophical, spiritual, and scientific—as fully as the art itself. This is a kind of figure-ground problem. The art, seen against this context, will, I hope, take on more definition and meaning. The cultural ground, with the art placed against it, should reveal what formed and gave sustenance to the art—which in turn contributed to that context.

In *American Painting of the Nineteenth Century* I emphasized the formal values of the art which had, I felt, been overlooked in much earlier writing. Here, I stress ideas, and attempt to show how the history of ideas flows freely through the membranes that compartmentalize the various disciplines comprising a culture. In the nineteenth century these compartments were less restrictive than they are now.

In using this methodology I have abandoned more familiar practices in order to approach the problems that interest me. The book is not arranged chronologically, nor does it attempt to give a "history" in the traditional sense of naming all the landscape painters and summarizing their biographies and artistic contributions. Rather it aspires through certain thematic identifications toward a form of cultural art history that probes for what, in Panofsky's terms, might be called *iconological* roots.

This interdisciplinary focus is more horizontal than vertical. While many of the artists presented here live on into the 1870's and beyond, much of the key activity may be said to center around the mid-century—the decade from 1850 to 1860 when everything came to a climax—that both epitomized the age and nourished the seeds of its conclusion. This activity is revealed as much by contemporary letters, journals, periodicals, and criticism as by the art itself. I place great stress on those texts that elucidate the concerns of the paintings.

As an art historian I am, however, very aware that the art comes first. The paintings, drawings, and photographs demand the primary reading. One goes from the art to the culture hoping to find there what the art has already told us. To reverse the procedure would be to

risk imposing on the art a priori conclusions unsupported by the artistic evidence—however convincing such cultural ideas may be.

In "reading" the art, we will of course learn a great deal about the culture that produced it, and about its response to that culture. I feel that this enterprise may also cast some light on the cultural context in which we find ourselves today, more than a hundred years later. Some American attitudes, it seems to me, are remarkably durable.

In making this multidisciplinary approach, I am presuming in advance on the generosity of my colleagues. I am entering into other fields, all of which have their specialists, as does mine. I do so in the hope that my colleagues in related disciplines will approve my intent, though they may not always agree with my performance. My belief in the need for a more "ecumenical" art history has overcome a natural scholarly reserve.

The main theme of this book is conveyed by its title, *Nature and Culture:* the conversion of the landscape into art, the evolution of an American culture and its relation to Western art and culture at large. Emerson, ever obliging, may have finished my title when he quoted Plato, as was his habit: "He said, Culture; he said, Nature; and he failed not to add, 'There is also the divine.' "

October 1978 B. N.
Barnard College,
Columbia University

Acknowledgments

The gathering of materials for this book depended on the generosity and cooperation of many individuals, institutions, and publications. Among these, I would like to acknowledge and thank especially:

Elizabeth Baker of *Art in America,* Professor Eleanor Tilton of Barnard College, Richard Slavin, Alan Dages of Olana, Butler Coleman, William McNaught and William Woolfenden of the Archives of American Art, Linda Ferber of the Brooklyn Museum, Joan Washburn of the Washburn Gallery, New York, John Walsh of the Museum of Fine Arts, Boston, Elaine Dee of the Cooper-Hewitt Museum of Design, Charles Eldredge of the University of Kansas Museum of Art, Ellen Sharp and Dr. Frederick Cummings of the Detroit Institute of Arts, John Wilmerding of the National Gallery of Art, Professor David Huntington of the University of Michigan, Jane Van Turano of the *American Art Journal,* Alfred Hunt and the staff of the Hunt Institute for Botanical Documentation. Ms. Bea Ellsworth generously made Cropsey's work, papers, and library available to me.

"The Nationalist Garden and the Holy Book" first appeared in *Art in America* in January–February 1972. "Grand Opera and the Still Small Voice" appeared in *Art in America* in March–April 1971. "Americans in Italy: Arcady Revisited" formed the catalogue essay for *The Arcadian Landscape,* an exhibition at the University of Kansas Museum of Art in November–December 1972, and was printed in *Art in America* in January–February 1973. "Changing Concepts of the Sublime" first appeared in the *American Art Journal* in Spring 1972. Some of the ideas that comprise the chapter "America and Europe, Influence and Affinity" were first presented at the Nineteenth-Century American Art Symposium at the Metropolitan Museum of Art in 1970, and were subsequently printed in *The Shaping of Art and Architecture in Nineteenth Century America* (Metropolitan Museum, 1972). The chapter "The Meteorological Vision: Clouds" was first presented as a lecture at the Nineteenth-Century American Art Symposium at the University of Delaware in 1973. The section on the axe first appeared as "The Double-Edged Axe" in *Art in America,* January–February 1976.

The research for this volume was substantially aided by my receipt of a Guggenheim Fellowship in 1974, and by the willing adjustment of Barnard College and the Department of Art History and Archaeology of Columbia University to the suspension of my teaching duties for that year.

My debts to my students are only partly indicated by the occasional footnotes that recognize their specific contributions. The cooperative "workshop" atmosphere that has characterized my seminars in American Art in the Graduate Faculty of Columbia University over nearly a decade while this book was in preparation has been filled with insights and enthusiasm, all of which fed my thoughts, as they enriched my life. In this context, I am grateful to Elizabeth Garrity, Mary Ann Lublin, Annette Blaugrund, Fred Adelson, Katherine Manthorne, Jean O'Leary, Kenneth Maddox, and Ella Foshay.

Linda Minarik and Joellyn Ausanka typed the manuscript with scrupulous attention to detail. I am especially indebted to the staff of Oxford University Press. James Raimes showed rare editorial understanding of my ideas, intentions, and aims. Stephanie Golden's unique alertness and unfailing intelligence aided the book immeasurably, as did Deborah Bowen's perseverance and ingenuity in tracking down difficult photograph sources. Frederick Schneider undertook the problems of design with special sensitivity. All these people generously contributed vast resources of time, energy and ability, and I thank them.

I would also like to thank my family for their patience over this long period, particularly my late parents, Sadie and Joseph Novak, who are responsible for all my scholarly endeavors. There is no adequate way to thank my husband, Brian O'Doherty, for his inspiration and support.

Contents

PART ONE

I
Introduction:
The Nationalist Garden
and the Holy Book

In the beginning all the world was America.
JOHN LOCKE[1]

In the early nineteenth century in America, nature couldn't do without God, and God apparently couldn't do without nature. By the time Emerson wrote *Nature* in 1836, the terms "God" and "nature" were often the same thing, and could be used interchangeably. The transcendentalists accepted God's immanence. More orthodox religions, which had always insisted on a separation of God and nature, also capitulated to their union. A "Christianized naturalism," to use Perry Miller's phrase, transcended theological boundaries, so that one could find "sermons in stones, and good in every thing." "Nature," wrote Miller, "somehow, by a legerdemain that even so highly literate Christians as the editors of *The New York Review* could not quite admit to themselves, had effectually taken the place of the Bible. . . ."[2]

That legerdemain was facilitated by the pervasive nature worship not only of Emerson, but of Wordsworth, Rousseau, and Schelling. With this added international force it is not surprising that most religious orthodoxies in America obligingly expanded to accommodate a kind of Christianized pantheism. Ideas of God's nature and of God *in* nature became hopelessly entangled, and only the most scrupulous theologians even tried to separate them. If nature was God's Holy Book, it *was* God (fig. 1; color).

3

The implications of this for morality, religion, and nationalism make the concept of nature before the Civil War indispensable to an understanding of American culture. Like every age, the early nineteenth century entertained contradictions it did not attempt, or perhaps dare, to resolve. By asking the apparently simple question "How did Americans see and interpret nature?" we are quickly brought into the heart of these contradictions.

In recent years a number of brilliant historians have tried to isolate and define the ideas the nineteenth century projected on nature, ideas that strove to reconcile America, nature, and God. In *Errand into the Wilderness,* Perry Miller suggests that "Nature—not to be too tedious —in America means the wilderness."[3] In *Virgin Land,* Henry Nash Smith speaks of the American agrarian dream as the Garden of the World.[4] In *The American Adam,* R. W. B. Lewis suggests the idea of Adamic innocence before the Fall.[5] To these three (nature as Primordial Wilderness, as the Garden of the World, as the original Paradise) we can add a fourth—America awaiting the regained Paradise attending the millennium. These myths of nature in America change according to the religious or philosophical lenses through which they are examined. Accepting this lability, Leo Marx found it convenient to discriminate between two concepts of the Garden, the primitive and the pastoral[6]—a distinction that fortuitously resolves an important antinomy between ideas of wilderness (God's original creation, untamed, untouched, savage) and the agrarian Garden of man's cultivation. The mutability of these myths assisted the powerful hold nature had on the nineteenth-century imagination. As with any shared overriding concept whose terms are not strictly defined, each man could interpret it according to his needs. Nature's text, like the Bible, could be interpreted with Protestant independence.

The new significance of nature and the development of landscape painting coincided paradoxically with the relentless destruction of the wilderness in the early nineteenth century. The ravages of man on nature were a repeated concern in artists' writings, and the symbol of this attack was usually "the axe," cutting into nature's pristine— and thus godly—state. In his "Essay on American Scenery" (1835), an essay that articulates the spirit that was to dominate much American landscape painting for thirty years, Thomas Cole found America's wildness its most distinctive feature,

because in civilized Europe the primitive features of scenery have long since been destroyed or modified. . . . And to this cultivated state our western world is fast approaching; but nature is still predominant, and there are those who regret that with the improvements of cultivation the sublimity of the wilderness should pass away; for those scenes of solitude from which the hand of nature has never been lifted, affect the mind with a more deep toned

emotion than aught which the hand of man has touched. Amid them the consequent associations are of God the creator—they are his undefiled works, and the mind is cast into the contemplation of eternal things.[7]

In his funeral oration for Cole, William Cullen Bryant extolled the early landscapes and noted "delight . . . at the opportunity of contemplating pictures which carried the eye over scenes of wild grandeur peculiar to our country, over our ariel mountain-tops with their mighty growth of forest never touched by the axe, along the banks of streams never deformed by culture. . . ."[8] This consciousness of destruction is never far from contemporary criticism. Reviewing two landscapes by Cole's Hudson River colleague, J. F. Cropsey, in 1847, *The Literary World* pointed out the artist's role in preserving the last evidences of the golden age of wilderness: "The axe of civilization is busy with our old forests, and artisan ingenuity is fast sweeping away the relics of our national infancy. . . . What were once the wild and picturesque haunts of the Red Man, and where the wild deer roamed in freedom, are becoming the abodes of commerce and the seats of manufactures. . . . Yankee enterprise has little sympathy with the picturesque, and it behooves our artists to rescue from its grasp the little that is left, before it is too late."[9] Such intense reverence for nature came only with the realization that nature could be lost. Given the indissoluble union of God and nature at this moment, the fate of both God and nature is obvious. A future mourning the loss of faith and consumed with ecological nostalgia was not far away. But though the nineteenth century acknowledged its fears to some extent, it worked hard to reconcile the various myths, to retain God and nature in any combination that seemed workable. Thus, if Wilderness became cultivated ("deformed by culture," in Bryant's phrase), it could still be a Garden. If the Garden was not Paradise, it could offer the possibility of a Paradise to be regained. To this idea of Paradise, original or regained, much energy was devoted (fig. 2).

Though the idea of primal innocence received its main exposition from Whitman rather late in the pre–Civil War period we are discussing, the reconciliation to its loss was premised on the idea of Adam's "fortunate Fall." The elder Henry James felt that Adam's original estate had all the happy blindness of the state of nature, undisturbed by the rigors of self-consciousness. Adam's state was

purely genetic and premoral . . . a state of blissful infantile delight unperturbed as yet by those fierce storms of the intellect which are soon to envelope and sweep it away, but also unvisited by a single glimpse of that Divine and halcyon calm of the heart in which these hideous storms will finally rock themselves to sleep. Nothing can indeed be more remote (except in pure imagery) from distinctively *human* attributes, or from the spontaneous life of man, than this sleek and comely Adamic condition, provided it should turn

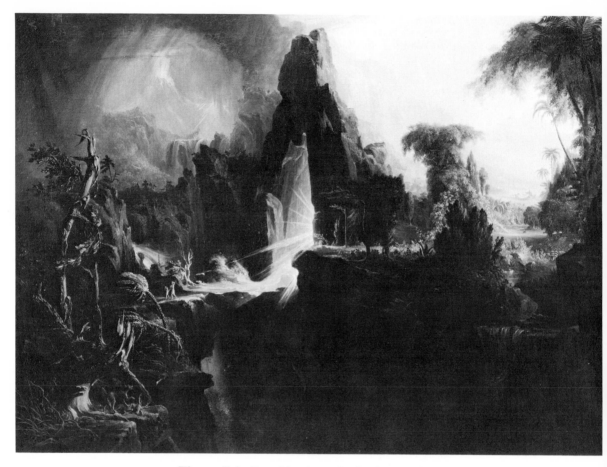

2. Thomas Cole. *Expulsion from the Garden of Eden,* c. 1827–28
Oil on canvas, 39″ × 54″. M. and M. Karolik Collection, Museum of Fine Arts, Boston

out an abiding one: because man in that case would prove a mere dimpled nursling of the skies, without ever rising into the slightest Divine communion or fellowship, without ever realizing a truly Divine manhood and dignity.[10]

So after detailing the drawbacks of Paradise on the basis that perfect happiness is hardly worth having unless one knows one has it, the stage was set for the fortunate Fall, putting an optimistic complexion on Original Sin. The notion of the fortunate Fall, R. W. B. Lewis points out, can be traced back almost to the fourth century in Christian theology, and allows for "the necessary transforming shocks and sufferings, the experiments and errors, in short, the experience— through which maturity and identity may be arrived at."[11]

For those who did not subscribe to the concept of Adamic innocence,

6

or to the fortunate aspect of the Fall, the recovery of Paradise, the coming of the millennium prophesied in the Book of Revelation, might also be discerned in American nature, which now took on the aspect of the New Jerusalem. The series of awakenings, of evangelical revivals, that spread through many American towns from upstate New York to the newer territories in the West, were a powerful force in the national psyche. Apocalyptic shudders of remorse carried with them an ardent belief that the believers were chosen, that America itself was the chosen land, and that the millennium was at hand.

Each view of nature, then, carried with it not only an esthetic view, but a powerful self-image, a moral and social energy that could be translated into action. Many of these projections on nature augmented the American's sense of his own unique nature, his unique opportunity, and could indeed foster a sense of destiny which, when it served to rationalize questionable acts with elevated thoughts, could have a darker side. And the apparently innocent nationalism, so mingled with moral and religious ideas, could survive into another century as an imperial iconography.

> . . . The noblest ministry of nature is to stand as the apparition of God. It is the organ through which the universal spirit speaks to the individual, and strives to lead back the individual to it.
>
> Emerson, *Nature*

> We can never see Christianity from the catechism—from the pastures, from a boat in the pond, from amidst the songs of wood-birds, we possibly may.
>
> Emerson, "Circles"[12]

Since the landscape was a holy text which revealed truth and also offered it for interpretation, artists who painted the landscape had a choice of what to transcribe and interpret. They could paint what Lewis calls "Yankee Genesis," or they could paint Revelation, with or without evangelical overtones (fig. 3). Creation and revelation were in fact key words in nineteenth-century philosophy, theology, and esthetics—though, again, their meanings varied enormously according to context.

"We distinguish the announcements of the soul, its manifestations of its own nature, by the term *Revelation*," wrote Emerson. "These are always attended by the emotion of the sublime."[13] "Sublimity" is also an important word in nineteenth-century nature terminology. By the time Emerson was writing, the sublime had been largely transformed from an esthetic to a Christianized mark of the Deity resident in nature. Indeed the gradual fusion of esthetic and religious terms

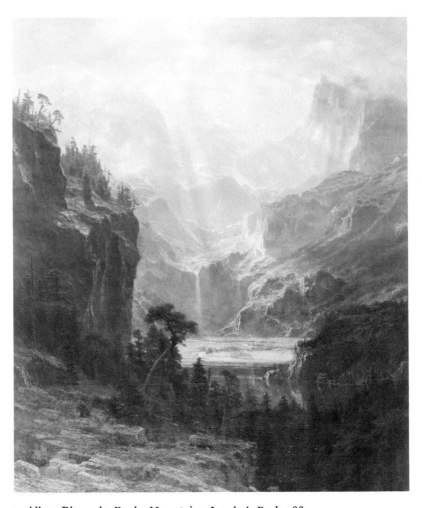

3. Albert Bierstadt, *Rocky Mountains, Lander's Peak*, 1863
Oil on canvas, 44⅜″ × 36½″. Fogg Art Museum, Harvard University, Cambridge,
Massachusetts, bequest of Mrs. William Hayes Fogg

is an index of the appropriation of the landscape for religious
and ultimately, as we shall see, nationalist purposes. Science,
so prominent in the nineteenth-century consciousness, could hardly
be left out either. Landscape, according to the mid-century critic
James Jackson Jarves, was "the creation of the one God—his sensuous
image and revelation, through the investigation of which by science or
its representation by art men's hearts are lifted toward him."[14] Science
and art are both cited here as routes to God; and this continued
attempt to Christianize science was made urgent by the growing stress
it was placing on the traditional interpretations of God's nature. It

was hoped that art's interpretive capacities would reconcile the contradictions science was forcing on the nineteenth-century mind.

Revelation and creation, the sublime as a religious idea, science as a mode of knowledge to be urgently enlisted on God's side—with these the artist, approaching a nature in which his society had located powerful vested interests, was already in a difficult position. In painting landscape, the artist was tampering with some of his society's most touchy ideas, ideas involved in many of its pursuits. Any irresponsibility on his part might result in a kind of excommunication. The nineteenth century rings with exhortations to the artist on the high moral duties of his exceptional calling—entirely proper for landscape painters, those priests of the natural church. There is no question, in early-nineteenth-century America, of the intimate relation between art and society, a fact that has to be emphasized after a century of modernism.

Since artists were created by God and generously endowed by him with special gifts, the powers of revelation and creation extended to them too. How to exercise these divine rights was the subject of much discussion. Asher B. Durand cautioned the young artist "not to transcribe whole pages [of nature] indiscriminately 'verbatim ad literature'; but such texts as most clearly and simply declare her great truths, and then he cannot transcribe with too much care and faithfulness."[15] He suggested starting with a humble naturalism, for "the humblest scenes of your successful labors will become hallowed ground to which, in memory at least, you will make many a joyous pilgrimage, and, like Rousseau, in the fullness of your emotions, kiss the very earth that bore the print of your oft-repeated footsteps."[16] As is clear from this passage, Durand's famous "Letters on Landscape Painting" (1855) frequently adopt the tone of a religious manual instructing a novice. And as a spiritual instructor sometimes does, Durand tried to make the burden of humble labors less heavy by pointing to their goal. Landscape painting, he wrote, "will be great in proportion as it declares the glory of God, by representation of his works, and not of the works of man . . . every *truthful* study of near and simple objects will qualify you for the more difficult and complex; it is only thus you can learn to read the great book of Nature, to comprehend it, and eventually transcribe from its pages, and attach to the transcript your own commentaries." But he immediately cautions on the priorities involved and warns the acolyte not to overvalue hard-won technical facility: "There is the letter and the spirit in the true Scripture of Art, the former being tributary to the latter, but never overruling it. All the technicalities above named are but the language and the rhetoric which expresses and enforces the doctrine. . . ."[17]

Thomas Cole, though no less reverent, was more assertive in empha-

sizing the creative role of the artist than was Durand, who always remained the devout naturalist: "Art is in fact man's lowly imitation of the creative power of the Almighty."[18] Cole also said, "We are still in Eden; the wall that shuts us out of the garden is our ignorance and folly."[19] This reinforces a matter often indispensable to the whole machinery of nature worship—morality. Cole implies that, seen with the guiltless eye, nature would be perceived as perfection, as Eden. The flaws are not in nature, but in ourselves.

From this point of view Cole's own development is instructive. The first two paintings in the *Course of Empire* series, the savage and pastoral states, move from the Wilderness to the Garden, two powerful mythic conceits in America, as we have seen. Then, consummation of empire, lush, sensual, and hedonistic, is followed by destruction and desolation (figs. 4–8). The moral of Cole's parable was mused over in the contemporary reviews. "Will it always be so?" wrote one reviewer. "Philosophy and religion forbid." For when "the lust to destroy shall cease and the arts, the sciences, and the ambition to excell in all good shall characterize man, instead of the pride of the triumph, or the desire of conquests, then will the empire of love be permanent."[20] The expression of such pious sentiments penetrated to the furthest reaches of secular society, even when their incongruity was marked. Cole himself projected a sequel to this series, based on Christianity (*The Cross and the World*, left incomplete at his death), in which the empire of love would triumph. The two series may be seen as parables of the fate of pagan and of Christian man. Christianity could redeem history, the landscape, the world.

So the strongly moral reception of Cole's *Course of Empire* was a salient part of the age. If, like nature, art was a divine force, and the artist himself bound by his divine task, morality, served by art and nature, was enlisted to assist man toward his divinity, and didactically encouraged at all turns. Despite the suggestions of some critics that the love of nature had its amoral aspects, the opposite idea was energetically cultivated. ". . . In regard to landscape art," wrote the critic H. T. Tuckerman, "it is apparent that the impression must depend upon the habits of observation and the degree of moral sensibility of the spectator."[21] Emerson was, as usual, more optimistic: "Nor can it be doubted that this moral sentiment which thus scents the air, grows in the grain, and impregnates the waters of the world, is caught by man and sinks into his soul. The moral influence of nature upon every individual is that amount of truth which it illustrates to him."[22] To a writer in *The Crayon* in 1855, "the man to whom nature, in her inanimate forms, has been a delight all his early life, will love a landscape, and be better capable of feeling the merits of it than any city-bred artist. . . ."[23] The *Southern Literary Messenger* in 1844 treated

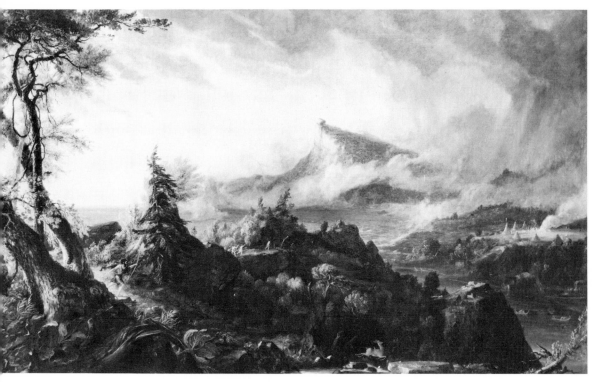

4. Thomas Cole, *The Course of Empire, Savage State,* 1836
Oil on canvas, 39¼″ × 63¼″. The New-York Historical Society

5. Thomas Cole, *The Course of Empire, Pastoral State,* 1836
Oil on canvas, 39¼″ × 63¼″. The New-York Historical Society

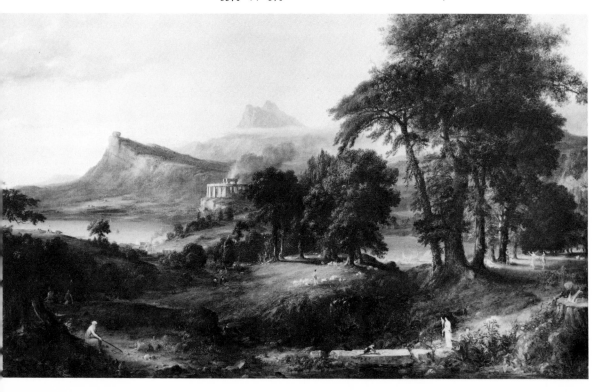

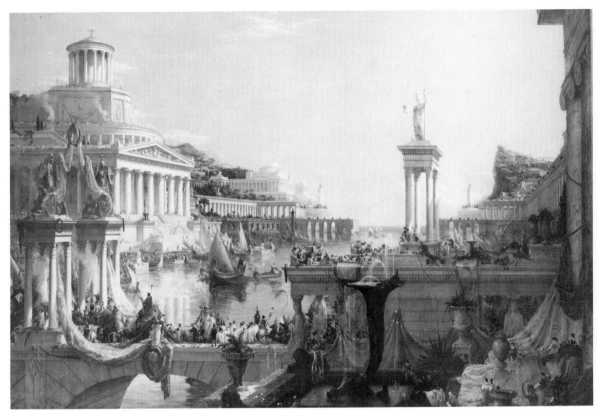

6. Thomas Cole. *The Course of Empire, Consummation,* 1836
Oil on canvas, 51″ × 76″. The New-York Historical Society

7. Thomas Cole. *The Course of Empire, Destruction,* 1836
Oil on canvas, 39¼″ × 63½″. The New-York Historical Society

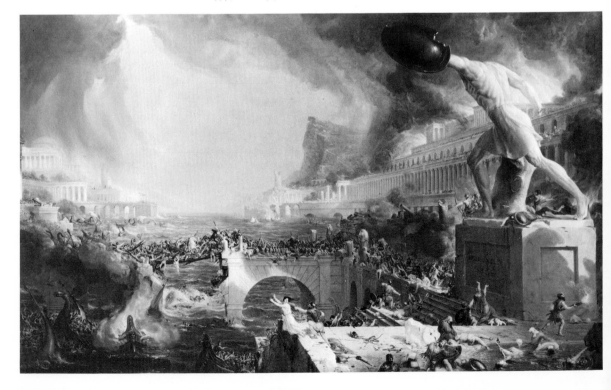

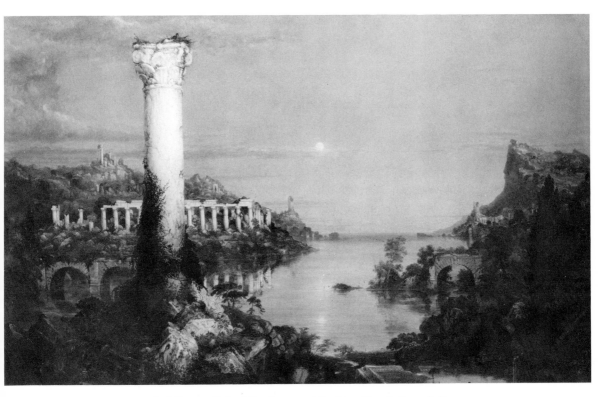

8. Thomas Cole, *The Course of Empire, Desolation,* 1836
Oil on canvas, 39½″ × 61″. The New-York Historical Society

the problem in an article called "The Influence of the Fine Arts on the Moral Sensibilities," by the Reverend J. N. Danforth, who observed: "[The painter] seeks to stir the deep sea of human sensibility. He desires to reach the most retired and secret foundations of feeling in man, and hence he must commune for days and nights with nature herself in her multiplied forms and in her beautiful developments. Some minds are more affected by *natural scenery* than by any other source of moral influence."[24]

So it was "the legitimate and holy task of the scenic limner," as Tuckerman put it, to interpret nature.[25] And Durand, whose writings on the whole lack the sententiousness that afflicted many of his contemporaries, concluded:

It is impossible to contemplate with right-minded, reverent feeling, [nature's] inexpressible beauty and grandeur, for ever assuming new forms of impressiveness under the varying phases of cloud and sunshine, time and season, without arriving at the conviction

—"That all which we behold
Is full of blessings"—

that the Great Designer of these glorious pictures has placed them before us
as types of the Divine attributes, and we insensibly, as it were, in our daily
contemplations,

—"To the beautiful order of his works
Learn to conform the order of our lives."[26]

All that the artists and public had to do was to read what William
Sidney Mount called "the volume of nature—a lecture always ready
and bound by the Almighty," and virtue presumably would triumph.[27]
For the Holy Book was open to all. To read, interpret, and express its
truths required dedication, cultivation, and sensibilities enlightened
by Christian morals.

The close connection between nature and art as routes to spiritual
understanding had been asserted earlier by the German writer Wil-
helm Wackenroder in "Outpourings from the Heart of an Art-Loving
Friar" (1797):

I know of *two miraculous languages* through which the Creator has enabled
men to grasp and understand things in all their power, or at least so much of
them—to put it more modestly—as mortals can grasp. They enter into us by
ways other than words, they move us suddenly, miraculously seizing our entire
self, penetrating into our every nerve and drop of blood. One of these miracu-
lous languages is spoken only by God, the other is spoken by a few chosen
men whom he has lovingly anointed. They are: *Nature and Art*.

Since my early youth, when I first learned about God from the ancient
sacred books of our faith, *Nature* has seemed to me the fullest and clearest
index to His being and character. The rustling in the trees of the forest and
the rolling thunder have told me secrets about Him which I cannot put into
words. A beautiful valley enclosed by bizarre rocks, a smooth-flowing river
reflecting overhanging trees, a pleasant green meadow under a blue sky—all
these stirred my innermost spirit more, gave me a more intense feeling of
God's power and benevolence, purified and uplifted my soul more than any
language of words could have done. Words, I think, are tools too earthly and
crude to express the incorporeal as well as they do express material reality.[28]

Like such German contemporaries as Caspar David Friedrich, nine-
teenth-century American artists united nature and art in the single
votive act of landscape painting. Thus they spoke the two "miraculous
languages" at once. In that they were blessed with creative gifts, they
reproduced in little the divine act of Creation. Their interpretation of
their duties ranged from a humble naturalism to a baroque romanti-
cism. Humble in their exaltation and exalted in their humility, they
were perfect media between nature and their fellow man, between the
God in them and their human estate. As curates of nature interpreting
its Holy Book, as proxies for the divine, they were implicated in tasks

that demanded as fine discriminations as modernist art, though the terms of their involvement were, if anything, more complex.

God has promised us a renowned existence, if we will but deserve it. He speaks this promise in the sublimity of Nature. It resounds all along the crags of the Alleghanies. It is uttered in the thunder of Niagara. It is heard in the roar of two oceans, from the great Pacific to the rocky ramparts of the Bay of Fundy. His finger has written it in the broad expanse of our Inland Seas, and traced it out by the mighty Father of Waters! The august TEMPLE in which we dwell was built for lofty purposes. Oh! that we may consecrate it to LIBERTY and CONCORD, and be found fit worshippers within its holy wall!

JAMES BROOKS
The Knickerbocker, 1835[29]

With such a range of religious, moral, philosophic, and social ideas projected onto the American landscape, it is clear that the painters who took it upon themselves to deal with this "loaded" subject were involved not only with art, but with the iconography of nationalism. In painting the face of God in the landscape so that the less gifted might recognize and share in that benevolent spirituality, they were among the spiritual leaders of America's flock. Through this idea of *community* we can approach a firm understanding of the role of landscape not only in American art, but in American life, especially before the Civil War. The idea of this community through nature runs clearly through all aspects of American social life in the first half of the nineteenth century, and its durability is still evidenced by its partial survival as the myth of rural America.

While I am not concerned here with the reasons why this myth was so necessary and durable, we should investigate further the idea of community. God in or revealed through nature is accessible to every man, and every man can thus "commune" (as the word was) with nature and partake in the divine. God in nature speaks to God in man. (This can be seen as a way of moving man back to the center of the universe, using as passport a discreet humility, which is confident, however, of its ultimate virtue and godliness.) And man can also commune with *man* through nature—a communing which requires for its representation not the solitary figure, but two figures in a landscape, the classic exemplar of which, in American landscape art, is Durand's portrait of Cole and Bryant, *Kindred Spirits* (fig. 9). This picture is evidence not only of singular contemplation after a transcendental model, but of a sharing through communion, of a potential community.

The sense of community fostered by the natural church was reinforced by an all-pervasive nationalism that identified America's des-

9. Asher Brown Durand, *Kindred Spirits,* 1849
Oil on canvas, 44″ × 36″. The New York Public Library

tiny with the American landscape. In 1848, James Batchelder, in a
book called *The United States as a Missionary Field,* wrote: "Its sub-
lime mountain ranges—its capacious valleys—its majestic rivers—its
inland seas—its productiveness of soil, immense mineral resources,
and salubrity of climate, render it a most desirable habitation for man,
and are all worthy of the sublime destiny which awaits it, as the foster
mother of future billions, who will be the *governing* race of man."[30]

There was a widespread belief that America's natural riches were
God's blessings on a chosen people. Perhaps it is safe to say that de-
spite its international complexion, nineteenth-century nature worship

16

was more strongly nationalistic in America than elsewhere. For nature was tied to the group destiny of Americans united within a still-new nation, "one nation, under God." This is perhaps a key explanation for the acceptance of immanence by the religious orthodoxy.

The community awareness of that one nation, united under God and nature (or under God *as* nature), received further reinforcement early in the nineteenth century from the evangelical revivalism sweeping the country. Thus, a writer in the *Spectator* in 1829 observed that the Gospel could "renew the face of communities and nations. The same heavenly influence which, in revivals of religion, descends on families and villages . . . may in like manner, when it shall please him who hath the residue of the spirit, descend to refresh and beautify a whole land."[31] It was only God's grace, according to the Reverend David Riddle in 1851, "not enterprise, or physical improvements, or a glorious constitution and good laws, or free trade, or a tariff, or railroads and steamships, or philosophy, or science, or taste . . . that bringeth salvation, appearing to every man, and inwrought into the heart of every man, that can save us from the fate of former republics, and make us a blessing to all nations."[32]

That grace had been apparent to the earliest settlers in the midst of America's natural bounties. As Tocqueville had said: "There is no country in the world in which the Christian religion retains a greater hold over the souls of men, than in America. . . . Religion is the foremost of the institutions of the country."[33] If, within the decade of the Reverend Riddle's writing, the axe, growing technology, and a dawning sense of Darwinian savageries began to threaten the dream of an American Paradise, and of a nature which was both benevolent and godly, the belief in a chosen national destiny did a lot to keep such awareness at bay. No wonder that Christianity and nationalism, two forms of hope, two imprimaturs of destiny, continually emerged from the face of American nature.

The unity of nature bespoke the unity of God. The unity of man with nature assumed an optimistic attitude toward human perfectibility. Nature, God, and Man composed an infinitely mutable Trinity within this para-religion. This gave confidence to all aspects of nature study, from the detail with its microscopic perfection (the microscope further revealed divine truths) to the grandeur of huge spaces. And in the mutability which landscape presents, God's moods could be read through a key symbol of God's immanence—light, the mystic substance of the landscape artist. Thus the landscape painters, the leaders of the national flock, could remind the nation of divine benevolence and of a chosen destiny by keeping before their eyes the mountains, trees, forests, and lakes which revealed the Word in each shining image (fig. 10; color).

II
Grand Opera
and the Still Small Voice

Each precise object or condition or combination or process exhibits a beauty
. . . the multiplication table its—old age its—the carpenter's trade its—the
grand opera its— . . .

WHITMAN[1]

He will get to the Goal first who stands stillest.

THOREAU[2]

The Leatherstocking novels . . . go backwards from old age to golden youth.
That is the true myth of America. She starts old, old, wrinkled and writhing
in an old skin. And there is a gradual sloughing off of the old skin, towards a
new youth. It is the myth of America.

D. H. LAWRENCE[3]

In the mid-nineteenth century the American preoccupation with na-
ture manifested itself in several distinct types of landscape painting.
Two of these may now be seen as polarities, though it can also be
claimed they shared similar goals. The large-scale, popular landscapes
by such artists as Church, Bierstadt, and Moran seemed to satisfy the
myth of a bigger, newer America. But a more modest kind of expres-
sion, practiced by some of the same artists, and by others who dealt
more exclusively with this idiom, may have indicated some of the nine-
teenth century's profoundest feelings about nature. The recognition
of this polarity now seems a central issue in understanding nineteenth-
century American painting.

Both modes continued the late-eighteenth-century notion of Amer-
ica as the "Virgin Land," a world unsullied by civilization. In express-
ing this idea, the larger, more operatic paintings tended to impose
older European conventions. The smaller paintings seem to have for-
mulated their own conventions by a more original transformation of

European models—tempered perhaps by paradigms of order established by the industrialism rapidly eradicating the primordial wilderness.

The question of what was old and new arises here, in art as well as nature. In this context D. H. Lawrence's "true myth" can be seen as only part of a larger mythology which would include also the myth of the separation from and attachment to the Old World—the love-hate relationship that transported American artists to the National Gallery in London, to the Louvre, to the museums and palaces of Italy, and then compelled them to return.

One of the strongest attachments to Europe revealed itself in the enchantment with history painting, which absorbed such major figures as Copley, West, Trumbull, Vanderlyn, Allston, Morse, and Cole, signaling an ambition that has not yet been fully defined. It seems to have been synonymous with size, engaging the great European masters in rivalry through an appropriately aggressive scale, as well as an aggressively announced "nobility." Perhaps for these artists large size was automatically endowed with monumentality and grandeur, those aspects of history painting that prompted Morse to refer to it as the intellectual branch of the art. Presumably, the ideal could be approached only if it was larger than life. Such grandness of size and ambition may have helped reaffirm the artist's status, at least in his own eyes, in a country which, Copley claimed, treated the artist as a shoemaker.

To some extent, then, the public had to be trained to respect Ambition, along with the didactic imperatives which accompanied it. Perhaps from the very beginning the American public (paying admission to see West's *Christ Healing the Sick* at Philadelphia, and, in 1836, netting Cole close to a thousand dollars for a showing of *Course of Empire*) approached art with expectations of entertainment and enlightenment. The ever-present popular respect for the artistic tour de force was augmented, mingled perhaps with the awe engendered by contact with the sublime. The overtures to sublimity in America's early history painting were readily transferred to the landscape, and lead to a study of artistic rhetoric, that style of formal declamation which is the appropriate mode for public utterance. Such a study also involves a consideration of art as spectacle. Persisting late into the nineteenth century, this art had a clear twentieth-century heir in the film, which rehearsed many of the nineteenth century's concerns.

The transfer of the rhetoric and aims of history painting to landscape was substantially effected by a single artist—Thomas Cole. His career

presents us with the interesting paradox of an artist who, though considered the country's leading landscapist, had difficulty in securing commissions for his cyclical extravaganzas, *The Course of Empire* and *The Voyage of Life*.

For Cole's cycles were effective public art—not unlike the museum art of today. It was one thing to view such spectacles. It was quite another to own them, or even to have the wall space to accommodate them. Cole's serial narratives involved another important factor. The entire philosophy of *Course of Empire* could be grasped only if one proceeded in systematic fashion through the whole series. *Voyage of Life* obviously could only reach its foregone conclusion by traversing the river of life with Cole's Everyman from infancy to old age—rehearsing the past for the old and providing a prospective moral textbook for the young (figs. 11–14).

Thus the public was already experiencing a kind of "motion art" with Cole's cycles, albeit the spectators were the ones in motion. The kinetic or cinematic aspects of such art had of course a popular counterpart in the panorama, which, however, permitted the public to stand still while the canvas unrolled. The overlap between Cole's serious cycles, which represented, for him at least, his most profound philosophical thought, and the popular art of the panorama is an important juncture of the high art of history painting, appreciated by an intellectual elite, and public or popular art.

Cole's career coincided with the discovery of the American landscape as an effective substitute for a missing national tradition. America was thus both new and old—new in that its undiscovered and unsettled territories were the proper habitat for that radical innocent, the noble savage celebrated by Rousseau and the Lake Poets; old in that these same forests and mountains spoke, as Chateaubriand suggested, of America's most significant antiquity—one that registered more purely in its uncultivated state.

Once this landscape had become a repository of national pride, the cultivation of the landscape experience (even by challenging it through risk and danger) was one of the key preoccupations of the age. Critics admonished their readers to experience nature fully, since only the man practiced in reading nature's text could appreciate paintings dealing with that experience. The nature experience was considered a crucial amenity for the moral man, and, as we have seen, was readily accepted by society as a religious alternative. Elevated by such moral projections, it was easy for landscape to assume the mantle of history painting. But there is a certain irony in the democratization of the elitist Grand Style as it was transformed into landscape art. The most ennobling of experiences very readily became the most widely disseminated form of popular entertainment.

11. Thomas Cole, *The Voyage of Life, Childhood,* 1839
Oil on canvas, 52″ × 78″. Munson-Williams-Proctor Institute, Utica, New York

12. Thomas Cole, *The Voyage of Life, Youth,* 1840
Oil on canvas, 52½″ × 78½″. Munson-Williams-Proctor Institute, Utica, New York

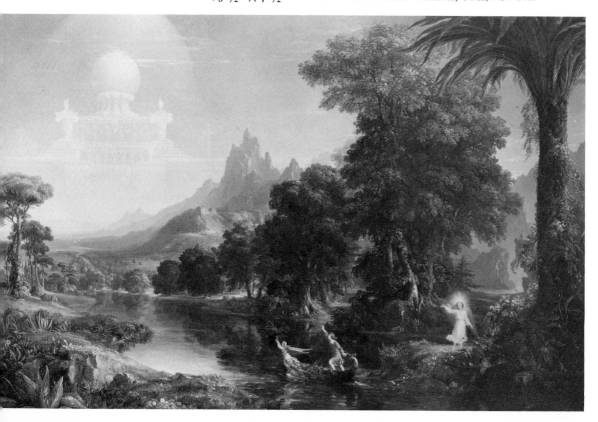

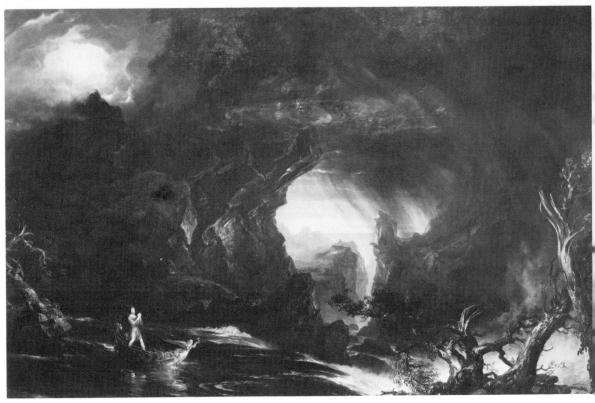

13. Thomas Cole, *The Voyage of Life, Manhood*, 1840
Oil on canvas, 52″ × 78″. Munson-Williams-Proctor Institute, Utica, New York

14. Thomas Cole, *The Voyage of Life, Old Age*, 1840
Oil on canvas, 51¾″ × 78¼″. Munson-Williams-Proctor Institute, Utica, New York

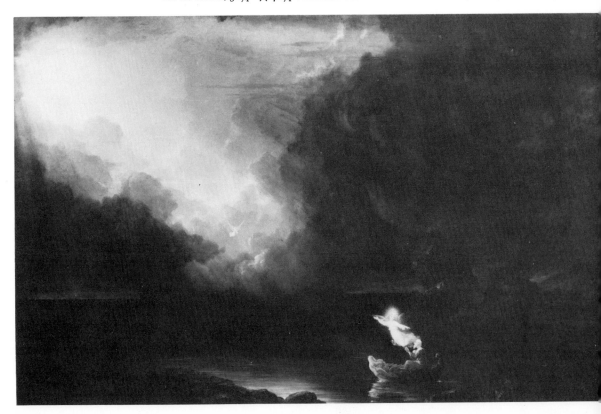

15. Henry Lewis, *Panoramic sketch of Quincy, Illinois,* 1848
Watercolor, 5¼″ × 9½″. The Missouri Historical Society, St. Louis

Thus the connection between history painting, landscape art, and the popular panorama assumes a tantalizing and somewhat paradoxical cast. The panorama, with its geologic and scientific certitudes and overtones of documentary edification, was a careful visual encyclopedia of travel fact (fig. 15). It made little pretense at being anything but a kind of theatricalized *National Geographic.* Henry Lewis's *Mammoth Panorama of the Mississippi River,* painted on 45,000 square feet of canvas, representing the Mississippi from St. Louis to the Falls of St. Anthony, was offered to public view at the Louisville Theater in Kentucky in 1849. Seats were available through a box office—dress circle and parquet for fifty cents, the second tier of boxes for twenty-five cents. Doors opened at seven forty-five and the Panorama commenced moving at "8½ precisely."[4] What was in fact on offer was a moving picture, with all its social appurtenances.

The gradual unrolling of a panorama took several hours, generally affording the audience only a glimpse of each of the many sites and objects depicted. As an experience, it was cumulative and extended in time. The totality could not be apprehended instantaneously. Commentators and pianoforte music complemented the visual image—a practice that transferred smoothly to the silent film. As a precursor of

23

the movie travelogue, the panorama had the transience of both the performance and the newspaper. It was disposable experience and disposable art. As active working art, the panorama, winding and unwinding on its cylinders before thousands of viewers, ultimately wore out. Few survive.[5]

But the kind of easel art that was closest to the panorama in intention has survived, with many of the theatrical overtones of the popular spectacle. The connection between some aspects of nineteenth-century landscape painting and the panorama was noted by James Jackson Jarves when he observed: "The countryman that mistook the *Rocky Mountains* for a panorama, and after waiting a while asked when the thing was going to move, was a more sagacious critic than he knew himself to be."[6] Bierstadt's *Rocky Mountains* (fig. 16) and Church's

16. Albert Bierstadt, *The Rocky Mountains,* 1863
Oil on canvas, 73¼″ × 120¾″. The Metropolitan Museum of Art, New York, Rogers Fund, 1907

Heart of the Andes were among the most popular paintings of their time. Not only did they educate would-be travelers to the wonders and glories of far-flung places, but they were considered, as the panoramas had been, artistic tours de force, meticulous in detail, magical in effect.

Indeed, detail and effect composed their fundamental dialectic, a point recognized by H. T. Tuckerman in 1867 when he wrote of *The Rocky Mountains:* "Representing the sublime range which guards the remote West, its subject is eminently national; and the spirit in which it is executed is at once patient and comprehensive—patient in the careful reproduction of the tints and traits which make up and identify its local character, and comprehensive in the breadth, elevation, and grandeur of the composition."[7]

Proper "elevation and grandeur" depended to a large extent for Tuckerman on what he termed "general effect."[8] Perhaps it was inevitable that the American artists seeking grandeur through general effect should refer instinctively to the European convention that most blatantly signified the "ideal" in landscape. Thus they looked to Claude for a compositional structure which, once adapted, remained little more than a superficial imposition of a worn-out structural cliché. In so doing they were following the example of the history painters, who had heeded Sir Joshua Reynolds's advice that the artist take a shortcut to nature by learning from those who had already solved the problems. Fortunately the definition of general effect seems also to have included handling of light and atmosphere, and here Claude, and Turner as well, were put to far more constructive use. Light and atmosphere, in the best operatic works of Church and Bierstadt, often succeeded in establishing a unity through what might be termed "excessive" effect, disarming judgment with a dazzle of color that masked compositional inadequacies.

Tuckerman was apparently astute enough to recognize that, while Claudian compositional clichés (see below, p. 228) rarely had a dynamic function but stamped themselves on a surface comprised of details, those details sometimes became, through sheer accretion, a unity in themselves. Of *Heart of the Andes* (fig. 17), he remarked that "four or five pictures might easily be cut out of this one: it is full of the most photographic imitation of natural objects and effects."[9]

Quite apart from the tacit recognition that Church could indeed have made use of photographs to certify various details within the picture, Tuckerman's observation postulates either a composition without unity which simply did not hang together, or the kind of cumulative situation in which aggregations of detail found their own cohesion. In the latter instance, the part could stand for the whole, as in a section of a painting by Pollock, whose work raises somewhat

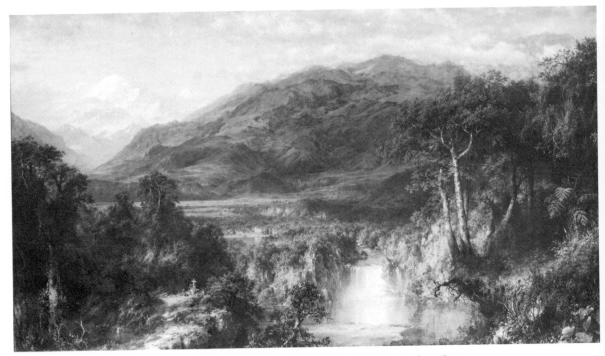

17. Frederic Edwin Church, *The Heart of the Andes,* 1859
Oil on canvas, 66⅛″ × 119¼″. The Metropolitan Museum of Art, New York,
bequest of Mrs. David Dows

similar questions of detail, effect, and ambition. (Indeed abstract expressionism in its flirtation with the idea of a grand style—in which the idea of abstraction is now substituted for the idea of nature—is the locus of a similar struggle between indigenous ambitions and European conventions.) As with the panorama, experiencing these landscape paintings involved a gradual revelation, segment by segment, often enhanced by the common practice of viewing them through opera glasses, further isolating detail through a stereoscopic intimacy that still remains curiously satisfying.

By and large the contemporary critics were more than satisfied, often in fact overwhelmed, and the public followed suit. According to Tuckerman, "the American work of art which attracted most attention, and afforded the greatest promise and pleasure in the spring of 1863," was Bierstadt's *Rocky Mountains,* "one of the most essentially representative and noble illustrations of American landscape art."[10]

Jarves was one of the few to protest what he called "the direction of exaggerated actions and effects . . . bigness, greatness, largeness" culminating in "full-length landscapes."[11] In 1864 he wrote critically of Church's paintings: "Who can rival his wonderful memory of de-

26

tails, vivid perception of color, quick, sparkling, though monotonous touch, and iridescent effects, dexterous manipulation, magical jugglery of tint and composition, picturesque arrangements of material facts and general cleverness? With him color is an Arabian Nights' Entertainment, a pyrotechnic display, brilliantly enchanting on first view, but leaving no permanent satisfaction to the mind, as all things fail to do which delight more in astonishing than instructing."[12] Such criticism, though perhaps a bit harsh, might also be applied to Olana, Church's palatial home, the Arabian Nights fantasy he designed to overlook the Hudson in 1872. A congress of glittering parts, a delirium of exotic effects, Olana was the architectural embodiment of the flamboyance with which Church often approached landscape in both North and South America.

Jarves also disagreed with other critics on the relation of such paintings to the spectator. Of Bierstadt's *Rocky Mountains* he wrote: "All this quality of painting is more or less panoramic, from being so material in its artistic features as always to keep the spectator at a distance. He can never forget his point of view, and that he is looking at a painting."[13] Yet the public and critics who admired the panoramas made a special point of emphasizing, as did a letter to the *Missouri Republican* in 1849 about Lewis's *Panorama of the Lower Mississippi,* that "the artist had succeeded in imposing on the senses of the beholder and inducing him to believe that he is gazing, not on canvas, but on scenes of actual and sensible nature. . . ."[14]

The issue however was paradoxical in that the spectator's experience could be simultaneously intimate and distant—the kind of communal intimacy that is a commonplace of the film and the theater experience. The possibility of simultaneous intimacy and distancing often occurs too with works of enormous scale when, intimidated by size, we are drawn closer, by a curious tropism, to engage detail or be enveloped by atmosphere. The scanning of detail through opera glasses would have augmented this intimacy, dispelling communal distance through the privacy of individual focus. Yet perhaps his awareness of the communal or popular nature of such an experience led Jarves, one of the period's most vocal exponents of an ideal, elitist art, to reject any claims on the part of the large landscapes to being high art. In effect, he failed to recognize the subtle conversion of Grand Style ambition to the "full-length landscape."

That ambition had been at least partly recognized by Tuckerman when he spoke of Church's *"enterprise,"* quoting the comment of a London critic in 1863 on seeing Church's *The Icebergs:* "The picture altogether is a noble example of that application of the landscape-painter's art to the rendering of the grand, beautiful and unfamiliar aspects of nature, only accessible at great cost of fatigue and exposure

and even at peril of life and limb, which seems to be one of the walks in which this branch of the art is destined to achieve new triumphs in our time."[15]

This reference to risk and danger also emphasizes the tour-de-force appeal of such works.[16] Such a tour de force invoked ideas of sublimity pertaining to nature and the artist, and this is of some importance in connecting the "full-length landscapes" to the earlier Grand Style. For one of the myths associated with these works has to do with their newness, with the idea that the "grand, beautiful and unfamiliar aspects of nature" were approached freshly by American artist-adventurers who were, in Tuckerman's phrase, "unhampered by pedantic didaction."[17] Yet, as we have seen, it was the wilderness rediscovered via Claude and Turner, in at least a partial restatement of Reynoldsian eclecticism. The friction between new landscape and old conventions, which might have been expected to generate some energies, remained minimal. Americans immersed in awe before these painted natural wonders were often viewing them through European spectacles. Lawrence's myth does not apply in this instance.

Where could it apply? Where in America could we find the old skin really sloughing off? It is a question that leads immediately into larger issues and needs continual qualification. For even the myth that some American conventions were developed wholly pragmatically, out of the experience of the land, may require amending. The "newest" landscapes produced in America at this time were not the large, operatic pieces wheeling in their Claudian flats from the wings, but small, intimate paintings whose horizontal extensions mimic the format of the huge panoramas. These are the quietistic paintings we now call "luminist." And for these too some European prototypes must be considered.

If the operatically sublime drew on the ideal art of Claude and Turner for inspiration, the transcendental luminist paintings, modest in size and apparent ambition, may have drawn on the Dutch tradition. If the larger paintings utilized a baroque rhetoric, the smaller paintings employed the frugality of classic understatement. Both modes can be said to rely on detail and effect—but with a considerable difference. Detail in the larger paintings often elicited awe. But as Jarves rightly observed, the "artist's labor trail" remained, and this painterly reminder of the artist's presence—a testament to his impresario-like sublimity—interposed itself between the spectator and the painted object.

In the luminist painting, the eradication of stroke nullifies process and assists a confrontation with detail. It also transforms atmospheric "effect" from active painterly bravura into a pure and constant light

in which reside the most interesting paradoxes of nineteenth-century American painting. They are paradoxes which, with extraordinary subtlety, engage in a dialectic that guides the onlooker toward a lucid transcendentalism. The clarity of this luminist atmosphere is applicable both to air and crystal, to hard and soft, to mirror and void. These reversible dematerializations serve to abolish two egos—first that of the artist, then the spectator's. Absorbed in contemplation of a world without movement, the spectator is brought into a wordless dialogue with nature, which quickly becomes the monologue of transcendental unity.

Scale and size enter this problem in a provocative way. In contrast to Church's *Heart of the Andes,* measuring 66″ by 119″, a luminist painting by Heade might measure as little as 10″ by 18″. Church, like the panoramists, seems to be equating grandness with largeness, and the relationship of the spectator to the picture remains, as already discussed, rather problematic. Only in the most fortuitous circumstances does such experience become genuinely environmental.

In a luminist painting, on the other hand, monumentality seems accomplished through scale, but not size. Proportionate to the objects in the picture, the space, even more than in the large works, gives an impression of limitless amplitude. A perfect miniaturized universe offers to the spectator an irresistible invitation in terms of empathy. The spectator is urged to conceptualize his size and enter the luminist arena in which figures, when they exist, are no larger than twigs.

Significantly, the luminist artists duplicated the horizontal extensions of the panorama in their pictures' proportions. I say significantly because I am suggesting that they had a profound understanding of the structural means whereby the popular panorama could be transformed back into high art. In contrast to the baroque atmosphere of the operatic works, the classic organization of the luminist pictures, halting the diffusion of the rutilant atmosphere, brought the nineteenth century as close as it could come to silence and the void (fig. 18).

This transcendence, consonant with an age steeped in Emerson, Swedenborg, and spiritualism, was achieved not only in the paintings by such luminists as Lane and Heade, but in smaller works, also luminist in feeling, by some of the same Hudson River men who could turn out Grand Style landscape. Church, Bierstadt, and especially Kensett, in such paintings as *Lake George* (see fig. 24) and *View from Cozzens' Hotel near West Point* (New-York Historical Society), could achieve luminism's perfect equipoise. And since Kensett particularly is known to have had constant and steady sales throughout his lifetime, it seems obvious that there was some audience for these works.

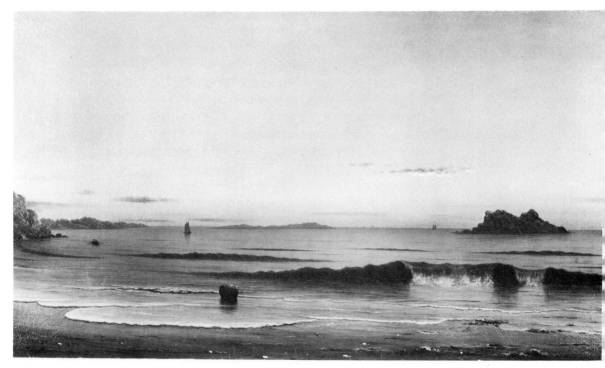

18. Martin Johnson Heade, *Twilight, Spouting Rock Beach,* 1863
Oil on board, 19½″ × 36⅛″. John D. Rockefeller collection

It is very possible that the artists distinguished between a public and a private role to which appropriate conventions might be assigned, and that there existed a public and a private taste. Official public taste seems to have been unmoved by luminist quietism—not the first time that the best art of a period would be hidden behind more overt and enterprising performances. If indeed the luminists did have recourse to Dutch examples such as van Goyen and van de Velde to confirm their unframed vistas and independence of Claudian conventions, they might have expected critical neglect. For the Dutch realists were constantly devalued by the critics, including Jarves, who perpetuated Sir Joshua's insistence on the ideal. Jarves shared Sir Joshua's contempt for the homely, unassuming "imitation" of the Dutch.

This must have been a good part of the reason that Jarves, though unwilling to accept the geological cosmoramas of Church and Bierstadt as high art, did not recognize the luminist transformation of Dutch prototypes into a transcendent hyper-realism that met his own definition of high art: "the effect of high art is to sink the artist and spectator alike into the scene. It becomes the real, and in that sense,

true realistic art, because it realizes to the mind the essential truths of what it pictorially discloses to the eye. The spectator is no longer a looker-on, as in the other style, but an inhabitant of the landscape."[18]

As is the case with many critics, Jarves did not recognize the art he called for. But at least he was the only important critic who was not beguiled by the rhetoric of the operatic landscapes. For the others, it was simply easier to embrace the obvious sublime in the large works, which offered such vicarious dangers to life and limb (fig. 19; color), than to enter selflessly into the transcendental world summoned through luminist quietude (fig. 20). On the one hand, Western humanism maintains its anthropomorphic bias. On the other, American art declares a certain kinship with oriental ideas.

The American East and West are also deeply involved in this dichotomy. Though often executed by eastern artists, the operatic paintings frequently dealt with the landscapes of the American West, and surely partook of the frontier myth so convincingly described (despite all subsequent revisions) in Frederick Jackson Turner's frontier hypothesis. That frontier, as defined by Turner, would have satisfied Lawrence's concept of a constant American rejuvenation:

The frontier is the line of most rapid and effective Americanization. The wilderness masters the colonist. It finds him a European in dress, industries, tools, modes of travel, and thought. It takes him from the railroad car and puts him in the birch canoe. It strips off the garments of civilization and arrays him in the hunting shirt and the moccasin. . . . Little by little he transforms the wilderness, but the outcome is not the old Europe. . . . The fact is, that here is a new product that is American. . . . Moving westward, the frontier became more and more American . . . the advance of the frontier has meant a steady movement away from the influence of Europe, a steady growth of independence on American lines."[19]

The irony, however, is that most of the artists dealing with the frontier did not really invent new artistic conventions but assembled their operatic conceits from the esthetics of history painting, from the late-eighteenth-century concepts of the sublime, and from the ideal compositions of Claude and later J. M. W. Turner. The large paintings dealing with the West were not more and more American, but often more and more baroque in their rhetoric and ambition. Perhaps, however, one might qualify this with the afterthought that the whole frontier hypothesis, in its idea of constant expansion—what Turner called "this perennial rebirth, this fluidity of American life"[20]—was by definition baroque in its quality of becoming.

Yet Turner spoke too of "a return to primitive conditions on a continually advancing frontier line" and of "continuous touch with the simplicity of primitive society."[21] His reference to the primitive is provocative. For in terms of Wölfflinian development, the closest state

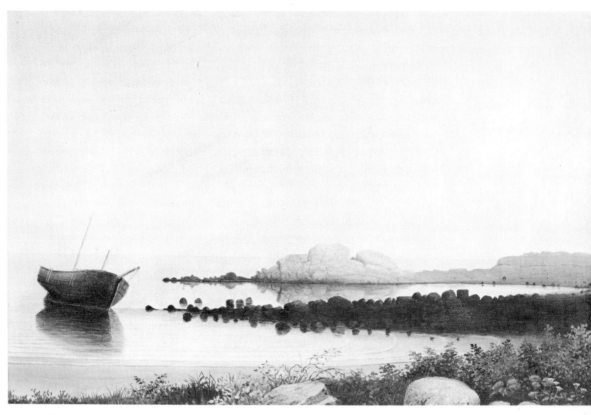

20. Fitz Hugh Lane, *Brace's Rock*, 1863
Oil on canvas, 10″ × 15″. Private collection. Photo courtesy Museum of Fine Arts, Boston

to the primitive is not the baroque, but the classical. In the history of American painting, the art that keeps in continuous *artistic* touch with the primitive is that of the luminists. Though some artists painted luminist pictures in the West, and though we can find luminist silence there, luminist art had little relationship to the expanding frontier myth, but maintained itself, if sometimes precariously, in a classic state.

In contrast to the operatic landscape, luminism is classic rather than baroque, contained rather than expansive, aristocratic rather than democratic, private not public, introverted not gregarious, exploring a state of being rather than becoming. It did not impose the conventions of a European formula on the landscape, but discovered, possibly in Dutch painting, structural epigones which it then transformed. In this transformation, the myth of a pristine nature could be recovered convincingly. It was largely recovered, not so much in the

new West as in New England, a stronghold of the East that Turner might have considered corrupted by European civilization. In the East, too, nature was threatened by an industrialism that at the same time, by emphasizing clarity and measurement, may have offered paradigms fortifying the certainties of time and place in luminist painting.

It seems clear that the dichotomy we have been speaking of resulted from different responses to social, psychological, esthetic, and philosophical pressures. In literature, although there are never point-for-point parallels, Whitman and Dickinson are often considered the instructive exemplars of this polarity. More recently, it manifested itself in abstract expressionism with De Kooning and Rothko. Thus perhaps we have characterized two types of expression in America, one which strains the boundaries of art in pursuit of its aims and one which reinforces the nature of art while redefining it. Each pole also gathers to itself a definition of sublimity—one reconfirming a traditional interpretation, the other departing from and restructuring it.

III
Sound and Silence: Changing Concepts of the Sublime

In the literature of landscape painting, the word "sublime" has played a suitably "exalted" role. Its venerable history has been documented in such studies as Samuel H. Monk's *The Sublime*,[1] and the characteristics it acquired in the late eighteenth century have until now generally stood for its interpretation. In the nineteenth century, however, the word, already loaded with meaning, took on additional baggage. By mid-century, we can speak of several interpretations of the sublime, so that the original concept, which more or less maintained its traditional meaning, existed side by side with its offspring. These later sublimes not only subtly alter the original meaning of the word, but affect our understanding of landscape attitudes in mid-nineteenth century America.

The late-eighteenth-century sublime, interpreted largely in terms of Burke's definition, was associated with fear, gloom, and majesty. Majesty had to do with scale and size, exemplified particularly by mountain scenery. The sublime was primarily an esthetic, and to experience it was to have an esthetic reaction. This reaction provoked intimations of infinity and thus of Deity and the divine.[2] It was an overwhelming divinity, dwarfing the observer who, though he aspired to transcendence, rarely forgot his own insignificance. Such humility magnified awe. As Mrs. Radcliffe put it, in *The Italian*: "Here, gazing upon the stupendous imagery around her, looking, as it were, beyond the awful veil which obscures the features of Deity, and conceals Him from the eyes of His creatures, dwelling as with a present God in the midst of His sublime works; with a mind thus elevated, how insignificant would appear to her the transactions, and the sufferings of this world! How poor the boasted power of man, when the fall of a single cliff from those mountains would with ease destroy thousands of his race assembled on the plains below."[3]

Though silence, too, was sometimes part of the older sublime, it

was generally suspenseful, attended by terror and dread, and often interrupted by the uproar of cataracts, earthquakes, fires, storms, thunder, volcanoes: "Nothing is more sublime than mighty power and strength. A stream that runs within its banks is a beautiful object; but when it rushes down with the impetuosity and noise of a torrent, it becomes a sublime one."[4] The eighteenth-century interest in Longinus took up his suggestion that "Nature impels us to admire not a small river 'that ministers to our necessities,' but the Nile, the Ister [Danube] and the Rhine; likewise the sun and the stars 'surprise' us, and Aetna in eruption commands our wonder."[5] Kant, who transferred the sublime from a quality residing in the object to the perceiver's state of mind, associated sublimity with natural cataclysms—lightning, storms, mountains, waterfalls.

Thus, even for the philosopher who influenced so much transcendental idealism, the sublime reflected overwhelming natural energies. Nature was often conceived of as wild and savage, coinciding with the vogue for Ossian's poetry and for Salvator's landscapes. And the connection of the sublime with the picturesque, with *pictures* (Gilpin speaks of picturesque sublimity and picturesque beauty), opens the door to the other pictorial hero of the moment, Claude, who was, of course, because of his calm repose, put forward as an example of the beautiful in contrast to Salvator's sublimity.

This older romantic-Gothick sublime endured well into the American nineteenth century. As concept and vision, it was nourished, first, by the uncultivated wilderness of the East, then by the penetration of the majestic western territories. Many of its attributes can be recognized in the more ambitious works of the Hudson River school, which often drew on the conventions of Claude and on the moods of Salvator. The active energy and noisy cataclysm of Church's adventures in South America relate to the older sublime.

In his diary of 1857 in Ecuador, Church writes of his journey to the volcano Sangay (July 11th) (fig. 21; see also fig. 42):

I knew there could be no view of Sangay this night without a scramble and as there was a couple of hours to spare I seized my sketch book and commenced the ascent of the hill behind us. It seemed not very high but the exertion of working through the grass was tremendous and I toiled and toiled while every little eminence which I gained revealed a still more elevated one above, but I persevered and was rewarded finally, by planting my feeting [*sic*] on the summit. Clouds hung around the mountains everywhere and I looked in vain in the direction of Sangay for a sight of the mountain or smoke—So turning my back, I commenced a sketch of the picturesque mountains at the Southwest, where the clouds did not hang low enough to cover the snow line. Gradually the clouds broke away, the sun came out and gilded with refined gold every slope and ridge that it could touch, and the most lovely blue contrasted with the rich color—

My sketch finished, I turned my back and lo! Sangay, with its lofty plume of smoke stood clear before me. I was startled with the beauty of the effect—above a serrated, black, rugged pile of rocky mountains two columns arose, one creamy white against the blue sky melted itself away into thin vapor and was lost in the azure. The other, black and sombre, piled up in huge rounded forms cut sharply against the rich white of the first, and piling itself up higher and higher gradually diffused itself into a yellowish smoky vapor out of which occasionally would burst a mass of the black smoke. . . .

I commenced to sketch the effect as rapidly as possible, but constant changes took place and new beauties revealed themselves as the setting sun turned the black smoke into burnished copper and the white steam into gold. At intervals of two or three minutes an explosion would take place; the first intimation was a fresh mass of smoke with sharply defined outline rolling above the black rocks and immediately a dull rumbling sound which reverberated among the mountains. I was so delighted with the changing effects that I continued making rapid sketches of the different effects until night overtook me and a chilly dampness warned me to retrace my steps. . . .[6]

Church's emphasis is on the aural as well as visual drama of the experience. The sublime, from this point of view, is clearly very difficult

21. Frederic Edwin Church, *Distant View of Sangay, Ecuador,* 1857
Oil with pencil on paperboard, 8⅘″ × 14⅕″. The Cooper-Hewitt Museum of Design, New York, Smithsonian Institution

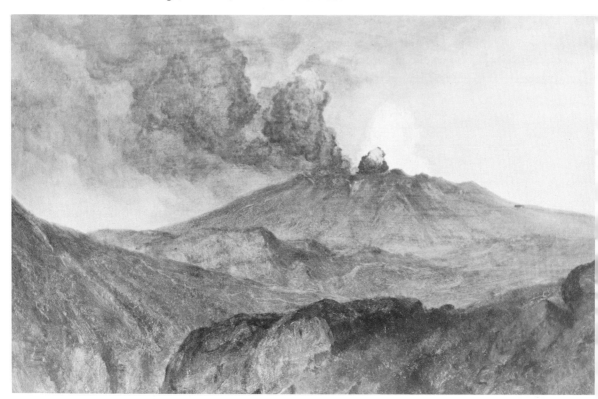

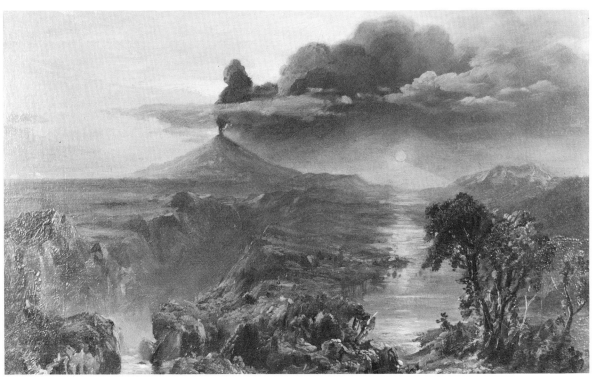

22. Frederic Edwin Church, *Study for Cotopaxi,* 1861
Oil on canvas, 7″ × 11¾″. The Nelson Holbrook White Collection

to attain. One must scale the heights, risk "life and limb," as Tucker-
man noted, at "great cost of fatigue and exposure" to experience it.[7]
The journey itself is not only a tour de force, but assumes a special
moral significance.

The introduction of a pious morality often signaled the increasing
Christianization of the sublime. In such operatic paintings as *Heart
of the Andes* (see fig. 17) or *Cotopaxi* (figs. 22 and 28, color), the senses
are blurred in a paroxysm of activity. Cotopaxi erupts. Sounds fill the
air. One is reminded of the noisy conversions of the evangelical revival
especially prevalent in the upstate New York area that spawned so
many Hudson River painters: shouting, biting, groaning, etc. The
tumult of such paintings corresponds to the moment of destruction in
the Apocalypse and the moment of conversion in revivalism. Here
sublimity overwhelms with a deafening roar. It maintains its ties with
the older sublime through its stress on man's insignificance in the face
of God's terrible power.

Yet, in the writings of artists and critics alike, these awesome con-

notations of divinity, traditionally attached to the sublime through intimations of infinity, become more specifically religious, even Protestant, in nature. That Church's histrionic paintings called to mind the Apocalyptic consumption of the world by fire is suggested by Tuckerman's remark, in writing of *Heart of the Andes:* "Seldom has a more grand effect of light been depicted than the magnificent sunshine on the mountains of a tropical clime, from his radiant pencil. It literally floods the canvas with celestial fire, and beams with glory like a sublime psalm of light."[8]

Thus the sublime was being absorbed into a religious, moral, and frequently nationalist concept of nature, contributing to the rhetorical screen under which the aggressive conquest of the country could be accomplished. The older sublime was a gentleman's preserve, an aristocratic reflex of romantic thought. The Christianized sublime, more accessible to everyone, was more democratic, even bourgeois. Its social effect was thus far wider. The change in the meaning of the sublime, then, was intimately connected with the power the landscape exerted over the American mind, enhancing the landscape artist's status as a useful member of his society.

As early as 1835, in his "Essay on American Scenery," Thomas Cole, Church's mentor and teacher, had offered a clue to still another shift in meaning. Cole introduces the traditional idea of the sublime when he finds in the mountains of New Hampshire "a union of the picturesque, sublime and the magnificent," and in the Sandwich range, especially, a mixture of "grandness and loveliness . . . the sublime melting into the beautiful, the savage tempered by the magnificent."[9] But in addition to such familiar late-eighteenth-century notions of the sublime, Cole cautions the reader to "learn the laws by which the Eternal doth sublime and sanctify his works, that we may see the hidden glory veiled from vulgar eyes."[10]

Nature is both sublime and sanctified. The task of artist and spectator is to unveil, to *reveal* the hidden glory. As we have noted, the idea of revelation, and also of Revelation, is often found in conjunction with this Christianized sublime. Durand, in his "Letters," picked up his friend Cole's theme twenty years later. To his hypothetical student, he writes: "I refer you to Nature early, that you may receive your first impressions of beauty and sublimity, unmingled with the superstitions of Art. . . ."[11] And though he continues that "Art has its superstitions as well as religion," he notes shortly after: "There is yet another motive for referring you to the study of Nature early—its influence on the mind and heart. The external appearance of this our dwelling-place, apart from its wondrous structure and functions that minister to our

well-being, is fraught with lessons of high and holy meaning, only sur-
passed by the light of Revelation."[12] For Emerson, the connection be-
tween the sublime and Revelation was even more profound: ". . . *Rev-
elation* . . . attended by the emotion of the sublime . . . is an influx
of the Divine mind into our mind."[13]

But Cole, in the same seminal essay of 1835, also suggested that revela-
tion, as an experience of the sublime, was not necessarily apocalyptic.
He refers to a moment when, confronted by two lakes in Franconia
Notch, he was "overwhelmed with an emotion of the sublime such as
I have rarely felt. It was not that the jagged precipices were lofty, that
the encircling woods were of the dimmest shade, or that the waters
were profoundly deep; but that over all, rocks, wood and water,
brooded the spirit of repose, and the silent energy of nature stirred
the soul to its inmost depths."[14]

This experience of sublimity through repose, this apprehension of
silent energy, had important connotations for the future. "I would
not be understood that these lakes are always tranquil," Cole con-
tinues, "but that tranquillity is their great characteristic. There are
times when they take a far different expression, but in scenes like
these the richest chords are those struck by the gentler hand of nature"
(fig. 23).[15]

With a sublime discovered not in sound, but in silence (in what
Emerson called "the wise silence" of the Over-Soul), we move into an-
other philosophical region. Such a concept is essentially mystical, re-
calling Meister Eckhart, who was rediscovered by the German idealists
so avidly read by Emerson. Eckhart spoke of "the central silence" of
the soul, in which it is attuned to "this utterance of God's word."[16]

Silence in the older sublime was unsettling, even awesome. The ele-
ment of peace and tranquility in the later sense of the sublime is in
opposition to the earlier concept. That there was some audience
for such quiet sublimity is suggested by Tuckerman's record of criti-
cism of a painting of Lake George by Kensett: "Mr. Kensett has
long been accepted as a most consummate master in the treatment of
subjects full of repose and sweetness, and been honored by critics and
painters for the simple and unpretending character of his works. . . ."
Tuckerman then observes, "The subdued tone of the autumnal at-
mosphere and foliage in this picture is tender and true; its effect is
singularly harmonious; how exquisite the clouds, warm the atmo-
sphere, and effective the large oak in the foreground; and above all,
what sublime repose."[17]

If the older sublime could be characterized by the vigorous sound
of a cataract, the repose of Lake George, steeped in silence, found its

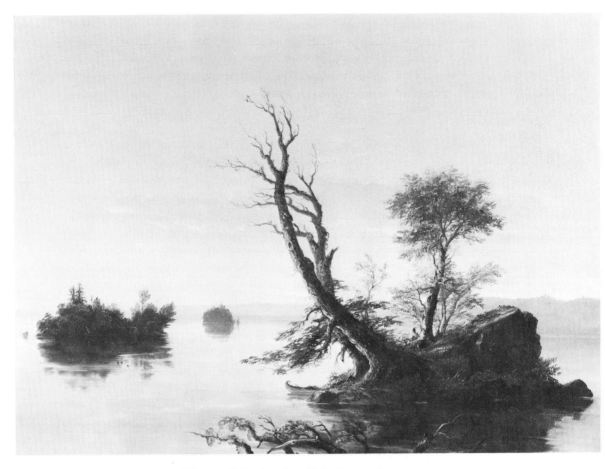

23. Thomas Cole, *American Lake Scene*, 1844
Oil on canvas, 18¼″ × 24½″. The Detroit Institute of Arts, gift of Douglas F. Roby

aural equivalent in unruffled water. Water has a special significance in American landscape painting, linking different kinds of esthetic and landscape. The subject of much contemporary comment, the "unruffled mirror" motif bears strong feelings.

Even in the large, dramatic compositions, which maintain contact with the older sublime, water often inserts a quota of stillness, symbolizing a spirit untroubled in its depths and unifying both surface and depth in its reflection of the world above. The artist and spectator, after scaling the picture's height and descending to its valleys in an empathy that was encouraged, could here find rest. Thus when we see pockets of still water in nineteenth-century American landscape we may speak of a contemplative idea, a refuge bathing and restoring

the spirit, and of a compositional device marrying sky and ground by bringing the balm of light down to the earth on which the traveler stands.

When Cole, in the same essay, speaks eloquently of the "purity" and "transparency" of water and isolates "the unrippled lake, which mirrors all surrounding objects" and expresses "tranquillity and peace," and in which the most perfect, and therefore the most beautiful, reflections may be found, he is voicing a form of idealism which once more recalls the traditional language of Christian mysticism.[18] Clear, pure water has always been an obvious Christian symbol, frequently of the Virgin. It reappears now, in the writings of Emerson and of Thoreau, who called a lake "the landscape's most beautiful and expressive feature. It is earth's eye; looking into which the beholder measures the depth of his own nature."[19] Of Walden, he wrote, "Walden is a perfect forest mirror. . . . Nothing so fair, so pure, and at the same time so large, as a lake, perchance, lies on the surface of the earth. Sky water. It needs no fence. Nations come and go without defiling it. It is a mirror which no stone can crack . . . a mirror in which all impurity presented to it sinks, swept and dusted by the sun's hazy brush. . . ."[20]

Such expanses of water, "like molten glass cooled but not congealed,"[21] occur most frequently in American art in the transcendental luminist landscapes, which suggest to us Emerson's observation: "The laws of moral nature answer to those of matter as face to face in a glass."[22] The still, glassy surfaces of luminist landscapes, perfect mirrors of God's word, recall Eckhart's "The eye and the soul are also mirrors, and whatever stands in front of them appears within them."[23] In paintings by Heade, Lane, Gifford, Kensett, and countless others who practiced this quietistic mode at least occasionally, silence, soul, mirror are all related, swept and dusted, as Thoreau suggests, by light (fig. 24).

Light is, of course, more than any other component, the alchemistic medium by which the landscape artist turns matter into spirit. For Durand, sunlight was, among other things, a type of the divine attribute.[24] For Cole, the sky itself was "the soul of all scenery, in it are the fountains of light, shade and color. . . . It is the sky that makes the earth so lovely at sunrise, and so splendid at sunset. In the one it breathes over the earth the crystal-like ether, in the other the liquid gold."[25]

In American art especially, light has often been used in conjunction with water to assist spiritual transmutation, either dissolving form, as in some of Church's large South American pieces, or rendering it crystalline, as in the works of Lane. In the former, light is more closely attached to what we generally call atmosphere, and has a dif-

fusive, vaporous quality (fig. 25). In the latter, light itself partakes of the hard shiny substance of glass (fig. 26).

In all instances, the spirituality of light signals the newly Christianized sublime. In the large paintings by Church and Bierstadt light moves, consumes, agitates, and drowns. Its ecstasy approaches transcendence, but its activity is an impediment to consummating a complete unity with Godhead. In its striving it is Gothic, in Worringer's terms, and human.[26] Though it draws on the older concept of the sublime, it extends the esthetic to a religious attitude, maintaining nonetheless a distance from Deity. Although overwhelming scale establishes the insignificance of artist and viewer, the painting, through the stroke which activates atmosphere, avoids negation of the artist's ego. Perhaps the difference between the two later concepts of the sublime lies precisely in the extent to which such paintings are still anthropomorphic.

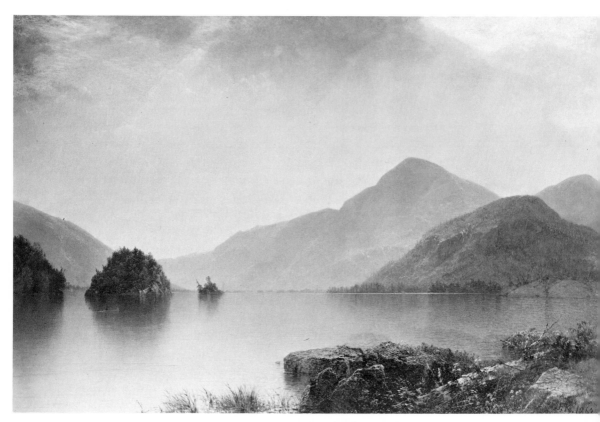

24. John F. Kensett, *Lake George*, 1869
Oil on canvas, 44″ × 66¼″. The Metropolitan Museum of Art, New York, bequest of Maria DeWit Jesup

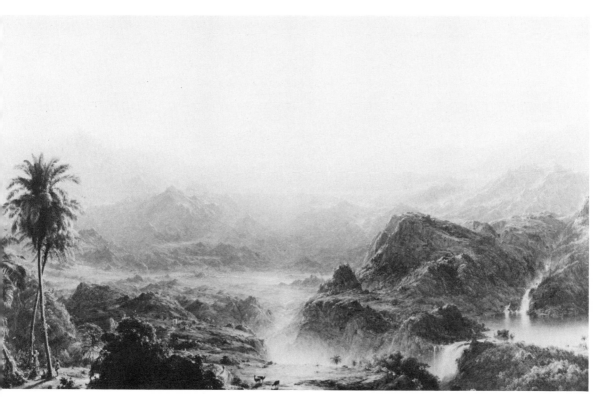

25. Frederic Edwin Church, *The Andes of Ecuador,* 1855
Oil on canvas, 48″ × 75″. Reynolda House, Winston-Salem, North Carolina

In the smaller, luminist paintings, also executed occasionally by Church and Bierstadt, light, because of its silent, *unstirring* energy, causes the universe, as Emerson would have it, to become "transparent, and the light of higher laws than its own" to shine through it.[27] For Emerson, the soul in man "is not an organ . . . not a faculty, but a light. . . . From within or from behind, a light shines through us upon things and makes us aware that we are nothing, but the light is all."[28] Such a concept is not unlike Eckhart's idea of the soul "coming into the unclouded light of God. It is transported so far from creaturehood into nothingness that, of its own powers, it can never return to its agents or its former creaturehood."[29]

Eckhart's "nothingness" involves a mystic abandonment of self which ultimately distinguishes the American transcendental landscapes from those which maintain an anthropomorphic tie to the ego in the midst of spiritual experience. The admonitions to the painter to lose sight of himself in the face of nature came from many quarters. We find it in the popular periodicals and in the artists' journals, as

43

26. Fitz Hugh Lane, *Western Shore with Norman's Woe,* 1862
Oil on canvas, 21½" × 35½". Cape Anne Historical Association, Gloucester,
Massachusetts

well as in transcendental writing.[30] But in actual practice, only in
luminist quietism does the presence of the artist, his "labor trail," dis-
appear. Such paintings, in eliminating any reminders of the artist's
intermediary presence, remove him even from his role of interpreter.
In their quiet tranquility, they reach to a mystical oneness above time
and outside of space. In this new concept of sublimity, oneness with
Godhead is complete, and the influx of the divine mind is no longer
mediated by the theatrical trappings of the late-eighteenth-century
Gothick.

PART TWO

IV

The Geological Timetable: Rocks

The Trinity of God, Man, and Nature was central to the nineteenth-century universe. Nature itself was illuminated by another Trinity: art, science, and religion (fig. 27). Nature's truths, as revealed by art, could be further validated by the disclosures of science, which revealed God's purposes and aided the reading of His natural text. At mid-century, landscape attitudes were firmly based on this unity of faith, art, and science—a precarious unity, as we shall see. Common to all three was an idea that obsessed the period: Creation.

Behind much landscape art in America was a desire to approximate the moment of Creation itself. This was so whether the artist respectfully duplicated nature in the work of art (Durand), or whether his aim was to imitate the creative powers of God (Cole). Cole's reference to "those scenes of solitude from which the hand of nature has never been lifted"[1]—his concern for these "undefiled works" of God—partly reflected the ideas of Rousseau and the late-eighteenth-century sublime. But the urge to touch origins became a quest for primal truths that would redeem the present.

So strong was the belief in the powers of science that there was no difficulty in aligning its aims with those of art. "By unfolding the laws of being . . . ," wrote James Jackson Jarves, science "carries thought into the infinite, and creates an inward art, so perfect and expanded in its conceptions that material objects fashioned by the artist's hand become eloquent only as the feeling which dictated them is found to be impregnated with, and expressive of, the truths of science. The mind indignantly rejects as false all that the imagination would impose upon it not consistent with the great principles by which God manifests himself in harmony with Creation. As nature is His art, so science is the progressive disclosure of His soul, or that divine philosophy which, in comprehending all knowledge, must include art as one of its forms." Jarves, aware perhaps of the contradictions inherent in his proposition, tried to reconcile an inspirational art with scientific truth. Art, he went on, "should exhibit a scientific

47

27. Albert Bierstadt, *A Storm in the Rocky Mountains—Mount Rosalie*, 1866
Oil on canvas, 83″ × 142¼″. The Brooklyn Museum

correctness in every particular, and, as a unity, be expressive of the
general principle at its center of being. In this manner feeling and
reason are reconciled, and a complete and harmonious whole is ob-
tained. In the degree that this union obtains in art its works become
efficacious, because embodying, under the garb of beauty, the most of
truth." Truth and beauty, those pillars of the nineteenth-century mind,
stand firm. And art will be "valuable as an elementary teacher by rea-
son of its alliance with science. . . ."[2]

Such thoughts summarize fairly accurately those of the age—
aware of frictions between reason and feeling, between truth and
beauty, between historical and mythical time. To a degree these
themes engaged advanced thinking everywhere. But in America, they
were intensely experienced within the context of landscape painting.

Science had rapidly become an article of the American faith in prog-
ress. As Russel Nye puts it: "Nearly every leader of American thought
agreed that science provided the best possible tool with which man

48

might discover those fundamental laws and truths—in nature and human nature—on which progress depended."[3]

For Jefferson, scientific knowledge "should be useful in social, moral, legal, cultural and spiritual affairs," reaching into "the mass of mankind . . . [to] circle the extremes of society, beggars and kings."[4] Perry Miller has noted that America was quickly able to identify science with the national destiny. As Richard Harlan announced at the University of Pennsylvania in 1837: "What may not be expected in a country like our own? where the monstrous forms of superstition and authority, which tend to make ignorance *perpetual,* by setting bounds to the progress of the mind in its inquiry after physical truths, no longer bar the avenues of science; and where the liberal hand of nature has spread around us in rich profusion, the objects of our research."[5]

In the first half of the century, the American sciences and the art of landscape painting developed rapidly and concurrently. Botany, zoology, meteorology, astronomy, geography, geology, emerging from under the rubric of natural philosophy and natural history, separated out into quickly moving currents. Early in the century, astronomy, because it was "the perfect form of contemplation," could more than any other science "exalt the soul and fill it with sublime conceptions of the great Author of nature. . . ."[6] Very quickly, however, it was challenged by geology, which remained the locus of some of the most controversial arguments about God, man, and religion for the better part of the century.

In the aged rocks and primeval forests so exhilarating to the romantic poets and artists resided crucial clues to Creation. It was the artists' task, as much as the scientists', to discover and interpret the truths of nature. Whenever science, especially geology, could assist this pursuit, it was appropriated for artistic purposes.

Mircea Eliade speaks of myths as being "always an account of a 'creation,'" dealing only with "that which *really* happened."[7] In this sense, geology was the Great Myth of the nineteenth century. It offered Americans a past at once more recent and more remote: the wilderness, ever new in its virginity, also stretched back into primordial time. That past was crucial in establishing an American sense of identity—sought nowhere more than in landscape painting. By augmenting science with inspiration, the artist could get closer to the elusive enigmas of Creation, and also approach solutions that might confirm America's providential destiny.

So we find Jarves noting of Bierstadt's landscapes: "The botanist and geologist can find work in his rocks and vegetation. He seizes upon natural phenomena with naturalistic eyes."[8] While Tuckerman, writing of Church, remarks:

His taste in reading suggests a scientific bias; he has long been attracted by the electrical laws of the atmosphere, and has improved every opportunity to study the Aurora Borealis. . . . The proof of the scientific interest of such landscapes as have established Church's popularity, may be found in the vivid and authentic illustrations they afford of descriptive physical geography. No one conversant with the features of climate, vegetation and distribution of land and water that characterizes the portions of North and South America, as represented by this artist, can fail to recognize them in all his delineations. It is not that they merely give us a vague impression, but a positive embodiment of these traits. The minute peculiarities of sky, atmosphere, trees, rocks, rivers and herbage are pictured here with the fidelity of a naturalist.[9]

The artist's descriptive fidelity had, of course, to be combined with Tuckerman's idea of "general effect." Church's *Cotopaxi* (fig. 28; color), he wrote, "is both in general effect and in authentic minutiae . . . absolutely and scientifically true to the facts of nature and the requirements of art." Even more important: "we recognize the manner and method of Nature in her volcanic aspects."[10] This grand concern—to reveal the actual "manner and method of Nature"—goes far beyond specific detail. It may be, in its most profound sense, what Tuckerman means by "general effect." Getting the general effect raised the role of the artist to its noblest apogee. More modestly, the desire simply to *know* may have led the artists to join the westward expeditions, to read what they could of contemporary science and study the specimens of flowers pressed and dried into their herbariums. Truth to specific detail conferred credibility on their landscapes. But science was most important because, as Jarves put it, it talked "face to face with spirit, disclosing its knowledge direct to mind itself."[11] So revealing nature's "manner and method" required a certain worldview, a scientific frame of reference through which nature's basic working principles could be grasped and made a part of the work of art.

At mid-century, the artists' belief in the unity of God and nature remained undisturbed, nor was it apparently shaken by the publication of *The Origin of Species* in 1859. This attitude was consistent with the tone of pre-Darwinian science, which ingeniously rationalized each step towards Darwinism with a powerful religious idealism. The "new science" has perhaps been read too quickly into references to organic change in the pre–Civil War era.[12] This derives from the doubtful premise that an *awareness* of organic change alone (apart from natural selection and mutation of species) was equivalent to Darwinism. It also leads to some misunderstanding of the art of the period.[13]

Until *Origin* appeared, organicism could still be explained as one more indication of God's ordered control of all things on earth (and

in heaven). In 1842, the same year that Darwin wrote his preliminary essay for *Origin,* the American geologist-theologian Edward Hitchcock wrote:

It appears that one of the grand means by which the plans of the Deity in respect to the material world are accomplished is constant change: partly mechanical, but chiefly chemical. In every part of our globe, on its surface, in its crust, and we have reason to suppose, even in its deep interior, these changes are in constant progress. . . . In short, geology has given us a glimpse of a great principle of *instability,* by which the *stability* of the universe is secured; and at the same time, all those movements and revolutions in the forms of matter essential to the existence of organic nature are produced. Formerly, the examples of decay so common everywhere were regarded as defects in nature; but they now appear to be an indication of wise and benevolent design—a part of the vast plans of the Deity for securing the stability and happiness of the universe.[14]

Such scholars as Gillispie, Eiseley, and Lovejoy have dealt at length with the work of Darwin's forerunners, though, predictably, there are disagreements about the importance of their contributions. Eiseley notes: "By the end of the eighteenth century, the *idea* of unlimited organic change had spread far and wide. It certainly was not a popular doctrine, but it had long been known in intellectual circles, largely through the popularity of Buffon."[15] Indeed, Buffon has been singled out, along with Sir Charles Lyell, the American physician William Wells, and the controversial Robert Chambers, as an important precursor of Darwin's theories.[16] Lovejoy especially, in a historic article, "The Argument for Organic Evolution before *The Origin of Species*" (1909), holds that the theory of evolution was substantially complete before Darwin. Lovejoy's article concludes with A. W. Benn's suggestion that Robert Chambers's *The Vestiges of the Natural History of Creation* (1844) would generally have been accepted "as convincing, but for theological truculence and scientific timidity. And Chambers himself only gave unity to thoughts already in wide circulation. . . . The considerations that now recommend evolution to popular audiences are no other than those urged in the 'Vestiges.' "[17] In *Genesis and Geology* (1951) Gillispie suggests that Lovejoy does not adequately allow for the inclusion "in the whole scientific situation" of "the persistence into the 1840's of the idea of a superintending Providence in natural history."[18] As Gillispie's study makes clear, the widespread belief in the providential role of God was not really challenged until *Origin.*

In science, as in art, the seeds of new theories germinate beside older ideas more firmly planted in the cultural soil. If Chambers's *Vestiges* was rejected when it appeared, it was probably not only because of "theological truculence and scientific timidity" but because providen-

tial ideas were still too pervasive. To understand American landscape painting in the pre-Darwinian era, we must appreciate the role of providence in the shaping and control of nature as conceived by science before *Origin*.

In the late eighteenth and early nineteenth centuries geology was dominated by the polemic battle of the Neptunists and the Vulcanists (or Plutonists). The Neptunists, followers of Abraham Werner (1750–1817) believed that stratification of the earth's crust was caused by the precipitation of layers of rock out of a universal sea which had covered the earth.[19]

The Vulcanists supported James Hutton (1726–97), who held that "dynamic forces in the crust of the earth created tensions and stresses which, in the course of time, elevated new lands from the ocean bed," while other exposed surfaces eroded.[20] Hutton found the "decaying nature of the solid earth" to be "the very perfection of its constitution as a living world."[21] Related to the clash between the Wernerians and the Huttonians, respectively, were the theories of catastrophism and uniformitarianism. Catastrophism held that all the large world changes were due to sudden and violent cataclysms, punctuated by long periods of calm; the uniformitarians believed geological phenomena were produced by natural forces operating uniformly over long periods of time.[22] The symbolism of Werner's sea was also appealing to those who wished to remind the world of the Noachian deluge. Eiseley notes that "by the end of the eighteenth century, catastrophism . . . was the orthodox and accepted view of geology upon the past history of the earth."[23]

That history, however, soon began to lengthen. Gillispie observes that by 1820 the age of the earth had been vastly extended, and "the effort to connect Holy Writ directly to earth history was now felt to have been discreditable to all concerned. The actual origin of the earth's surface could no longer be identified with specific scriptural events. On matters such as this . . . the Huttonian attitude had prevailed."[24] Nonetheless, "the main positions of providential natural history were still secure. . . ."[25] Even when biblical accounts had been scientifically disproved, the geologists found ways to accommodate new scientific discoveries to the divinity of Creation. That most geologists, in England and America, were also clergymen strengthens the point. As T. H. Huxley put it, "Extinguished theologians lie about the cradle of every science as the strangled snakes beside that of Hercules."[26]

Early in the century providential planning was further popularized as the concept of design. This was largely through the influence of

William Paley's *Natural Theology* (1802), a widely used text still in the Harvard curriculum as late as 1855.[27] Even Darwin had early read and absorbed Paley's famous dictum:

There cannot be design without a designer; contrivance without a contriver; order without choice; arrangement, without any thing capable of arranging; subserviency and relation to a purpose, without that which could intend a purpose; means suitable to an end, without the end ever having been contemplated, or the means accommodated to it. Arrangement, disposition of parts, subserviency of means to an end, relation of instruments to an use, imply the presence of intelligence and mind.[28]

Design held steadily in the pre-Darwinian era, a blueprint perhaps for the Platonic ideas with which artists like Thomas Cole invested the landscape. Cole, unlike Hitchcock at about the same time, still thought in terms of defects: "By true in Art I mean imitation of true Nature & not the imitation of accidents, nor merely the common imitation that takes nature indiscriminately. All nature is not true. The stunted pine —the withered fig tree, the flower whose petals are imperfect are not true . . . the imitation of art should be the imitation of the perfect as far as can be in Nature, & the carrying out of principles suggested by Nature." And, "What I mean by true in Nature is—the fulfillment in themselves, the consummation . . . of created things, of the objects & purposes for which they were created."[29]

Cole's idea of perfect self-fulfillment and purpose in nature might be considered beside John Dewey's illuminating essay "Darwin's Influence upon Philosophy" (1909). Dewey observes that from the Greeks to Darwin "the classic notion of species carried with it the idea of purpose. In all living forms, a specific type is present directing the earlier stages of growth to the realization of its own perfection. . . . Nature, as a whole, is a progressive realization of purpose strictly comparable to the realization of purpose in any single plant or animal."[30]

This, Dewey reminds us, was the "regnant philosophy" of Europe for over two thousand years. In the pre-Darwinian era organicism stopped firmly short of the mutability of species. Species were still fixed, and if change entered the picture, constancy, as Hitchcock suggested, lay behind the change. Gillispie writes: "Mutation of species was not seriously under discussion before 1844, and not seriously in prospect until 1859—nowhere, that is, except in Darwin's immediate and restricted circle."[31]

Fixity of species was still connected, however tenuously, to the Great Chain of Being, which as Lovejoy suggests had begun to change subtly by the late eighteenth century.[32] The older idea of the Chain of Being, with each rung of the ladder of nature carefully separated, seems, however, to have maintained itself well into the nineteenth century.[33] As Eiseley has pointed out, "the Scala Naturae in its pure form asserts

the immutability of species."[34] This immutability of species, crucial to the mechanism of design, remained essentially undisturbed until *Origin*.

Pre-Darwinian science, then, accommodated discovery to design. Each new revelation was quickly enlisted as a proof of providential creation. Paradoxically, the last thing the age intended was to disprove God. But it had an obsession to uncover and share His earthly secrets. The artists, like the scientists, wanted to discourse "face to face with spirit." If science could help them, they eagerly accepted its aid. To assume a scientific attitude towards nature, to read its "manner and method" through the lens of science, was, in this sense, a religious act.

What could the American artists have known of current scientific ideas and attitudes? Which aspects of the pre-Darwinian breakthroughs filtered into their awareness through periodicals, books, or lectures? Until we know more about the artists' libraries and reading habits, we have little to go on. But the evidence at hand prompts a few speculations.[35]

They were surely familiar with Sir Charles Lyell, the British geologist whose theories profoundly affected Darwin's early development.[36] Darwin, who read Lyell's *Principles of Geology* (1830) during his voyage on the *Beagle,* later wrote: "I always feel as if my books came half out of Lyell's brain, and that I never acknowledge this sufficiently; . . . for I have always thought that the great merit of the *Principles* was that it altered the whole tone of one's mind. . . ."[37]

In the 1830's, during one of his frequent visits to America, Lyell commissioned the Pennsylvania artist Russell Smith to do a painting of Niagara Falls. Smith also did scientific illustration for Lyell,[38] as well as for Benjamin Silliman, the founder of the prestigious *American Journal of Science and Arts,* which presented many of the more recent scientific theories. Lyell, who fought mutability for a long time and only accepted it reluctantly,[39] gave a series of eight lectures at the Broadway Tabernacle in New York in 1840.

Who sat in the audience he instructed on the rock formations of the Palisades across the Hudson? Which artists might he have inspired when he mentioned Mt. Aetna, so frequently painted by American landscapists in Italy (fig. 29)? Echoing some aspects of the sublime, he spoke of the mood that prevailed there except when floods occurred: "The silence which pervades on this account is quite remarkable, for no torrents dash from the rocks, nor is there any movement of running water as in most mountainous countries. Not a rill runs down the sides. All the rain that falls from the heavens, and all the water from the melting snow, is instantly absorbed by the porous lava."[40]

29. Thomas Cole, *Mount Aetna from Taormina, Sicily,* 1844
Oil on canvas, 32½″ × 48″. The Lyman Allyn Museum, New London, Connecticut

By then, Lyell was well known and respected in American artistic and literary circles. Emerson reported in *The Dial* in 1842: "After holding annual meetings in New York and Philadelphia, the Geologists assembled in April of this year in Boston, to the number of forty, from the most distant points of the Union. . . . Mr. Lyell from London was present."[41]

Emerson owned at least one copy of Lyell's famous and influential *Principles,* in an 1837 edition.[42] According to Whicher: "He read Lyell about 1836; and about that time a new note slips into his forest thoughts. It spoke of 'archaic calendars of the sun and the internal fire, of the wash of rivers and oceans for durations inconceivable'; of 'Chimborazo and Mont Blanc and Himmaleh,' of the 'silent procession of brute elements.' . . . 'Why cannot geology, why cannot botany speak and tell me what has been, what is, as I run along the forest promontory, and ask when it rose like a blister on heated steel?' "[43]

More than anyone else, it was Lyell who, in 1830, extended the

55

earth's age indefinitely in the general mind. Yet this enhanced rather than destroyed the sense of wonder at Creation, exchanging the 6,000-year Mosaic timetable for a regressive infinity more appealing to the growing romantic appetite for the primordial. This transfer from biblical to geological time, from textual youth to a literal antiquity read in strata and fossils, did not violate the idea of the providential role in Creation. As Hitchcock wrote in 1842: "A minute examination of the works of creation as they now exist, discloses the infinite perfection of its Author, when they were brought into existence; and geology proves Him to have been unchangeably the same, through the vast periods of past duration, which that science shows to have elapsed since the original formation of our earth. . . . Geology furnishes many peculiar proofs of the benevolence of the Deity."[44] What we know of the landscapists' attitude to geology indicates that the new scientific discoveries reinforced, rather than ruptured, their faith. As the Hudson River landscapists were developing, the world aged into this primeval infinity. The landscapists already had a poetic base for their sensibility for time and wildness in the works of the English Lake Poets with which they were so familiar, and in the works of such American poets as Bryant. But to verify poetic intuitions with science must have offered them that element of the specific which was a pragmatic American need, even in discourse with the ideal.

The ideal was, in effect, made actual through geological revelation. In some ways, this was the perfect merger of the truth and beauty sought in each esthetic quest. Cole, who took a Wordsworthian pleasure in America's hoary trees, whose romantic sense of "time" was integral to how he painted the landscape, whose works are a dialogue between the cultivated antiquity of past civilizations and the natural antiquity of the untouched wilderness, spoke easily of geological time in his essay "Sicilian Scenery and Antiquities" (1844). Of Aetna he wrote: "From the silence of Homer on the subject, it is supposed that in his remote age the fires of the mountain were unknown; but geologists have proof that they have a far more ancient date."[45]

Cole owned at least one book on geology, Comstock's *Geology*, which shared his library shelf with a book on the history of quadrupeds, two volumes by an "Oxford Graduate," and a great deal of poetry, including Coleridge, Keats, Schiller, Southey, Byron, Cambell (*sic*), Wordsworth, Ossian, Milton, and Thompson.[46] In his copy of the *Literary World* for Saturday, October 16, 1847, he would have been unlikely to miss an article, just preceding a notice on the Art Union, reporting on the meetings of the American Association of Naturalists and Geologists. Here he could read that "Professor Agassiz made a report on the geographical distribution of animals along the coast of New England. His remarks tended to the conclusion of

separate and local creation of animals. . . ." He might also have noted the reports on Mr. Hall's investigation "into the Paleontology of the lower geological strata of New York"; Professor Henry's experiments on light and heat; Commander Wilkes's observations on the depth and saltness of the ocean; Professor Emmons's paper on the distribution of inorganic matter in forest and fruit trees; and Professor H. D. Rogers on the geological age of the rocks of Maine, a subject surely pertinent to Cole's visits in the forties to Mount Desert.[47]

Cole's interest in the new scientific developments is also signaled by his letter to Benjamin Silliman dated November 11, 1839:

My friend, Mr. Wm. Adams of Zanesville, Ohio has informed me that several weeks ago he forwarded to you a collection of Fossils that he had procured at my request. He apologizes for having allowed so great a length of time to elapse since I requested him to get these Fossils and is very desirous of ascertaining whether they arrived in safety, or are considered by you as interesting or valuable. . . . I am very much disappointed in not having had the opportunity of gratifying my desire of visiting New Haven during the past summer, but I shall endeavor to console myself with the hope that another summer will not pass without renewing the agreeable impressions my former visit made.

Silliman answered on November 15, 1839, that he had not yet received the fossils, and added, "It is gratifying to us all that you recollect your visit here with pleasure & we hope it may be renewed at any time when your convenience will permit. . . . Short as your visit was it left on every member of my family the most agreeable impression and we would be most gratified to have it renewed. . . ."

The references to Cole's visit remain provocative. How much contact did American artists have with scientific figures of Silliman's stature? Silliman, the famous Yale professor of chemistry and natural history, was, we know, a staunch friend and supporter of the history painter John Trumbull. He went on geology trips with another history painter, artist-inventor Samuel Morse, and was familiar with the scientific efforts of Charles Willson Peale. He was also in contact with Robert Gilmor, Jr., Cole's early patron, and was related by marriage to another patron, Daniel Wadsworth. Of the leading landscapists, he knew not only Cole, but Durand.[48] The founder of the "sole organ" of research "with both a nationwide circulation and an audience in Europe,"[49] Silliman was also the first president of the Association of American Geologists (1840), reaching thousands of Americans through his lectures.

Despite his contact with advanced scientific ideas, Silliman insisted that all nature's associations were "elevated and virtuous." He was reluctant to abandon scriptural truth completely, and included a chapter on the geological action of the Flood in a geology textbook

he edited. Only "with this double view" could he feel that "Science and Religion may walk hand in hand."[50]

Since Silliman's comments about nature's virtues were made in the 1820's, his attitudes might be dismissed as those of an earlier generation. Yet even at his most enlightened, his concept of the relation between science and religion, between virtue and nature, endured in his own thought—as in that of many of his contemporaries—with much of the obstinacy of the rocks under discussion. As late as 1859, the year of *Origin*, a writer in *The Crayon* speculated about "The Relation between Geology and Landscape Painting" and reminded the landscapist that "his picture is a representation of moral principles and sentiment; not merely an imitation." The landscapist always has

companions, who entertain and instruct. . . . Each stone bears upon its surface characters so plainly legible that he 'who runs may read.' The parti-colored lichens add grace and symmetry to the massive boulders, which have journeyed from the Polar seas, as they reposed upon the breast of some crystal iceberg. These the artist sees and enjoys, and when the last touch is given to his sketch and the pencil is laid aside, his thoughts revert to those old times, when flora and fauna existed supreme, since breath had not yet given life to man. . . . It is for his own interest and reputation as an artist, to understand what will conduce to the adornment of his work and what will detract from its perfection, and consequently, though perhaps unintentionally, he is a geologist.

Like Emerson, the writer poses questions as much concerned with scientific enigmas as with artistic and poetic ones: "Continually meeting with different strata, the query naturally arises, why this diversity? He meets with immense fissures and volcanoes and asks himself whence did they originate and by what convulsion were they produced? To him, therefore, properly belongs the study of geology as he more thoroughly than any other can imitate what nature has produced."[51]

At least until the year this was written, the landscape artists' speculations about geology and the earth's age were infused with the "moral principles and sentiment" that reinforced providential planning. The artists' status as interpreters of godly design could only be enhanced by geological knowledge. By drawing nearer to the moment of Creation —and thereby to its "cause"—they endorsed, as Cole had stressed, their own role as Creators.

With every geological discovery America grew older. Geological time, transcending exact chronology, was infinite and thus potentially mythical. Through geology, chronological time was easily dissolved in a poetic antiquity that fortified the "new" man's passion for age.

30. Ralph Waldo Emerson, 1803–82
Photo courtesy Emerson House, Concord, Massachusetts

From this point of view, the "nature" of the New World was superior to the "culture" of the Old. The axe wounded God's "original" creation even more blasphemously than did the artist who allowed his imagination to tamper with God's nature. Civilization's axe, chipping away at American nature, made it younger by removing evidence of natural antiquity. It could add a cultural veneer, but nothing like the cultural antiquity of Europe. Americans would do better to hold onto their only antiquity, the primordial certificate of God's hand. God's donation of this ancient land further underscored

their sense of imperial destiny. How could they abandon a concept of providential planning that so neatly reinforced the national purpose?

An early familiarity with Lyell's advanced ideas,[52] which so nourished Darwin, never caused Emerson (fig. 30) to waver in his belief in divine planning. How surprising, then, that in addition to the predictable works by Swedenborg and the Persian poets, Emerson had in his library a copy of Robert Chambers's *Explanations, a Sequel to Vestiges of the Natural History of Creation* (1846), as well as an 1845 copy of *Vestiges* itself.[53] What could *Vestiges* have meant to Emerson —since, as Lovejoy maintains, Chambers had already voiced in *Vestiges* the crux of Darwin's revolutionary theory?[54] What did Emerson think about this controversial book, perhaps the most important single work before Darwin's *Origin,* one about which Darwin himself had reservations, and which had been violently rejected by Darwin's strongest supporter, T. H. Huxley?[55]

In a letter to Samuel Gray Ward, on April 30, 1845, Emerson wrote:

Did you read Vestiges of Creation. The journals I am told abound with strictures & Dr Jackson told me how shallow it was, but I found it a good approximation to that book we have wanted so long & which so many attempts have been made to write. All the competitors have failed, & the new Vyvian, if it be he has outdone all the rest in breadth & boldness & one only want to be assured that his facts are reliable. I have been reading a little in Plato (in translation unhappily) with great comfort and refreshment[.][56]

A few months later, on June 17, he wrote to Elizabeth Hoar: "New books we have but you do not care for those Lord's Poems & the Life of Leibnitz. Eothen & the Vestiges you have read? the Vestiges, the Vestiges? Farewell, dear sister. . . ."[57]

In his journal for that year he wrote: "we owe to every book that interests us one or two words. Thus to Vestiges of Creation we owe 'arrested development.' . . . To Plato we owe a whole vocabulary."[58] Elsewhere, at the end of a long discussion of *Vestiges,* he noted: "Well, and it seems there is room for a better species of the genus Homo. The Caucasian is an arrested undertype."[59]

Is it significant that on the few occasions when Emerson mentions *Vestiges,* he tends to mention Plato, literally in the same breath? For all his interest in *Vestiges,* it never seems to have shaken his Platonic confidence in an absolute backdrop behind nature's flux. As Whicher wrote on Emerson's ultimate attitude to evolution: "At the heart of nature, where before he had seen a matter opposed to life, he now saw vitality and change. But this dissolution of the present order of nature only strengthened his belief in her governing laws."[60]

Whicher puts it succinctly: "beyond motion lies rest." Emerson's concept of evolution did not imply a "Darwinian belief in the trans-

mutation of species by natural selection, but simply 'a series of events in chronological sequence; life being regarded historically as later in appearance than inorganic matter, and the higher forms of life as following the lower in a graduated scale of ascent.' Behind and through the natural sequence worked the same higher Cause."[61]

Emerson's main reservation about *Vestiges* was its theological tone:

What is so ungodly as these polite bows to God in English books? He is always mentioned in the most respectful and deprecatory manner, "that august," "that almighty," "that adorable providence," etc. etc. . . . Everything in this Vestiges of Creation is good, except the theology, which is civil, timid, and dull. . . . It is curious that all we want in this department is collation. As soon as the facts are stated we recognize them all as somewhere expressed in our experience or in history, fable, sculpture, or poetry. We have seen men with tails in the Fauns and Satyrs. We have seen Centaurs, Titans, Lapithae. All science is transcendental or else passes away.[62]

Vestiges offered Emerson a provocative continuity from a classical and mythological past perhaps as real to him as these new revelations of science. Despite his reservations about the "ungodly" theological tone, something in the providential references must have satisfied him. Emerson may not have grasped the radical implications of *Vestiges*, with its speculations on the transmutation of species. Ever the great assimilator, he simply added *Vestiges* to his poetic cosmology, where it jostled Plato and the Persian poets, but did not disturb them. Besides *Vestiges*, Emerson's bookshelves held William Paley's *The Principles of Moral and Political Philosophy* (1788), Edward Hitchcock's *The Religion of Geology and Its Connected Sciences* (1855), and Thomas Hills's *Geometry and Faith, a Fragmentary Supplement to the Ninth Bridgewater Treatise* (1849).[63] All reaffirmed providential planning and guidance.

Having accommodated *Vestiges*, then, how would Emerson have dealt with Darwin? Though there is no indication that Darwin was in his library,[64] he knew of *Origin* almost immediately after its publication. On February 5, 1860, he wrote to his wife, Lidian, from Lafayette, Indiana: "—I have not yet been able to obtain Darwin's book which I had depended on as a road book. You must read it—'Darwin on Species.' It has not arrived in these dark lands."[65] Emerson had further access to Darwin's ideas through T. H. Huxley, whose writings he knew.[66] Lidian Emerson herself wrote to their son on January 18, 1864, favoring Agassiz in the famous Darwin-Agassiz controversy.[67] And on those rare occasions when he made written mention of Darwin, Emerson was apt to speak of Darwin and Agassiz in the same breath, as though the whole issue were a simple affair of preference open to debate.[68]

The scarcity of references to Darwin is revealing. In all likelihood

as he did with Chambers, Emerson happily fitted Darwin's ideas into the ideal framework of a providential theory he never really abandoned. Of the two famous Harvard scientists with whom he might have formed a friendship—Asa Gray (fig. 31), Darwin's supporter, and Louis Agassiz (fig. 32), Darwin's chief American antagonist—he predictably chose Agassiz, to whom he entrusted the education of his daughter.[69] The great debate that affected the view of Nature and God in America was conducted between these two scientists.

Though Gray tried hard to accommodate Darwinism to design, it was Agassiz who, when asked how species had originated, responded: "A species is a thought of the Creator."[70] Agassiz's concept was of a plan of Creation which "has not grown out of the necessary action of physical laws, but was the free conception of the almighty Intellect, matured in his thought, before it was manifested in tangible external forms. . . ."[71] This fused perfectly American providential beliefs and the American concern with Mind.

The general American attitude to Darwinism and to providential planning may be gauged by Agassiz's enormous popularity. His *Contributions to the Natural History of the United States* (1857) drew 2,500 subscriptions, "a support such as was never before offered to any scientific man for purely scientific ends."[72] Agassiz was one of the eleven original founders, in 1856, of the Saturday Club, along with Emerson, Richard Henry Dana, Jr., James Russell Lowell, Samuel Gray Ward, and Benjamin Peirce, later superintendent of the U.S. Coastal Survey.[73] His name was mentioned to Ward by Emerson as early as December 26, 1849.[74] Longfellow was elected to the club in 1857 at Agassiz's suggestion, and Hawthorne in 1859. Asa Gray was not invited to join until 1873, the year of Agassiz's death.[75]

Agassiz's role was so prominent that outsiders called the group "Agassiz's Club." The voluble Swiss scientist to whom Thoreau offered specimens—fish, insects, and birds—had settled permanently in America in 1846. He had attended Schelling's famous lecture series "The Relation of the Real and the Ideal" at the University of Munich, which doubtless further endeared him to Emerson, who wrote of him in 1852: "I saw in the cars a broad-featured, unctuous man, fat and plenteous as some successful politician, and pretty soon divined it must be the foreign professor who has had so marked a success in all our scientific and social circles, having established unquestionable leadership in them all; and it was Agassiz."[76]

Edward Waldo Emerson, in *The Early Members of the Saturday Club,* makes a point of noting that Dana "especially abhorred Darwinism, and the godlessness that he found in the scientific theories of later investigators. Agassiz's religious feeling and struggle against Darwin must have been a comfort to him."[77]

31. Asa Gray, 1810–88
Photo courtesy Hunt Institute for Botanical Documentation, Pittsburgh

Agassiz, then, had a special significance for the members of that elite Saturday brotherhood. He represented the forces of science used for faith, and his professional and popular success preserved the idea of providential planning. Oliver Wendell Holmes described the Saturday meetings thus: "At that time you would have seen Longfellow invariably at one end—the east end—of the long table, and Agassiz at the other. Emerson was commonly near the Longfellow end, on his left. . . . The most jovial man at table was Agassiz; his laugh was that of a big giant."[78] Agassiz had every reason to laugh. He was admired by many of the leading figures of his day. They in turn were delighted to have in their midst a man whose scientific credentials, such as his work in glaciology, were impeccable. He could also tell them what they wanted to hear—that God was inviolable, and that all the latest scientific developments traced His guiding hand into nature's smallest details. Science was, as Emerson suggested, "transcendental."

32. C. E. Watkins, *Louis Agassiz*, 1807–73, detail
Photo courtesy Houghton Library, Harvard University, Cambridge, Massachusetts

33. William J. Stillman, *The Philosopher's Camp in the Adirondacks,*
c. 1857–58
Oil on canvas, 20⅛″ × 30″. Concord Free Public Library, Concord, Massachusetts,
bequest of E. R. Hoar

In 1857, some members of the Saturday Club founded the Adiron-
dack Club (fig. 33). The chief instigator was W. J. Stillman, who in-
duced many members of the Saturday group to buy and thus preserve
22,500 acres in the Adirondacks around Ampersand Pond for $600.
Since he was co-editor of America's leading art journal, *The Crayon,*
Stillman's admiration for Agassiz is not unimportant:

For Agassiz, I had the feeling which all had who came under the magic of his
colossal individuality. . . . his wide science gave us continual lectures on all
the elements of nature—no plant, no insect, no quadruped hiding its secret
from him. The lessons he taught us of the leaves of the pine, and of the
vicissitudes of the Laurentine Range, in one of whose hollows we lay; the way
he drew new facts from the lake, and knew them when he saw them. . . . the
daily dissection of the fish, the deer, the mice (for which he had brought his
traps) were studies in which we were his assistants and pupils.[79]

Stillman commented that when Agassiz and Jeffries Wyman, a doctor who was Hersey Professor of Anatomy at Harvard Medical School, had discussions on scientific subjects, "science seemed as easy as versification when Lowell was in the mood, and all sat around inhaling wisdom with the mountain air."[80]

Emerson's library, of course, included several of Agassiz's books: *A Journey in Brazil* (1868), inscribed to Emerson; *Lake Superior: Its Physical Character, Vegetation and Animals, Compared with Those of Other and Similar Regions . . .* (1850); and *Methods of Study in Natural History* (1863). It also included an *Address Delivered on the Centennial Anniversary of the Birth of Alexander von Humboldt,* given by Agassiz under the auspices of the Boston Society of Natural History (1869),[81] with a note including a summary of Emerson's remarks. Though the relationship with Agassiz may have helped distance Emerson from Darwin, both he and Agassiz admired Darwin's great predecessor—and Agassiz's early mentor—Humboldt. Emerson owned not only the famous *Cosmos,* in what might have been an incomplete 1847 set, but Humboldt's *Aspects of Nature, in Different Lands and Different Climates . . .* (1849) and *The Travels and Researches of Alexander von Humboldt . . . a Condensed Narrative of His Journeys in the Equinoctial Regions of America, and in Asiatic Russia . . .* (1833).[82] "The wonderful Humboldt," he wrote in his journal in 1845, "with his extended centre, expanded wings, marches like an army, gathering all things as he goes. How he reaches from science to science, from law to law, tucking away moons and asteroids and solar systems in the clauses and parentheses of his encylopaedical paragraphs!"[83]

Yet Humboldt's most fervent American admirer, in the arts at least, was not Emerson but the landscape painter Frederic E. Church. On the shelves of Olana, Church left behind him a five-volume edition of *Cosmos* (1849–59), Humboldt's *Narrative of Travels to the Equinoctial Regions of America . . . ,* volumes 1 and 2 (1852), and an 1849 edition of the *Aspects of Nature*—the very same works (though sometimes in different editions and translations) owned by Emerson.[84]

Church also owned copies of Darwin's *The Expression of Emotion in Man and Animals* (1873) and *The Journal of Researches into the Natural History and Geology of the Countries Visited during the Voyage of H.M.S. Beagle round the World,* volumes 1 and 2 (1852).[85] For Darwin, of course, Humboldt was—next to Lyell—his most important early influence. Humboldt inspired him, as he did Church later, to undertake his South American journey. Through Humboldt, Darwin arrived at the theory of natural selection that would challenge God and the idea of nature as God. For Church—and Emerson—Humboldt's science was simply another route that further revealed God's encompassing purpose.

Church is the great exemplar of how the official concerns of the age found their way into landscape painting. His interests were broader, his involvement in natural science more intense, than those of any artist of his era. He is a paradigm of the artist who becomes the public voice of a culture, summarizing its beliefs, embodying its ideas, and confirming its assumptions. In his work, science, religion, and art all pursued the same goal, their harmonious coexistence embodying the ideal world-view of the nineteenth century before it was betrayed by the very instruments it used to advance its cause—observation, pragmatism, and science itself.

Church clearly understood the need to provide America with appropriate images and icons. With Emerson and Agassiz he completes still another trinity: of transcendentalism, providential science, and devotional art. To both Church and Emerson, Humboldt offered an immensely attractive prospect—merging exploration, exoticism, baroque energy, and pragmatic observation infused with flashes of transcendence.

In his introduction to *Cosmos,* Humboldt observes: "Nature is a free domain, and the profound conceptions and enjoyments she awakens within us can only be vividly delineated by thought clothed in exalted forms of speech, worthy of bearing witness to the majesty and greatness of the creation."[86] From the outset, he shares not only the landscapists' concern with Creation, but their need for a rhetoric appropriate to nature's majesty. "In considering the study of physical phenomena," he continues, "not merely in its bearings on the material wants of life, but in its general influence on the intellectual advancement of mankind, we find its noblest and most important result to be a knowledge of the chain of connection, by which all natural forces are linked together, and made mutually dependent upon each other; and it is the perception of these relations that exalts our views and ennobles our enjoyments."[87] Humboldt's language throughout *Cosmos* is not always so didactic. But the tone of his introduction must have appealed to Church's Grand Style ambitions. Pragmatic observation, suitably "ennobled" by rhetoric, could be applied to the highest artistic purpose. Church's strivings after sublimity could only have received further confirmation, if not indeed their initial impulse, from Humboldt's observation that "everywhere, the mind is penetrated by the same sense of the grandeur and vast expanse of nature, revealing to the soul, by a mysterious inspiration, the existence of laws that regulate the forces of the universe."[88]

Humboldt made the tropics as appealing to Church as he had to Darwin:

He who, with a keen appreciation of the beauties of nature manifested in mountains, rivers, and forest glades, has himself traveled over the torrid zone, and seen the luxuriance and diversity of vegetation, not only on the cultivated sea-coasts, but on the declivities of the snow-crowned Andes, the Himalaya, or the Nilgherry Mountains of Mysore, or in the primitive forests, amid the net-work of rivers lying between the Orinoco and the Amazon, can alone feel what an inexhaustible treasure remains still unopened by the landscape painter between the tropics in both continents. . . . Are we not justified in hoping that landscape painting will flourish with a new and hitherto unknown brilliancy when artists of merit shall more frequently pass the narrow limits of the Mediterranean, and when they shall be enabled, far in the interior of continents, in the humid mountain valleys of the tropical world, to seize, with the genuine freshness of a pure and youthful spirit, on the true image of the varied forms of nature?[89]

The botanical veracity of Church's plant studies, the astute observation of his erupting volcanoes (see fig. 21), show the accuracy of the best descriptive science. Examining the notebooks, drawings, and rapid oil sketches, pausing over the delicate, careful drawings of ferns and tropical details, one thinks immediately of Humboldt's advice to the artist in the section "Landscape Painting in Its Influence on the Study of Nature":

Colored sketches, taken directly from nature, are the only means by which the artist, on his return, may reproduce the character of distant regions in more elaborately finished pictures; and this object will be the more fully attained where the painter has, at the same time, drawn or painted directly from nature a large number of separate studies of the foliage of trees; of leafy, flowering or fruit-bearing stems; of prostrate trunks, overgrown with Pothos and Orchideae; of rocks and of portions of the shore, and the soil of the forest[90] [figs. 34, 35].

Yet Humboldt, like Church, never abandons the age's demands for a blend of the real and the ideal. He refers to "the ancient bond which unites natural science with poetry and artistic feeling" and to the distinction which "must be made in landscape painting, as in every other branch of art, between the elements generated by the more limited field of contemplation and direct observation, and those which spring from the boundless depth of feeling and from the force of idealizing mental power. The grand conceptions which landscape painting, as a more or less inspired branch of the poetry of nature, owes to the creative power of the mind are, like man himself, and the imaginative faculties with which he is endowed, independent of place." But "an extension of the visible horizon, and an acquaintance with the nobler and grander forms of nature, and with the luxurious fullness of life in the tropical world" would clearly be useful.[91] He even maintains that "much aid might be further derived by taking photographic pictures, which, although they certainly cannot give the

34. Frederic Edwin Church, *Tropical Vines, Jamaica,* May 1865
Oil with pencil on paperboard, 12″ × 9″. The Cooper-Hewitt Museum of Design,
New York, Smithsonian Institution

leafy canopy of trees, would present the most perfect representation
of the form of colossal trunks, and the characteristic ramification of
the different branches."[92]

Both Darwin and Church responded to Humboldt's sense of "Nature
considered *rationally* . . . submitted to the process of thought, [as] a
unity in diversity of phenomena; a harmony, blending together all
created things, however dissimilar in form and attributes; one great
whole . . . animated by the breath of life."[93] Church also shared
Humboldt's recognition of the heroic and imaginative possibilities of

35. Frederic Edwin Church, *Palm Trees, Jamaica,* June 1865
Oil on paperboard, 12″ × 20″. The Cooper-Hewitt Museum of Design, New York,
Smithsonian Institution

landscape painting: "Landscape painting . . . requires for its devel-
opment a large number of various and direct impressions, which, when
received from external contemplation, must be fertilized by the pow-
ers of the mind, in order to be given back to the senses of others as a
free work of art. The grander style of heroic landscape painting is the
combined result of a profound appreciation of nature and of this in-
ward process of the mind."[94] In such passages, Humboldt not only re-
hearses the tone of the Grand Style, but touches on that ubiquitous
concern with Mind so readily extended in America to Universal Mind.

Church must have pored over his volumes of *Cosmos,* then executed
his luxuriantly baroque views of tropical scenery seduced by the fiery
heat of Cotopaxi, whose conical form, Humboldt had noted, was the
most beautifully regular, "among all the volcanoes that I have seen
in the two hemispheres."[95] Though photography may have helped
Church to hold on to "various and direct impressions," it in no way
compromised his vision of a heroic landscape art that was easel paint-

ing's closest approximation to the panorama.[96] Humboldt had even advised that "panoramas are more productive of effect than scenic decorations, since the spectator, inclosed, as it were, within a magic circle, and wholly removed from all the disturbing influences of reality, may the more easily fancy that he is actually surrounded by a foreign scene."[97]

Church's "full-length" landscapes, such as *Heart of the Andes*, made the spectator feel that he was "actually surrounded by a foreign scene," and achieved the purpose Humboldt envisaged for panoramic works: "to raise the feeling of admiration for nature" and to increase "the knowledge of the works of creation, and an appreciation of their exalted grandeur."[98] Humboldt suggested that "besides museums, and thrown open, like them, to the public, a number of panoramic buildings, containing alternating pictures of landscapes of different geographical latitudes and from different zones of elevation, should be erected in our large cities."[99] Church made a public sensation when he flanked *Heart of the Andes* with black crepe curtains, lit it by gas jet, and surrounded it with tropical vegetation taken from the site. In one month, receipts totaled more than three thousand dollars. As popular spectacle, *Heart of the Andes* fulfilled all Humboldt's prophecies for the painter who opened up the "inexhaustible treasure" of the tropics.

But Church's sensational reputation as a painter of theatrical travelogues detracts from the real point. Behind the popular success was an almost agonized desire to make the spirit of nature gleam through each detail, "revealing to the soul," as Humboldt put it, "by a mysterious inspiration, the existence of laws that regulate the forces of the universe." Church's South American journeys, like Humboldt's and to some extent Darwin's, were part of a spiritual quest.

When Darwin sailed on the *Beagle* late in December 1831, he took along Humboldt's *Personal Narrative*, as well as Milton, the Bible, and Volume 1 of Lyell's *Principles of Geology*.[100] When he reached Brazil's tropical rain forests he wrote: "I never experienced such an intense delight. . . . I formerly admired Humboldt, I now almost adore him; he alone gives any notion of the feelings which are raised in the mind on entering the Tropics."[101]

That Church, like Darwin, "adored" Humboldt, is indicated by a letter to Bayard Taylor of June 13, 1859, voicing his regret "when a friend communicated the sad intelligence of Humboldt's death—I knew him only by his great works and noble character but the news touched me as if I had lost a friend—how much more must be your sorrow who could call him friend."[102] *Heart of the Andes*, Church's pictorial affirmation of God in nature, variously hailed as Paradise, Eden, and the redemption of Easter Sunday,[103] was painted in 1859—

the year that saw Darwin's *Origin* published, and Humboldt's death.

The ironies of that pivotal year speak for themselves. Darwin and Church—both sharing Humboldt's passion for the tropics, his love of exotic adventure, his pragmatic observation, his synthetic intuitions—had each been involved in a quest for truth which they hoped would reveal Creation. The physical difficulties of their voyages to South America were similar. Darwin, we are told,

planned (in 1835) to cross the Cordilleras by the highest and most dangerous route. . . . He took with him two guides, ten mules, and a madrina, a mare with a bell around her neck. . . . They rode for hour after hour in the icy wind, stopping only for Darwin to clamber up rocks, geological hammer in hand, fighting for breath at the high altitudes. On the ridges the atmosphere was so rarefied that even the mules were forced to stop every 50 yards. . . . At night, they slept on the bare earth. Yet the rewards were great: "The peaks, already bright in the sun, appeared in gaps in the mist [to be] of stupendous height . . . cloudless, airy everlasting look."[104]

When Church was en route to Guaduas on June 2, 1853, "Suddenly, the mules left the road and took us to a point filled with thorns and vines, and after being very scratched by the thorns and caught by the vines, we naturally decided that it could not be the right road to Guaduas."[105] On July 11, 1857, not far from Sangay: "We were now about 13,000 feet above the sea—and we were frequently obliged to dismount in order to assist the animals through some difficult passage. The rain of last night made the ground very slippery. . . . We had just crossed a river with very steep banks and my horse was toiling up the opposite bank through the long grass on the very edge of the slope, when he made a misstep and instantly horse and rider were somersetting down the bank. . . ."[106]

Yet for Church also there were rewards: "An extraordinary stillness struck me which was heightened by the rapid silent motion of the clouds about the mountain tops, we are near them now, and the rolling of the smoke from the burning of paramo grass. How silent these mountains are . . . a slight rainstorm gathered in the east and passed to the south and on the falling mist among the mountains the sun produced a curious prismatic effect although quite common in these countries" (July 10, 1857).[107]

For Darwin, risk and adventure were intrinsic to the quest. He was willing to accept whatever results logic and intelligence dictated. Church's adventure was part of the heroic stance of the artist in search of the ideal. His exalted purpose demanded physical travail. By bringing the aims of the landscapist closer to the divine *intention* of the Creator, he unveiled the mysteries of Creation to embody them in his art.

Darwin wished to uncover the truth. Church encouraged truth to reflect a spirit he refused to doubt. He used science and observation

wherever they could serve this purpose. As Louis L. Noble points out in his broadside for *Heart of the Andes* (1859): "Some apprehension of the process of landscape-*making* by the instrumentalities of the Creator, is necessary in order successfully to conduct the process of landscape-*painting* by the feeble instrumentalities of man. . . ."[108]

That apprehension was precisely Tuckerman's "manner and method of Nature," an idea closely connected, as we have seen, to "general effect" and also to Jarves's "general principle." If Tuckerman cautioned the landscapist to strike the proper balance between detail and general effect, Humboldt showed concern that the scientist achieve this equilibrium, and in so doing offered Church not only the inspiration for his tropical adventures, but a fortification of the esthetic that dominated his age:

I think we ought to distinguish here between him whose task it is to collect the individual details of various observations, and study the mutual relations existing among them, and him to whom these relations are to be revealed, under the form of general results. . . . There is, perhaps, some truth in the accusation advanced against many German scientific works, that they lessen the value of general views by an accumulation of detail, and do not sufficiently distinguish between those great results which form, as it were, the beacon lights of science, and the long series of means by which they have been attained. This method of treating scientific subjects led the most illustrious of our poets [Goethe] to exclaim with impatience, "The Germans have the art of making science inaccessible." An edifice cannot produce a striking effect until the scaffolding is removed, that had of necessity been used during its erection.[109]

For Church, the scaffolding was intense observation—the careful delineation of each frond, leaf, and flower. In *Heart of the Andes* he could be accused of so indulging in microscopic detail that the "general principle" of nature was lost—implied only by the remains of a Claudian composition that carried distant overtones of heroic, ideal intention. Yet his own contemporaries, including his friend Noble, had seen in *Heart of the Andes* "a knowledge of the roughening and the smoothing of the earth, by the powers which haunt its sunless caverns, and toil and contend upon its face . . . essential . . . to an intelligent perception of that face, as we behold it. To the artist who would truthfully picture it, certainly, indispensable knowledge. Without that, his work cannot have the expression and significance of the actual—cannot have that organic unity—cannot have that all pervading life, energy and beauty which conspire to make it a genuine creation of art, in contradistinction to the work of the mere mechanic.

"What is said of the earth, may be said of the living growth upon it. In obedience to subtle forces rise the organic structures of the vegetable kingdom." The artist must know all this for if not, "a want of it will find, in the pictured plants, trees and woods, a corresponding

want of truthfulness, and therefore, of necessity, want of proper expression, strength and beauty." For Noble, "in no other section of the globe (Humboldt himself not excepting the Alps and the Himalaya) could the landscape painter acquire such an extent and variety of knowledge suited to his purposes, and receive such inspiration and impulse."[110]

Church shared this feeling and maintained it. Nearly ten years later he wrote to his friend William Osborn (September 29, 1868): "The Alps disappointed us both—and I have no desire to revisit them. . . . You will perhaps raise your eyebrows when you hear my sweeping remarks about the Alps—but they have nothing which is not vastly exceeded by the Andes and lack many important features which make the Andes wonderful and exclusive."[111]

The meticulous detail of *Heart of the Andes* helped its spectacular success, accommodating the public's delight in "near looking." But once the specific "truths" were certified, Church was also deeply concerned with the issue of "general principle." Humboldt had observed: "The distinction between dissimilar subjects, and the separation of the general from the special, are not only conducive to the attainment of perspicuity in the composition of a physical history of the universe, but are also the means by which a character of greater elevation may be imparted to the study of nature. By the suppression of all unnecessary detail, the great masses are better seen, and the reasoning faculty is enabled to grasp all that might otherwise escape the limited range of the senses."[112]

Though *Heart of the Andes* may stress detail over effect, Church's other paintings of the tropics are more synthetic, suppressing, as Humboldt put it, all unnecessary detail, so that the "greater masses are better seen." In such paintings as *The Andes of Ecuador* (see fig. 25) and *Cotopaxi,* the handling of light transforms each scene into Humboldt's "one great whole animated by the breath of life." Light identifies compositional with cosmic and spiritual unities which in turn subsume scientific apprehensions of the "manner and method of Nature." Though Church reports on his scientific homework in small bits of foreground detail, a consuming light engulfs the terrain. Here, parting company with Darwin, and even with Humboldt, he stands with Emerson and Agassiz. For such dazzling worlds were surely originated by Agassiz's "thought of the Creator," by Emerson's "fire, vital, consecrating, celestial, which burns until it shall dissolve all things into the waves and surges of an ocean of light" by which "we see and know each other, and what spirit each is of."[113]

This spiritual context puts Church's scientism firmly in the service of religion, as it did the researches of those geologist-clergymen whose "extinguished" bodies surrounded the cradle of Darwinian science.

Church resisted Darwin's revelations by means of an attachment to Revelation that endured in America as long as landscape painting was a national force. That mystical light faded with his generation, its departure hastened by the advent of a new "scientific" light—impressionism.

Church's reconciliation between science and spirit was reflected in his reading. He studied the latest researches of Tyndall on clouds and glaciers, of Lomell on light, of Rood on perception and Chevreul on color. Yet he also read works such as Geikie's *Hours with the Bible or The Scriptures in the Light of Modern Discovery and Knowledge* (1888) which claimed that the Bible "is the only story of the origin of our race which we can harmonize with our natural conception of God or with science . . . the full light of science does not eclipse the truth of the Bible, but only leads us, by its discoveries, to understand the sacred pages aright."[114]

As late as 1882, Church received from William M. Bryant a copy of his *Philosophy of Landscape Painting* where Church could read, as in earlier, pre-Darwinian literature, that "religious conceptions are ever inextricably involved in the art of the world, and landscape painting finds its true significance and strictly legitimate task in the representation of those phases of nature that are most profoundly expressive of the Spiritual and Divine."[115] Church's library at Olana is an extraordinary testament to the artist's continued efforts to accommodate post-Darwinian science with religion. In his 1891 volume *Natural Selection and Tropical Nature* (a reprint of essays first presented in the 1870's), Alfred Russel Wallace—a scientist perhaps as responsible as Darwin for evolutionary ideas—suggests that Darwin "really had faith in the beauty and harmony and perfection of creation, and was enabled to bring to light innumerable adaptations, and to prove that the most insignificant parts of the meanest living things had cause and a purpose."[116]

In Church's copy of Louis Figuier's *World Before the Deluge* (1865) Darwin is mentioned only for his ideas about coral formations and megatheroid animals, while the author maintains that "geology is . . . far from opposing itself to the Christian religion, and the antagonism which formerly existed has given place to a happy agreement. Nothing proves with more certainty than the study of geology, the evidences of eternity and divine unity; it shows us, so to speak, the creative power of God in action. We see the sublime work of creation perfecting itself unceasingly in the hands of its divine Author, who has said 'Before the world, I was.' "[117]

In 1892, John Fiske, in *The Idea of God As Affected by Modern Knowledge,* brought it all full circle when he maintained: "Without adopting Paley's method, which has been proved inadequate, we may

nevertheless boldly aim at an object like that at which Paley aimed. . . . Although it was the Darwinian theory of natural selection which overthrew the argument for design, yet. . . . when thoroughly understood, it will be found to replace as much teleology as it destroys."[118]

Teleology indeed, remained remarkably intact for most of the American landscape painters of Church's generation. Darwin came into the picture too late to upset the reverential tone that had characterized the American landscape tradition from its outset. That tradition was rooted too deeply in pictorial conventions of the Christianized sublime, and—more important—in the national purpose and destiny. Realism and idealism—the overt dialectic with which the age consciously defined its identity—expressed and masked an explosive bundle of contradictions—to which we are now heirs and with which modernism has coped by a variety of strategies.

The age was not simple. The artists, as part of the age, revealed in their esthetic the contradictions in their society between science and art, between empiricism and the ideal, between analysis and synthesis, between technology and nature. An ecumenical spirit of reconciliation was the only course for artists who wished to accommodate science, religion, and art. In this, they reflected their society, dissolving contradictions in a spiritual light that was ultimately an act of faith.

Of these artists, Church was the greatest ecumenical spirit. Huntington suggests that for all the advice Church got from Humboldt, he got a thousand times more from Ruskin.[119] Though there is some validity to this—since Church shared Ruskin's insistence on a spiritual principle animating all artistic endeavors, however soundly grounded in science—Church did not fear the "dessication of nature" by science in the same way as did Ruskin, who wrote that "the man who has gone, hammer in hand, over the surface of a romantic country, feels no longer, in the mountain ranges he has so laboriously explored, the sublimity or mystery with which they were veiled when he first beheld them, and with which they are adorned in the mind of the passing traveller."[120] By and large, Ruskin also thought Darwinism fallacious, stating on at least one occasion, in 1872: "I have never heard yet one logical argument in its favour, and I have heard, and read, many that were beneath contempt."[121] For Church, a spiritual accommodation of Darwinism was sufficient, without recourse to contempt.

Like Emerson, who wrote of the *Vestiges* and Plato in the same sentence, and uttered the names of Agassiz and Darwin in one breath, Church simply found in science and idealism, in pragmatic relativity and absolutism, the elements of his world-view. His sensibility was that of the grand synthesizer. For all his partiality to detail, he wanted Humboldt's "greater masses" to be "better seen." His art can be seen only in terms of sublime unities, with light, the great organizer, the

measure of his grand Ambition. It is the prime example of the last concerted effort of an artistic community to preserve the idea of a privileged nature—reflecting divine truth, bearing lessons, healing the spirit. He was thus, at that time, the "national" painter, offering in the accommodations and reconciliations of his art a rare embodiment of the public concerns of his society—seeing in the alliance between art and science an opportunity to follow the "progressive disclosure of His soul."

V

The Meteorological Vision: Clouds

The sky is the daily bread of the eyes.
RALPH WALDO EMERSON

. . . Such fantastic feathery scrawls of gauze-like vapor on this elysian ground! We never tire of the drama of sunset. I go forth each afternoon and look into the west a quarter of an hour before sunset, with fresh curiosity, to see what new picture will be painted there, what new panorama exhibited, what new dissolving views. Can Washington Street or Broadway show anything as good? Every day a new picture is painted and framed, held up for half an hour, in such lights as the Great Artist chooses, and then withdrawn, and the curtain falls.

HENRY DAVID THOREAU[1]

Sky in American art has a clearly identifiable iconography. The painters of a culture deeply imbued with transcendental feeling found in it the purity of renewal, the colors of hope and desire, heavenly reflections of earthly nostalgias. They also cast upward to the sky the shrewd empirical glance that constantly corrected their powerful system of ideal beliefs. The sky is a finely tuned paradigm of the alliance between art and science. In that mutable void, the landscape artist's concerns—poetic, ideal and symbolic, empirical and scientific—were sharpened rather than blurred. As the source of light, spiritual as well as secular, the sky relieved absolutism with infinite moods, unchanging ideals with endless process. No wonder the artists fixed their particular attention on those moist cargoes that described the void in brief but repeated compositions: clouds.

The Americans had a strong precedent for their interest in clouds in Constable, who was well known to them. In the same year, 1855, that *The Crayon* published Jasper Cropsey's important essay "Up Among the Clouds,"[2] it also printed C. R. Leslie's note on skies, which itself incorporated Constable's famous letter of October 1821:

"I have done a great deal of skying, for I am determined to conquer all difficulties, and that among the rest. That landscape painter who does not make his sky a very material part of his composition, neglects to avail himself of one of his greatest aids. . . . It will be difficult to name a class of landscape in which the sky is not the key-note, the standard of scale, and the chief organ of sentiment. . . . The sky is the source of light in Nature and it governs everything; even the common observations on the weather of every day are altogether suggested by it . . ." [fig. 36].

Leslie remarks that on the back of each of Constable's studies were "memoranda, of the date, the time of day, the direction of the wind, and other remarks: for instance—'Sept, 6th, 1822, looking S.E.; 12 to 1 o'clock, fresh and bright between showers; much the look of rain all

36. John Constable, *Cloud Study,* 1822(?)
Oil on paper, 18⅞" × 23¼". Ashmolean Museum, Oxford

the morning, but very fine and grand all the afternoon and evening.' "[3]

The meteorological tone of these notations is attributed by Kurt Badt to Constable's possible knowledge of Luke Howard's pioneering *Climate of London*, published from 1818 to 1820, just before Constable's spurt of cloud studies in 1821–22.[4] Howard's "Essay on the Modifications of Clouds"—the first chapter of the first volume—was offered to the Askesian Society in London in the winter of 1802–3, and then published, in 1803, in Tilloch's *Philosophical Journal*.[5] Around 1812, it formed the basis for Thomas Forster's first chapter in his *Researches About Atmospheric Phenomena*, which Constable referred to in a letter to George Constable on December 12, 1836.[6]

The stress on the catalytic effect of meteorological sources on Constable's content has not gone unchallenged. Louis Hawes, objecting to Badt's thesis, emphasizes the empiricism of Constable's cloud observations.[7] But one theory need not exclude the other. One can maintain, as Hawes does, that Constable was an empiricist who observed very closely, and also accept Badt's premise that Constable's marvelous observing faculties may have received order and direction from a knowledge of Howard's pioneering work. Both scholars, perhaps, base their views on different theories of perception. Constable, we may be sure, used (as any artist does) whatever would assist him in his cloud studies (fig. 37)—just as the Americans brought a whole esthetic-religious-scientific body of ideas to their study of the skies.

Whatever the source of Constable's meteorological awareness, it is paralleled in the American tradition from Allston's *Landscape, American Scenery: Time, Afternoon, with a Southwest Haze* (Museum of Fine Arts, Boston) to Burchfield's and Hopper's careful citing of time and weather in their titles. Some Americans developed an obsessive concern with weather: one thinks of Mount replacing earlier technical notes with weather data in the sixties; of Cole's meticulous observations; of Homer's long waits for the right moment in his late sea studies.

Yet the conceptual foundations of such meterological concerns were to be found early in the nineteenth century in Europe, and involved one of its greatest culture heroes—Goethe, whose ideas are so frequently paralleled in American thought. If there is some controversy about Constable's reliance on Howard's work, there is none about Goethe's relation to it. When Goethe discovered Howard he became obsessed with him. Goethe knew Howard's "Essay on the Modification of Clouds" from a translation of the first half in the *Annalen der Physik* of 1815.[8] In 1820 he wrote "The Shape of Clouds According to Howard"[9] (fig. 38), and followed it with a poem "To the Honored Memory of Howard," on the theme of making the impalpable palpable:

37. John Constable, *Copy after Alexander Cozens' Engravings of Skies,*
c. 1821–22(?)
Pencil and ink on paper, 3⅝" × 4½". Courtauld Institute of Art, London

> He grips what cannot be held, cannot be reached,
> He is the first to hold it fast,
> He gives precision to the imprecise, confines it,
> Names it tellingly!—yours be the honor!—
> Whenever a streak [of clouds] climbs, piles itself
> together, scatters, falls,
> May the world gratefully remember you.[10]

Howard's classification of clouds into nimbus, stratus, cumulus,
and cirrus also inspired Goethe to write poems that went so far as to
establish for them a hierarchy of noble spirituality—not unlike the
artistic hierarchy of his day. Thus, the cirrus was a cloud in which
"the noble impulse mounts always higher."[11] Goethe's preoccupation
with clouds was scientific and symbolic.[12] He valued Howard's work be-
cause it gave order to the mutable heavens, enabling anyone who
looked at the sky to see with system. But he also valued it because it
aided the onlooker to divine the eternal system which was the ulti-
mate source of all natural order: *Sich im Unendlichen zu finden*—to
find oneself in the infinite.[13]

Goethe's obsession with Howard and clouds transmitted itself to the

38. Luke Howard, *Cloud Study*, c. 1803
Watercolor on paper, 5½" × 8½". Royal Meteorological Society, Bracknell, Berkshire, England

Dresden circle of painters, especially Carl Gustav Carus, who wrote his famous *Nine Letters on Landscape Painting* between 1815 and 1824. After reading Goethe on clouds and on Howard, Carus acknowledged that his own ideas "about the condition of landscape painting in modern times found release." In Goethe's poem to Howard, Carus found "the idea of a second kind of perfection in art based on higher knowledge." Here and in later, similar poems, pure and perfect scientific knowledge was transfigured into poetic vision through a rebirth of the spirit. Goethe's poetic insight, based on "long and earnest atmospheric studies," was for Carus an example of art as "the crown of science."[14] Understanding based on observation and study could probe infinite enigmas. The sky, the quintessence of air and light, was "the real image of the infinite . . . the most essential and most glorious part of the whole landscape."[15] The Dresden circle shared Carus's enthusiasm. Around 1821, the Norwegian Johann Christian Dahl started

82

investigating clouds in Dresden, possibly stimulating Karl Blechen to similar studies.[16] The German interest was intense, and like the American, it closed the cycle between observation and spirit.

While the Americans' pragmatic and scientific instincts can be identified with Constable, their profound philosophical affinities are aligned with the German and Scandinavian landscape painters (see Chapter X). As Carus maintained, once the landscape painter understood earthly life, he must then have explained to him "the influences of the fourth and most spiritual element"—fire and light—so that he might undertake his work with a feeling of reverence and worship.[17] Clouds and light in America must be considered against this background of pragmatism, science, and Deity.

In "Up Among the Clouds," Cropsey sounds like Carus when he quotes, " 'The heavens declare the glory of God, and the firmament showeth His handiwork' " (fig. 39). Yet he also counsels the artist to "look out on the widespread horizon, and study some of its phenomena and laws," and follows with a rush of sharp observations referring to the "luminous, palpitating air . . . constantly varied . . . more deep, cool, warm or grey—moist or dry—passing by the most imperceptible gradations from the zenith to the horizon—clear and blue through the clouds after rain—soft and hazy when the air is filled with heat, dust and gaseous exhalations. . . ."[18] This knowledgeable observation predicates that mix of seeing and knowing, of pragmatism and scientific understanding, integral to the American vision of nature. In the case of clouds, there are also neo-Platonic echoes, those echoes which frequently arise when discussing the relations of the specific to the type.

Knowledge of the type to which specific cloud configurations belonged enabled the artist to impose order on the momentarily seen and observed—and thus pierce its essence. Variety observed could reveal a basic truth of type (fig. 40). The specific reality, carefully observed, could lead to an understanding of the ideal. In the case of clouds, their transient uniqueness, making observation urgent, clarified the dialogue betwen the particular and the typical.

From here it would not be difficult to arrive at a Ruskinian idea of truth, both material and spiritual. Ruskin, who devoted a lot of energy to clouds in *Modern Painters,* also stimulated the Americans' interest. Cropsey quotes him several times in his short essay. Ruskin's stress on Turner's skies is reflected in Cropsey's references here to Turner; he does not refer to Constable at all.

How does Turner fit into this iconography of clouds (fig. 41)? The Americans, as we have seen, shared some of Constable's pragmatism

and what now seems his awareness of meteorological ideas. But the stress on poetic vision found in the Germans and in Ruskin leads to Turner's *imagination* rather than to Constable's *eye*. The Americans rarely could allow imagination to remove itself too far from reality. Thus Cole found Turner's later works, especially, "gorgeous but altogether false."[19] But neither could the Americans easily settle for Constable's matter-of-fact naturalism. Despite his reverential acknowledgment of the idea of God in nature,[20] Constable was perhaps more interested in passionately *depicting* nature through painterly codes than in pursuing its elusive inner spirit. This also applies to his clouds.

39. Jasper F. Cropsey, *Cloud Study*, June 22, 1850
Pencil, white gouache, and gray wash on paper, 6⅞″ × 5″. Newington-Cropsey Foundation, Hastings-on-Hudson, New York. Photo courtesy Archives of American Art, Smithsonian Institution

40. Jasper F. Cropsey, *Cloud Study,* undated

Sketchbook, pencil on paper, 5″ × 7″. Newington-Cropsey Foundation, Hastings-on-Hudson, New York. Photo courtesy of Archives of American Art, Smithsonian Institution

Quite apart from what they read of Ruskin's luminous apologia for the artist, the Americans were appreciative of Turner's cloud effects. During his visit to London in 1840, Durand studied Constable's clouds at C. R. Leslie's,[21] but, according to his son John, also visited Turner. At the time he found Turner "factitious and artificial,"[22] but years later (1855) in the "Letters on Landscape Painting" he noted, "Turner gathered from the previously unexplored sky alone, transcripts of Nature whose mingled beauty of form and chiaroscuro have immortalized him, for the sole reason that he has therein approached nearer to the representation of the infinity of Nature than all that have gone before him."[23] In the *Crayon* of the same year, Leslie's note on Constable's skies begins with a brief nod to Turner's "transcendent power

41. J. M. W. Turner, *Sunset*, c. 1846–51
Watercolor on gray paper, 7″ × 10⁷⁄₁₆″. The Fitzwilliam Museum, Cambridge, England

of expressing atmospheric phenomena" which "more than atoned for eccentricities that would have ruined a lesser man. . . ."[24]

So it is not surprising that Cropsey at the same time finds "Turner . . . almost the only artist, ancient or modern, that has given us successful studies of the beautiful clouds of this region."[25] The region Cropsey refers to here is that of the cirrus, "the highest and most distant cloud formation." Quoting Bloomfield, Shelley, and Wordsworth, Cropsey finds in the cirrus "infinite beauty," "unobtrusiveness," "extreme delicacy," and "completeness of form"; while his description is not as exalted as Goethe's "noble impulse" mounting "always higher," it conveys the ethereal spirit of this most elevated of cloud forms. The cumulus, however, most stimulates Cropsey's fantasy, with "its grand masses of dreamy forms floating by each other, sometimes looking like magic palaces, rising higher and higher, and then topling [*sic*] over in deep valleys, to rise again in ridges like snowy mountains, with lights

86

essential character than can be violated without incurring the charge of falsehood. . . ."[34]

Church did not have to wait for Ruskin to tell him this—it had been the practice of his teacher, Cole, since at least 1825. Ruskin fortified what the Americans were already doing. His color observations again parallel the kind of pragmatic notations found in Cole's and Church's drawings. "If you watch for the next sunset," wrote Ruskin, "when there are a considerable number of . . . cirri in the sky, you will see . . . that the sky does not remain of the same color for two inches together; one cloud has a dark side of cold blue, and a fringe of milky white; another, above it, has a dark side of purple and an edge of red; another, nearer the sun, has an underside of orange and an edge of gold; these you will find mingled with, and passing into the blue of the sky, which in places you will not be able to distinguish from the cool gray of the darker clouds, and which will be itself full of gradation, now pure and deep, now faint and feeble. . . ."[35]

Ruskin, like Goethe, had his own hierarchy of clouds—this, however, a connoisseur's hierarchy. The central cloud region, the habitat of the ordinary cumulus, was "comparatively uninteresting." In a comment worthy of Sir Joshua, he notes that cumuli are the favorite clouds of the Dutch painters, "quite good enough for all ordinary purposes . . . for cattle to graze, or boors to play at nine-pins under. . . ." Even nature, he adds with satisfaction, is not fond of these clouds and so introduces "some manifestation of finer forms, sometimes approaching the upper cirri, sometimes the lower cumulus."[36]

The incipient irony of the connoisseur, however, is a minor Ruskinian note. Even in dealing with these lower forms, the artist's truth could be tested by how he expressed *"infinity* always and everywhere, in all parts and division of parts."[37] Infinity, a word also cherished by Goethe, was always the redemptive feature. Mid-nineteenth-century esthetics could hardly exist without it, and where could it find a better resonance than in the skies? Like Cropsey, Ruskin found more to provoke his imagination in the rain cloud of the lower region, where "all that is beautiful may be made manifest . . . all that is hurtful concealed. . . ."[38] Praising such climatic effects in Turner, Ruskin noted the "absolute necessity of scientific and entire acquaintance with nature, before this great artist can be understood."[39] And here enters, once again, a major matter of conscience for the nineteenth-century artist—the practical relation between scientific knowledge and poetic truth. While Goethe and Carus had seen empirical observation as a route to transcendental infinity, the practical discretions involved in a successful consummation of the particular and the general were matters of considerable soul-searching.

Like the Americans, Ruskin was wary of scientific truth unelevated by artistic truth. As late as 1872, in *The Eagle's Nest,* he cautioned that if the artist "is quite sure that he can receive the science of [things] without letting himself become uncandid and narrow in observation, it is very desirable that he should be acquainted with a little of the alphabet of structure—just as much as may quicken and certify his observation, without prejudicing it. . . . The first thing you have to ask is, Is it scientifically right? That is still nothing, but it is essential."[40]

The powers of the ideal, however, restrained the empirical and curious eye. In 1856, in *Modern Painters* III, Ruskin maintained, like the Germans and Americans, that "the simplest forms of nature are strangely animated by the sense of the Divine presence; the trees and flowers seem all, in a sort, children of God. . . . I much question whether anyone who knows optics, however religious he may be, can feel in equal degree the pleasure or reverence which an unlettered peasant may feel at the sight of a rainbow."[41]

Reading Ruskin, American painters might have been inspired to get it "scientifically right," though that was "still nothing." As pragmatic observers, however, they may have had more faith in the possibility of fusing science and spirit than had Ruskin. With the revelation of the divine presence in nature as their ultimate aim, they endlessly drew the mutable faces of the heavens, capturing each quick transformation with eager pencils, fortifying their eyes with educated minds, seeing and knowing in one reverent perception.

American cloud studies can be traced back at least as far as the early drawings of Alvan Fisher in 1816 (fig. 43).[42] The notebooks of Cole, Cropsey, and Church, among others, testify to their abiding interest in clouds. In 1825, the young Cole copied in his notebook the formulae for painting skies from William Oram's *The Art of Coloring in Landscape Painting.*[43] He gleaned such information as: "Those which are uppermost are made in their shadows blue white and India Red only." He followed these instructions with his own observations of "water governed by the sky," of "a Misty Morning when the sun is about an hour high," of the sky "After Sunset, immediately after Rain." Of the morning sky in summer about eight or nine o'clock after rain, he noted that "the clouds in such a sky ar[e] very romantically shaped. The[y] fly in strata one above another the under side of each cloud is darker and bolder than the upper. . . . The clouds in the highest part are the warmest into their shades, but their lights perfectly white." This 1825 notebook is filled with observations of the *look* of the sky at a specific moment. He notes "a very fine sky about

43. Alvan Fisher, *Cloud Study*, 1816
Chalk on paper, 6¾″ × 5½″. M. and M. Karolik Collection, Museum of Fine Arts, Boston

4 o'clock in the afternoon in March the sun to the right—the large center cloud extremely light. . . . The Rainbow is on the outer edge of the rain and gradually mingles with it."[44] Such empirical observations abound in Cole's notebooks (fig. 44).[45] The myriad particulars of those mutable events—clouds—could, in good neoclassic fashion, instruct the artist's understanding of the general. Significantly, in the notebooks of the American landscapists, clouds are rarely generalized in the manner Ruskin had found so heinous in the Old Masters.

Cole studied clouds in America and abroad—where he looked at the sky as much as at the ancient monuments. Cropsey's interest in clouds is indicated by numerous undated notebook drawings as well as by

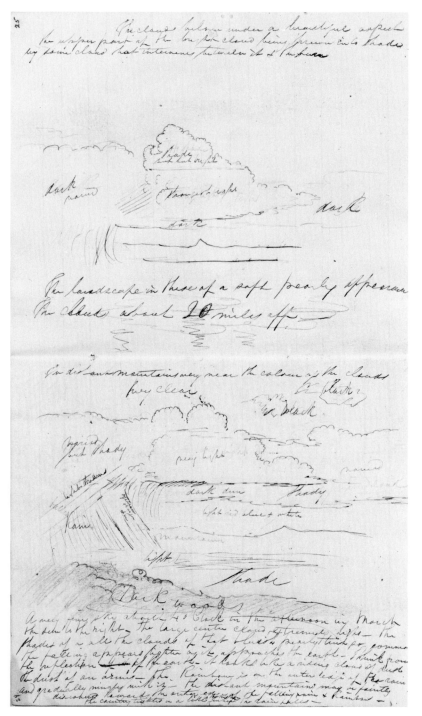

44. Thomas Cole, *Cloud Study*, 1825
Pen and pencil on lined paper, 7¹¹⁄₁₆″ × 6⅝″. The Detroit Institute of Arts

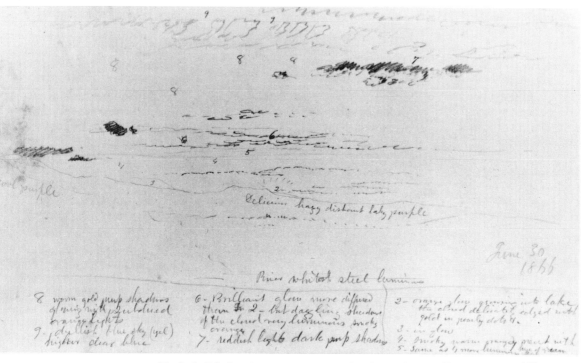

45. Frederic Edwin Church, *Landscape sketch, Hudson Valley*, June 30, 1866
Pencil on paper, 4⅜″ × 8½″. The Cooper-Hewitt Museum, New York, Smithsonian
Institution

his singular essay.[46] But it is Church who exhibits the most frequent,
even obsessive, preoccupation with the changing effects of clouds (fig.
45). Like Cole, Church often used code numbers for colors, and his
voluminous notations reveal a strong urge to arrest the slow boil and
slide of cloud formations.[47] How does this relate to the impressionists'
grasp of the ephemeral? The Americans' awareness of change was
strongly monitored by a necessity to stop it, making of each moment,
as Emerson had said, a "concentrated eternity." This attitude is re-
flected in Church's encounter with Sangay in 1857 (see figs. 21 and 42):
"I commenced to sketch the effect as rapidly as possible but constant
changes took place and new beauties revealed themselves as the setting
sun turned the black smoke into burnished copper and the white
steam into gold. . . . I was so delighted with the changing effects that
I continued making rapid sketches."[48] Confronting process with "rapid
sketches"—matching the rate of change with speed of execution—en-
abled Church to research the proper moment to halt process, or to add
up the sum of moments into a synthetic idea of arrested time. Even in

93

these swift notations, we sense an inclination to still process as much as to record it.

Pursuing this fugitive vision, Cole, in an 1827 notebook, wrote of the sky seen from the Mountain House: "Once about noon after a rain there appeared several very imposing effects but to sketch or to describe them is almost beyond the power of man for one changed into another in so short a time."[49] In this area of the quick sketch—of unpretentious, and often inspired data-gathering—Bierstadt's sky studies occupy an increasingly high position (fig. 46). In the cloudscapes, Bierstadt, at his best with atmospheric effect, was free to forget his public, to establish an intimate dialogue with cloud and sky alone. These modest studies, in which the artist is literally in the clouds, are some of his most subtle and important works. Generally executed alla prima in oil, they pose potent oppositions to the technical and rhetorical machinery of the larger compositions. And they raise a largely unexplored issue: What were the artists' attitudes to *the sketch* in mid-nineteenth-century America?

Despite our own contemporary predilections for such "unfinished" works, these sketches—and drawings—were, for all the pleasure the artists took in them, largely means toward an ambitious goal—the formal picture. With sketches the artist "fixed" reality, then bore it off to the studio for further examination. There pragmatic observation could be transformed into the desired poetic and divine truth; the general idea could quietly transfigure natural fact. The terms of this transformation were the main esthetic issue: the narrow but noble obligation within which each artist turned his equivocations—which were matters of conscience—into style.

How did clouds fare in the larger, finished works? Did they function as structural factors? If so, how much was truth of type altered to conform to compositional needs? Are the clouds still recognizable in terms of meteorological classification? How close did the artists stay to the scientism of their observation and knowledge? How much did they conventionalize and adapt? How did clouds condition light and modify the landscape? And how did they serve to carry out the total esthetic which dominated the artists' vision?

The major cloud regions isolated by Ruskin and Cropsey, and roughly based on Howard's classifications, are readily recognizable. The *International Cloud Atlas* now lists hundreds of variations on these basic types,[50] but the generic distinctions remain much the same as when Howard established them. Since both Cropsey and Ruskin laud the rain cloud's potential, we can expect some memorable American works

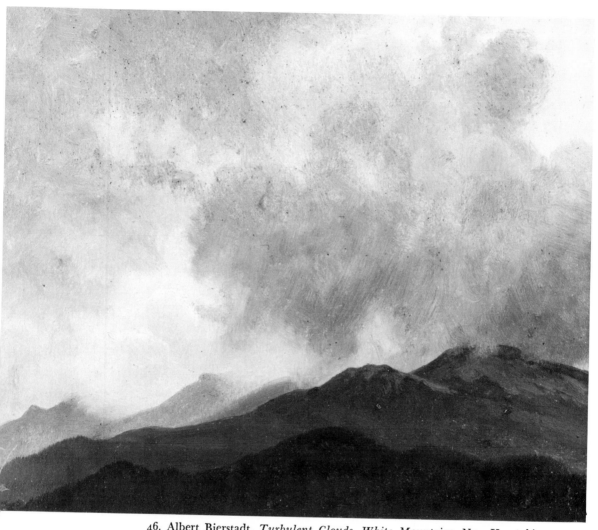

46. Albert Bierstadt, *Turbulent Clouds, White Mountains, New Hampshire (Presidential Range)*, undated
Oil on paper, 9″ × 11″. Collection Mr. and Mrs. Maurice Glickman. Photo courtesy Florence Lewison Gallery, New York

to be based on it. A splendid example, predating both Cropsey and Ruskin, is Cole's famous *Oxbow* (1836; Metropolitan Museum of Art, New York): the passing storm, alternating with brilliant light in the distance, wipes across the picture from right to left, creating patterns of light and dark in the sky that temper the tone of the landscape below. Here are those overtones of majestic renewal that betray the noble aims lingering behind even Cole's humbler views of nature. In

Storm in the Mountains (M. and M. Karolik Collection, Museum of Fine Arts, Boston), Bierstadt's ambitious instinct for a rather belated Gothick sublimity directed him, in contrast to his brilliant but modest cloud studies, to the awesome potential of the rain cloud. Light and dark clouds swirl into a tunnel-like wreath that is not only the focus but the substance of the composition, recalling some of the cavernous late-eighteenth-century landscapes of such artists as Joseph Wright of Derby as well as some of the Gothick tunnels of his nearer contemporary, Cole. Even the quieter luminist works of Heade and Lane recognize the rain cloud's potential for mood. In Heade's *Storm over Narragansett Bay* (Amon Carter Museum, Fort Worth), an almost surreal foreboding is in large part evoked by reflecting the darkness above in the water below, recalling Cole's comments about "water governed by the sky." In Lane's *Schooners Before Approaching Storm* (fig. 47), the rain cloud is suspended over a still sea, which counteracts—indeed almost contradicts—the activity above. Painters of very diverse aims and

47. Fitz Hugh Lane, *Schooners Before Approaching Storm,* 1860
Oil on canvas, 24″ × 39⅝″. John D. Rockefeller collection

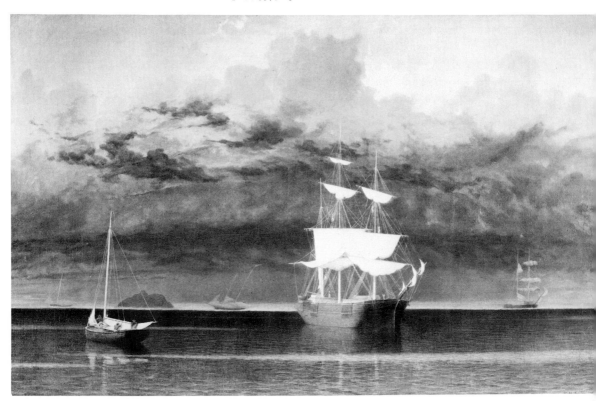

esthetics, then, did not confine themselves exclusively to one variety of cloud, though any cloud, once introduced, was modified according to their particular aims. The sky, Constable's "chief organ of sentiment," was closely observed and stringently managed.

But it was not so much the storm cloud, with its obvious propensities for sublimity, that attracted the Americans; it was the central cloud region—the area of the cumulus about which Ruskin had his reservations. Although Ruskin was obliged to recognize its potential for variety, the rounded forms of the simple cumulus were, he felt, easily conventionalized and this—to his irritation—had led not only the Dutch, but Claude, Poussin, and Salvator astray. But he was willing to admit that their deficiencies came from drawing the cumulus in separate masses. Nature rarely confined herself to such masses, which formed only a thousandth part of her variety, but built up "a pyramid of their boiling volumes," covered the "open part of the sky with mottled horizontal fields," broke through these with sunbeams, tore up their edges with local winds, and scattered "over the gaps of blue the infinitude of multitude of the high cirri. . . ."[51]

Only this variety could relieve for Ruskin the banality of the central cloud region. And variety was precisely what the Americans found in it. Taking their cues perhaps from the Dutch, they made the widest pictorial use of this cloud genre. Some of their results might have pleased Ruskin, though it is difficult to imagine him being really pleased by any skies other than Turner's. In the transparent, mutable cumulus the Americans found endless possibilities which mirrored the larger esthetic issues behind each painter's specific vision. On occasion, however, they were seduced into mannerisms. In Bierstadt's *Mount Whitney* (fig. 48; color) for all its atmospheric virtuosity, the edges of the clouds piling up at the left are mechanically rounded. Similarly, Ruskin might have discarded as false the convention within which the clouds are locked in Heade's *Sunlight and Shadow: The Newbury Marshes* (private collection).

But the pragmatic corrective and the meteorological sensitivities of the moment kept the Americans from those fallacies Ruskin had identified in the Old Masters. Even when commandeered to serve symbolic truths, American clouds tended to be specific and easily recognizable. Rather than adapt the clouds to their needs, the American landscapists carefully studied the clouds so that they could choose those forms, tones, opacities, and transparencies that best served their structural and esthetic needs. Thus Bierstadt repeatedly piled extraordinary varieties of cumulus one on the other, to create a theater of rhetoric beaming down tangible doses of sublimity. As rhetoricians, Church and Bierstadt favored the tumultuous sky into which emotion could be

projected under the convincing guise of observation and truth. The rapid changes of light at such times were faithfully observed and recorded, then placed at the service of a devotional idea—the sky itself as the vessel of spirit.

Church, perhaps the most industrious of all American cloud students, chose the ordered formations of a perfectly observed altocumulus to set the mood for his masterpiece, *Twilight in the Wilderness* (see fig. 1; color). The flame-like shapes, their reflections suffusing the stilled landscape below, enact a baroque ecstasy in the heavens. Church often presented a transcendent Deity through this apocalyptic majesty, projecting those feelings of reverence of which Cropsey and Carus had spoken, in forms that, however closely observed, engender an almost abstract energy. The sky is perhaps the most apt locus for the reciprocal energies of observation and abstract invention to mesh in a definition of divinity.

One American artist—and one alone—was so attached to a particular cloud that it is virtually a signature of his work. Martin Johnson Heade, Church's good friend, chose the cumulus lenticularis to reinforce the horizontals that characterize his extended, miniature panoramas. In such a picture as *Sunset on Long Beach* (fig. 49), the clouds are, one might say, further steps ordering a space that aspires to the mensurational infinity of classicism—a measured rather than immeasurable eternity. Stretching along the extended canvas, formed with a

49. Martin Johnson Heade, *Sunset on Long Beach*, c. 1875–85
Oil on canvas, 10¼″ × 22″. M. and M. Karolik Collection, Museum of Fine Arts, Boston

50. Martin Johnson Heade, *Omotepe Volcano, Nicaragua*, 1867
Oil on canvas, 18½″ × 36½″. Private collection

deliberateness that leaves them no option but to remain palpable, they seem as much at the service of an ordering sensibility as merely proffered by the sky itself. Much as he may have respected nature, Heade respected measure more. Yet these "French bread" clouds do exist in nature at sunset, when the cumulus humilis dwindles to these simple bars that conveniently fortify his insistent horizontal rhythms. They establish that preface, as it were, to the quiet transcendence that characterizes his art—though they frequently retain a trace of that eccentricity—almost mannerism—that sometimes lends an anticipatory, even menacing mood to his work.

It would be a simple matter to assign to Church and Bierstadt on the one hand, and to Heade on the other, those versions of a Christianized sublimity defined in Chapter III, and to relate to these choices of cloud types the iconographic hierarchies evolved both in Europe and America. Heade, to apply Goethe's symbolic system of cloud values, was one of the few to use the most noble and aspiring cloud, the cirrus. In *Omotepe Volcano, Nicaragua* (fig. 50), he combines it with delicate varieties of cumulus. But on occasion Bierstadt, the master of cumuli, also studied the cirrus. So we must not impose categories on a problem that was, in some ways, as varied and amorphous as the clouds. It is my contention that these clouds and com-

99

binations were not used unconsciously, but that the sky itself, es-
pecially in a tradition singularly devoted to the concept of light as
spirit, was studied closely, and that its symbolic duties were fully un-
derstood (fig. 51; color).

This is so even when, at first glance, an artist appears to have little
interest in clouds. Lane especially seems drawn to a variety of gentle
cirrus and cumulus formations. We are often barely aware of them,
until we remember to look. Lane's clouds, far from setting the quiet
tone of the canvas, follow it, signaling a specific kind of expressive
and symbolic purity. That symbolism can be extended even further—
for if the delicate cirrus, on the margin of invisibility, was the most
noble of clouds, the clear sky in its unbroken infinity approaches di-
vine purity. In the glowing light radiating from Lane's harbor scenes,
as also in the cloudless skies over Kensett's beaches (fig. 52; color), this
ideal is often met, suggesting Goethe's identification of "the pure
cloudless sky with the calm of eternal bliss."[52]

VI

The Organic Foreground: Plants

Your voiceless lips, O Flowers! are living preachers,
Each cup a pulpit, every leaf a book—[1]

In Henry Inman's *Mumble the Peg* (fig. 53), a simple, even banal genre scene, two children are playing a game. Dominating the foreground is a small, isolated plant. We look at it with some puzzlement. Does its prominence signal some message we are missing, some allegory of growth perhaps—or a plant symbol we cannot recognize? We are aware that an elaborate system waits to echo the plant's promptings.

When H. T. Tuckerman responded to *Mumble the Peg,* he ignored the plant but concentrated on the "vegetable" life of the two boys: "The freshness of their looks, like the verdure on which they are stretched, is as the smile of the best spring that preceded the manhood 'of our discontent'—gleaming through the long vista of years."[2] Elsewhere, in an essay on flowers, Tuckerman found in them "the objectless, spontaneous luxury of existence that belongs to childhood. They typify most eloquently the benign intent of the universe; and by gratifying, through the senses, the instinct of beauty, vindicate the poetry of life with a divine sanction."[3] Children and flowers were part of an organic cosmology, a sentimental universe that both illustrated and masked the cultural significance of plants.

Meditating on their "brief duration," Tuckerman also found in flowers "a moral significance that renders their beauty more touching, and as it were, nearer to humanity than any other species of material loveliness." Flowers, he wrote, "are related to all the offices and relations of human life." And, "instead of looking at them through the microscopic lens of mere curiosity, or according to the fanciful and hackneyed alphabet that Floral dictionaries suggest, let us note their influence as symbols and memorials."[4]

If nature was the theater of large religious and moral ideas, what role did flowers and plants play? What did the precise foreground de-

101

53. Henry Inman, *Mumble the Peg*, 1842
Oil on canvas, 24″ × 19½″. The Pennsylvania Academy of the Fine Arts, Philadelphia, bequest of Henry C. Carey

tails of the nature paintings mean to the artists (figs. 54, 55)? What was their attitude to botany, and to the organic world-view of their age? Such questions bring us swiftly into the period's major controversies: religious, moral, scientific, philosophical.

The gathering and rendering of plants—part artistic, part scientific—was a prominent part of the earliest American explorations. Two Englishmen—John White in the 1580's and Mark Catesby in the 1730's and '40's were the great predecessors of the nineteenth-century landscapists, whose notebooks abound with drawings of leaves and plants. Catesby apologized for his primitivism: "As I was not bred a Painter I hope some faults in Perspective, and other Niceties, may be more

54. Asher Brown Durand, *Hills, Dale and Bracken,* undated
Oil on panel, 20″ × 29½″. Private collection

55. Durand, *Hills, Dale and Bracken,* detail

readily excused, for I humbly conceive Plants, and other Things done in a Flat, tho' exact manner, may serve the Purpose of Natural History, better in some Measure than in a more bold and Painter like Way."[5] The explicitness of his drawings derived from this empirical common sense: "In designing the Plants, I always did them while fresh and just gather'd. . . ."[6]

This interaction of the empirical eye with the categories of natural history became a major theme of the nineteenth-century artist. The early urge to label, with its emphasis on classification, persisted longer in America than abroad, as Americans held tenaciously to the "artificial" system of Linnaeus. Since this was bound to absolute fixity of species, the American devotion to this concept and to its religious implications is easily understood. The tendency to categorize also coincided with an American preoccupation—even obsession—with gathering statistics, and with a practical curiosity about the new continent—a curiosity that almost brought the botanist Asa Gray and Nathaniel Hawthorne together as colleagues on the Wilkes expedition of 1838.[7]

By the time Emerson was exposed to the French botanist Antoine Laurent de Jussieu's natural method at the Jardin des Plantes in Paris in 1833,[8] the taxonomic grip of the Linnaean system was relaxing. Ideas of organic unity were abroad, partly through contact with the ideas of the Germans and of Coleridge. Coleridge's notion of the organic unconsciousness of genius—"What the plant is by an act not its own, and unconsciously, that must thou *make* thyself to become"[9]— found little resonance in American artists. His good friend Allston, one of the few who speculated on the problem of genius, paradoxically insisted on a real distinction between nature and art.[10]

But Coleridge's analogy between men and plants—"the same power in a lower dignity"[11]—is paralleled in Emerson and Thoreau. "The greatest delight which the fields and woods minister," wrote Emerson in *Nature* in 1836, "is the suggestion of an occult relation between man and the vegetable. . . . They nod to me, and I to them."[12] The application of Coleridge's organic notion to the artist (on Shakespeare: "Growth as in a plant")[13] is echoed by Thoreau's "Some poets mature early and die young. Their fruits have a delicious flavor like strawberries."[14] Coleridge's organic theory of the work of art ("All is growth, evolution, *genesis*—each line, each word almost, begets the following")[15] might result in Thoreau's conclusion: "Most poems, like the fruits, are the sweetest toward the blossom end."[16] The organic metaphor began to insinuate itself into whatever was subject to temporal cycles of growth and decay.

Thoreau could have been familiar with some of Coleridge's ideas through such writings as *Aids to Reflection,* published in America in

1829 (Emerson read it the following year).[17] But in American litera-
ture, the man-plant analogy went back at least as far as Crèvecoeur in
1782. "Men are like plants," he wrote; "the goodness and flavour of
the fruit proceeds from the peculiar soil and exposition in which they
grow. We are nothing but what we derive from the air we breathe,
the climate we inhabit, the government we obey, the system of reli-
gion we profess, and the nature of our employment."[18]

Crèvecoeur's comment is an obvious early source for the idea of a
national art rooted in American soil. The *Gesamtorganismus,* which
M. H. Abrams has treated as "an artistic genre or a national litera-
ture . . . conceived to grow in time as a single work grows in the
imagination of the individual artist,"[19] was of course a concept of key
importance to such Germans as Johann Gottfried Herder, "the found-
ing father of historical organology."[20] Reading Herder, Emerson must
have been affected by such ideas as: "The first and last question is:
What is the nature of the soil? What is it adapted to? What has been
sown therein? What is it able to bear? . . . The nature, virtue and
perfection [of Shakespeare's creation] rests on this fact, that it differs
from the former; that out of the soil of his time, precisely this other
plant grew up."[21] The environmental nourishment of genius provided
a theoretical framework for analysis. The poets of the Italian and En-
glish Renaissance were, to Coleridge, "like fair and stately plants,
each with a living principle of its own, taking up into itself and di-
versely organising the nutriment derived from the peculiar soil in
which [each?] grew. . . In all their hues and qualities they bear wit-
ness of their birthplace and the accidents and conditions of their in-
ward growth and outward expansion."[22]

In his enthusiasm for such organic parallels, Emerson related hu-
man to natural history:

All the facts in natural history, taken by themselves, have no value, but are
barren, like a single sex. But marry it to human history, and it is full of life.
Whole floras, all Linnaeus' and Buffon's volumes, are dry catalogues of facts;
but the most trivial of these facts, the habit of a plant, the organs, or work,
or noise of an insect, applied to the illustration of a fact in intellectual phi-
losophy, or in any way associated to human nature, affects us in the most
lively and agreeable manner. The seed of a plant—to what affecting analogies
in the nature of man is that little fruit made use of, in all discourse, up to
the voice of Paul, who calls the human corpse a seed. . . .[23]

Emerson's reference to Linnaeus again testifies to the prolonged hold
of his system in America. It also recalls the German philosopher who
made the most serious attempt to expand Linnaeus's contribution:
Goethe—who, "for Emerson, Alcott and Thoreau . . . always re-

mained the most important of the Germans."[24] Goethe devoted intense
energy to the pursuit of this botanical goal. "I go on reading Linne,"
he wrote to Frau von Stein in 1785; "I have to, since I have no other
book with me. It is the best way to read a book conscientiously. . . .
This book was not made for reading, but for recapitulation, and it has
done me the most valuable service, since I have thought about most
of the points."[25] Elsewhere he noted, "That which he [Linne] sought
by force to hold apart had, according to the innermost urge of my na-
ture, to strive toward union."[26] Over eighteen months later, he wrote
triumphantly from Rome to Frau von Stein again:

Tell Herder I am near the secret of the reproduction and organization of
plants, and that it is the very simplest you could imagine. . . . Tell him I
have discovered quite definitely and unmistakably where the germ lies hidden,
that I have already a general conception of the rest and that there are only a
few points now to fix more precisely. My "Primal-Plant" [the archetype], will
be the most extraordinary creation in the world, one that nature herself
might envy me. With this model and the key to it one can go on and on
indefinitely inventing plants, which must be consistent, I mean plants which,
even though they do not exist, might exist, not just picturesque and poetic
shadows or semblances, but possessing the quality of inner truth and necessity.
The same law will be applicable to all other living things.[27]

Goethe's concept of the *Urpflanze* developed after a seminal en-
counter in the mid-1780's in Padua's Botanical Garden with an an-
cient palm, *Chamaerops humilis* L., said to have dated back to 1584.
This encounter carried with it all the mystery of invention and genius,
and the controversial value of Goethe's botanical contributions in
The Metamorphosis of Plants (1790) in no way diminishes this. Agnes
Arber notes that Goethe, in his theory of plant members, "visualized
the indescribably various appendicular organs of plants all as expres-
sions of one form—the leaf. In his wider study of morphology he went
further in the same direction, and he reached the concept of a single
type in accordance with which everything was fashioned."[28] Goethe,
Arber suggests, was here utilizing a type concept that "is a device for
figuring out the problems of existence to which those who see these
problems on broad lines have frequently resorted."[29]

The point is well taken. But Arber rejects the idea of Platonic ref-
erences in the type concept as Goethe uses it. She sees his *Blatt* as "a
conjectural concept, enabling a hypothetical situation to be visual-
ized."[30] It seems to me, however, that his archetypal plant did have
some Platonic overtones. In this, it relates to Thomas Cole's neo-
Platonic quest for a "true nature" which would fulfill its predestined
purpose: ". . . the most beautiful leaf & flower will be that which has
performed its various functions to the greatest perfection."[31] Again,
one recalls John Dewey's observation on the classic notion of species,

whereby a specific type directs the earlier stages of growth to realize its own perfection. From this teleological inevitability, Goethe posited plants that *might* exist, "possessing the quality of inner truth and necessity." This, then, is the pre-Darwinian vision: the orderly development of defined species to their appointed perfection, never subverted by the short circuits of mutation. In this ideal unwinding, the organic image of growth from seed to flower is powerfully infused by the authority of a divine will.

More than any other American artist, Cole would have responded to Goethe's concept of the artist as someone who "in the practise of art . . . can only vie with nature when [he has] at least to some extent learned from her the process that she pursues in the formation of her works." The artist, maintains Goethe, should produce "in his works not merely something which is easily and superficially effective, but in rivalry with nature, something spiritually organic [*Geistig-Organisches*] . . . at once natural and above nature."[32] Art for Cole was, as we have noted, "man's lowly imitation of the creative power of the Almighty"[33]—an unusual willingness for an American artist to vie with nature.

He paid in part for the daring of his ambition—a romantic ambition—through the continued disappointments of unenlightened patronage, which deprived him—in a plant-like simile—of opportunity for growth. On July 22, 1838 he wrote:

There is a climbing plant attached to an oak in our grove that I have watched year after year, & find never getting larger or stronger—In spring, it puts forth a few leaves and spreads a few green tendrils, but the winter entirely blasts them, & the slender, woody stem often remains without any increase of size.

> My fate resembles thine
> I toil to gain a sunnier realm of light
> And excellence—waste & pine
> In the low shadow of this world of night.
>
> The genial seasons sometimes bear me up,
> Till Hope persuades, I ne'er again shall stoop,
> But quickly comes the withering blast to blight
> My rich and prided growth, & I remain
> The same low thing to bud—to blight again.[34]

The bud-bloom-decay simile stands beside Cole's concept of perfect nature in much the same way that evolutionary concepts of organicism begin to stand beside fixity of species and type. In this book, the rigorous hold of the latter in America has been emphasized. But the initial threats to the type concept could occur more readily in the

vegetable than in the mineral—and geological—world. Concepts of organic change and of fixity increasingly existed side by side. Both donated common metaphors through which the age unconsciously betrayed its thinking. The dominant metaphor was based on the inorganic and also classic obsession identified with measure, precision, mineral absolutism. This larger metaphor "explained" the world. The vast stretches of time and space now accessible to the imagination were structured with the mensurational habits of the physical sciences, habits which dominated much of the artists' thinking as well.[35] This set of assumptions shared by both artists and scientists gave the society—and the art—its extraordinary consistency. The subject retains vast opportunities for research.

But as the nineteenth century progressed, the other—organic metaphor—was also present, though on a more domestic and intimate scale. We might speculate that the organic metaphor revealed the individual psyche, while the mensurational metaphor still dominated the communal mind. Life, in this personal image, was a kind of sublime wasting sickness, its brevity the source of further moral lessons. Indeed, as Cole's poem illustrates, the pervasive moral system quickly invaded the organic metaphor. Men are plants, they strive towards the light, they cannot flourish in darkness, their fruits are rich or blighted. Out of this world of unceasing process could erupt those threats to fixity of species.

Goethe ingeniously maintained fixity of type in his *Urpflanze* by incorporating within it the delirium of process. On May 17, 1787, he wrote to Herder: "It had occurred to me that in the organ of the plant which we ordinarily designate as *leaf,* the true Proteus lay hidden, who can conceal and reveal himself in all forms. Forward and backward, the plant is always only leaf, so inseparably united with the future germ that we cannot imagine one without the other."[36] "It is a becoming aware," he had written earlier to Frau von Stein, "of the form with which nature so to speak, always plays, and in playing brings forth manifold life."[37]

This union of being and becoming is at the center of the transcendentalism of Emerson and Thoreau, where nature and process were means of exploring the relation of time to eternity. Grass, wrote Thoreau, "is a symbol of perpetual growth—its blade like a long green ribbon, streaming from the sod into the summer, checked indeed by the frost, but anon pushing on again, lifting its last year's spear of withered hay with the fresh life below. . . . So the human life but dies down to the surface of Nature; but puts forth its green blade to eternity."[38] Emerson attacked the idea with his usual energy and ended with a memorable phrase: "Genius detects through the fly, through the caterpillar, through the grub, through the egg, the con-

stant individual, through countless individuals the fixed species, through many species the genus; through all genera the steadfast type, through all the kingdoms of organized life the eternal unity. Nature is a mutable cloud which is always and never the same."[39]

Emerson read Goethe's *Introduction to Morphology* and *The Metamorphosis of Plants* between 1830 and 1840, remarking that this "laid the philosophic foundations of comparative anatomy in both vegetable and animal worlds."[40] But as Vogel reminds us, "he found in the writings of this German not so many new ideas as the confirmation of those already long established in his mind."[41] Being and becoming are not only the two sides of a universal coin that have, singly or jointly, concerned philosophers and scientists for centuries. In the early nineteenth century, they also represent a particular juncture of neoclassicism and romanticism, of Newtonian mechanics and proto-evolutionary organicism.

The absolutism and flux subscribed to by both Emerson and Thoreau could coexist in America as long as absolutism prevailed, as long as the green blade struck eternity. Thus while finite time was represented by plant similes of seasonal change and cyclical mortality, eternity was not far away. "At one leap," wrote Thoreau, "I go from the just opened buttercup to the life everlasting."[42]

This absolutism informs the botanical references in the art and writing of the period. All things, all processes—particularly the engines of poetry—move inexorably from the particular to the eternal, which forms their ever-present backdrop. Cole's poem of autumn written in 1842 is typical:

> The yellow forest lies beneath the sun
> Quiet; although it sufferth decay.
> The brooklet to the Ocean-deep does run
> With gentle lapse and silent, melts away;
> The clouds upon the evening sky are bright
> But wasting mingle with the glorious light.
>
> So may the soul in life's declining hours
> Like the still forest never once complain
> And flow unmurmuring adown its course
> Like yonder brooklet to the Eternal Main;
> And as the clouds upon the sunset sky
> Be mingled with the radiance on high.[43]

Cole's poetry is a virtual anthology of the common ideas of the day. The sentiments are somewhat worn. Time was organic: "Another year like a frail flower is bound / In time's sere withering aye to cling."[44] Mortality infected all: "Beauty doth fade—its emblem is a leaf / That mingles with the earth in quick decay."[45] And he could

always gather himself for the obligatory transcendent leap: "All things live to die and die to be renewed again / Therefore we should rejoice at death and not complain."[46]

Mortality and the seasons, man in the autumn of his life, floral destiny as a vegetable analogue for human destiny: these are long-standing commonplaces in intellectual history, new neither to the nineteenth century nor to America. But at that moment in America there was a rich fusion between the eighteenth-century picturesque and the new "organological" readings of history, philosophy, esthetics, and science. The new disciplines were powerfully transfused by cyclical nostalgias. Predictably, Cole, the most philosophical of the American landscapists, attached his theories of time and mortality to seasonal images in his poetry and in his major cyclical paintings. There the bud-bloom-decay-renewal metaphor was amplified into meditations on life, civilization, and religion. While *The Course of Empire* ended on the pessimistic note of *Desolation,* the last series, *The Cross and the World,* promised spiritual redemption. Between these, *The Voyage of Life* offered reassuring angels welcoming Old Age into the heavenly realm. Of *Childhood* in that series (see fig. 11) Cole wrote, "The rosy light of the morning, the luxuriant flowers and plants, are emblems of the joyousness of early life."[47] The flowers (fig. 56), like childhood itself, were a kind of heavenly abundance, and the pastoral identification of life with the seasons was complete.

In this regard—the seasons as metaphor—one American painter, Cropsey, occupies a curious position. His colors, flushed with autumnal excess, signify an extreme fidelity to nature at the picture's expense (a form of conceptual integrity). In these autumnal paintings, Peter Bermingham—who refers to Cropsey as "Cole's following of one"— sees an "interesting link bweween the last vestiges of seasonal treatment with allegorical overtones," as in Edward Hitchcock's *Religious Lectures on the Peculiar Phenomena of the Four Seasons* of 1853, and "the ultra-objective approach of Darwin."[48] Though he touches on the Hudson River school's concern—a somewhat retardataire concern —with decay and erosion, Bermingham emphasizes that "for Cropsey . . . there was nothing melancholy about the wonders of nature, sublime though they seemed to be."[49]

But however they might be concerned with time and transience, one wonders if the Hudson River men were ever really melancholy. Much of their mortal nostalgia seems to have been, like young Werther's, part of the age's emotional equipment. Nostalgia, which like sentimentality has been called "unearned emotion," side-tracked the troubling moral issues raised by progress into comfortable meditations on time's passage.

However much he brooded about "the Ruffian Time," Cole opposed

56. Cole, *The Voyage of Life, Childhood,* detail

this melancholy with spiritual optimism. Though autumn leaves were annual reminders of transience, hopes of spiritual renewal were everpresent. Flowers and greenness refreshed his thoughts. "O for a single blade of grass! if it were only one inch in length, it would cheer my drooping spirits."[50] As with Thoreau ("greenness so absorbs our attention"[51]), an inch of green grass could lift Cole's spirits; a leaf could spell eternity: "How the soul is linked in harmonies & associations! A word spoken now recalls a word spoken years back. . . . One thing brings into the minds vision another very dissimilar—A feather may remind one of greatness & Empire; a mist, of Heaven; a rock, of the unsubstantial nature of things; a leaf may suggest to the mind a child paradise a departed parent or a living friend—"[52]

111

The linkage Cole refers to reverberates through all his writings. It is of course a period habit—to relay thought through well-established cycles in an allegorical system of reminiscence. For Cole and his contemporaries the scent of flowers was assimilated into a universe of associations. Of his visit to Vaucluse in October 1841, he wrote: ". . . I descended the valley, crossed the little bridge at the village, and climbed the crag on which the ruin stands. . . . Roofless, many of its walls thrown prostrate, its halls and courts are filled with flowering plants and odoriferous shrubs, thyme, and lavender. I plucked some flowers as a memento, and departed."[53] "No one," wrote Thoreau, "has ever put into words what the odor of water-lilies expresses. A sweet and innocent purity. The perfect purity of the flower is not to be surpassed."[54] The period found in flowers and their odors further proof of an accommodating Deity's generous plenitude. Returning toward Fair Haven, Thoreau perceived at Potter's fence:

the first whiff of the ineffable fragrance from the Wheeler meadow—as it were the promise of strawberries, pineapples, etc. in the aroma of the flowers, so blandly sweet—aroma that fitly foreruns the summer and the autumn's most delicious fruits. It would certainly restore all such sick as could be conscious of it. . . . It is wafted from the garden of gardens. . . . If the air here always possessed this bland sweetness, this spot would become famous and be visited by sick and well from all parts of the earth. It would be carried off in bottles and become an article of traffic which kings would strive to monopolize. The air of Elysium cannot be more sweet.[55]

This tone was, for the most part, echoed by the artists. But recent scholarship has attempted to correct the idea of the age's undiluted optimism by following into the darker psychological territory explored by Leslie Fiedler in his analysis of the American novel. "Like Hawthorne," writes Theodore Stebbins, Martin Johnson Heade "was a child of the Puritans; similarly, Heade apparently shared the writer's deep sense of sin, as well as his conviction of the reality and permanence of evil."[56] Stebbins stresses Heade's awareness of the flower as a symbol of female sensuality. Heade's flowers certainly have a sinuous, sensual and exotic energy (fig. 57), and if they do associate with women and with evil, they are a rare instance of pessimism—of, we might say, floral pessimism—in American art. For by and large, the artists enthusiastically endorsed the world view of their age. No corrosive ironies entered the garden. There is little in the visual art to parallel such literary conceits as deadly beauty and ambiguous attraction.

Evil was more readily recognized by a Hawthorne, a Poe, or a Melville, who have few correspondences in this regard in the visual arts of their moment. In "Rappaccini's Daughter," Hawthorne's hero, Giovanni Guasconti, rejoices that "in the heart of the barren city, he had the privilege of overlooking a spot of lovely and luxurious vege-

57. Martin Johnson Heade, *Study of Lealia purpurata and another orchid,*
c. 1865–75
Oil on canvas, 8½″ × 13″. St. Augustine Historical Society, Florida

tation. It would serve . . . as a symbolic language to keep him in com-
munion with Nature."[57] Giovanni strolls in Doctor Rappaccini's gar-
den, inhales the fragrance of a shrub created specially by the doctor
and becomes, like his beloved Beatrice, a noxious avatar: "There was
a swarm of summer insects flitting through the air in search of the
food promised by the flower odors of the fatal garden. . . . He sent
forth a breath among them, and smiled bitterly at Beatrice as at least
a score of insects fell dead upon the ground. 'I see it! I see it!' shrieked
Beatrice. 'It is my father's fatal science!' "[58] Nature is poisoned by
man's science. Beatrice becomes a sister to the deadly shrub. We are
far from Thoreau's benevolent "Old trees are our parents and our
parents' parents."[59] Yet, science was also establishing the unity of
human and vegetable nature. As Asa Gray put it, "The fact is that a
new article has recently been added to the scientific creed—the essen-
tial oneness of the two kingdoms of organic nature."[60]

The hazardous questions thus posed may have led to reservations

113

about the scientific process. In the act of investigation, in the possession of knowledge, there was, perhaps, a transgression of godly prerogatives. Some mysteries are best left alone. Life falters at the touch of the analytical process. In the "we murder to dissect" point of view lay the preservation of mystery and faith. The investigative process focused those conflicts between reason and feeling, logic and poetry that troubled the romantic mind. "Empirical science is apt to cloud the sight,"[61] said Emerson. While Thoreau noted: "If you would make acquaintance with the ferns, you must forget your botany. You must get rid of what is commonly called *knowledge* of them."[62]

Thoreau, who always suffered his difficulties with less optimism, attempted to contain the discipline of science itself: "Science does not embody all that men know, only what is for men of science."[63] The cursory lip-service paid by scientists to the idea of Deity troubled him: "Men of science, when they pause to contemplate 'the power, wisdom and goodness' of God, or as they sometimes call him, 'the Almighty Designer,' speak of him as a total stranger who it is necessary to treat with the highest consideration. They seem suddenly to have lost their wits."[64] He resisted the encroachment of science on faith with ingenuity and eloquence:

The mystery of the life of plants is kindred with that of our own lives, and the physiologist must not presume to explain their growth according to mechanical laws, or as he might explain some machinery of his own making. We must not expect to probe with our fingers the sanctuary of any life, whether animal or vegetable. . . . Science is often like the grub which, though it may have nestled in the germ of a fruit, has merely blighted or consumed it and never truly tasted it. Only that intellect makes any progress toward conceiving of the essence which at the same time perceives the effluence. The rude and ignorant finger is probing in the rind still, for in this case too, the angles of incidence and excidence [*sic*] are equal, and the essence is as far on the other side of the surface, or matter, as reverence detains the worshipper on this, and only reverence can find out this angle instinctively. Shall we presume to alter the angle at which God chooses to be worshipped?[65]

The angle Thoreau was obviously seeking, the angle beyond science, "at which God chooses to be worshipped," is familiar through Ruskin's advice:

For all his own purposes, merely graphic, we say, if an artist's eye is fine and faithful, the fewer points of science he has in his head the better. But for purposes *more* than graphic, in order that he may feel towards things as he should, and choose them as *we* should, he ought to know something about them. . . . Cautiously, therefore, and receiving it as a perilous indulgence, he may venture to learn, perhaps as much astronomy as may prevent his carelessly putting the new moon wrong side upwards; and as much botany as will prevent him from confusing, which I am sorry to say Turner did, too often, Scotch firs with stone pines.[66]

Not too much science for artists—or writers. But surely some. The conflict between knowledge and poetry was acutely experienced by Thoreau and brought to some kind of temporary resolution. He provides a remarkable model of the nineteenth-century conscience troubled by science, here experienced on the level of language: "Some of the early botanists, like Gerard, were prompted and compelled to *describe* their plants, but most nowadays only measure them, as it were. . . . I am constantly assisted by the books in identifying a particular plant and learning some of its humbler uses, but I rarely read a sentence in a botany which reminds me of flowers or living plants. Very few indeed write as if they had seen the thing which they pretend to describe."[67] Yet earlier, he had noted: "How copious and precise the botanical language to describe the leaves, as well as the other parts of a plant! Botany is worth studying if only for the precision of its terms, —to learn the value of words and of system."[68]

Thoreau's readings in botany were serious, disciplined, and historical; he found the works of Theophrastus, "the father of botany," a great stimulus—"they were opera"[69]—and read Linnaeus's *Philosophia Botanica* "which Rousseau, Sprengel, and others praised so highly—I doubt if it has ever been translated into English. It is simpler, more easy to understand, and more comprehensive, than any of the hundred manuals to which it has given birth."[70] He not only read the "fathers of the science," but quotes Asa Gray in the journals. He found, in 1851, ready analogies between Gray's description of plant organs and human beings, and went on to absorb these into the moral idealism that preserved intact the idea of a godly nature:

There is, no doubt, a perfect analogy between the life of the human being and that of the vegetable, both of the body and the mind. . . . I am concerned first to come to my *Growth,* intellectually and morally (and physically, of course, as a means to this, for the body is the symbol of the soul), and to bear my *Fruit,* do my *Work, propagate* my kind, not only physically but *morally,* not only in body but in mind. . . . As with the roots of the plant, so with the roots of the mind, the branches and branchlets of the root are mere repetitions for the purpose of multiplying the absorbing points, which are chiefly the growing or newly formed extremities, sometimes termed *spongelets.* It bears no other organs. So this organ of the mind's development, the Root, bears no organs but spongelets or absorbing points.[71]

Arber notes that Goethe, typically, asked at one point "how he could be expected to concern himself with such an organ as the root, which shows no ascending progress."[72] But Thoreau found in Gray's work on the root mysterious and wonderful analogies for intellectual growth: ". . . The most clear and ethereal ideas (Antaeus-like) readily ally themselves to the earth, to the primal womb of things. They put

forth roots as soon as branches, they are eager to be *soiled*. No thought soars so high that it sunders these apron-strings of its mother. . . . No idea is so soaring but it will readily put forth roots. . . . No thought but is connected as strictly as a flower, with the earth. The mind flashes not so far on one side, but its rootlets, its spongelets, find their way instantly to the other side into a moist darkness, uterine. . . ."[73]

Yet for all the stimulus he found in his reading, Thoreau's last journals return to his distrust of systems and theoretical science:

In proportion as we get and are near to our object, we do without the measured or scientific account, which is like the measure they take, or the description they write, of a man when he leaves his country, and insert in his passport for the use of the detective police of other countries . . . the real acquaintances and friends which it may have in foreign parts do not ask to see nor think of its passport. Gerard has not only heard of and seen and raised a plant, but felt and smelled and tasted it, applying all his senses to it. You are not distracted from the thing to the system or arrangement. In the true natural order the order or system is not insisted on. Each is first, and each last.[74]

"Applying all his senses to it . . ." Nothing so underlines the threat posed to abstract systems by the empirical sense. It is a poignant, indeed paradoxical moment, in that through the empirical experimental method Darwin will effectively remove God from nature. Yet Thoreau, like the artists, was his own natural scientist, gathering plants in his "botany-box"—his straw hat—and studying them with a method he did not himself consider systematically botanical: ". . . The most natural system is still so artificial. . . . I often visited a particular plant four or five miles distant, half a dozen times within a fortnight, that I might know exactly when it opened, beside attending to a great many others in different directions and some of them equally distant, at the same time."[75]

The artists, we can speculate, mixed theoretical knowledge and observation in much the same way.

Cropsey's library included a volume titled *Beautiful Ferns* (1882), with a text by Daniel Cady Eaton, professor of botany at Yale; *Wood's Class Book of Botany* (1845); *Botany for Ladies, or a Popular Introduction to the Natural System of Plants, according to the classification of De Candolle,* by Mrs. Loudon (1842), inscribed to Cropsey with regards of J. M. Falconer, 15 May 1847; and Gray's *First Lessons in Botany and Vegetable Physiology,* illustrated by Isaac Sprague (1857) In addition to such books, which indicate a familiarity, albeit popular, with the works of leading botanical names of his period, we find *Trees of the Northern United States* by Austin C. Apgar (1892), with the

1. Frederic Edwin Church, *Twilight in the Wilderness*, 1860
Oil on canvas, 40″ × 64″. The Cleveland Museum of Art, Mr. and Mrs. William H. Marlatt Fund

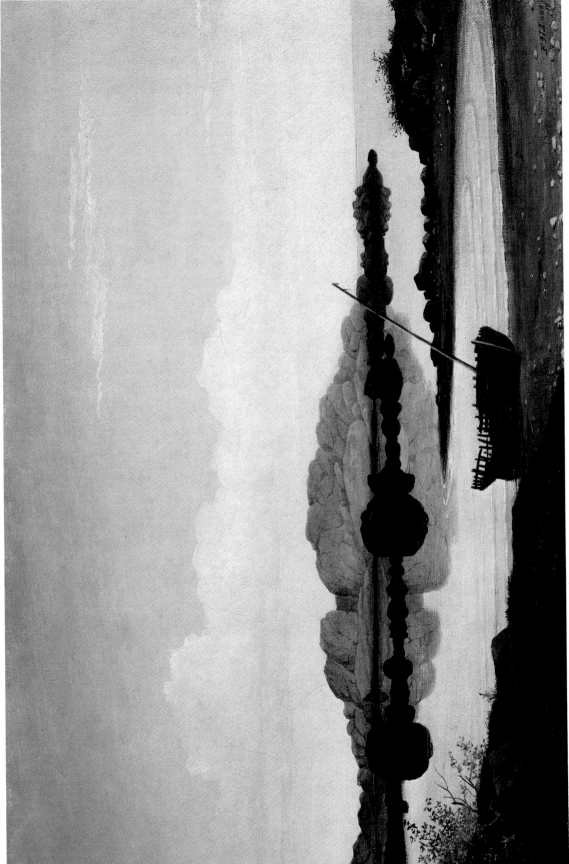

Fitz Hugh Lane, *Brace's Rock*, 1864

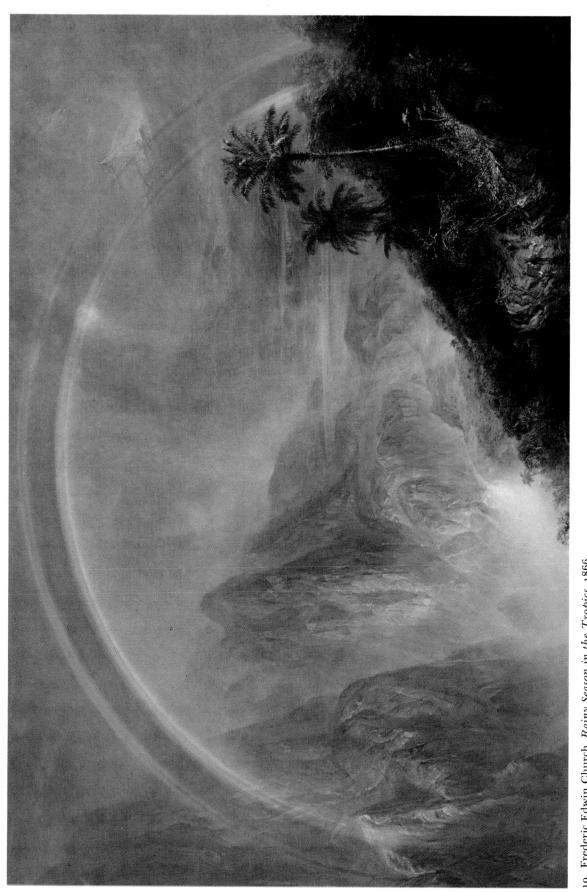

19. Frederic Edwin Church, *Rainy Season in the Tropics*, 1866
Oil on canvas, 56¼" × 84³⁄₁₆". California Palace of the Legion of Honor, The Fine Arts Museums of San Francisco

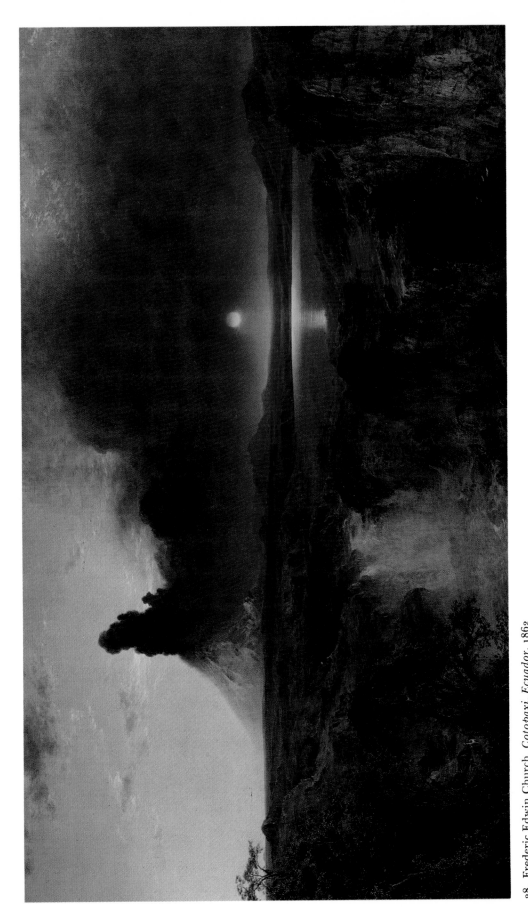

28. Frederic Edwin Church, *Cotopaxi, Ecuador*, 1862
Oil on canvas, 48″ × 85″. The Detroit Institute of Arts

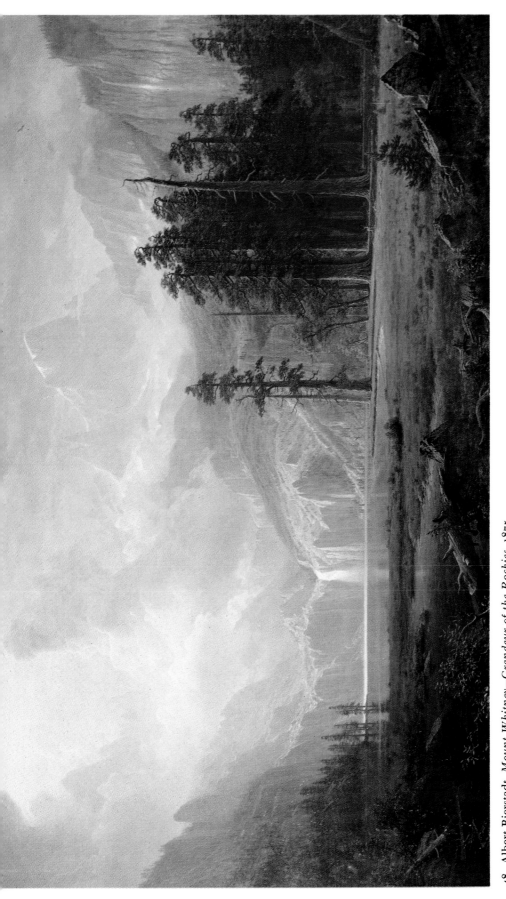

48. Albert Bierstadt, *Mount Whitney—Grandeur of the Rockies,* 1875
Oil on canvas, 67½″ × 115¼″. The Rockwell-Corning Museum, Corning, New York

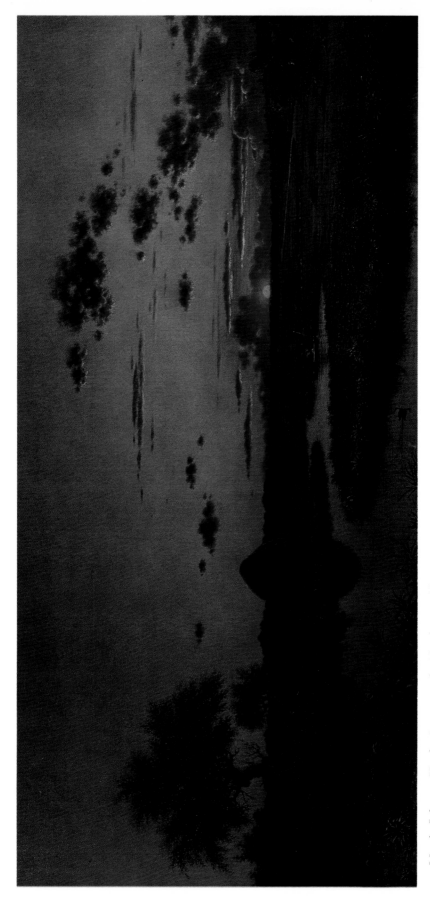

51. Martin Johnson Heade, *Sunset on the Marshes*, c. 1865–70
Oil on canvas, 26⅜″ × 52½″. The White House, on loan from private collection

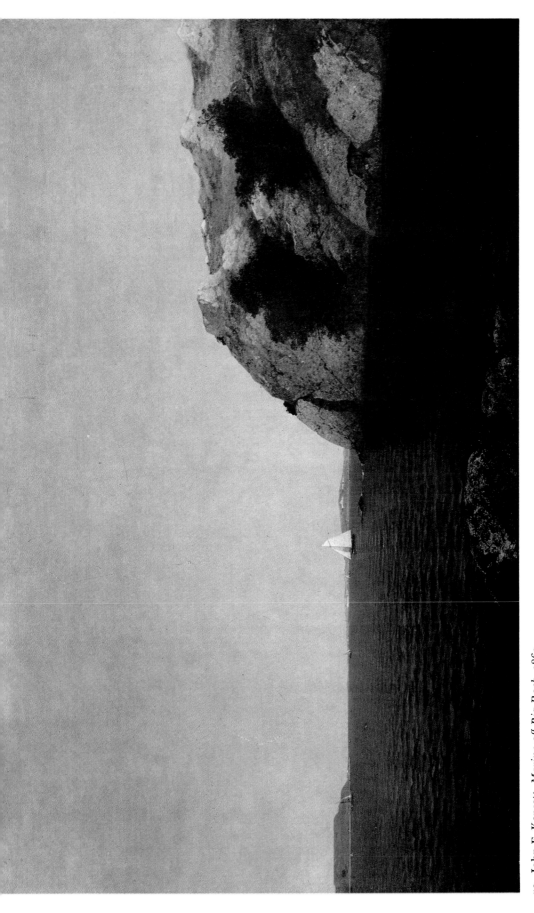

52. John F. Kensett, *Marine off Big Rock*, 1869
Oil on canvas, 27¼″ × 44½″. Cummer Gallery of Art, Jacksonville, Florida, bequest of Ninah M. H. Cummer

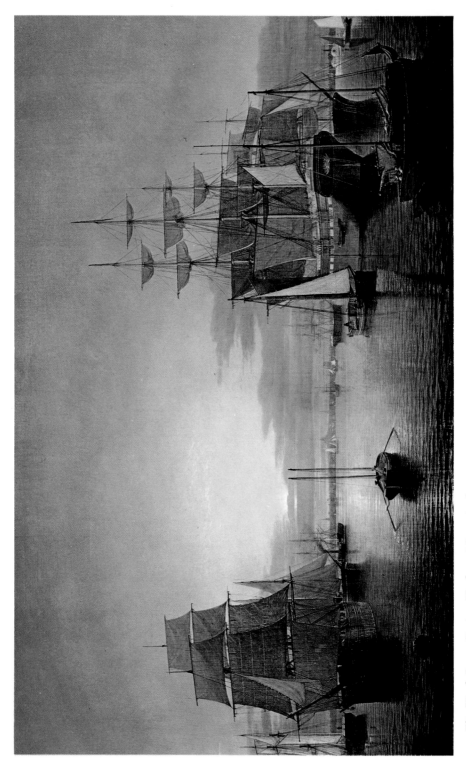

150. Fitz Hugh Lane, *Boston Harbor at Sunset*, 1850
Oil on canvas, 26¼″ × 42″. M. and M. Karolik Collection, Museum of Fine Arts, Boston

legend "Trees are God's Architecture" on the frontispiece; *A History of British Forest-Trees* by Prideaux John Selby (1842); *Gardening for Children,* by Rev. C. A. Johns (1848), which still preserves between its pages the visiting card of Mr. W. Holman Hunt; *Wild Flowers,* by Amanda B. Harris (1882); *Pressed Flowers from the Holy Land,* by Rev. Harvey B. Greene (1896); *The Life of a Tree, Being a History of the Phenomenon of Vegetation from the Seed to the Death of the Plant* (1849); *Twenty Lessons on British Mosses or First Steps to a Knowledge of that Beautiful Tribe of Plants,* by William Gardiner (1846), which still contains pressed mosses; and *Green Fields and Their Grasses,* by Anne Pratt (1852).

The frontispiece of *Garden Fables or Flowers of Speech* by Mrs. Medhurst (1861) bears this verse by Longfellow: "In all places then, and in all seasons, / Flowers expand their light and soul like wings, / Teaching us, by most persuasive reasons, / How akin they are to human things." Other members of the family also cared about growing things. Cropsey's daughter Lilly (who painted flowers) owned *Indian Summer, Autumn Poems and Sketches* (1883) inscribed with her name, with flower illustrations by L. Clarkson. Mrs. Cropsey kept a scrapbook of pressed autumn leaves, and in 1847–8 composed a rich herbarium of flowers gathered at Italian monuments, much like the one at Olana assembled for Cole and Church possibly by Mrs. Church.[76]

Church's library at Olana, in addition to the rich resources of Humboldt's *Cosmos,* provided *Gray's School and Field Book of Botany for Beginners and Young People* (1857, 1868), illustrated by Sprague, which possibly belonged, to judge from an 1886 inscription, to F. W. Church; an 1868 edition of *Gray's Lessons in Botany,* also illustrated by Sprague; Gray's *Manual of Botany of the Northern United States* (1889); Alphonse Wood's *Botany, a Classbook of Botany for Colleges, Academies* (1850) inscribed "H. W. Beecher" and signed "C. E. Church."[77] Added to these were a large number of general books on science, religion, and travel—mostly tropical travel—also dealing in some way with vegetation and botany. Even allowing that some books clearly belonged to other members of the Church family, here are vast storehouses of fact and theory.

In Church's copy of Robert Hunt's *The Poetry of Science* (1854), we read:

In the aspect of visible nature, with its wonderful diversity of form and its charm of colour, we find the Beautiful, and in the operations of these principles, which are ever active in producing and maintaining the existing conditions of matter, we discover the Sublime. The form and colour of a flower may excite our admiration; but when we come to examine all the phenomena which combine to produce that piece of symmetry and that lovely hue—to learn the physiological arrangement of its structural parts,—the chemical ac-

tions by which its woody fibre and its juices are produced—and to investigate those laws by which is regulated the power to throw back the white sunbeam from its surface in coloured rays—our admiration passes to the higher feeling of deep astonishment at the perfection of the processes, and of reverence for their great Designer. There are indeed "tongues in trees," but science alone can interpret their mysterious whispers, and in this consists its poetry.[78]

If Hunt's belief in the poetry of science seems more optimistic than Thoreau's, it was probably because he was more willing than Thoreau to adulterate the methods of science with spirit. Church, reading the reference to the sublime, must have responded to this subtle blend of poetry, mystery, science, and God.[79]

The botanical books in the artists' libraries may have helped them, as Ruskin suggested, "to get it right." But, as with clouds, they supplemented concept and theory with a close investigation of the particular object. Occasionally, reality was perfect enough—through selection, artistic modification, or both—to touch upon the ideal type sought by Goethe and Cole. It also could represent a point on the spectrum between the real and the ideal, fostering the understanding of the ideal through the study of individual variety favored by Leonardo and after him, Sir Joshua.

The artists' drawings and sketches are direct, incisive, and botanically correct. They report on the plant in its actual context—as the individual representative of a species rather than its archetypical ideal. They habitually address instructive comments to themselves. In his notebook of 1832, Cole notes beside an acanthus plant that the leaves are "dark green glossy with whitish veins"[80] (fig. 58). Cropsey's annotations, though lengthy, are also brisk and to the point. On a precise drawing of sugar cane (see fig. 62) he writes: "Leaf coal green with a whitish stem like the Indian corn[.] Stalk same col. but whitish, and yellowish where decaying. purplish at the bottom of stalk. rings close together at the bottom. Some leaves broken off. leaves sometimes 6 or 7 ft long—stalk 12 or 15 feet smaller stalks inside. leaves generally about 6 or 7 inches apart. one on Each side opposite Each other." He is always careful to use Latin names—*Linaria vulgaris* (toad flax, fig. 59), *Cirsium lanceolatum* (common thistle)—and to note when the flowers bloom. When he drew the *Yucca gloriosa* (Adam's needle, fig. 60), in Kensington Garden, in July 1859 (probably during the same London stay when he made an appointment with Ruskin at Denmark Hill for "Wednesday at two o'clock"),[81] he wrote: "The flower is of a bell shape straw col—greenish inside."[82]

Cropsey's plant studies, however, detach themselves from the category of notes to become drawings of the highest quality. The delicate shading on leaf or petal, the alertness of his crayon, make him (to resort to a nineteenth-century habit of classification) the Amer-

58. Thomas Cole, *Acanthus*, from Sketchbook No. 7, 1832
Pencil on paper, 8¾″ × 12¼″. The Detroit Institute of Arts, William H. Murphy
Fund

ican Watteau of the flower. A study of laurel leaves is placed on the
page with a delicate asymmetry that recalls oriental flower painting;
a single plant, unfolding in light and dark, assumes the microcosmic
intensity of a Dürer (fig. 61). There is a control, a freshness of impulse,
that comprise a sophistication largely unacknowledged.

Church's drawings and sketches ardently report on the multiplicity
of tropical vegetation. The *gestures* of plants captivated him—the
movement of a tree fern or a frond of wild sugar cane (fig. 63); the
aspects assumed by a single philodendron leaf in different lights. The
wet immediacy of his oil sketches fuses with the organic properties
of his botanical subjects. The paint itself, a vital juice, becomes an
organic metaphor. In studies such as *Cardamum* (fig. 64), the painterly

119

59. Jasper F. Cropsey, *Linaria vulgaris* (*toad flax*), undated
Sketchbook, pencil on paper, 7″ × 5″. Newington-Cropsey Foundation, Hastings-on-Hudson, New York. Photo courtesy The Archives of American Art, Smithsonian Institution

60. Jasper F. Cropsey, *Yucca gloriosa (Adam's needle)*, July 1859
Pencil on paper, 10⅛″ × 6⅞″. Newington-Cropsey Foundation, Hastings-on-Hudson, New York. Photo courtesy The Archives of American Art, Smithsonian Institution

61. Jasper F. Cropsey, *Leaf Study,* undated
Pencil, white gouache on paper, 6⅞″ × 9⅞″. Newington-Cropsey Foundation, Hastings-on-Hudson, New York. Photo courtesy The Archives of American Art, Smithsonian Institution

handling of the yellow-centered purple-and-white blossoms contrasts rather sharply with the renderings of his friend Heade.

Heade's glossy flowers achieve the quality of becoming through their writhing linear gestures (fig. 65); Church's, from the immediacy of the paint. In both instances, a sense of organic process is conveyed by formal means. Yet Heade's smooth surfaces also embalm his subjects in a crystalline time. By contrast, Church's proto-impressionism of touch suggests the flower's momentary fleeting life. He reminds us —as do his annotations about "dead leaves"—that, paradoxically, in some ways, the advocates of the old sublime may have touched more acutely on Darwinian *process* than did the practitioners of luminism.

Heade, however, made his flower paintings (fig. 66) a somewhat

segregated category. For the Hudson River men, the flower and plant studies—like their cloud studies—served a larger purpose. They were indeed microcosms, destined for a larger whole, a part of Humboldt's "nature considered *rationally* . . . a unity in diversity of phenomena; a harmony blending together all created things, however dissimilar in form and attributes; one great whole . . . animated by the breath of life."[83]

Once more we are reminded of the reconciliation of detail and effect stressed by contemporary esthetics. Fostered by the growing understanding of evolution, the union of being and becoming extended itself to the concepts of ideal and real, the macrocosm and microcosm that embraced all the scientific, philosophic, and esthetic concerns behind mid-century landscape painting. The artists collecting "the individual details of various observations," in Humboldt's terms, were discovering "mutual relations," "under the form of general results."[84] While those "general results" informed the entire concept of the landscape, subsuming organic and mineral worlds alike, the foreground drew the "near looker" close to the surface which mimicked the sensation of a leaf felt, a flower scented.

We are especially aware of such details in paintings like Church's *Heart of the Andes* (see fig. 17) or Bierstadt's *Storm in the Rocky Mountains, Mount Rosalie* (see fig. 27). In the latter, flowering plants at the lower right (fig. 67) pull the observer beyond the surface into the picture. Then, as we are drawn deeper to stand on this or that abutment of rock, we gradually realize that we are dealing with a synthesis of separate views. Detail and effect are expertly manipulated in impossible juxtapositions that become remarkably believable. Some contemporary critics were unconvinced: "The whole science of geology cries out against him. . . . The law of gravitation leagues itself with geological law against the artist."[85] Yet the painting is a "synthesis" of the preoccupations of the mid-century landscapists—the floral details of the foreground, the small pool of silence, the valley below stretching to the light-bathed cragged rocks of the mountains, providential sunbeams framed by Wagnerian clouds. Within such a synthesis, the flowers and plants, imbued with a formidable wealth of association, are perhaps the best emblem of being and becoming fused in one. But in bearing the concerns of the fast-growing botanical sciences, they also represent a threat to, as well as an affirmation of, the religious optimism of the age.

That threat was heightened by the botany of Asa Gray, who upheld Darwin against Agassiz. Though, as we know, the artists were aware of Agassiz's and Gray's research and ideas, to what degree still remains

62. Jasper F. Cropsey, *Sugar Cane*, 1859(?)
Sketchbook, pencil on paper, 10⅛″ × 6⅞″. Newington-Cropsey Foundation, Hastings-on-Hudson, New York. Photo courtesy The Archives of American Art, Smithsonian Institution

63. Frederic Edwin Church, *Mountain Landscape, Jamaica (sugar cane)*, August 1865
Oil with pencil on paperboard, 11⅕″ × 11⅘″. The Cooper-Hewitt Museum of Design, New York, Smithsonian Institution

problematic. Like most artists, the landscape painters may have been in search of "what they could use." What they could use in Gray was his wealth of empirical botanical detail, his passionate urge to elicit facts—and to relate those facts to some system that would confirm the data so convincingly offered by the senses. From Agassiz they could pick up the amplified idealism that surrounded the results of his research like an otherworldly halo. As his biographer, Edward Lurie, has pointed out, Agassiz also had deep empirical impulses. To Agassiz, however, facts were "the works of God, and we may heap them together endlessly, but they will teach us little or nothing till we place them in their true relations, and recognize the thought that binds them together as a consistent whole."[86]

We might, without too much distortion, see in Gray the provider of the authentic detail, the figure whose work presided over the

artists' foregrounds with botanical authority. While Agassiz's idealism—a great unifying belief in Mind—might be consonant with the artists' desires to be true to the general effect, offering also a way of treating facts as "works of God." Seen in the context of the artists' needs, the two figures' careers—and their relation to each other—are almost a model (in another discipline) of the issues that troubled the age, and of the contradictions that pulled it slowly apart.

Gray himself was an interesting mix of advanced and traditional ideas. He was one of the first to accept the French "natural" system in lieu of the Linnaean. Under the influence of the Genevan botanist, Augustin-Pyramus De Candolle, he became aware of Goethe's theory of the metamorphosis of leaves into flowers.[87] He also adopted the somewhat retrograde idea of constancy of species.[88] While discarding the concept of the Chain of Being in a single series, he held at the

64. Frederic Edwin Church, *Cardamum,* June 1865
Oil with pencil on paperboard, 10⅘" × 8³⁄₁₀". The Cooper-Hewitt Museum of Design, New York, Smithsonian Institution

65. Martin Johnson Heade, *Magnolia Flower*, c. 1885–95
Oil on canvas, 15⅜″ × 24″. The Putnam Foundation, Timken Art Gallery, San Diego

same time to the idea of order based on design popularized by Paley. His career brought him inevitably, it seems, into the orbit of Harvard and Concord. Having relinquished the rare opportunity to travel to the South Seas with the Wilkes expedition in the late 1830's, he went first to a professorial post at the University of Michigan, and then in 1842 to Harvard. At about this time, his biographer Dupree suggests, "mention of Goethe dwindled and disappeared from his textbooks."[89]

He heard Lyell's Lowell Institute lectures in 1845,[90] shortly before he delivered his own. His exposure to this giant figure who formed such a stepping-stone for Darwin was surely important in Gray's development. The following year he joined Agassiz (and Darwin as well) in criticizing Chambers, considering his *Explanations: A Sequel to the Vestiges of the Natural History of Creation* in an article in the *North American Review*.[91] This was largely because Chambers had raised— among other points—the idea of a kind of developmental Chain of Be-

ing from one species to another—which Gray had already rejected in its traditional form. Darwin ultimately corrected Chambers's errors and arrived at conclusions that carried through some of Chambers's key ideas. Gray was to become Darwin's strongest supporter in America.

His passion for original data, confirmed by observation, was similar to that of many of the artists. Artists and scientists found common cause in the surveys of the West. Gray was powerfully stimulated by "the first fruits of the great railroad surveys" in 1854. "Torrey swamped me," he wrote, "by sending me a good part of Pope, Bigelow (Whipple's Expedition), Beckwith & c.—collections—to be worked up at once

66. Martin Johnson Heade, *Apple Blossoms,* 1880
Oil on canvas, 14″ × 12″. Private collection

67. Bierstadt, *A Storm in the Rocky Mountains—Mount Rosalie,* detail

for Government Reports."[92] He was so immersed in material that his friend Joseph Hooker wrote to him in 1861, "What a pest, plague and nuisance are your official, semi-official & unofficial Railway reports, survey &c. &c. &c. Your valuable researches are scattered beyond the power of anyone but yourself finding them. Who on earth is to keep in their heads or quote such a medley of books—double-paged, double titled & half finished as your Govt. vomits periodically into the great ocean of Scientific bibliography."[93]

What the artists in the field did in miniature, Gray did on a heroic scale—collecting and categorizing the plants (fed by a steady stream of specimens from the Surveys), forming the giant herbarium at Harvard. His finest artist-illustrator, Isaac Sprague (a sometime landscapist who assisted Audubon on an expedition to Missouri), represented

these flora with a precise and literal delicacy that respected the truth and the art of conveying it (fig. 68). These were the illustrations the artists had on their shelves and must frequently have consulted. Beyond this, however, no evidence has yet appeared to indicate Gray's involvement with the major artists of his time. His philosophy, so notably lacking in idealism, could hardly move them. Likewise the transcendental overtones of their enterprise were alien to him. To Gray, transcendentalism itself was suspect. Dupree notes that "Gray treated Emerson and Thoreau with a silence that the accident of acquaintance and the hostility of Harvard to the Concord group cannot fully explain away. He was hostile to their whole way of looking at nature, to their idealism, to their German inspiration. . . . In resisting the idealism prevalent in American thought, Gray was starting on a lonely road. . . ."[94]

This resistance enabled Gray to become one of Darwin's primary American supporters, to follow that familiar "lonely road" of the modernist scientist or artist. Gray's advanced thinking isolated him from the support of his colleagues and from the aspirations of his society at large. While pungent empirical observation has been a force in American thought, it has been contained by a strong idealism. Given the power of that idealism in the nineteenth century, it was predictable that it was not Gray, but Darwin's chief antagonist, Agassiz, to whom the public—and the intellectuals—looked for confirmation of their values. Dupree has suggested that "Agassiz came to the United States bearing the very essence of German idealistic philosophy."[95] He "embodied all those revolutionary forces which had transformed eighteenth-century rationalism into the German idealism of the nineteenth century—not only Kant and Goethe but also Schelling and his *Naturphilosophie*."[96]

Though Lurie has argued that Agassiz did not actually "become a disciple of Naturphilosophie," he notes that through the lectures of Oken and Döllinger, Agassiz learned that "facts, by themselves, were only partial insights. The facts of nature were indications of profound cosmic significance";[97] and "by 1843, Agassiz became identified with a view of the world equally idealistic, equally a priori in its assumptions, as were the generalizations of Oken and Schelling."[98]

Whether or not Agassiz technically subscribed to *Naturphilosophie* is almost, for our purposes, beside the point. He was surrounded by its aura down to his German credentials. He was perceived this way, and this perception of him was compatible with American transcendental philosophy. His comment "A physical fact is as sacred as a moral principle" could have issued from the mouth of Emerson.[99]

Agassiz's reigning position in Boston and Cambridge has already been described. He also had an excellent rapport with the artists,

68. Isaac Sprague, *Nymphaea*
From Stuart, *The Genera of the Plants of the United States* (Boston, 1848), plate 42.
Photo courtesy New York Public Library

writers, and scientists whose work and ideas dominated American thought at mid-century, though our knowledge of his relationships with the artists is still scanty. His friend, the Reverend James Cooley Fletcher, who gathered specimens along the Amazon for Agassiz, encouraged Heade to go to Brazil. Agassiz became an admirer of Heade's hummingbirds, and shared Heade's friendship with the Emperor Dom Pedro II.[100] William Trost Richards, in turn, seems to have admired Agassiz, writing to James Mitchell at Harvard in 1854: "I almost envy your Geological Surveys with Professor Agassiz. I have long been wishing to study in an Elementary Manner Geology. Can you tell me any thoroughly good book. I must make it part of my discipline for the winter."[101]

Noble refers casually to an encounter between Agassiz and Church that seems matter-of-fact enough to have been part of an ongoing friendship: "Friday morning, June 17, 1859 / Yesterday, when I came on deck, I found C—— conversing with Agassiz. Although so familiar with the Alpine glaciers, and all that appertains to them, he has never seen an iceberg, and almost envied us the delight and excitement of hunting them. But not even the presence and the fine talk of the great naturalist could lay the spirit of sea-sickness."[102]

In 1862, Bierstadt wrote to Agassiz's protégé Alpheus Hyatt, a Harvard paleontologist: "Remember me to Agassiz and tell him how difficult it is [to get to Colorado] and next summer the government may give us $10,000 to do what we please with. Let us hope to live a summer yet, in the far west."[103] Before his trip west with Fitz Hugh Ludlow in 1863, Bierstadt asked Agassiz to recommend someone to accompany them, but Agassiz replied that he was "sorry to say that those of my young friends whom I could fairly recommend as desirable companions on your journey are not in a position for going and those who could go I would not recommend."[104] In the same letter (April 28, 1863), Agassiz observed cordially: "I can hardly realize that I have been in New York without seeing you or even leaving you a note. But I have been so driven, while at the same time I was not well at all, that I had to leave again as soon as my absolute duty was performed. . . . Allow me once more to congratulate you upon your great success and achievement in your last picture. I hear only the highest praise of it."[105]

Agassiz's friendships were close. Within the Concord group, he was valued not only by Emerson but by Thoreau, who dined with him at Emerson's on March 20, 1857, and recounted his own experiment "on a frozen fish."[106] Thoreau, the prototypical nature-lover, seems not to have recognized the rare irony of his description of Emerson and Agassiz shooting game in the Adirondacks (August 23, 1858): "[Emerson] says that he shot a peetweet for Agassiz, and this, I think he

said, was the first game he ever bagged. He carried a double-barrelled gun,—a rifle and shotgun,—which he bought for the purpose, which he says received much commendation. . . . Think of Emerson shooting a peetweet (with shot) for Agassiz, and cracking an ale-bottle (after emptying it) with his rifle at six rods!"[107]

Excluded from these companionable exchanges, and even from such illustrious scientific societies as the Lazzaroni,[108] Gray first challenged Agassiz in a series of debates held at the American Academy in Boston in 1859. By then, Gray had developed a concept of genetic connection of species directly antagonistic to Agassiz's idea that "a species is a thought of the Creator."[109] In supporting Darwin, Gray showed his ultimate willingness to accept the idea of transmutation of species subverting the orderly genetic agenda. He had rejected this idea in embryo in Chambers.

Like Agassiz, Gray held firmly to design—even after accepting Darwin. But Agassiz's idealism provoked the more stolidly empirical Gray. The Swiss professor's emphasis on Mind offended Gray's keen awareness of natural development. For Gray, conclusions drawn from observation had more meaning than theoretical frameworks into which observations were forced. In a sense, Agassiz's conceptual approach was imposed even on God's methodology. Nothing occurred without God's thought. It was, in effect, the most immutable blueprint of providential planning. Creation—or from a catastrophic point of view, creations—were the alpha and omega of all existence. This was the magic the artists and writers were eager for. It stood behind their encounters with the virgin landscape and transfigured the content of most nature painting at mid-century.

William James Stillman, commenting on the debates years later, felt that if Agassiz had lived longer he would have accepted evolution. Yet for a long time Mind remained invincible in nineteenth-century American culture. Stillman quotes one of Agassiz's Cambridge talks:

I believe that all these correspondences between the different aspects of animal life are the manifestations of mind acting consciously with intention towards one object from beginning to end. This view is in accordance with the working of our minds; it is an instinctive recognition of a mental power with which our own is akin, manifesting itself in nature. For this reason, more than any other, perhaps, do I hold that this world of ours was not the result of the action of unconscious organic forces, but the work of an intelligent, conscious power.[110]

At the Cambridge Scientific Club debate in the spring of 1859, Gray introduced Darwin's ideas, which he defined about that time as "the only noteworthy attempt at a scientific solution" of "the fundamental and most difficult question remaining in natural history"—"to bring the variety as well as the geographical associations of existing

species more within the domain of cause and effect."[111] These great debates—one of the keys to nineteenth-century American thought—had their paradoxes: each point of view, perhaps, responded to the other's more provocative signals in ways that obscured potential areas of agreement. Ultimately, the fundamental issue was God, faith, the whole social-political-religious apparatus that sustained the society's consistency and belief in itself. Yet, as Stillman sagely points out, Darwin himself did not deliberately seek to attack the Creator and overturn the society. "Agassiz," Stillman wrote, "maintained the presence of 'Conscious Mind in Creation'; Darwin did not deny it explicitly, nor did he admit it."[112]

Agassiz's emphasis on Mind (as well as his genial personality) made him an American hero. Gray's more obvious empiricism paralleled some aspects of American pragmatic observation. But even more, American culture stressed Mind—Mind raised to the level of divinity, a "mental power with which our own is akin." The artists, in their esthetic dilemmas, remained poised, in a way, between Gray and Agassiz. There is a remarkable similarity between the fundamental issues debated by the artists and the assumptions of the two great scientists in their heroic debates. The terminology was different, but the realism-idealism controversy, also involving the forces of American empiricism, was substantially the same. The issue was not clear-cut. In the art, as in the science, polarities were blurred by the reciprocal transactions between opposing ideas that had more in common than their proponents thought. It was the artists' habit to negotiate between these ideas, to find a common ground for their resolution.

Many of the great landscapes are defined by their attempt to resolve these dilemmas anew in each picture, transcending the routine recipes of the general effect. The artists' treatment of the plant world, investigated for its specificity and then extended toward a grand ideal, can be seen ultimately as an effort to maintain Agassiz's idea of "conscious mind in Creation." It was this idea that fortified the artists' most profound belief: that landscape was informed by the Mind of the Creator.[113]

PART THREE

VII

The Primal Vision: Expeditions

Adventure is an element in American artist-life which gives it singular zest and interest.

<div align="right">

H. T. TUCKERMAN[1]

</div>

The landscape artist's prominent role in the exploration of the American continent was as diverse as that great adventure itself. In style, it ran the gamut from the simple topographical description of the earlier western expeditions to the baroque glorification of the great surveys of the seventies. The locale ranged from desert heat through the climatic extremes of the South American tropics to the icy expanses of the Arctic. The artist was explorer, scientist, educator, frontiersman, and minister. He ran arduous risks and suffered extreme hardships which certified his "heroic" status. This heroism became a kind of tour de force in the vicinity of art.

In Europe, the tour de force generally received its scale from the artist's Ambition, set resplendently within a major tradition. In America, it consisted in simply "getting there." The artist became the hero of his own journey—which replaced the heroic themes of mythology— by vanquishing physical obstacles en route to a destination. For the ambition of the artistic enterprise was substituted the ambition of the artist's Quest—itself a major nineteenth-century theme. In this displacement of the heroic from the work of art to the persona of the artist lay, perhaps, part of the attraction of unexplored territory for the American artist at mid-century.

Some of the works resulting from the heroic journeys were themselves vast and monumental. Their size and ambition matched the scale of the artist's physical difficulties. The simplest topographer, like Samuel Seymour (fig. 69), who accompanied the Long expedition to the Rockies as early as 1819, had to withstand the hostilities of climate, terrain, and Indians. He achieved the heroic by the sheer force of will which enabled him to be *there:* he captured the landscape in images

View near the base of the Rocky Mountains

69. Samuel Seymour, *View Near the Base of the Rocky Mountains*, 1820
Watercolor on paper, 8½″ × 5⅜″. The Beinecke Rare Book and Manuscript Library, Yale University, New Haven, Connecticut

which, in Tuckerman's words, would "extend the enjoyment which time and space limit." Such images, often disseminated in the government-sponsored reports, not only fortified the scientific observations of the artist's expeditionary colleagues, but underlined the complex role of the artist-scientist. Tempered by a strong American pragmatism, these works occasionally extended the artist's activity beyond that of simple cataloguer to that of synthesizer and theorist.

By the 1860's, Tuckerman could comment that part of the "signal triumph" of such American artists as Church and Bierstadt was that "both have explored distant regions for characteristic and fresh themes."[2] Yet the intent behind Church's wearing journeys to South America and Labrador, behind Bierstadt's trip with Lander's expedition to the Rockies, was not merely a desire to paint exotic subjects, nor even to acquaint a grateful public with fresh geographical glories. Sensationalism, exalted rhetoric, and reportage played their parts. But the artists' deepest intentions were, as Humboldt required, to reveal

the forces that regulate the universe, and to make everyone who saw their pictures a witness to its laws.

Artists are now scattered, like leaves or thistle blossoms, over the whole face of the country, in pursuit of some of their annual study of nature and necessary recreation. Some have gone far toward the North Pole, to invade the haunts of the iceberg with their inquisitive and unsparing eyes—some have gone to the far West, where Nature plays with the illimitable and grand— some have become tropically mad, and are pursuing a sketch up and down the Cordilleras, through Central America and down the Andes. If such is the spirit and persistency of American art, we may well promise ourselves good things for the future.

Cosmopolitan Art Journal, 1859[3]

The artistic component of the western explorations requires a more careful treatment than it has received. There is room here only for a sketch of some of the highlights. The roster of names includes a member of one of America's first artistic families, Titian Ramsay Peale, who in 1819 joined the Long expedition as a naturalist, along with the landscapist Samuel Seymour. Between 1832 and 1840 George Catlin visited forty-eight different tribes, "the greater part of which I found speaking different languages, and containing in all 400,000 souls. I have brought home safe, and in good order, 310 portraits in oil, all painted in their native dress, and in their own wigwams; and also 200 other paintings in oil, containing views of their villages . . . and the landscapes of the country they live in" (fig. 70).[4] Ultimately, like the Humboldt-inspired Church, Catlin continued his explorations in South America. Humboldt's interest in the American continent also inspired Prince Maximilian of Wied-Neuwied to explore the North American West in 1832–34 along with the Swiss artist Karl Bodmer (fig. 71), who recorded the soon-to-be-extinct Mandan Indians, as well as some striking aspects of the Missouri landscape. Seth Eastman, who trained at the United States Military Academy at West Point with C. R. Leslie and R. W. Weir, also painted the Indians and landscape of the West from the thirties through the fifties while serving with the army. (He was elected an "honorary member amateur" of the National Academy of Design in 1838.) One of the most sophisticated artists working in the West at that time was Alfred Jacob Miller, who in 1837 accompanied the Scotsman Sir William Drummond Stewart on a hunt along the Seedskeedee and into the Rockies. Miller's later paintings were done from sketches taken on the spot many years earlier. Nonetheless, in addition to some fine Indian paintings and landscapes he made superb visual records of the quickly vanishing fur trappers and mountain men.

The artists who participated in the government-sponsored army

expeditions of the 1840's and 1850's are often, if not less heroic, less well known. One of the most famous, John Mix Stanley (fig. 72), accompanied Colonel Steven Watts Kearney's march to the Pacific in 1846 and recorded with distinction the landscapes of the Southwest. A veteran artist-explorer who made many trips through the West in the 1840's, he also traveled with the Isaac I. Stevens Pacific Railroad Survey of 1853 into North Dakota and Washington, and ultimately was called on to complete illustrations for the Beckwith Report after the death of Richard Kern. The three Kern brothers had accompanied

70. George Catlin, *Buffalo Chase in Winter, Indians on Snowshoes*, c. 1830–39 Oil on canvas, 24″ × 29″. National Collection of Fine Arts, Smithsonian Institution

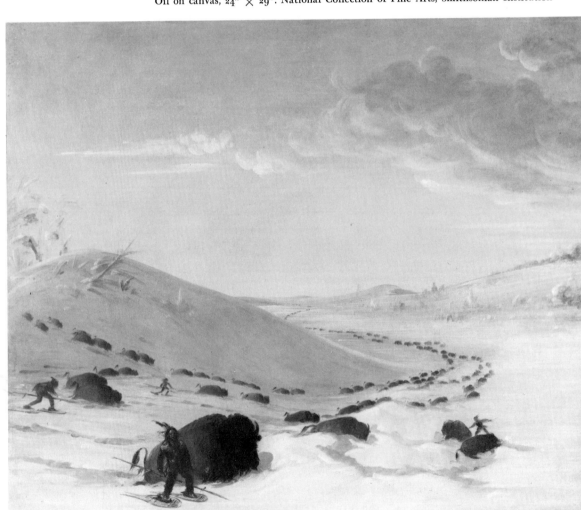

71. Karl Bodmer, *View of the Junction of the Missouri and Yellowstone Rivers,* June 25, 1833
Watercolor, 10¼″ × 16¾″. Joslyn Art Museum, Omaha, Collections of the Northern Natural Gas Company

John C. Frémont's famous expedition to the Rockies in 1848. Benjamin was killed on this trip by Ute Indians. Edward and Richard Kern survived to join a military expedition headed by James H. Simpson into Navajo country in 1849, and each joined subsequent expeditions as well. Richard was killed by a band of Pah-Utah Indians on the Gunnison Pacific Railroad Survey of 1853. Gunnison's death, along with Kern, left Lieutenant E. G. Beckwith in charge, and Beckwith's continuing party was soon joined by one of the finest of the western illustrators, Baron F. W. von Egloffstein.[5]

Beckwith's report indicates the difficulties the topographic artist faced:

Proceeding then, for two, three, or four miles upon the trail, the distance, of course, varying with the formation of the country, the topographer again assumed the most favorable position in the vicinity for his purposes, and repeated the labors of the previous hour. In addition to this constant labor

along the trail, it frequently, almost daily, became necessary to leave it and make distant side trips, ascending elevated mountain peaks and ridges to obtain correct and distant views of the country, and I cannot speak too highly of the fidelity, zeal and ability with which Mr. Egloffstein always performed these onerous labors. . . . It is not necessary here to describe the beauty, extent and grandeur of the scenes which from these positions, in the pure atmosphere of this portion of our country, greeted him, frequently embracing an area equal to that of some of our Atlantic States, and presenting a multitude of plain and mountain outlines, with snow-capped peaks rising just on the verge of the horizon, and frequently remaining in sight for days, serving as points of reference, and all of which were carefully traced and noted for the delineation of the country.[6]

Beckwith's admiration for the dedication and care with which Egloffstein performed his "onerous labours" suggests a kind of comradeship underscored in the diary which Heinrich B. Möllhausen

72. John Mix Stanley, *Herd of Bison Near Lake Jessie*
Illustration. From *The United States Pacific Railroad Reports of Explorations and Surveys: 47th and 49th Parallels*, Vol. XII, plate X. Kansas State Historical Society, Topeka, The Taft Collection

73. H. B. Möllhausen, *The Grand Canyon of the Colorado*
Illustration. From *Reisen in die Felsengebirge Nord-Amerikas* (?) by H. B. Möll-
hausen, 1861. Kansas State Historical Society, Topeka, The Taft Collection

(fig. 73) had kept on his journey with Lieutenant Whipple's expedi-
tion in 1853–54. Möllhausen describes a day of rest in camp:

No other than trivial and necessary tasks were undertaken, and in these every
one suited his own convenience, and paid as much attention to his comfort
as possible. The greater part of the company might be seen seated on their
blankets, mending their clothes or their shoes, or reading in old thumbed-out
books, or playing at cards, and here and there, a bearded fellow was lying on
the edge of the water, and in a leisurely manner washing his linen. . . . From
the field-smithy, indeed, are heard the strokes of the hammer, indicating hands
more industriously employed in replacing the lost shoes of the mules; but the
astronomer is falling asleep over his angle measurements and tables of loga-
rithms, and near him is one supposed to be making an entry in his journal,
but the pencil has fallen from his hand, and his condition seems to imply the
infectious character of laziness. The botanist, however, had early in the morn-
ing carefully laid out a whole pile of damp papers to dry on the grass, and

now, sitting in the shadow of his tent, he is helping the naturalist to skin a wolf, and taking the opportunity to give him a lecture on anatomy. . . . I mention these little daily occurrences of our wandering life, as illustrative of the twofold character of the Expedition. Having to open a way through almost unknown regions, where we might have to defend ourselves from hostile encounters, it had a dash of the military character; but the inquiry into the geological formation of the country, and its animal and vegetable life, and the determination of distances &c., by astronomical observation, formed, as will be seen, our principal business.[7]

The artists of the *Pacific Railroad Reports* varied in quality, but they shared the same dedication and suffered the same risks. A. B. Gray, J. C. Tidball, Arthur Schott, J. J. Young, A. H. Campbell—all devoted their artistic as well as physical energies to enlighten and inspire the readers of the surveys. The famous reports cost the government over a million dollars to publish. Though the works of the survey artists, mainly tinted lithographs, were widely disseminated in the thirteen volumes of the series, most of the artists did not achieve widespread fame.[8]

By the late 1850's, however, well-known names begin to appear on the list of artist-explorers. John F. Kensett went west in 1854, and again in 1857, 1868, and 1870.[9] Albert Bierstadt made the first of several journeys to the Rockies with Colonel Frederick Lander's expedition in 1859.[10] The 1870's was the period of the great national surveys. Clarence King reconnoitered the fortieth parallel; Ferdinand V. Hayden traveled through the Rockies and Colorado; George M. Wheeler journeyed through the Southwest; and Major John Wesley Powell made the almost legendary trip along the Colorado River through the rapids of the Grand Canyon.[11] By then the list of artists had expanded to include Thomas Moran, who began a life-long career as a major western artist with the Hayden survey of 1871.[12] Samuel Colman went west probably for the first time in 1870, possibly again in 1871, in 1886, 1888, and finally in 1898–1905.[13] Worthington Whittredge traveled to New Mexico probably in 1866 with General Pope, then joined Kensett and Sanford R. Gifford on a railroad trip to Denver in 1870, possibly returning west the following year.[14] In Denver, Gifford left his friends and traveled for a while with Hayden.[15] Whittredge's account is revealing:

When he [Gifford] accompanied Kensett and myself to the Rocky Mountains he started fully equipped for work, but when he arrived there, where distances were deceptive, he became an easy prey to Col. Hayden, who offered him a horse. He left us and his sketch box in cold blood in the midst of inspiring scenery. We neither saw nor heard from him for several months, until one rainy day on the plains we met him travelling alone in the fog towards our ranch by the aid of his compass. He had done literally nothing in the way of work during a whole summer spent in a picturesque region. Yet we dare not say that he did not study.[16]

As early as 1853 Frederic Church made his first trip to South America, returning there in 1857. His friend Heade in 1863 visited and painted the Brazilian forests. Church chased icebergs in the Arctic Circle with Noble in 1859. William Bradford visited Labrador in 1861 and continued to visit the Arctic until at least 1869. Four of these artists—Church, Bierstadt, Moran, and Bradford—are better known for their paintings of "fresh" subject matter than for anything else. To this list of artist-explorers, we can add the more important photographers who joined the western expeditions: Alex Gardner, William H. Jackson (fig. 74), Timothy O'Sullivan, C. E. Watkins, Eadwaerd Muybridge, among others.[17] Even this abridged record makes an impressive catalogue. What were they really looking for?

What are the temples which Roman robbers have reared—what are the towers in which feudal oppression has fortified itself—what are the blood-stained associations of the one, or the despotic superstitions of the other, to the deep forests which the eye of God has alone pervaded, and where Nature, in her unviolated sanctuary, has for ages laid her fruits and flowers on His altar!

<div style="text-align: right">CHARLES FENNO HOFFMAN[18]</div>

The opposition between Europe's antiquity and their own wilderness had given Americans an alternative past. They could not look back on a long tradition as could other cultures which, as some travelers in Arcadia pointed out, were often bloody and despotic. But they could relate to an antiquity still unspoiled by man—purer and by implication closer to God. Nascent American history was at that moment being bloodied by Indian conflicts, but this did not bother many of them. As Tocqueville noted, "honest citizens" commented to him: "This world here belongs to us. . . . God, in refusing the first inhabitants the capacity to become civilised, has destined them in advance to inevitable destruction. The true owners of this continent are those who know how to take advantage of its riches."[19]

Natural antiquity beckoned the American adventurer-hero across compelling spiritual as well as physical frontiers. It sometimes drew simultaneously on the tradition of cultivated antiquity. The resulting mixture of themes, associations, and conventions even now tends to defy disentanglement, and the language used by travelers and artists alike to describe the fresh new lands was at times couched in terms of European associations.

Marching toward New Mexico, Worthington Whittredge was impressed by the vastness of the plains: "Nothing could be more like an Arcadian landscape than was here presented to our view."[20] Albert Bierstadt, on his first trip west with Lander's expedition, compared the Rockies to the Bernese Alps. Of the Wahsatch region he wrote:

"The color of the mountains and of the plains, and indeed, that of the entire country, reminds one of the color of Italy; in fact, we have here the Italy of America in a primitive condition."[21]

These associations are tantalizing. Italy had always offered to Americans the promise of a timeless Arcady. In America, the heroic quest penetrated the mythic past of natural antiquity, restoring timeless beginnings. This perception of a remote and timeless antiquity could slowly be released into the present and future by the "hand of man," which sloughed off age with each civilizing incursion.

74. W. H. Jackson, *View East from the East Bank of the Grand Cañon in Yellowstone,* 1878
Photograph. The National Archives.

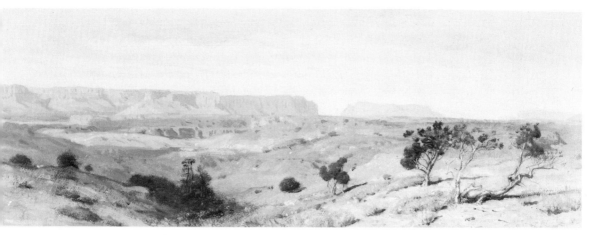

75. Samuel Colman, *Colorado Canyon,* undated
Oil on board, 9″ × 23¾″. The Kennedy Galleries, New York

Tocqueville, on his journey to America in 1831–32, remarked that
"in but few years the impenetrable forests will have fallen. The noise
of civilization and of industry will break the silence of the Saginaw.
. . . It is this consciousness of destruction, this arrière-pensée of quick
and inevitable change that gives, we feel, so peculiar a character and
such a touching beauty to the solitudes of America. One sees them
with a melancholy pleasure; one is in some sort of a hurry to admire
them. Thoughts of the savage, natural grandeur that is going to come
to an end become mingled with splendid anticipations of the tri-
umphant march of civilization."[22] Tocqueville's arrière-pensée seems
appropriate here, as does Thomas Cole's reminder that American
sublimity was that of a "shoreless ocean un-islanded by the recorded
deeds of man."[23] In America, the untouched void represented by
natural antiquity also tempted artists to fill it in.

Choosing vistas that resembled Arcadia was one strategy for drawing
on the bank of associations stored in the cultivated past. Samuel Col-
man, traveling west after the railroad had penetrated the western
territories, painted calm, serene vistas very like those of the Roman
campagna which had occupied him and his fellow-artists a bit
earlier (fig. 75). Such views, with their dry, pink-ochre tonalities and
horizontal extensions, simply replaced Roman aqueducts with natural
rock.

A still more expedient method was to impose artistic conventions,
especially Claude's, upon the natural terrain. Thus the exotic South
American landscape hardly disturbed Church's stock Claudian formu-
lae. Thomas Moran merged Claude's compositions and Turner's

147

atmosphere in baroque compositions that quote the seventeenth century-traditions. Humboldt himself, in his introduction to *Cosmos*, had spoken, as we have seen, of the necessity for "exalted" forms of speech, worthy of bearing witness to the majesty and greatness of Creation. He thus opened the door to conventions of rhetoric familiar to the heroic landscape art of the late eighteenth century, and beyond these, to baroque formulae. These traditional canons of sublimity were lavishly applied in the paintings of Church, Bierstadt, and Moran at a time when the exploration of North and South America was well advanced. These artists were relatively late arrivals in the long procession of artist-explorers.

Many of the earlier works could be read, as suggested, as simple topographic recordings (on occasion they were modestly amplified by the conventions of the late-eighteenth-century picturesque). Though the development is not totally consistent, we can follow a Wölfflinian progression from the more linear and occasionally primitive early works to the baroque engines of Church and Moran (fig. 76). This

76. Thomas Moran, *The Chasm of the Colorado*, 1873–74
Oil on canvas, 84⅜″ × 144¾″. The National Collection of Fine Arts, lent by U.S. Department of the Interior

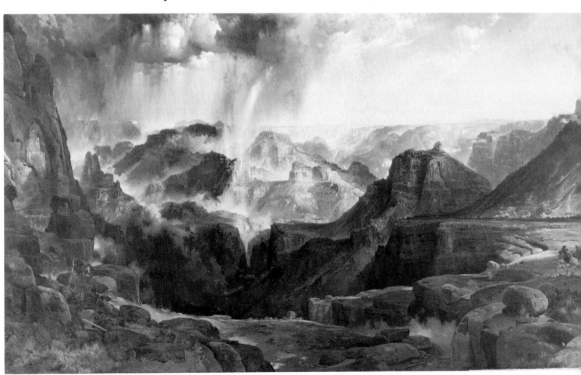

suggests that the process of discovery itself, as it developed its own history and past, became subject to the "civilizing" influence of artistic conventions. Such artistic "civilizing," along with the verbal associations, withdrew newness from the terrain at the very moment it was exalting it. The act of seeing was a form of possession that donated to the new landscape those perceptual habits we call conventions, in turn determined by the ideas of the age.

For the vast expansive prairies, the immense extensions of space, the awesome mountains, the forbidding and majestic scale that characterized the varied landscape of the West could only then, as now, be called "sublime." Yet, as we have seen, sublimity had many faces. Tocqueville, during his fortnight in the American wilds, spoke of "a silence so deep, a stillness so complete, that the soul is invaded by a kind of religious terror. . . . More than once in Europe we have found ourselves lost deep in the woods, but always some sound of life came to reach our ears. . . . Here not only is man lacking, but no sound can be heard from the animals either . . . all is still in the woods, all is silent under their leaves. One would say that for a moment the Creator has turned his face away and all the forces of nature are paralyzed."[24]

The theme of silence and solitude, variously interpreted, runs through these western accounts, as it does through the many uninhabited paintings. To Washington Irving ". . . there is something inexpressibly lonely in the solitude of a prairie. The loneliness of a forest seems nothing to it. There the view is shut in by trees, and the imagination is left free to picture some livelier scene beyond. But here we have an immense extent of landscape without a sign of human existence."[25] Francis Parkman, who was also oppressed by the monotony of the plain, in which "no living thing was moving . . . except the lizards that darted over the sand and through the rank grass and prickly pears at our feet," found the area near Fort Laramie "a sublime waste, a wilderness of mountains and pine-forests, over which the spirit of loneliness and silence seemed brooding."[26]

But if Irving and Parkman were a bit disenchanted with the desolate plains and prairies, Worthington Whittredge, on his journey with General Pope, was deeply moved by them: "I had never seen the plains or anything like them. They impressed me deeply. I cared more for them than for the mountains, and very few of my western pictures have been produced from sketches made in the mountains, but rather from those made on the plains with the mountains in the distance. Whoever crossed the plains at that period, notwithstanding its herds

of buffalo and flocks of antelope, its wild horses, deer and fleet rabbits, could hardly fail to be impressed with its vastness and silence and the appearance everywhere of an innocent, primitive existence."[27]

That innocence was one theme, of course, of James Fenimore Cooper's Leatherstocking novels, in which Cooper made reference to the "holy calm of nature": "the air of deep repose—the solitudes, that spoke of scenes and forests untouched by the hands of man—the reign of nature, in a word, that gave so much poor delight to one of [Deerslayer's] habits and turn of mind."[28] Silence and solitude were the natural companions of that type of sublimity perhaps closest to the Creator. (And indeed, sublimity and Creation, those two master words of the landscape attitude in the nineteenth century, are also key words for the esthetic and intent of exploration.) Tocqueville's silence, in the deepest sense, offered the serenity of "universal peace" when the "universe seems before your eyes to have reached a perfect equilibrium" and the "soul, half asleep, hovers between the present and the future, between the real and the possible, while . . . man listens to the even beating of his arteries that seems to him to mark the passage of time flowing drop by drop through eternity."[29] This was the same silence Cole found three or four years later in Franconia Notch, where the overwhelming emotion of the sublime was provoked by "the spirit of repose" brooding over nature, and "the silent energy of nature stirred the soul to its inmost depths."[30]

In the East also, Thoreau could write: "Those divine sounds which are uttered to our inward ear—which are breathed in with the zephyr or reflected from the lake—come to us noiselessly, bathing the temples of the soul, as we stand motionless amid the rocks. The halloo is the creature of walls & masonwork; the whisper is fitted in the depths of the wood, or by the shore of the lake; but silence is best adapted to the acoustics of space."[31] Such acoustics were available too in the vast expanses of the West. Solitude could lead to peace or dread, immense space to universal tranquility or overwhelming awe—that is, to the newer, more tranquil sublimity or to the older, rhetorical one. The artists were capable of practicing both simultaneously. In consonance with the rhetorical heroism of their quest, the older sublime was generally more in evidence.

Both concepts of the sublime drew more directly on religious feelings than the late-eighteenth-century version. Many of the travelers' associations when confronted with western nature were overtly religious. On encountering the Tucumcari region, Heinrich Möllhausen spoke as an artist-geologist when he found himself "here on the wide plain rejoicing the eye by the regularity of its structure, and setting one to calculate how many thousands of years Nature must have been at work chiselling and dressing these stones, before she could have

brought the original rough mountain mass to its present form."[32] His geological sense of time in no way impeded his spiritual sense: "Here, as amidst the wilderness of waters, in the dark primeval forest, among the giant mountains, Nature builds a temple that awakens feelings not easily to be expressed; but the pure joy we feel in the works of the Almighty Master may well be called worship. . . . The fact that clear springs so often gush out amongst the rocks amidst these grand scenes, inviting the wanderer to rest near them, may even suggest the idea that hard rock has been thus smote and the water made to gush forth, to detain man the longer before these natural altars."[33]

The idea of the West as a "natural church" occurs repeatedly. Washington Irving, setting out to tour the prairies, was at a certain point "overshadowed by lofty trees, with straight, smooth trunks, like stately columns; and as the glancing rays of the sun shone through the transparent leaves, tinted with the many-colored hues of autumn, I was reminded of the effect of sunshine among the stained windows and clustering columns of a Gothic cathedral. Indeed there is a grandeur and solemnity in our spacious forests of the West, that awaken in me the same feeling I have experienced in those vast and venerable piles, and the sound of the wind sweeping through them supplies occasionally the deep breathings of the organ."[34]

Clarence King, too, having ascended Mount Tyndall, found that "the whole mountains shaped themselves like the ruins of cathedrals —sharp roof-ridges, pinnacled and statued; buttresses more spired and ornamented than Milan's; receding doorways with pointed arches carved into blank facades of granite, doors never to be opened, innumerable jutting points with here and there a single cruciform peak, its frozen roof and granite spires so strikingly Gothic I cannot doubt that the Alps furnished the models for early cathedrals of that order."[35] For the writer Fitz Hugh Ludlow, who like King at one stage traveled with Albert Bierstadt, the artist making his color-studies amid western nature sat in a "divine workshop."[36]

King felt, as he sat on Mount Tyndall, a "silence, which, gratefully contrasting with the surrounding tumult of form, conveyed to me a new sentiment. I have lain and listened through the heavy calm of a tropical voyage, hour after hour, longing for a sound; and in desert nights the dead stillness has many a time awakened me from sleep. For moments, too, in my forest life, the groves made absolutely no breath of movement; but there is round these summits the soundlessness of a vacuum. The sea stillness is that of sleep; the desert, of death —this silence is like the waveless calm of space."[37]

Ludlow, confronting the Valley of the Yosemite from Inspiration Point, saw "a sweep of emerald grass turned to chrysoprase by the slant-beamed sun—chrysoprase beautiful enough to have been the

tenth foundation-stone of John's apocalyptic heaven. . . . Not a living creature, either man or beast, breaks the visible silence of this inmost paradise; but for ourselves, standing at the precipice, petrified, as it were, rock on rock, the great world might well be running back in stone-and-grassy dreams to the hour when God had given him as yet but two daughters, the crag and the clover. We were breaking into the sacred closet of Nature's self-examination."[38]

In this context, the ambition of the artist-explorers goes far beyond that of the enterprising adventurer in search of excitement. There was, surely, something of the entrepreneur in much of the large-scale popular art that came out of the exploration; Bierstadt made poster-like replicas of his western experiences years later. But the most profound intentions of the artist-explorers coincided exactly with their role as curates of the natural church. They were rehearsing and reliving Genesis through the landscape, just as the geologists were attempting to do. Their cooperation with the scientists of the expeditions was a natural function of their similar roles. Together, they were archaeologists of the Creation, uncovering beginnings with all the proprieties of their sacred mission.

To them, the newness of the landscape insured the freshness of their vision, and thus its sanctity. That vision, unsullied by the intervention of the layman, arched from the "undefiled" land—fresh as Creation itself—through the eye of the artist, that devout interpreter, to the pictorial image. Knowledge of Creation could to a large extent insure artistic creation. That creation would maintain its absolute integrity against organic decay or man's desecration. The eager spectator, in receiving the image, also received a sacred blessing. To penetrate Creation, even by proxy, was to assume at least some of the attributes of the Creator.

According to Whittredge, Gifford told him that "no historical or legendary interest attached to landscape could help the landscape painter, that he must go behind all this to nature as it had been formed by the Creator and find something there which was superior to man's work, and to this he must learn to give intelligible expression."[39] Whittredge recalled Gifford's remarks only in general terms, but he added that though "these ideas were not new or wonderful . . . he impressed me as a man earnestly looking into a problem, as in truth he was."[40] One suspects that Whittredge did not find these ideas new or wonderful because they were usual and even ordinary for the landscape painters of the mid-century.

Whittredge, born in Ohio, had early developed a feeling for the prairie and for a kind of primitivism which he sought again on a later western journey (fig. 77). Probably this was why Kit Carson represented for him a special solitary sensibility: "I had all my life wanted to meet

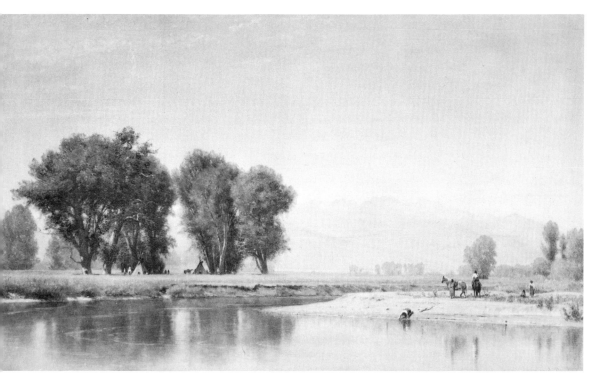

77. Worthington Whittredge, *On the Plains, Colorado*, 1877
Oil on canvas, 30″ × 50″. St. Johnsbury Athenaeum, St. Johnsbury, Vermont

a man who had been born with some gentle instincts, and who had lived a solitary life, either in the woods, or somewhere where society had not affected him and where primitive nature had had full swing of his sensibilities."[41]

Such nature feelings, and such a preference for the gentle, solitary spirit, were of course as much a part of New England transcendentalism as of western exploration. Thoreau had stated in *Walden:* "For the most part it is as solitary where I live as on the prairies. . . ." And, "I am no more lonely than a single mullein or dandelion in a pasture, or a bean leaf, or sorrel, or a horse-fly, or a humble-bee. I am no more lonely than the Mill Brook, or a weathercock, or the north star, or the south wind, or an April shower, or a January thaw, or the first spider in a new house."[42] These thoughts were as evident in the small, narrow paintings of the New England luminist Lane as in the large works describing the infinitely extending prairies.

In aiming for a solitary vision resulting from a single, primal encounter with the most "undefiled" nature, these landscapists can be seen as representatives of R. W. B. Lewis's Adamic man. Though the

more bombastic of them, Church, Bierstadt, and Moran, could turn that encounter into an apocalyptic revelation, rehearsing Creation through Resurrection, the quieter images found more apt counterparts in transcendental philosophy. All aspects—the quiet and the bombastic, the outgoing and the reflective—were joined in the work of the poet most associated with the western quest. Whitman's ebullient verses had in them much of the baroque adventures of Church and Moran, yet in *Leaves of Grass* he could write eloquently of a noiseless, patient spider:

> I mark'd, where, on a little promontory, it stood, isolated;
> Mark'd how, to explore the vacant, vast surrounding,
> It launch'd forth filament, filament, filament, out of itself;
> Ever unreeling them—ever tirelessly speeding them.[43]

To him, the "western central world" was "that vast Something, stretching out on its own unbounded scale, unconfined, which there is in these prairies, combining the real and ideal, and beautiful as dreams."[44] For Whitman, the "beauty, terror, power" of the West were "more than Dante or Angelo ever knew," and he was as struck by the atmosphere as was Thomas Moran, who was already painting the atmospheric effects Whitman described so eloquently: ". . . perhaps as I gaze around me the rarest sight of all is in atmospheric hues. The prairies . . . and these mountains and parks seem to me to afford new lights and shades. Everywhere the aerial gradations and sky effects inimitable; nowhere else such perspectives, such transparent lilacs and grays. I can conceive of some superior landscape painter, some fine colorist, after sketching awhile out here, discarding all his previous work, delightful to stock exhibition amateurs, as muddy, raw, and artificial."[45]

Like Whittredge, Whitman delighted in the long, level plains:

Then as to scenery . . . while I know the standard claim is that Yosemite, Niagara Falls, the upper Yellowstone and the like, afford the greatest natural shows, I am not so sure but the prairies and plains, while less stunning at first sight, last longer, fill the esthetic sense fuller, precede all the rest, and make North America's characteristic landscape. Indeed through the whole of this journey . . . what most impressed me, and will longest remain with me, are these same prairies. Day after day, and night after night, to my eyes, to all my senses—the esthetic one most of all—they silently and broadly unfolded. Even their simplest statistics are sublime.[46]

For Whitman, "a typical Rocky Mountain canyon, or a limitless, sealike stretch of the great Kansas or Colorado plains, under favoring circumstances, tallies, perhaps expresses, certainly awakes, those grandest and subtlest element[al] emotions in the human soul, that all the marble temples and sculptures from Phidias to Thorwaldsen—all paintings, poems, reminiscences, or even music, probably never can."[47]

Yet he still had high hopes for the effect of the western landscape on American art, and wondered: "The pure breath, primitiveness, boundless prodigality and amplitude, strange mixture of delicacy and power, of continence, of real and ideal, and of all original and first-class elements, of these prairies, the Rocky Mountains, and of the Mississippi and Missouri Rivers—will they ever appear in, and in some sort form a standard for our poetry and art?"[48]

In embodying the fresh new amplitude he sought, Whitman was himself a type of Adamic hero. As Lewis puts it, Whitman thought of the poet as the vicar of God, the son of God, God himself.[49] Yet our artist-curates, in searching the vast uncharted territories, had scarcely less ambition. Insofar as the multiple versions of solitude, silence, and, by final implication, sublimity touched on the Creator, they touched on their most important motivation. Behind the recourse to the cult of the wilderness, primitivism, and the artistic alliance with science was that single aim: to get back to the beginning. The artists

78. Albert Bierstadt, *Yosemite Valley, Glacier Point Trail*, 1875–80
Oil on canvas, 54″ × 84¾″. Yale University Art Gallery, New Haven, Connecticut

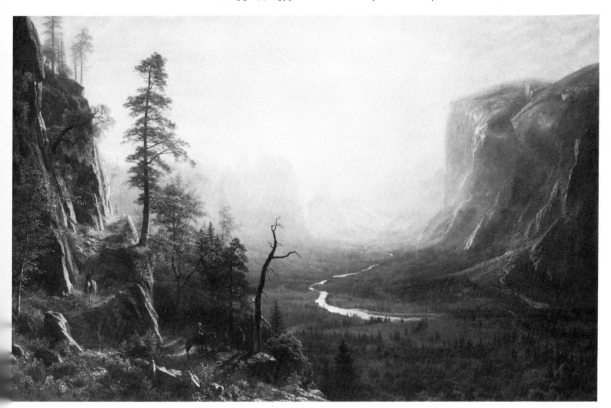

sought not only Tuckerman's "fresh and characteristic themes." They wanted to be the first to behold God's work since the moment of nature's birth, and in this primal vision, to behold God. Like Thoreau's poet, they were "Nature's brothers." They toiled across the prairies, climbed their mountains, tracked icebergs and ascended volcanoes—all so that when they were asked: "What see you when you get there?" they could answer, with Natty Bumppo: "Creation . . . all creation" (fig. 78).[50]

VIII
Man's Traces:
Axe, Train, Figure

Axe

All then was harmony and peace—but man
Arose—he who now vaunts antiquity—
He the destroyer—amid the shades
Of oriental realms, destruction's work began—
.
And dissonant—the axe—the unresting axe
Incessant smote our venerable ranks. . . .

> THOMAS COLE
> *"The Complaint of the Forest"*[1]

There are daily used for mining and building purposes, one hundred and twenty-five thousand feet, BM, of lumber and square timber, the cost of transporting which cost $20 per thousand, making an annual consumption of one hundred and eight thousand cords of wood, and 40 million feet of lumber. . . . [coming from] the inexhaustible forests of California.

> *Evidence Concerning Projected Railway* . . .[2]

While Thoreau meditates on his use of the axe to make himself a dwelling place in nature, he also mourns lost trees, which he misses like human beings.[3] National identity is both constructed and threatened by the double-edged symbol of progress, the axe that destroys and builds, builds and destroys. The paradoxes of this relationship to nature are sharply revealed in the "civilizing" of the land. Progress toward America's future literally undercut its past (fig. 79).

In chopping away at the forests, Americans were not only terminating the primordial age that made America unique. They were also leveling what William Cullen Bryant had called God's first temples. Insofar as this involved an attack on America's religion of God-in-nature, it was a profane act. But expediency strongly suggested that nature could be "humanized" without violating nature-as-God.

157

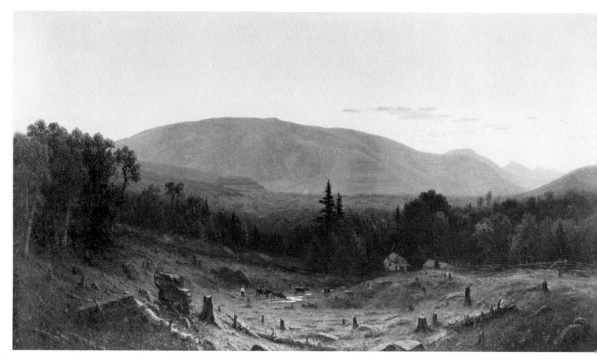

79. Sanford Gifford, *Twilight on Hunter Mountain*, 1866
Oil on canvas, 30½" × 54". Private collection

Central to this rationalization was the idea of the Garden.[4] Conceivably, wilderness could be transformed through the pastoral ideal into a rural Paradise, resembling the biblical Eden painted by Cole in his *Expulsion from the Garden of Eden* (1827–28; see fig. 2). At the right, a verdant Eden is represented with the same Claudian gentility that distinguishes Cole's *Pastoral State* in *The Course of Empire* (1836; see fig. 5), while on the left Adam and Eve are expelled into a "howling" wilderness, set with picturesque, storm-ravaged trees that go back to Salvator.[5] The picture could be read as a text on nature and culture, with fallen man faced with the task of recovering culture from the wilderness. Like no other American artist, Cole mediated this dilemma of the wilderness. Seven years after he painted the *Expulsion*, he wrote that "although an enlightened and increasing people have broken in upon the solitude, and with activity and power wrought changes that seem magical, yet the most distinctive, and perhaps the most impressive, characteristic of American scenery is its wildness."[6]

How could this dilemma be, if not resolved, at least lived with? How much could man touch God's "undefiled works"? Was there a

point beyond which progress and cultivation should not go? At what point did the arc from virgin wilderness through the pastoral ideal to the industrial landscape swerve from constructive accord with God's will to human destructiveness toward nature? From these questions arose early ecological awarenesses that have led almost teleologically to the ones we bear so heavily now. In 1789, Dr. Nicholas Collin in "An Essay on Natural Philosophy and Its Relationship to the Development of the New World" observed: "Our stately forests are a national treasure, deserving the solicitous care of the patriotic philosopher and politician. Hitherto, they have been too much abandoned to the axes of rude and thoughtless wood-choppers. . . . In many parts of the country a preservation and encrease of the timber for fuel and domestic uses render these queries important."[7]

But Yankee "efficiency" understood domestic needs more readily than the ecological responsibilities so apparent to these thoughtful early artists, writers, scientists, and philosophers. When the lesson hit home, there was just enough time (and nature) left to establish the artificial enclaves known as parks. To some extent, landscape gardening attempted to deal with the problem of respecting nature. Yet nature's prolixity had, apparently, to be edited. A. J. Downing cautioned his readers in 1859 that "the Beautiful, embodied in a home-scene" was attained "by the removal or concealment of everything uncouth and discordant, and by the introduction and preservation of forms pleasing in their expression, their outlines, and their fitness for the abode of man."[8] So "undefiled" nature hardly had a chance, whether ravaged by friend or foe. Tocqueville's sensitivity to this is striking: "All that one feels in passing through these flowery wildernesses where everything, as in Milton's *Paradise*, is ready to receive man is a quiet admiration, a gentle melancholy sense, and a vague distaste for civilized life, a sort of primitive instinct that makes one think with sadness that soon this delightful solitude will have changed its looks. . . . The facts are as certain as if they had already occurred. In but few years these impenetrable forests will have fallen."[9]

After the colonial period, according to Hans Huth, the "axe was even accepted as the appropriate symbol of the early American attitude toward nature." No one describes this attitude better than Cooper in *The Pioneers*. As Billy Kirby, a professional logger, goes to work, he treads the woods like Hercules, measuring the trees with deliberation:

Commonly selecting one of the most noble, for the first trial of his power, he would approach it with a listless air, whistling a low tune; and wielding his ax, with a certain flourish, not unlike the salutes of a fencing master, he would strike a light blow into the bark, and measure his distance. The pause that followed was ominous of the fall of the forest, which had flourished there

for centuries. The heavy and brisk blows that he struck were soon succeeded by the thundering report of the tree, as it came, first cracking and threatening . . . finally meeting the ground with a shock but little inferior to an earthquake. From that moment the sounds of the ax were ceaseless, while the falling of the trees was like a distant cannonading. . . . [Ultimately] the jobber would collect together his implements of labor, like the heaps of timber, and march away, under the blaze of the prostrate forest, like the conqueror of some city, who, having first prevailed over his adversary, applies the torch as the finishing blow to his conquest.[10]

The battle and the conquest are, for Cooper, but "little inferior to an earthquake," and man's violence has an effect close to the most elemental of natural calamities. Billy Kirby was in the vanguard of the so-called march of civilization, with history and progress as cohorts. The artist's job, as a minority view saw it, was to get there first and document a doomed nature. Facing nature's inevitable decline, this task teems with ironies. Only when the colonist had cleared the forest and made it fit for "man's abode" could he approach the luxury of loving it. Roderick Nash has observed that "appreciation of wilderness began in the cities" and that "in the early nineteenth century American nationalists began to understand that it was in the *wildness* of its nature that their country was unmatched."[11] And as Tocqueville observed, the mortality of nature suddenly made it more desirable. The "consciousness of destruction" gave a "touching beauty to the solitudes of America. . . . one is in some sort of hurry to admire them."[12] The artists had to hurry. The reviewer of Cropsey's landscapes in the *Literary World* of 1847 reminded them that ". . . even the primordial hills, once bristling with shaggy pine and hemlock, like old Titans as they were, are being shorn of their locks, and left to blister in cold nakedness in the sun. . . ."[13]

Cole, the first fully equipped landscape painter in America, was one of the first to recognize the problem. More astute philosophically than his successors, he had a fuller grasp, I think, of the implications of civilization. Yet his paintings were also more readily touched by "art" than those of any of his landscape peers. His "nature" had already been "civilized" by art history, in its way as potent a challenge to the primordial wilderness as the axe. Obviously, Cole enjoyed exercising this graceful option. It was kinder to let the ancient trees stand, altering them at will in a composition, or imposing Claudian pastorales on them when the mood demanded. The artist made the necessary changes on the canvas. Nature remained intact.

Cole's sense of temporal crisis was repeatedly expressed in his poetry and notebooks, and he invented such titles as "On seeing that a favorite tree of the Author's had been cut down." The famous "Complaint of the Forest" notes: "We feed ten-thousand fires! In one short day / The woodland growth of centuries is consumed. . . ."[14] The

stress is on the disparity between natural time and man's time, which, in its extraordinary accelerations, can consume eons of growth. This destruction was radically emphasized by geological revelations such as Lyell's in 1830 that the age of the world extended indefinitely back into time. Geological time, with all its poetic possibilities, dominates the landscape paintings of this period. Time—"hallowed," "hoary," "mellow," a kind of mythic infinity extending beyond human measure—suffuses the way the artists confront the "patriarchal trees." The late-eighteenth-century concept of the picturesque so successfully employed by Cole in many of his landscapes could be handily adapted to signify this time awareness.

But Cole's strong feelings about the axe also found abrupt expression in paintings in which the cut stump suggests a new iconology of progress and destruction. Going back to Gilpin's tree that records the "history of some storm," the new iconology sets up a dialogue between the ravages of time and the ravages of man which has persisted until the present. In Cole's art, natural time offers a rhetorical springboard for meditation:

> Stop the Ruffian Time! Lay hold!
> Is there then no power so bold!
> None to meet his strength midway—
> Wrest from him his precious prey,
> And the Tyrant-Robber slay.[15]

Preoccupied as he is with the passage and effects of natural time, Cole always ends up with an affirmation of faith:

> And anon shall one appear
> Brighter than the Morning Star:
> He shall smite that Spectre frore
> Time shall, clasped by Death no more,
> Take a new name—Evermore.[16]

The effects of man's time, of man's destruction, obviously could never offer the same opportunities for meditation on God's immemorial will. Yet Cole, caught like all his contemporaries between nature and culture, was willing to admit that "the cultivated must not be forgotten, for it is still more important to man [than wilderness] in his social capacity."[17] Nonetheless, his use of the stump symbol has few poetic overtones, making only a wry understated commentary on this modification of God's nature. In paintings such as the *Expulsion* (see fig. 2), *The Oxbow* (Metropolitan Museum of Art, New York), and *Landscape with Tree Trunks* (Rhode Island School of Design), Cole used the storm-ravaged tree, a palimpset of time associations, almost as a signature. This natural picturesque is of a totally different order from what we might call the man-made or unnatural picturesque, the

cut stump of the wood-chopper, utilitarian man feeding his ten thousand fires. The blunt factualism of the stump symbol is clear from a comparison of Cole's two paintings of a favorite scene in the Catskills, executed with and without "the mighty trunks, the pride of years."[18]

In *View on the Catskill, Early Autumn* (1837; fig. 80), a tree richly endowed with an umbrella of leafage dominates the left foreground, and a taller spray of delicate trees provides a Claudian frame at the right. Six years later, another version of the same site, *River in the Catskills* (fig. 81), is slightly altered in accordance with Cole's concepts of compositional license and his free use of notebook sketches. In addition, no tall trees are now present to serve as focusing or framing devices. The formal effect of this is to change the pictorial structure from the obviously pastoral and Claudian-derived to the more direct horizontal design favored by the luminists. Perhaps some of the trees in the first version had never actually existed in the site itself. Cole may have imposed them on what looks like a horizontal landscape in order to

80. Thomas Cole, *View on the Catskill, Early Autumn,* 1837
Oil on canvas, 39″ × 63″. The Metropolitan Museum of Art, New York, gift in memory of Jonathan Sturges by his children

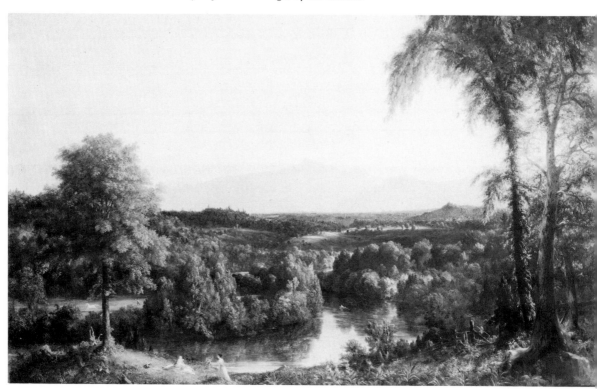

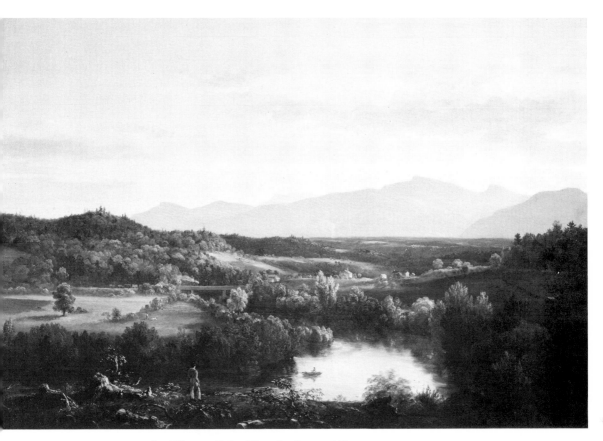

81. Thomas Cole, *River in the Catskills,* 1843
Oil on canvas, 28¼″ × 41¼″. M. & M. Karolik Collection, Museum of Fine Arts, Boston

heighten the pastoral effect. (This may be particularly true, I feel, of the trees at the right.) In the second version the trees are glaringly absent. Evidence of some prior existence remains in the prominent stump at the left. Closer examination shows that in the first version a small stump occupies the far left foreground; it persists in the later painting, in much the same place, but the full-leafed tree is gone, and the foreground is strewn with fallen branches.

The two pictures demonstrate some progress from the ideal to a more pragmatic encounter with the real, from mythic time to human time. For Cole that reality was filled with poignancy. In a letter to his patron Luman Reed on March 26, 1836, Cole lamented that "they are cutting down all the trees in the beautiful valley on which I have looked so often with a loving eye. This throws quite a gloom over my spring anticipations. Tell this to Durand—not that I wish to give him

pain, but that I want him to join with me in maledictions on all dollar-godded utilitarians."

Two days later, Cole, ever the temperate gentleman, wrote again to Reed:

After I had sealed my last letter, I was afraid that what I had said about the tree-destroyers might be understood in a more serious light than I intended. My "maledictions" are gentle ones, and I do not know that I could wish them any thing worse than that barrenness of mind, that sterile desolation of the soul, in which sensibility to the beauty of nature cannot take root. One reason, though, why I am in so gentle a mood is, that I am informed some of the trees will be saved yet. Thank them for that. If I live to be old enough, I may sit down under some bush, the last left in the utilitarian world, and feel thankful that intellect in its march has spared one vestige of the ancient forest for me to die by.[19]

In the same group of letters, Cole corresponded with Reed about the *Course of Empire* commission. Though this series was praised by a public which paid willingly to see it, that public seemed unaware that the pictures' didacticism could apply to them. *Course of Empire* was a fantasy about imperial pagan ambition. America, a Christian nation, could not succumb to a similar fate. The so-called March of Empire, in America, was always shielded by its Christian intent. God had given white America the mandate to develop the land and endowed it with the technology to do so. God's blessings could never be withdrawn. Unfortunately, the noble savages, or Indians, for all their connection with a primitivism for which nineteenth-century Americans were already nostalgic, were not similarly blessed. As Tocqueville had noted, Americans felt that "God, in refusing the first inhabitants the capacity to become civilized, has destined them in advance to inevitable destruction. The true owners of this continent are those who know how to take advantage of its riches."[20]

Thus, the moral of *Course of Empire* went largely unnoticed by the American public that acclaimed it, a public confident—almost smug—about its ability to take advantage of the continent's riches. The land was being cleared for man's abode; Billy Kirby was now the conqueror. And the stump, suddenly filling the foregrounds of other American paintings of the period, becomes a symbol of the march of civilization.

The roseate foreground of Sanford Gifford's *Twilight on Hunter Mountain* (see fig. 79) is punctuated with such reminders of past sylvan glories, which occupy and measure the space like so many fallen soldiers on a battlefield. One has a sense of the aftermath of a special kind of crusade or war, in which man, triumphant (in this case a settler and his herd), achieves a kind of pastoral calm at the center of the enormous clearing. But there is little doubt that something has

been given up in return for this "progress." Similarly with Gifford's *Home in the Woods* (formerly Douglas B. Collins Collection): cultivation is the result of sacrifice, not only of man's time, labor, and exposure to hardship, but of some aspects of nature's very existence. In *Home in the Woods* the stumps have a choppy staccato rhythm that somehow approximates the sound of Cole's "dissonant axe."

That sound was, as Tocqueville suggested, "the noise of civilization and of industry."[21] It broke into the silence that the transcendental artists and philosophers were, at the very same moment, defining as a key correlative of the mid-nineteenth century. "Good as is discourse," wrote Emerson, "silence is better, and shames it."[22] Thoreau concurred: "To the highest communication I can make no reply; I lend only a silent ear."[23] And, "Occasionally we rise above the necessity of virtue into an unchangeable morning light, in which we have not to choose in a dilemma between right and wrong, but simply to live right on and breathe the circumambient air. There is no name for this life unless it be the very vitality of *vita*. Silent is the preacher about this, and silent must ever be, for he who knows it will not preach."[24]

The visual corollary of silence is stillness. Stillness and silence are the antipodes of the progressive noise and action of civilization. The modest luminist paintings embodying this silence are testaments to a profound yearning of the age. Yet their private quietude was ignored in favor of the more active "public" paintings of the Hudson River men, which often, as with Church and Bierstadt, invited entry by their very scale. The noise of civilization could also enter, and the sound of the axe followed. Those Hudson River landscapes that are marked by the stump symbol introduce the double-edged sense of accelerated time that defines new values, replacing myth with history, the individual with the community. The stump, then, signifies the community participation that constructs the social fabric.

The sound of the axe also adds a final footnote to the earlier sounds of the "old sublime." The sensibilities that had reacted to the "shouts of Niagara from the abyss" and to the groans and roars of Cotopaxi and Sangay now become aware of what Cole called "this human hurricane" of the axe. Partaking, probably without fully understanding it, of the positive overtones of the "sublime" noise of progress, they allow cultivation to overshadow destruction while the wilderness takes on form and manner.

Train

I like to see it lap the miles,
And lick the valleys up. . . .
 EMILY DICKINSON[25]

Colonizing the landscape cleared by the axe and bearing with it the
sounds of civilization, the railroad carried the new iconology further
(fig. 82). The nineteenth century endowed its desire to join places with
a mystical materialism. So the railroad enterprise was made radiant
by the transcendent optimism known as progress. Leo Marx reports
that by the 1830's, the locomotive was already "becoming a kind of
national obsession," and that "between 1820 and 1860 the nation was
to put down more than 30,000 miles of railroad track, pivot of the
transportation revolution which in turn quickened industrialization."[26]
Any comments on the cultural significance of railroads must ground
themselves firmly in Marx's pioneering work on the nineteenth cen-
tury's most ruthless emblem of power.

 The Iron Horse was welcomed by most communities without res-
ervation. Numerous new towns owed their existence to the railroad,
which engendered a new resort trade by virtue of one of industry's
end-products—leisure. The railroad threw bridges across the land-
scape in a way that made the bridge a metaphor for identifying access
with understanding. Its linear imperialism bore with it a heavy so-
ciological cargo. Like the great highways of the twentieth century and
the great rivers of the pre-technological era, the railroad spawned its
own culture. Railway culture was possibly the first modern culture to
fulfill the ancient desire to compress space and purchase time. Indeed,
time itself—as vast engines slid along the ever-converging rails, wooden
sleepers clicking off space as if on a horizontal clock—became a tech-
nological dimension.

 The exhilaration and rush of progress was easily identified with
this new force. Yet American "self-recognition," as Perry Miller puts
it, also perceived "an irreconcilable opposition between Nature and
civilization."[27] American identity equivocated between both in a kind
of perplexed vibration. Technology, the so-called applied science,
nourished the American passion for the utilitarian, a passion ex-
pressed by a rhetoric that often seems, in America, to follow the iden-
tification of utility with a perception of moral correctness. Marx has
brilliantly characterized the language accompanying the railroad en-
terprise as the "rhetoric of the technological sublime." Thus: "Objects
of exalted power and grandeur elevate the mind that seriously dwells
on them, and impart to it greater compass and strength. . . . Alpine

82. Alexander Gardner, *View Near Fort Harker, Kansas,* undated
Photograph. International Museum of Photography at George Eastman House

scenery and an embattled ocean deepen contemplation, and give their
own sublimity to the conceptions of beholders. The same will be
true of our system of Rail-roads. Its vastness and magnificence will
prove communicable, and add to the standard of the intellect of our
country."

In one of those special ironies occasionally doled out to us by his-
tory, the rhetoric of the technological sublime developed concurrently
with the nature rhetoric. This identification blurred the issue in a
way that legitimized—indeed sanctified—the great materialist urge.
Very early on (1787), Tench Coxe saw a bounteous nature as an en-
couragement to amass wealth—if that wealth were, of course, pur-
chased through the morality of work: "Providence has bestowed upon
the United States of America means of happiness, as great and numer-

ous, as are enjoyed by any country in the world. A soil fruitful and diversified—a healthful climate—mighty rivers and adjacent seas abounding with fish are the great advantages for which we are indebted to a beneficent creator. Agriculture, manufactures and commerce, naturally arising from these sources, afford to our industrious citizens certain subsistence and innumerable opportunities of acquiring wealth."[28] It soon became apparent that nature and the machine would both be harnessed to the same purpose—to fulfill the American concept of a future clearly blessed by an understanding God. This resulted in what could be described as laissez-faire morals: whatever happened was ultimately for the nation's good. Perry Miller's enormous "national ego" was convinced of its invincible rightness.

The rhetorical assimilation of the railroad provoked Whitmanesque excursions. The railroad was

. . . a Titanic colossus of iron and of brass, instinct with elemental life and power, with a glowing furnace for his lungs, and streams of fire and smoke for the breath of his nostrils. With one hand he collects the furs of the arctic circle; with the other he smites the forests of Western Pennsylvania. He plants his right foot at the source of the Missouri—his left on the shores of the Gulf of Mexico; and gathers into his bosom the ever-flowing abundance of the fairest and richest valley on which the circling sun looks down.[29]

This benevolent genie, controlling nature, was itself part of nature. As Perry Miller remarks: "the force of Nature, the majesty of Niagara, were transmuted into machinery and locomotives by passing through the brain of man."[30] Thus, the whole idea of progress, having passed through Mind (now the mathematical and engineering faculties of Mind—the other pole of Emerson's "We want our dreams and our mathematics"), could be extended to transcendental ideas that subsumed all of life as part of the same optimistic unity. Emerson, who could convert most negatives into positives tried especially hard to see the benefits of the machine with a kind of dogged sunniness: "Luckily for us, now that steam has narrowed the Atlantic to a strait, the nervous, rocky West is intruding a new and continental element into the national mind, and we shall yet have an American genius."[31] In 1856, considering English industrialism in *English Traits,* he began to voice his distrust of the effects of the machine: "In a change of industry, whole towns are sacrificed like ant-hills, when the fashion of shoestrings supersedes buckles, when cotton takes the place of linens, or railways of turnpikes, or when commons are enclosed by landlords. Then society is admonished of the mischief of the division of labor. . . ."[32]

Yet as Marx has pointed out, Emerson ended *English Traits* with the same positive nationalist refrain he so often voiced: "If it be not so, if the courage of England goes with the chances of a commercial

crisis, I will go back to the capes of Massachusetts and my own Indian stream, and say to my countrymen, the old race are all gone, and the elasticity and hope of mankind must henceforth remain on the Alleghany ranges, or nowhere."[33]

Thoreau, always more tough-minded than Emerson, heard the sound of technology differently: "The whistle of the locomotive penetrates my woods summer and winter, sounding like the scream of a hawk sailing over some farmer's yard, informing me that many restless city merchants are arriving within the circle of the town."[34] Though Marx reminds us that to Thoreau the train first sounded more like a partridge, Thoreau's ambivalence leans, if ambivalence can, toward the hawk. Hawthorne, too, had heard "the whistle of the locomotive—the long shriek, harsh, above all other harshness, for the space of a mile cannot mollify it into harmony. It tells a story of busy men, citizens from the hot street, who have come to spend a day in a country village, men of business; in short, of all unquietness; and no wonder that it gives such a startling shriek, since it brings the noisy world into the midst of our slumbrous peace."[35] The country-city, silence-noise oppositions set up here are, of course, nature-culture oppositions. Hawthorne's perception of the shriek that disturbs nature's stillness brings to mind Morris Graves's eloquent images of the 1940's, of birds "driven mad by the sound of machinery in the air." The sound pollution of the machine carries with it the nascent urban threat to pastoral calm, altering distance and place, presaging a telescoped world in which the machine would cannibalize nature—in transcendental terms, its own parent.

How did the artist meet this obvious challenge that threatened to rip whole tracts out of the Book of Nature? Though the machine provided certain paradigms of simplicity and measure for the American artist, who often utilized and invented, as well as admired it (as Eakins admired the locomotives at the Paris International Exposition of 1867),[36] it was still, in Marx's terms, *in* the Garden, and its threats to Paradise were evident enough. Yet how remote and insignificant are the trains that discreetly populate the American landscape paintings of the mid-century! The assertive symbol of the new age of steam is confined to distant twists of smoke, beneath which the eye searches for the linked line that bespeaks the new invention. Again and again one detects a train in an American landscape where one's eyes had not before picked up its presence. A close look at Cole's *River in the Catskills* (see fig. 81) yields a miniature train. In Cropsey's *Starrucca Viaduct* (fig. 83) and Inness's *Delaware Water Gap* (Metropolitan Museum of Art, New York) the train takes as much prominence as it will generally be given, but even here it is far away, its sound blending—as does the image—into more bucolic murmurs.

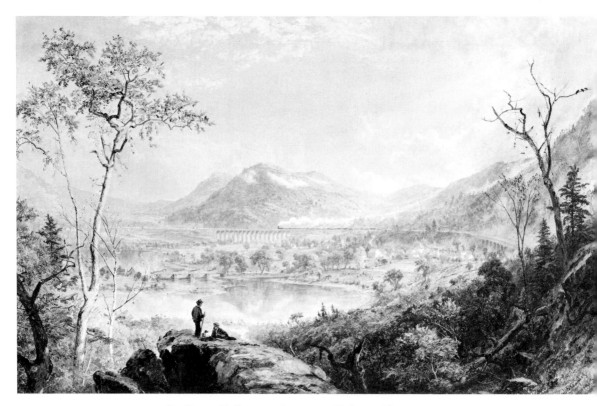

83. Jasper F. Cropsey, *Starrucca Viaduct*, 1865
Oil on canvas, 22⅛″ × 36⅜″. The Toledo Museum of Art, gift of Florence Scott
Libbey

Often in such pictures the locomotives emit plumes of smoke and
steam that mingle with the clouds. Such a blend of man-made and
natural vapors suggests several interpretations. First, that the steam
cloud has been absorbed by the larger modality of nature per se, just
as smoke and steam dispel into clear air. As part of the transcendental
whole the artists wished to preserve, it requires no more accent or iso-
lation than a distant tree or pool. It might indeed, should we pursue
this interpretation, signify the symbolic fusion of man and nature
through Mind—secular invention subsumed into the larger creation,
as the fuliginous emblem of power grazes mildly through the land-
scape.

In a convincing thesis eloquently put forward by Kenneth Maddox,
the train becomes part of a landscape tradition of the pastoral which
is "predicated . . . upon the clearing and cultivation of the American
wilderness—an ideal that temporarily combines both nature and civi-
lization, yet which is finally destined to be transformed into an Amer-

ican art distinguished by its machine and technological forms."[37] Such
a thesis properly assumes that an artistic convention is a closed system
that repels whatever disturbs its premises. In art we have a fascinating
history of technological inventions presenting art conventions with no
option but to exclude them. The automobile in twentieth-century art
provided one such example. There were few effective ways of includ-
ing it within an existing realist convention until the appearance of
American pop art. That in itself indicates a need for a fuller under-
standing of the relationship between high and popular art. In the
American prints—the popular form of the nineteenth century—con-
temporary with the paintings, the train receives full foreground ex-
amination (see fig. 86). The prints were a form of reportage: this is
how this new beast looked. The rhetoric of its presence was signified
by the point of view—how large it bulked—and the sense of modernity
and power conveyed as it lay there quietly smoking or shuddering. But
according to Maddox's premise a powerful pastoral convention could
allow the train to enter the painting only on that convention's terms.

Indeed, Maddox's researches give us a paradoxical insight. He has
recognized hosts of trains where one previously did not know they ex-
isted. Are we then not dealing with a matter of camouflage as much
as announcement? Can we speculate, to amplify his thesis, that there
are other forces keeping the train at a distance, as well as—through a
very American sense of veracity and conscience—forcing it at least into
the picture? Its presence, absence, or placement was, we may be sure,
not just a matter of an exclusive artistic convention alone. It partook
of the larger issues of conscience wherein the artists balanced their re-
sponsibilities toward Creation and the machine, toward the primeval
and the cultivated, toward God and man. Certainly the verbal rhetoric
and the visual evidence seem out of kilter and it seems appropriate to
ask why.

The artists' reluctance to recognize the dynamic importance of
smoke and locomotive could, as noted, be interpreted as a desire to
tailor the machine and its effects to the pastoral dream. It could also
be seen as an unwillingness to deal with this new man-made reality.
Certain guilts and repugnancies were surely attached to the desecra-
tion of nature for the sake of "human" civilization.

The American landscapists, whose ideality so often emerged out of
the specific, may have found themselves facing implications which
were almost impossible for them to absorb and accept. The integrity
of the artistic convention may have been augmented by a sense that
the train was profoundly antagonistic to the landscape before their
eyes.

So it is with a shock that we find a train forcing its way toward us
out of the middle distance to become the main protagonist in George

Inness's *Lackawanna Valley* (1855; fig. 84). This is one of the most puzzling pictures in American art, as well as one that aptly embodies the moment of juncture between nature and civilization. To the left are tall, graceful trees, placed precisely where Claudian convention dictates, complete with reclining figure, and symbolizing the pastoral mode. But the busily smoking locomotive approaching from the right center suggests that the elegiac mood is transitory, if not illusory. The foreground is scattered with the stumps of trees, to a degree that gives the picture a somewhat "documentary" look.

Marx still finds enough of the pastoral here to speak of the "industrialized version of the pastoral ideal."[38] Yet some of the shock of this picture—and it is, I think, a shocking picture—is due to the fact that the pastoral idea has been so rudely treated. In Durand's ambitious *Progress* (fig. 85), painted two years earlier, the accommodation, while not fully convincing, is less abrupt. On the left of that picture are

84. George Inness, *The Lackawanna Valley*, 1855
Oil on canvas, 33⅞″ × 50¼″. National Gallery of Art, gift of Mrs. Huttleston Rogers

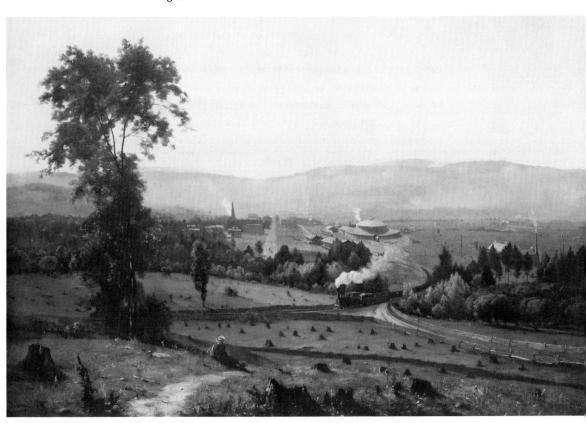

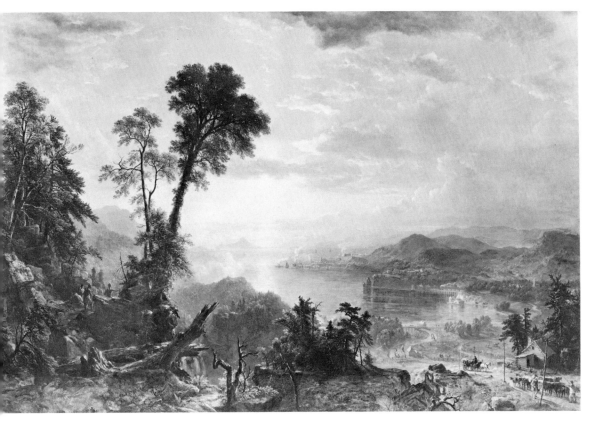

85. Asher B. Durand, *Progress*, 1853
Oil on canvas, 48″ × 71¹⁵⁄₁₆″. The Warner Collection of Gulf States Paper Corporation, Tuscaloosa, Alabama. Photo courtesy Hirschl and Adler Galleries, New York

vestiges of the picturesque—a storm-ravaged tree, and even Indians, emblems of the "old nature." New nature, at the right, is the Garden in which the puffs of smoke from steamboats, buildings, and a locomotive inoffensively announce the age of progress. The balanced reconciliation of nature and culture seems to have been achieved. Durand includes few of the wounds, such as the stump, necessary to achieve the happy balance he presents.

How did Inness feel about his subject? What does *The Lackawanna Valley* tell us about the artist's attitude toward one of the most pressing issues of his day, especially since this is among the few landscape paintings that forces the issue? Here we encounter difficulties. Inness, who started as a Hudson River artist, was in fact by instinct and equipment a generation in the future. He was a unique figure, not of the party of "nature" as the Hudson River painters understood it. The picture is also unique in his work. Although he included trains sev-

eral times in other paintings, the train never was so prominent in his work again. The reason the picture was painted at all removes some, but not all, of our questions. A commission from the Delaware, Lackawanna, and Western Railroad, it can be seen as a celebration of the age of steam in its conquest of time and space. We may be sure that that is the way the executives of the railroad saw it.

Nicolai Cikovsky, Jr., who has conducted the most meticulous examination of this picture and issue, tends to stress the optimistic accommodation of Inness's painting: "Inness does not condemn but rather condones, even glorifies, the situation he represents." Inness's feelings, Cikovsky notes, "are directly opposed to one of the central concerns of the Hudson River School—the pictorial hymning of America's purity and power through wilderness landscape. . . ."[39] *Lackawanna Valley* "may indeed represent Inness' declaration of independence from the current conventions (ideological and stylistic) of American landscape painting of the Hudson River School, and be an assertion of the modernity of his art, both through the novel artistic means that he employs, and equally through the glorification of the railroad, a well understood symbol of progress and 'the Present.' "[40] Maddox finds the picture "a 'classic' solution to Leo Marx's definition of the 'middle landscape' ideal," and suggests that Inness renounced "the wilderness mystique for the cultivated landscape."[41]

I think Cikovsky and Maddox are both correct in their interpretation of the picture, but my instinct is to modify slightly the painting's optimistic reading. As I understand Cikovsky's comments, Inness emphasizes the power and energy of the machine in a way his colleagues would not have done. However, not only the prominent presence of the train but the stumps in the foreground[42] lead me to suspect some ambiguity in Inness's attitude toward the progress he depicts. Of all the landscape artists (for the most part totally innocent of irony) he is perhaps the only one who might have entertained it. Though Inness was of the same generation as Church, Cropsey, and Gifford, he grew quickly into a personal style nourished by Barbizon. Indeed *Lackawanna Valley* was painted the year after his first visit to Paris. The painting, as Cikovsky suggests, belongs to a very different sensibility and expressive intent than that of his Hudson River contemporaries. The picture's interpretation remains open, and it is impossible to read it "correctly." It is a singular and somewhat mysterious picture. It underlines the dangers of reading "intention," particularly when our attitudes to the machine and nature have suffered such radical alterations.

Though generally the artists did not look closely at the train, confining it to the middle and far distance, they quickly used it as a

moving platform from which to inspect the landscape. Judging from Dickens's *American Notes* (1842), the early conditions were far from perfect: "There is a great deal of jolting, a great deal of noise, a great deal of wall, not much window, a locomotive engine, a shriek, and a bell. The cars are like shabby omnibuses, but larger: holding thirty, forty, fifty people. The seats, instead of stretching from end to end, are placed crosswise. . . . In the center of the carriage there is usually a stove, fed with charcoal or anthracite coal; which is for the most part red-hot. It is insufferably close; and you see the hot air fluttering between yourself and any other object you may happen to look at, like the ghost of smoke. . . ."[43]

But whatever their feelings about the destruction of nature, the artists, writers, and photographers were readily seduced by the railroads offering excursions, such as the one on the Baltimore and Ohio in June 1858, which presented, in five days from Baltimore to Wheeling, an opportunity to collect picturesque views. A contemporary description noted: "Latterly, steam and the fine arts have scraped acquaintance. The real and the ideal have smoked pipes together. The iron horse and Pegasus have trotted side by side in double harness, puffing in unison, like a well-trained pair. What will be the result of this conjunction Heaven knows. We believe it marks the commencement of a new era in human progress. . . ."[44]

It was not uncommon during this period for artists to ride outside on the engine cab and from this precarious perch to sketch the passing countryside. Though some of the Hudson River men braved the discomforts of pre-railroad travel to the western reaches of the continent, as did the artists who accompanied the early expeditions and the Pacific Railroad Reports, the railroad made later trips by the same and other artists much more comfortable.

Bierstadt, of course, first traveled west with Lander's expedition in 1859; he did his 1863 trip with Ludlow partly by rail, at the railroad's expense,[45] and returned west by rail in 1871 and in the 1880's. Whittredge, having spent his youth in Ohio, went further west in 1866 by horseback, but traveled by railroad in 1870 and possibly in 1871. Kensett went west in 1854, partly by rail in 1857, and again by rail in 1868 and 1870. Sanford Gifford went by rail in 1870 with Kensett and Whittredge and again in 1874. Samuel Colman made his first trip west by rail in 1870, possibly again the following year, in 1886, 1888, and between 1898 and 1905.[46] Whitman, typically embracing the machine as part of his larger encompassment of world, went west by rail in 1879 and commented on "the distances joined like magic."[47] Like Tuckerman, earlier, he found zest in adventure, remarking on the "element of danger" which was still felt, even by those more insulated from landscape and Indians by the Iron Horse.

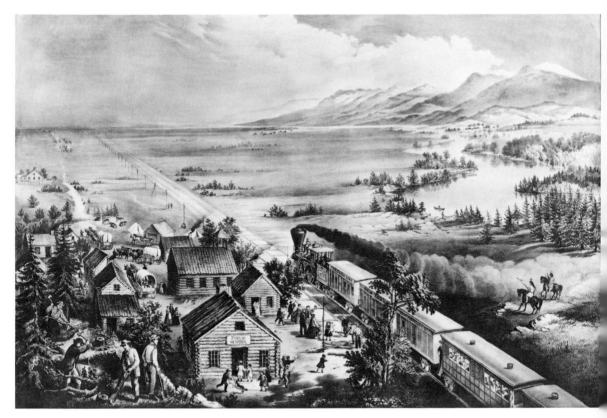

86. Currier and Ives, after Frances Flora Palmer, *Across the Continent:*
"Westward the Course of Empire Takes Its Way," 1868
Color lithograph, 17¾″ × 27″. The Thomas Gilcrease Institute of American History
and Art, Tulsa, Oklahoma

Some of that danger was recorded in paintings which dealt with
life on the frontier, such as Theodor Kauffman's *Railway Train At-*
tacked by Indians (1867; private collection). And the popular print-
makers, as we have said, took great delight in limning the locomotive,
giving it that visibility not generally found in the landscape paintings
(*Across the Continent: "Westward the Course of Empire Takes Its*
Way"; fig. 86). But the most exciting visual encounters with the rail-
road were those that took place through the mediation of yet another
machine—the camera. The photographer, having already accommo-
dated one machine within his artistic perspective, had much less diffi-
culty than the painters in accommodating still another.

Photography first entered the western terrains when the powerful
esthetic system that had sustained the vision of nature was at its apo-
gee in the mid 1860's. Through the seventies and eighties, while that

system was collapsing, the photographers roamed the western terri-
tories with remarkable results; their work sometimes triumphantly
sustained the conventions of the picturesque, at other times escaped
them, as extraordinary data pushed into their pictures with pragmatic
authority. So a major function of the artist was taken over by the pho-
tographer—the provider of authentic evidence. Armed with the ma-
chine, their work stamped with its imprimatur, the artist-photographers
confirmed the existence of the fantastic and of themselves as the agents
of its transfer. The truth of the photographic image is one of its most
durable conventions and that truth was accepted as an article of faith
by the photographers themselves and by their public.

As witnesses, their primary role was to document man's progress
into the wilderness. Here, the railroads that often hired them offered
the most plangent evidence. The laying down of the tracks forced an
intimate and incremental knowledge of the terrain; length by length,
the tracks surveyed the wilderness, progress also clocked by wooden
sleeper after sleeper laid across them. This grid-like ladder burrowed
through tunnels, cut through sidings, leaped across chasms, toiled up
gradients and slid triumphantly down. In the photographs, the tracks
documented the powers of civilization, their geometries projecting the
infinite resources of Mind.

By the time A. J. Russell recorded the historic *Driving of the Golden
Spike at Promontory, Utah,* on May 10, 1869 (fig. 87), which united
the Atlantic and Pacific coasts through the joining of the Union Pa-
cific and Central Pacific railroads, the landscape photographers had
amassed an impressive amount of evidence. They functioned either as
railroad employees like Russell and Gardner, who worked for the
Union Pacific, or initially as speculators, like Jackson, Muybridge,
and Watkins, who hoped to benefit from the public interest in the new
landscape. Some of the master photographers of the period—Jackson,
Watkins, O'Sullivan, Muybridge—ultimately became crucial members
of the big government surveys of the late 1860's and '70's. The results
of their efforts are now acknowledged as major contributions to the
visual arts in the nineteenth century.

Why has it taken so long to acknowledge this contribution? Perhaps
part of the answer resides in the nature of the medium itself. As I
have speculated elsewhere:

For those of us trained on paintings, the never-touched surface of the photo-
graph is elusively impersonal; its smooth tonality baffles our usual anxious
readings. The image has a factual lucidity that holds the surface. This instru-
ment [the camera], with its new "truth," in many ways fulfilled a mid-19th-
century injunction against "manner." Subject to the same proscriptions as
painting, narrowly bounded on the one side by manner and on the other by
the "merely mechanical," photography complied with the necessities of con-

temporary esthetics even as it transformed them. This transformation took place well within the context of contemporary nature attitudes.

In dealing with the raw landscape, the photographers often produced photographs that can be seen in terms of painterly conventions. The interchanges between Bierstadt, Watkins, and Muybridge, Jackson, Moran, and Gifford require a study in themselves. Watkins particularly resuscitated the Claudian sublime, by literally finding it. Again and again, however, in a dialectic now familiar to us, the photographers also pursue and represent silence, the iconography of which is equally familiar.[48]

But photography has also provided us with an unusual opportunity to study the railroad and its tracks—a closer view than the painters

87. A. J. Russell, *The Driving of the Golden Spike, Promontory, Utah, May 10, 1869*
Photograph. The Beinecke Rare Book and Manuscript Library, Yale University, New Haven, Connecticut

88. T. P. Rossiter, *Opening of the Wilderness*, c. 1846–50
Oil on canvas, 17¾" × 32½". M. and M. Karolik Collection, Museum of Fine Arts, Boston

generally allow us. In *Opening of the Wilderness* (fig. 88), T. P. Rossiter focuses on five engines at rest, their cowcatchers spread elegantly in front of them like fans, the plumes of smoke like those of cavalry chargers. It is a daring attempt by a painter to bring the powerful new giants into the pastoral clearing. To contemporary eyes, it must have incarnated the energy of progress itself: the new architecture of the round-house, the stumps testifying to fallen and consumed natural "monarchs." Such a picture must have been replete with the rhetoric of the "technological sublime." There is something Wagnerian about this armored grouping in the forest, more than a hint of an inevitable future purchased at an unknown price.

But such moments are rarely given to the painters, whose closer views generally confine themselves to variations on the theme of the pastoral watcher studying the distant train, as in Robert Havell, Jr.'s *Two Artists in a Landscape* (fig. 89). Here, the train moves laterally toward the left to what is apparently a waiting station, while a horse and cart point—in a too easily offered metaphor—in the opposite direction.

What a shock it is to come upon Jackson's photograph, *Cañon of*

179

the Rio Las Animas (Colorado; fig. 90), where we ourselves replace the pastoral watcher, our gaze now turned abruptly upwards to where the train, snaking through the rock, suggests the mineral identities of both. The point of view is rare in painting. We are conscious of being too close to the cliff above, of having to strain our gaze upward. We are, in fact, "in the picture," and aware of the struggle of the photographer to reach this site. The elevated train, in itself awesome, sends up mists of smoke that masquerade as natural atmosphere, partly consummating that fusion of the natural and the man-made suggested by rock and train.

More frequently, the photographs deal with the tracks. The tracks of course prompt fascinating speculations about the *actual* measurement of the landscape, as distinct from the conceptual biases of those who painted it. Such measurement in itself actualizes the painter's attempt at possessing the landscape. The tracks remind us of a whole culture's desire for certainty through measurement and statistics, illustrated by the figure of Thoreau measuring snow each morning at either side of the railroad tracks. By charting infinity, the tracks give it its finite end-point.

89. Robert Havell, Jr., *Two Artists in a Landscape*, c. 1850
Oil on canvas, 36″ × 50″. New York State Historical Association, Cooperstown

90. W. H. Jackson, *Cañon of the Rio Las Animas* (Colorado), c. 1880
Photograph. The Daniel Wolf Gallery, New York

That end-point often appeared on the horizon of the landscape photographs (Watkins's *Cape Horn, Oregon;* fig. 91). The tracks may or may not stand for Emerson's idea of "a railway journey in the direction of nature."[49] For the oblique perspectives into the American distance seem nothing so much as man-made, even art-like, as they mimic a mensurational perspective going back at least as far as Alberti. The horizontal railroad ties (Carbutt's *Westward the Monarch*) set up rhythmic progressions that function for the photographers as the planar "steps" had functioned for the luminist classicists. Yet no matter how classic the landscape in which they appear, they seem extranatural. The axe represented subtraction, and left behind the vestigial trace of action—the stump. The tracks are an addition, spanning the

spaces with shockingly regular geometry, stamping man's orderly control on the wilderness as much as if he had laid down a ruler. Yet that control is as double-edged as the axe. It accelerates time and telescopes distance; it relieves the danger and tediousness of protracted travel, making settlement easier. But it also carries within it, literally and figuratively, the germs of "culture."

Thus the scaling and location of the figure in relation to the landscape and track take on special meaning. In Russell's *Granite Cañon from the Water Tank* (fig. 92), the specks of figures are spatial coordinates and little else. The tracks, the result of the ant-like industry of these distant creatures, mark out a sublimely vast distance, demonstrating the role of communal Mind in dominating nature. One is not sure from this photograph, where space is the controlling factor, that

91. C. E. Watkins, *Cape Horn, Oregon,* 1868
Photograph. The Stanford University Libraries, Stanford, California

92. A. J. Russell, *Granite Cañon from the Water Tank,* c. 1868
Photograph. The Beinecke Rare Book and Manuscript Library, Yale University,
New Haven, Connecticut

the domination is fully effective. But the tracks hold their space more
firmly than the figures, which seem fragile enough to roll down the
inclines and be absorbed by the sliding stones. Man as part of nature's
processes here shares its organic fragility. But his product is less vul-
nerable. Its geometry courts absolute time.

In other photographs the figures assume rueful, ironic significance.
Sometimes isolated as a measurement, the figure in the landscape
often turns, for the first time, to the spectator, returning the camera's
gaze, its posture expressing awareness that it is no more than a unit of
measure, a stick to give scale, yet also aware that it is a living stick.
This slight self-consciousness inhabiting a unit of measure is enhanced
by its attraction to the lodestone of the camera, the universal donor
of consciousness to self. We recall the figures in the luminist land-
scapes, similarly situated by the artist for similar functions, but always
absorbed in the hush of their surroundings, unaware of the painter
whose slow process takes place far from where the figure sits or stands.

Often alone in the vast spaces where, as Whitman would have
it, even the "statistics are sublime," the figure beside the track (as
in Russell's *Malloy's Cut,* fig. 93) seems also caught between natural
and man-made forces. The track is an active agent of the transforma-

93. A. J. Russell, *Malloy's Cut, Near Sherman* (Wyoming), c. 1868
Photograph. The Beinecke Rare Book and Manuscript Library, Yale University,
New Haven, Connecticut

tion of nature into culture. Such figures often seem contemplative. They join with others in photographs in which the figure is set simply in natural surroundings. The solitary meditative figure is the literal trace of man's presence in nature, and a primary unit of nineteenth-century iconography. We would do well, then, to consider this figure as it presents itself in the paintings and photographs of the period.

Figure

Rarely a major protagonist in American landscape, the figure is more often engulfed in space, and sometimes absent. In Europe the figure in the landscape bulks larger than in America. One hesitates to stress this, because the difference (which also varies from country to country in Europe) is small. Yet even minute differences register something about the cultural attitudes to man and nature in Europe and America.

In some of Friedrich's landscapes, as in some of Lane's, the figure, its back to the spectator, contemplates the landscape. Occasionally the scale of the figure is very close to that of American works (compare Friedrich's sepia drawing *Landscape at Sunrise,* fig. 94, or his *Seashore*

with Fisherman [Kunsthistorisches Museum, Vienna] and Lane's *Owl's Head, Penobscot Bay,* fig. 95). There are provocative affinities between these horizontal compositions with figures on a darkened ground contemplating distances filled with light (Lane) or mist (Friedrich). The figures are scaled to be at one with nature, hinting at an ideal harmony.

The turned back—a major nineteenth-century motif—can, as in these examples, act as a surrogate inviting the spectator into the picture. It can also shut him out. Sometimes in Friedrich's work the figure enlarges to a point where it begins to occlude nature. Rather than inviting passage into deep space, the figure begins to seal it off. Man becomes far more important than nature. In Friedrich's *Wanderer over the Sea of Mist* (fig. 96), the change in scale switches contemplation into alienation, so that the mist pouring through the mountain passes below now signifies an abyss of separation.

In America, the figure rarely reaches the scale where the individual psyche can displace the transcendental void. The individual remains absorbed in and by nature. Even when the figures are larger than usual, as in *Kindred Spirits* (see fig. 9), Durand's posthumous tribute to Cole, showing Cole and the poet Bryant contemplating nature, the spectator is not excluded. He becomes a third party to their discourse. The figures of Cole and Bryant are not as large—relative to nature—as those in Friedrich's *Two Men Contemplating the Moon* (fig. 97). The Americans contemplate a sublime gorge, filled with light, each detail of rock and tree carefully limned—the perfect exemplar of the American negotiation between the real and the ideal. In the more overtly romantic Friedrich, vestiges of pictorial anthropomorphism animate the roots and branches of the tree. The ambience is less "real" on many levels; details are more generalized, the painting flatter, less spatially dense, and more abstract in execution.

Though both pictures are probably specific portraits, Friedrich's figures are identifiable only in the physiognomies of their backs. The protagonists in the Durand are fully recognizable. But their individuality does not separate them from nature. Friedrich's onlookers, on the other hand, gaze at the moon as if from a box in the theater. This separation approaches alienation again, and also belies easy assumptions about the "romanticism" of such a picture—that man and nature are "one." Worringer once commented that the northern temperament annihilates the individual through mysticism at the same moment that it claims its individuality.[50] Both elements co-exist in Friedrich's oeuvre. There are instances when—as in many American luminist works—Friedrich seems to contain man and nature in one transcendental arc. But he also frequently points toward that other direction which emphasizes rather than erases the self, perhaps a pre-

94. Caspar David Friedrich, *Landscape at Sunrise,* undated
Sepia drawing, 4$\frac{7}{10}$″ × 7″. Nationale Forschungs- und Gedenkstätten der klassischen
deutschen Literatur in Weimar

95. Fitz Hugh Lane, *Owl's Head, Penobscot Bay, Maine,* 1862
Oil on canvas, 16″ × 26″. M. and M. Karolik Collection, Museum of Fine Arts,
Boston

96. Caspar David Friedrich, *Wanderer over the Sea of Mist,* c. 1818
Oil on canvas, 38³⁄₁₀″ × 29¹⁄₁₀″. Hamburger Kunsthalle, Germany

lude to the alienations—from nature and self—of the expressionist psyche.

The famous American individualism rarely extended itself during this period into the impractical realms of alienation. As usual, Emerson could be depended on to soothe the disruptions of individuality with a generalized idea: "It seems to be true that the more exclusively idiosyncratic a man is, the more general and infinite he is, which, though it may not be a very intelligible expression, means, I hope, something intelligible."[51] This is another facet of the age's ingenuity

97. Caspar David Friedrich, *Two Men Contemplating the Moon*, c. 1819
Oil on canvas, 13⅗″ × 17⅕″. Gemäldegalerie Neue Meister, Dresden

in keeping traffic moving positively between the real and the ideal;
Cole and Bryant are in dialogue not only with each other as kindred
spirits, but with each other *through* the equally kindred spirit of na-
ture itself. No picture states more clearly the ideal consonance be-
tween man and nature. With the increase in alienation at the end of
the century, both nature and the individual psyche, now out of gear
with each other and themselves, mutate into disrupted fragments.

The specificity of Durand's nature conversation piece is, however,
an exception in American landscape painting; usually the figure is
only a discreet reflex of a larger idea. On the rare occasions when that
figure appears, its pedigree refers readily back to the tiny figure,

dwarfed by nature, respectfully inhabiting the engines of the eighteenth-century sublime and picturesque. (Beyond this figure lie the pastoral acres of Claude and occasionally Poussin; beside these, a tradition of the landscape occupied by genre figures [Le Nain]. Further back are the crowds of Altdorfer and Bruegel and the great example of Giorgione, where figures and landscape seem exhaled in a single inspired breath. All these, and hosts of others, can be read as signifying the terms by which an age defines its tenancy in the world, and all are direct or indirect ancestors of the figures that inhabit the American wilderness.)

But it is the small figure ubiquitous in European—particularly English—painting of the eighteenth century that emigrates into American painting in the early decades of the nineteenth century. There it maintains its size and scale until after one of the great disruptions of the national psyche—the Civil War, which, coinciding with the advent of Darwinian science, the spread of technology, and a new internationalism, altered irrevocably the conditions sustaining that figure's dialectical relationship with nature.

We can "read" the American landscape first in terms of the presence or absence of the figure. Its absence in American landscape has a more loaded meaning than in Europe. Bierstadt's scene of uninhabited nature, i.e., *Lander's Peak* (see fig. 3), penetrates what Ludlow called nature's "sacred closet." Man has not yet entered Eden. Sublimity belongs only to God. We know that the idea of Creation—of a primal and untouched nature—had an immense resonance for the American psyche. The uninhabited landscape amplifies this thought. The spectator, with no surrogate to license his entry into the picture, is all eyes, and the virgin space suggests that looking is a spiritual act composed of wonder and purification. (One type of figure can be introduced into this landscape without disrupting this—the Indian, who, as a function of nature, symbolizes its unexplored state. The Indians in Bierstadt's landscapes represent nature, not culture. Like the forests, the Indian exists in a state of nature, before he is cut down. His tenancy as a natural citizen is premised on his inseparability from nature. When separated, he dies.)

In Church's large tropical paintings, like *Heart of the Andes* (see fig. 17), the figures are hidden, like animalcules, in recesses in the foreground or middle distance—self-absorbed, conscious of the immediate surroundings which we see above and beyond. The empathetic observer, isolating them with opera glasses or rolled paper, could for a moment gain a distant intimacy with their tasks.

Though enveloped by the theatrical drama, these figures never actually drown in it. Church sets up paths for them to walk on, crosses for them to worship at. Somehow undaunted by the sublime

terribilità, they inch along the paths of still-primeval nature, indeed walk all over it. As they explore within the picture, they encounter nature as "spectacle" in much the same way that we ourselves are called to witness Church's "exalted nature." When set apart from the natural drama, as in *Rainy Season in the Tropics* (see fig. 19; color), where tiny figures traverse a darkened path in the lower right corner, they are not alienated from it, as Friedrich's separated figures so frequently are. Their active presence reinforces the anthropomorphic aspect of Church's transcendentalism. By not fully surrendering their humanity to nature's dominion, they are more divisible from the natural furniture than are the luminist figures, which often become a function of matter.

In a less dramatic way, many of the Hudson River men, including Church and Bierstadt on occasion, established the small figure in the landscape as a comfortable pastoral inhabitant. The Garden is already cultivated in Church's early *New England Scenery* (1851; George W. V. Smith Museum, Springfield, Mass.), as the figure follows a covered wagon across a foreground bridge. Two years earlier, in a similar composition (*Haying near New Haven;* fig. 98), the foreground is occupied by a hayfield, in which farmers perform their appropriate tasks. One has a sense of specific roles available within the larger natural dramas these figures witness or are indifferent to. Busy or at rest, assuming the postures of the mundane and everyday, the figures in these early works sometimes meet in small groups of a rudimentary social nature. More than in Church's tropical scenes, these figures (set apart formally and symbolically by planar distinctions) maintain a distance from nature: this allows for a more purposeful activity within nature, diminishing transcendental unities in favor of what we might call a middle phase of reconciliation between man and nature. The Garden is already acculturated to the point where it presents fewer problems to its human inhabitants, who stroll casually through the landscape or work with unconscious absorption at daily tasks, as in Durand's *Haying* (Vose Gallery, Boston) or Cropsey's *American Harvesting* (fig. 99). Like their Claudian models, the pastoral pictures, whether by Church, Bierstadt, Cole, Cropsey, or Durand, develop this facility of relationship between figure and landscape. Thomas Doughty was perhaps the earliest to set this tone, though he maintained the earlier picturesque scale.

Yet in Doughty also we encounter the thematic motif of the figure in the landscape that I find most tantalizing: the single figure, engaged in some sort of meditative dialogue with nature, "whose back makes us conscious of our own."[52] In paintings like *Romantic Landscape with a Temple* (fig. 100) or *In Nature's Wonderland* (The Detroit Institute of Arts), this figure—though often dwarfed by nature—

98. Frederic Edwin Church, *Haying Near New Haven*, 1849
Oil on canvas, 26½″ × 40″. The New Britain Museum of American Art, New
Britain, Connecticut

firmly holds his place. We find this figure in the nature paintings of
many Hudson River men (throughout Doughty's work, in Durand's
Early Morning at Cold Spring, fig. 101, occasionally in Cole): yet it is
a more frequent motif in the art of luminist painters such as Lane and
Heade, fortifying the contemplative silence that characterizes the
works themselves.

Like their Hudson River colleagues, Lane and Heade sometimes
put their figures to work—haying, setting out to sea, fixing boats. Yet
the relationship of these figures to a nature which is neither sublimely
awesome nor bovinely pastoral is different. The paintings are often
scaled down to the small figure. The solitary figure, especially, oper-
ates as a spatial coordinate, often becoming as much a part of nature
as the trees and rocks, which join with it in a harmonious unity de-
voted to maintaining geometric and Newtonian absolutes. This formal

unity between figure and elemental nature corresponds to a philosophical unity—more often established here than in other landscape paintings of the period. Man here is "part or parcel of God" and, correlatively, of His nature.

Often such figures are far away, totally absorbed, beyond hailing distance. The middle-distance figure in Heade's *Stranded Boat* (fig. 102) does not move or take action; it relates solely to the general mood of stillness and absorption. The atmospheric clarity in most luminist paintings suggests that sounds would carry, as they do in real landscape. Yet the figures in luminist paintings do not make a sound. Rather, they augment the silence. From Church's distant figures come the tinkle of mule bells, far cries, and shouts. The luminist figure, consonant with the quietistic mood, is unconscious of itself, and of us. It meditates inwardly, and the landscape meditates through it. It seems a function of a single idea—embracing water, rock, figure, twig,

99. Jasper F. Cropsey, *American Harvesting*, 1851
Oil on canvas, 35½″ × 52¾″. Indiana University Art Museum, Bloomington, gift of Mrs. Nicholas Noyes

100. Thomas Doughty, *Romantic Landscape with a Temple,* 1834
Oil on panel, 15½″ × 23″. Museum of Fine Arts, Boston, bequest of Maxim Karolik

etc., with that single "bell jar" mood. In such primary luminist images as *Owl's Head, Penobscot Bay* (see fig. 95), we are indeed aware of our own backs, watching ourselves through a surrogate absorbed in the transcendental vision.

Such figures appear again, as suggested earlier, in the western landscape photographs of the 1870's, though from somewhat different needs and premises. The photographs, in fact, rehearse these two options: the tiny figure dwarfed by awe as the last outpost of sublimity is opened up, or conversely, standing motionless against a sheet of light, of water or sky, in a way that echoes luminist painting.

The photographs make more frequent use of the silhouette technique to focus on man's presence. We may speculate whether this is related to the actuality of the photographic situation. Whatever the reason, the photographer has less control over reality than his painter colleagues, who can adjust it according to their ideal needs. Man is

101. Asher Brown Durand, *Early Morning at Cold Spring, N.Y.*, 1850
Oil on canvas, 47½″ × 59″. Montclair Art Museum, Montclair, New Jersey

there, in nature, and his thereness, sometimes more obvious in the photographs than in the paintings, is in the nature of irrefutable evidence. On occasion, as in Russell's *Skull Rock* (fig. 103), the small figures in the foreground melt deliberately into the stones, while allowing their companion to pose at the pinnacle of the rock like a pyramid builder who has reached the top. As in Jackson's photograph of the train snaking through the mountains, there is some desire for chameleon-like unobtrusiveness.

More often, however, we are conscious of these figures. The contemplative figure is a striking motif, engrossed in luminist quietude as

194

102. Martin Johnson Heade, *The Stranded Boat*, 1863
Oil on canvas, 22¾″ × 36½″. M. and M. Karolik Collection, Museum of Fine Arts, Boston

103. A. J. Russell, *Skull Rock, Dale Creek Cañon*, c. 1868
Photograph. Yale University Art Library, New Haven, Connecticut

104. W. H. Jackson, *View on the Sweetwater,* 1870
Photograph. The Academy of Natural Sciences of Philadelphia

in Jackson's *View on the Sweetwater* (fig. 104). As in luminism, neither man nor nature assumes dominance. If such figures are contemplating nature, what may we assume their contemplation means?

The contemplation of nature in the American nineteenth century requires a volume of its own. To contemplate is "to consider with continued attention; meditate on; study." Its synonyms are "behold, observe, ponder." Meditation on nature in the nineteenth century was a recognized avenue to the center of being. The very act of observing nature was virtuous, because nature conveyed a "thought which . . . is good."[53] "Looking" became an act of devotion. The morally correct beholder partook not only of Nature's goodness but of Deity. Emerson said: "The ruin or the blank that we see when we look at nature, is in our own eye. The axis of vision is not coincident with the axis of things, and so they appear not transparent but opaque. The reason why the world lacks unity, and lies broken and in heaps, is because man is disunited with himself. He cannot be a naturalist until he satisfies all the demands of the spirit. Love is as much its demand as perception. Indeed, neither can be perfect without the other. In the uttermost meaning of the words, thought is devout and devotion is thought. . . ." Emerson further tried to define the correct

moral posture: "There are innocent men who worship God after the tradition of their fathers, but their sense of duty has not yet extended to the use of all their faculties. And there are patient naturalists, but they freeze their subject under the wintry light of the understanding. Is not prayer also a study of truth—a sally of the soul into the unfound infinite?"[54]

The Emersonian unity of man and nature involved also the recognition of the unity of mind, God, and nature, and their relation to history:

Let it suffice that in the light of these two facts, namely that the mind is One, and that nature is its correlative, history is to be read and written.

Thus in all ways does the soul concentrate and reproduce its treasures for each pupil. He too shall pass through the whole cycle of experience. He shall collect into a focus the rays of nature. History no longer shall be a dull book. It shall walk incarnate in every just and wise man. . . . what does history yet record of the metaphysical annals of man? What light does it shed on those mysteries which we hide under the names Death and Immortality? Yet every history should be written in a wisdom which divined the range of our affinities and looked at facts as symbols.[55]

Thus, for Emerson, the individual could thrust mind into nature and become history incarnate. Emerson premised total unity: "the unity in variety—which meets us everywhere. All the endless variety of things make an identical impression. . . . A leaf, a drop, a crystal, a moment of time, is related to the whole and partakes of the perfection of the whole. Each particle is a microcosm, and faithfully renders the likeness of the world."[56]

The Emersonian unity is perhaps best epitomized by the famous transparent eyeball metaphor.[57] Meditation, defined here as musing, pondering, solemnly reflecting on sacred matters as a devotional act, was perhaps the best route to this mystical surrender of self. Thoreau felt it too:

If with closed ears and eyes I consult consciousness for a moment, immediately are all walls and barriers dissipated, earth rolls from under me, and I float, by the impetus derived from the earth and the system, a subjective, heavily laden thought in the midst of an unknown and infinite sea, or else heave and swell like a vast ocean of thought, without rock or headland, where are all riddles solved, all straight lines making their two ends to meet, eternity and space gambolling familiarly through my depths. I am from the beginning, knowing no end, no aim. No sun illumines me, for I dissolve all lesser lights in my own intenser and steadier light. I am a restful kernel in the magazine of the universe.[58]

This meditative surrender of self is most often conveyed by the luminist paintings in which, indeed, all straight lines evoke an eternity of which the figure, itself the embodiment of thought or Mind, partakes. In the frequent absence of such figures, we, the viewers, assume this role.

Yet the figures, when present, demand to be "read" in the light of contemporary nature attitudes. When, for example, we encounter the small figures walking through the sublime South American vistas of Church, we are reminded of Whitman's idea of "Nature, true Nature, and the true idea of Nature, long absent," which "must, above all, become fully restored . . . the whole orb, with its geologic history, the cosmos, carrying fire and snow, that rolls through the illimitable areas, light as a feather, though weighing billions of tons."[59] Such figures not only reinforce attitudes to science, Deity, cosmology, and morality. They are themselves insertions of culture into nature. We might see them, as we have, as part of nature, and even, within the meditative framework of transcendentalism, as involved in a mystical surrender of self to nature as God. But they can also be seen at times as intruders in the Garden of Creation, man bringing with him into "undefiled" nature, the structure designed for his survival.

There is here some of the moral blindness already signaled by the iconography of the stump and locomotive. It has to do with the optimism of what we may call the age of Emerson. All things of earth—man-made, nature-derived, or natural—are part of God and partake of His essential goodness. There is no evil. Where has it gone? To find it, we have to move to the literature of the era, but even here there are paradoxes. Those who try with difficulty to relate Melville to this moment might do better to recognize his essential anachronism. Melville himself gave us the clue in writing of Hawthorne: "Certain it is . . . that this great power of blackness in him derives its force from its appeals to that Calvinistic sense of Innate Depravity and Original Sin, from whose visitations, in some shape or other, no deeply thinking mind is always and wholly free."[60] Melville can be placed earlier than his age, or later, but his attitude to sin and evil makes him hard to fix in mid-nineteenth-century America, just as Poe and even to some extent Hawthorne are. They relate to one another, and to certain aspects of American and European thought. But the glare of mid-century American optimism throws their shadows in odd directions. If this optimism begins to seem too undiluted to be totally true, it still had its undaunted celebrators. Poe, Hawthorne, and Melville offered correctives to it within the literature of their time. As I have said, they had few parallels in contemporary American painting. Melville's sensibility in *Moby Dick* more readily meets our comments on Friedrich than it does that of any American painter. Melville wrote of the young Platonist on the masthead who has been "lulled" by the sea

into such an opium-like listlessness of vacant, unconscious reverie . . . that at last he loses his identity; takes the mystic ocean at his feet for the visible image of that deep, blue, bottomless soul, pervading mankind and nature. . . . In this enchanted mood, thy spirit ebbs away to whence it came; be-

comes diffused through time and space; like Crammer's sprinkled Pantheistic ashes, forming at last a part of every shore the round globe over.

There is no life in thee, now, except that rocking life imparted by a gently rolling ship; by her, borrowed from the sea; by the sea, from the inscrutable tides of God. But while this sleep, this dream is on ye, move your foot or hand an inch; slip your hold at all; and your identity comes back in horror. Over Descartian vortices you hover. And perhaps, at mid-day, in the fairest weather, with one half-throttled shriek you drop through that transparent air into the summer sea, no more to rise for ever. Heed it well, ye Pantheists![61]

This fear is compounded of a heavier dose of realism than transcendentalism allowed. The selfless dream could turn into the pragmatic nightmare of individual identity. The deadly danger of nature also is recognized in a way largely foreign to American painters. In a perceptive essay on American literary history, Stanley Bank has commented: "The total irony of Melville's sadly neglected *Pierre* is that in America's seeming innocence there is as much crime and depravity as could be found in any world, that American innocence lies in not recognizing evil rather than in not participating in it."[62]

Nature's wonder, nature's majesty, nature's sublime power, nature's embodiment of Deity were contemplated by the small meditating figures in these landscapes without much *recognition* either of nature's negative aspects or of the destructive potential of the "culture" symbolized by the action of the axe, the locomotive, and the figure of man himself. For the most part, these unobtrusive symbols are inserted into the landscape paintings with a discretion that suggests an unwillingness to recognize their hazardous implications. Whitman, perhaps the latest adherent of this attitude, best personifies it in his person and art:

> The axe leaps! . . .
> The shapes arise!
> Shapes of the using of axes anyhow, and the users
> and all that neighbors them, . . .
> Shapes of the friends and home-givers of the whole earth,
> Shapes bracing the earth, and braced with the whole earth.[63]

Whitman could see "over my own continent the Pacific Railroad surmounting every barrier"[64] and discovered that "Man, so diminutive, dilates beyond the sensible universe, competes with, outcopes space and time, meditating even one great idea."[65] The poet, says Whitman, "shall go directly to the creation. . . . Nothing can jar him . . . suffering and darkness cannot—death and fear cannot. . . . The sea is not surer of the shore or the shore of the sea than he is of the fruition of his love and of all perfection and beauty."[66] For Whitman, "the question of Nature, largely considered, involves the questions of the aesthetic, the emotional, and the religious—and involves happiness."[67]

That happiness was implicit in the nature paintings of the nine-

teenth century, recording a vulnerable present, offering images of a past we presently regret, as axe, train, and man only hint at the future to come. The outlines of that future were blurred by optimism and submerged in the unconscious assumptions of a chosen people. The responsibilities of the artist's estate included sharing generously with the less enlightened and gifted the great denominator of happiness—America's nature.

PART FOUR

IX
Arcady Revisited:
Americans in Italy

After he had returned to Rome for the third time, in December 1856, William Wetmore Story wrote: "To whatever the hand of man builds, the hand of Time adds a grace, and nothing is so prosaic as the rawly new" (fig. 105).[1] Later his biographer, Henry James, wondered: "How can one hope to find the right word for the sense of rest and leisure that must in olden summers have awaited here the consenting victims of Italy, among ancient things all made sweet by their age, and with Nature helping Time very much as a tender, unwearied, ingenious sister waits upon a brother, heavy of limb and dim of sight, who sits with his back against a sun-warmed wall."[2]

In *William Wetmore Story and His Friends* James found the proper words to retrieve for the reader the sense of "irrecoverable presences and aspects, the conscious, shiny, mocking void, sad somehow with excess of serenity"[3] that concerned him. For James himself had breathed "the golden air" of Italy soon enough after Story to share and understand his experience. "There was," he wrote, "half a century ago, in the American world in general, much less to give up, for 'Europe,' than there is today, but, such as it was, Story gave it up all. . . . And I may add that when I speak of the ingenuous precursor as giving up, I so describe in him but the personal act of absence. That was often compatible in him, after all, with the absolutely undiminished possession of the American consciousness. This property he carried about with him as the Mohammedan pilgrim carries his carpet for prayer, and the carpet, as I may say, was spread wherever the camp was pitched."[4]

The American pilgrim, it seems, rarely left his American consciousness behind him. Yet he was often willing to become Italy's "consenting victim." What was the nature of this seduction, and why, around the mid-century, did hundreds of American artists invite it? A seduction implies love, romance, passion—all words used by the nineteenth-century artists and writers who succumbed to the charms of Italy. Denis de Rougemont has noted that passion "means suffering,

105. John Rollin Tilton, *The Campagna*, 1862
Oil on canvas, 22½″ × 36¼″. Museum of Fine Arts, Boston, bequest of Catharine
A. Barstow

something undergone, the mastery of fate over a free and responsible person."[5] He also observes that "European romanticism may be compared to a man for whom sufferings, and especially the sufferings of love, are a privileged mode of understanding."[6]

The artists' love affair with Italy had this need for an understanding not possible in the raw New World Story had found prosaic. It was not so much that Italy was more beautiful than America, but that it was older, a property not generally considered to enhance seductiveness. But age, when coupled with cultivation, can be enticing. Italy was, in fact, so replete with the wisdom of the ages that it was removed from time. Time, in Italy, must have seemed universal and mythic. After a sufficient number of histories, after Etruria, ancient Rome, the Middle Ages, the Renaissance, and the Baroque, time underwent a curious compression which was also an infinite extension. The present was so diminished in importance that it left only the past and the future, or the past as future.

Thus, Charles Sumner wrote to Story in 1860: "I wish that I were there. I should like to feast my eyes on an Italian landscape, with glimpses at Italian art, and to feel that I was in Italy. But life is real, life is earnest—does not Longfellow say so?—and I have hard work here which I mean to do."[7]

One wonders how many of the artists made this distinction between real life—American life—and Italian life. At the Capitoline Museum,

Hawthorne, glancing out the window of the gallery containing the *Faun after Praxiteles*, noted "a vague sense of ponderous remembrances; a perception of such weight and density in a by-gone life, of which this spot was the centre, that the present moment is pressed down or crowded out, and our individual affairs and interests are but half as real here as elsewhere. . . . Side by side with the massiveness of the Roman Past, all matters that we handle or dream of nowadays look evanescent and visionary alike."[8]

By these standards, Italian life, as experienced by the American, was tantamount to a release from the pressures of life. In an atmosphere of golden reverie, the spirit could move freely, mortality could be both indulged and relieved by sentiment, and urgent social and political matters subsumed in a sense of human perfectibility once accomplished and now lost, in turn setting those pleasant esthetic emotions reverberating through the ancient world.

De Rougemont has observed of courtly love, "Whatever turns into a reality is no longer love."[9] So Italy had to remain either a reality made dream or a dream made real. In either case, as long as the dream aspect endured the participant would breathe the "golden air" with unique intoxication. "No Rome of reality was concerned in our experience . . . ," wrote James; "the whole thing was a rare state of the imagination, dosed and drugged, as I have already indicated, by the effectual Borgia cup, for the taste of which the simplest as well as the subtlest had a palate."[10]

The soul of this dream was art. Thus James continued: "Nothing, verily, used to strike us more than that people of whom, as we said, we wouldn't have expected it, people who had never before shown knowledge, taste, or sensibility, had here quite knocked under. They haunted Vatican halls and Palatine gardens; they were detached and passive on the Pincian; they were silent in strange places; the habit of St. Peter's they clung to as to a vice; the impression of the Campagna they stopped short in attempting to utter."[11]

For Italy itself was a museum of the past. One did not have to visit the galleries of the Uffizi or the Vatican. Everywhere—whether walking past the Florentine palazzi or driving on the Roman Campagna—one was inundated with art. The American went from a situation in which art was the exception to one in which it was commonplace. As James put it, in the words of Mrs. Hudson, Roderick's mother: " 'To think of art being out there in the streets!' "[12] Referring elsewhere to the "incomparable *entertainment* of Rome," James observed that "almost everything alike, manners, customs, practices, processes, states of feeling, no less than objects, treasures, relics, ruins, partook of the special museum-quality."[13] Whereas the pathetic American expatriate artist in James's "Madonna of the Future" states:

"We're the disinherited of Art. We're condemned to be superficial! We're excluded from the magic circle! The soil of American perception is a poor little barren artificial deposit! . . . An American, to excel, has just ten times as much to learn as a European! . . . We lack the deeper sense! We have neither taste nor tact nor force! How *should* we have them? Our crude and garish climate, our silent past, our deafening present, the constant pressure about us of unlovely conditions, are as void of all that nourishes and prompts and inspires the artist as my sad heart is void of bitterness in saying so! We poor aspirants must live in perpetual exile."[14]

Though James's hero responds, " 'You seem fairly at home in exile . . . and Florence seems to me a very easy Siberia,' "[15] the point is well made. One could argue certain artistic benefits on both sides of the Atlantic, as when Bryant cautioned Cole, departing for Europe, to keep that "wilder image bright." But James put it well when he wrote of the "state of being of the American who has bitten deep into the apple . . . of 'Europe' and then has been obliged to take his lips from the fruit. . . . The apple of 'America' is a totally different apple, which, however firm and round and ruddy, is not to be . . . negotiated, as the newspapers say, by the same set of teeth."[16]

The apple of Italy was surely, at that moment, more gently yielding to the tooth. American nature, particularly the ancient unspoiled forests, could offer accumulated time. But it was not a time mellowed and ennobled by association. As Cole had noted: "He who stands on Mont Albano and looks down on ancient Rome, has his mind peopled with the gigantic associations of the storied past; but he who stands on the mounds of the West, the most venerable remains of American antiquity, *may* experience the emotion of the sublime, but it is the sublimity of a shoreless ocean un-islanded by the recorded deeds of man."[17]

Noble phrases it acutely: "The great difference between Italian scenery and all other, with which he was acquainted, lay, with Cole, less in its material than in its moral and historic elements. Hitherto he had walked with nature in her maidenhood, her fair proportions veiled in virgin robes, affianced indeed to human associations, but unpolluted, unwasted by human passion. But now he was in converse with her, after long centuries of marriage with man."[18]

In some ways, cultivated antiquity was preferable to natural antiquity. For cultivated antiquity could offer the added benefit of example. Italy was the *didactic* museum of the past. James Jackson Jarves, disturbed by the familiar sight of American tourists in Santa Maria della Salute racing by the ceiling paintings, "whose sole reminiscences of European travel are the number and not the quality of sights," tried to remind Americans in 1855:

Europe is a storehouse of Art, but its value and lessons are lost in a great measure upon the nations that gave it birth. Still those silent voices speak. Out of old churches, mouldering tombs, time-honored galleries, there go forth eternal principles of truth, if rightly studied able to guide the taste and warm the heart of young America, and urge her on in the race of renown. . . . I . . . would press home to the heart of every American who goes abroad, the necessity, if he would do his duty to his own country, of reading and interpreting to his countrymen, so far as in him lies, these sacred writings on the wall.[19]

As Gombrich has stressed, art comes mainly from art. In Italy, the osmotic process was supremely efficient, and art could be absorbed along with the "golden air." The taste for ancient ruins and statuary, the clear identification by Americans with the imperial ambition that still marks Rome, are easily understandable. Nor does one have to wonder too long why the Americans were intrigued by such artists as Guido and Guercino. Guido especially, to judge from the paintings which still hang in the Palazzo Corsini, offered a suitable blend of bathos and sentiment, quite in keeping with some of the more lurid nineteenth-century American examples, which generally transferred the religious to a genre iconography. It seems quite clear why the famous portrait of Beatrice Cenci which hung in the Palazzo Barberini below Story's apartments meant so much to them (fig. 106)—though the popularity of this painting led Story to protest: "Pictures and statues have been staled by copy and description, until everything is stereotyped, from the Dying Gladiator, with his 'young barbarians all at play,' and all that, down to the Beatrice Cenci, the Madame Tonson of the Shops, that haunts one everywhere with her white turban and red eyes."[20]

Yet for Hawthorne, in 1858, Guido's portrait of the "Madame Tonson of the Shops" maintained its glory: "Its spell is undefinable—and the painter has wrought it in a way more like magic than anything else. . . . It is the most profoundly wrought picture in the world; no artist did it, nor could do it again; Guido may have held the brush, but he painted better than he knew. I wish, however, it were possible for some spectator, of deep sensibility, to see the picture without knowing anything of its subject or history; for, no doubt, we bring all our knowledge of the Cenci tragedy to the interpretation of it."[21]

Hawthorne could have read in the 1858 edition of Murray's *Handbook of Rome and Its Environs* that, "according to the tradition, it was taken on the night before her execution; other accounts state that it was painted by Guido from memory after he had seen her on the scaffold."[22] Today, confronting the painting at eye level in the Palazzo Corsini, the spectator can still find a haunting vulnerability in the

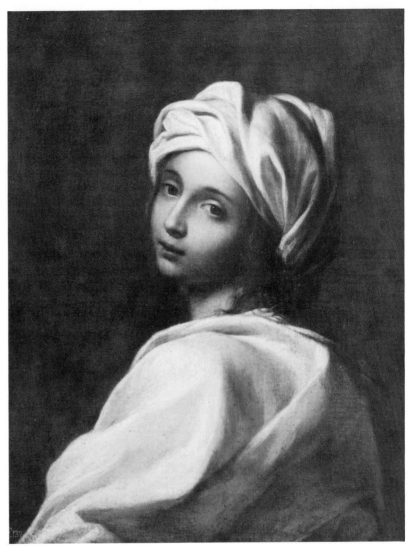

106. Guido Reni(?), *"Beatrice Cenci"*
Oil on canvas, 25⅕″ × 19½″. Galleria Nazionale d'Arte antica, Palazzo Corsini, Rome

child-like mouth and a pained innocence in the eyes. Even in a less sentimental age, we cannot escape the association. And what, in fact, would have remained for the nineteenth century not only of Guido's portrait, but of Italy, without association?

The nostalgic and moral overtones of association permeating the present enabled the nineteenth-century artists to see "the dirt of Rome" as "color"[23] and caused them to transform a world of "beggars, pickpockets, ancient temples and broken monuments, and clothes

hanging to dry about them" (Hawthorne)[24] into "the Italy we dreamed of; not the Italy of fleas, couriers, mendicants and postilions, but of romance, poetry and passion" (Story).[25]

Yet it was not enough for Italy to be transformed into a land of romance, poetry, and passion. In one of the most popular travel books of the period, George Stillman Hillard cautioned his readers: "As Rome cannot be comprehended without previous preparation, so it cannot be felt without a certain congeniality of temperament. Something of the imaginative principle—the power of going out of one's self and forgetting the actual in the ideal, and the present in the past—the capacity to sympathize with the dreamer, if not to dream—a willingness to be acted upon, and not to act—these must be wrought into the being of him, who would catch all the inspiration of the place. . . ."[26]

The artists themselves had to become part of the dream, to live what was in effect an esthetic life-style, closed to them under what Story had called "the bluer, but harder, more metallic American sky." Under the "vast, tender, and delicate" Italian sky, "looking down over the mysterious Campagna and listening to the continuous plash of fountains and the song of nightingales, you feel Italy, the Italy of Romeo and Juliet."[27]

Constant contact with cultivated antiquity posited all possible contrasts to the raw antiquity of the American wilderness. Nature was not an element to confront with awe in its new and primitive state, but a familiar old friend, drenched in poetry, footprinted by the great civilizations (fig. 107). To become part of that cultivation was to become, in a sense, a work of art.

Thus, there was an art-like convention to the frequent rituals which punctuated a typical day in Rome, whether these were the careful round of visits to the Vatican, the Borghese, or the Palazzo Barberini, or the drives on the Campagna. As James noted, "for rides . . . drives, walks, excursions of whatever sort, feasts *al fresco,* pictures *ad infinitum,* archaeology lively or severe" the Campagna offered "an education of the taste, a revelation of new sources both of solitary and of social joy" satisfying the "sense" and the "soul."[28]

And art-like conventions attached themselves to modes of seeing and experiencing. Washington Irving observed:

There is a poetic charm . . . that diffuses itself over our ideas in considering this part of the globe. We regard everything with an enthusiastic eye—thru a romantic medium that gives an illusive tinge to every object. 'Tis like beholding a delightful landscape from an eminence, in a beautiful sunset. A delicious mistiness is spread over the scene that softens the harshness of particular objects—prevents our examining their forms too distinctly—a glow is thrown over the whole that by blending and softening and enriching—gives the landscape a mellowness—a sweetness—a loveliness of coloring—not absolutely its

107. Thomas H. Hotchkiss, *Italian Landscape,* undated
Oil on canvas, 8½″ × 13½″. Private collection

own, but derived in a great measure from the illusive veil with which it is oerspread.[29]

The enthusiastic eye, the romantic medium, was surely responsible for the "coloring" that Italy assumed, transforming even the meals of "macaroni, fried fish, Bologna sausage and stufatino"[30] to which the poorer artists were condemned into the food of the gods. More appetizing fare, further supplemented by rich Italian wine, accompanied Harriet Hosmer and the Brownings on the picnics on the Campagna that she so enjoyed, and Hosmer's passion for Rome moved her more than once to compare it to Paradise: "If I should come out of Paradise to this place, I should think it perfect. . . ."[31] And, ". . . there is something in the air of Italy, setting aside other things, which would make one feel at home in Purgatory itself. In America I never had that sense of quiet, settled content such as I now have from sunrise to sunset."[32] As William Stanley Haseltine's daughter observed in her biography of her father, "Meat, herbs, bread, water and wine; news from home by one's plate; a fragrant cigar in one's pocket; the morning's work accomplished; the sun shining; youth beckoning—what more could Paradise offer?"[33]

In Rome, the Americans (and the English-speaking community in general) clustered in the area of the Piazza di Spagna, as they still do today. They ate at the Trattoria Lepri on the Via Condotti (Melville records that he dined there on nineteen cents in 1857),[34] and then crossed the street to the Caffè Greco, where they could mix with artists and writers of all nationalities, especially German and Austrian, and collect the mail which, if not sent to the bankers Packenham and Hooker up the block at 20 Piazza di Spagna, was held for them in an old gray cigar box still extant.

An observer at the Greco in 1842 remarked: "When you enter you find the smoke so dense that you can hardly see across the room, but through it dimly appear the long beards, fierce moustaches, slouched hats, slashed velvet jackets, frogged coats, and wild but intellectual countenances which characterize most of the young artists of Rome. All are smoking or taking their dinner coffee, or talking in a confusion of languages, compared to which Babel was an asylum for the deaf and and dumb."[35]

We can, to some extent, retrace steps, by considering what little we know of places of residence. Longfellow lived on the Piazza Navona in 1827, Hawthorne at 37 Via di Porta Pinciana in 1858; the Brownings were at 28 Via del Tritone in 1859–60 and at 126 Via Felice in 1860–61. Emerson stayed at the Penzione Tellenbach, Piazza di Spagna, in 1872. The Spanish Steps had been glorified by the presence in the early 1820's of Keats and Severn at 26 Piazza di Spagna, in a small

house with a patio opening onto the steps. Byron lived at no. 66, Mrs. Jameson at no. 53, and Story, before making the Palazzo Barberini his permanent home, stayed, in 1852, at no. 93. Kensett lived nearby, at 53 Via Due Macelli. In 1831, Cole, using Claude's old studio, known as the "Tempietto," on the corner of Via Gregoriana and Trinità dei Monti, at the top of the steps, was only a few houses away from the former studios of Poussin, at 9 Piazza della Trinità, and Salvator, on the Via Gregoriana. Morse, who often joined Cole on the Campagna, lived at 17 Via dei Prefetti.

Margaret Fuller lived, in 1847, on the Via del Corso, then at 60 Piazza Barberini, and in 1849, struggling for the short-lived Roman Republic, occupied the Casa Dies on Via Gregoriana, along with the Storys and other fugitive Americans. Henry James, having spent his first moments in Rome at the Hotel d'Inghilterra on Via Bocca di Leone in 1859 (an establishment which had housed the Storys in 1849), stayed at 101 Via del Corso in 1872. The Brownings and the Pages were at 43 Via Bocca di Leone around 1853–54.

Thackeray, like James, was at the Inghilterra in 1869, and also lived above the Caffé Greco at 86 Via Condotti. Mrs. Jameson was at 176 Via di Ripetta in 1859. The Storys, who counted among their intimates the Brownings and Margaret Fuller, lived on the second floor of the Palazzo Barberini from 1856 on. The landscape painters John Rollin Tilton and Thomas Hotchkiss also occupied rooms there. In 1858, J. G. Chapman was at 135 Via Babuino, and G. L. Brown was at 7 Vicolo dei Aliberti, off Via Babuino. William Page had a studio at 39 Via Babuino in the 1850's. In 1857–58, William Stanley Haseltine was at 107 Via Felice, in a house occupied also by Grego-vorius, and his friend James Freeman lived at 18 Trinità dei Monti.

As to the large colony of sculptors, the Englishman John Gibson was at 4 Via della Fontanella; the American Harriet Hosmer lived for a while on the Via Gregoriana and at 5 Via Margutta. In 1858 she had a studio adjoining Gibson's. Randolph Rogers lived at 53 Via Margutta and also, in 1858, at 4 Piazza Barberini. William H. Rinehart was at 58 Via Sistina; J. H. Haseltine, William's brother, at 30 Via Babuino. Thomas Crawford lived in the Villa Negroni near the Baths of Dio-cletian and built his studio within the Baths.

In Florence, the artists and writers gathered at the Caffé Doney, where Melville loved to have breakfast and afternoon tea. The sculptor Hiram Powers lived for many years on the popular artists' street Via dei Serragli, at no. 111. John Cranch, Horatio Greenough, and Samuel Morse were at 4488 Via Valfonda. Cole also lived there in 1831. Christopher P. Cranch had a studio in the Palazzo dei Servi di Maria on Via Gino Capponi, where Durand, Casilear, and Rossiter stayed in 1840–41. Emerson in 1873 and Melville in 1857 stayed at the

Hotel du Nord on Piazza Santa Trinità. Miner Kellogg lived at 23 Via Santa Maria in 1841. William Page, in 1850, had a studio at 17 Via dei Serragli. Ruskin, arriving with his parents in 1840, stayed at the Hotel Schneiderff. From 1845 on he stayed at the Hotel dell'Arno and the Gran Britannia. The Brownings, of course, spent most of their time in Italy, not long after their arrival in Florence in 1847, at the famous Casa Guidi.[36]

Despite this list of addresses, assuring us that they were indeed *there,* their descriptions of Italy sound a continual note of disbelief—as though the experience itself was not really apprehended, or fully possessed. We may wonder whether the illusiveness of Italy was a function of its elusiveness, whether Italy, as the beloved seen through Irving's romantic medium, could ever be possessed. Yet, surely, somewhere, life was real. It was real enough for the Italian poor, whose "misery indigence . . . ignorance" and "beggary" even Irving saw as the result of "baneful effects of despotic governments—of priest craft & superstition, of personal oppression and slavery of thought."[37] And it was real enough in some ways for the struggling American artists, of whom, wrote the astronomer Maria Mitchell, who was there in 1857-58, "every winter, there are a thousand . . . in Rome . . . and of the thousand artists in Rome very few are successful."[38]

Thomas H. Hotchkiss wrote to Samuel P. Avery in November 1862: "In the art world of Rome the prospects look very gloomy for the coming winter; with the present rate of exchange very few will leave home and of these none are likely to buy pictures."[39] Though Hotchkiss wrote again in May to say: "I have had much better success this winter in selling pictures than I expected. I shall be able to get through until next winter very comfortably,"[40] his reputation never extended far beyond his fellow artists during his lifetime, and remained buried for a century. Yet his paintings of the Roman Campagna capture James's golden air with all the mellowness described earlier by Irving, "derived in a great measure from the illusive veil with which it is oerspread."

For the artists who persisted in staying, whether wealthy American tourists bought their works or not, that veil must have been sufficient to obscure the difficult realities of living. The Italian sunshine made America seem very cold. As Harriet Hosmer wrote: "I glory in the Campagna, the art is divine, and I dearly love the soft climate. I should perish in the cold winters at home. . . ."[41] Yet Haseltine's daughter remarks of that period: "Sunshine they obtained in plenty; warmth was questionable; no central heating; no fireplaces in the huge, carpetless, brick-paved rooms of the old palazzi; the only symbols of light and warmth were the soft, subdued oil-lamps, which one wound up with a key, and a copper brazier, in the middle of the room,

filled with burning charcoal, and which, if not properly lit, gave out enough carbon-monoxide to put one to sleep."[42]

But if Italy could at times be cold in the winter, the presence of the sunshine, or perhaps even the thought of it, was sufficiently warming, as Sir Joshua might have put it, for the imagination. For the veil that spread itself before their eyes as they painted the Italian landscape was not only Irving's illusive veil, but the veil of the artistic conventions they adopted. Here, on Claude's own soil, they could use not only their own eyes but the eyes of art, putting the Claudian conventions to fullest use. Even before they made the voyage across the Atlantic, Claude, the artist of Gilpin's picturesque beauty, had for many of them epitomized the tranquility evoked by the quiet vistas of the Campagna. For Harriet Hosmer, "the long line of the Alban and Sabine hills" was "too serene to be disturbed by either the joys or sorrows of mortals."[43]

Mortality here could be replaced by immortality. The removal to the golden dream included artistic removal to earlier dreams. That removal came quite close to the present through familiarity with the works of Turner, but he too had kept his eyes on the Claudian paradigm, though amplifying the atmospheric veil of light that stood for time and association as it glowed over the ancient ruins.

One must not, however, overstress the example of artistic conventions. For the artists were also exposed to the same scenes that confronted Claude and Turner, subject to the same romantic glow, seduced by the same ruins. For Christopher Cranch, "there were open-air pictures waiting to be painted everywhere around us, and on the wonderful Campagna, so that there was a perpetual stimulus to draw and paint." Cranch, indeed, seems to have found "the climate . . . so mild that working out of doors was usually practicable."[44] It is not unreasonable to assume that the American lover, enthralled like Claude and Turner by the same beautiful "older woman," took a similar path of artistic pursuit.

This pursuit, enduring as it did well into the sixties, was something of an anachronism. For it was founded on an ideal of the picturesque, on an esthetic of the ruin (fig. 108), which belonged more properly to the late eighteenth and early nineteenth centuries, and which indeed had attracted many European artists to Italy at that time. Perhaps it is only natural that when American art reached some youthful maturity, it should in turn follow this example. But by then the cult of nature and the admiration for wilderness had grown sufficiently strong in America to offer a viable alternative for the landscape painter. In the eyes of many Americans, it was, indeed, preferable.

Even Cole, returning from Italy where his heart and feelings were most fully nourished, felt obliged to write to the U.S. consul in Rome

108. Thomas H. Hotchkiss, *Theatre at Taormina,* 1868
Oil on canvas, 15¾″ × 30¾″ Private collection

in 1842: "Must I tell you that neither the Alps nor the Apennines, no, nor even Aetna itself, have dimmed in my eyes the beauty of our own Catskills?"[45]

The American wilderness was real, and thus, for all its potential for sublimity, had none of the dream quality necessary for the courtly love lavished on the Italian Campagna. The American artist could marry the wilderness, which was, in many ways, more familiar to him. But Italy was his mistress and the affair could maintain its potency as long as the elusive mystery was maintained. The love potion was compounded of the mental "distancing" of time and of Irving's softening glow, which stemmed as much from the eye of the beholder as from the patina of age. As in most love affairs, the efficacy of the potion depended not only on the actual charms of the beloved but on the mental and emotional attitude of the lover. That attitude sought further to enhance the beloved by viewing her in optimum, often cosmetic, circumstances.

Thus the penchant for moonlit scenes, for the "Vatican by torchlight and the Coliseum by Bengal lights,"[46] for viewing Rome "bathed in moonlight—sleeping in a pale shroud of faint mist. Far away, like a dream, dim and delicate . . . St. Peter's against the thickened horizon; near by the Quirinal tower . . . the obelisk before the Trinità dei Monti . . . its dark needle at the end of the Gregoriana, and a thousand

domes and towers and arched loggias . . . [rising] all around, from the roofs."[47]

"We took advantage of the first fine moonlight to visit the Coliseum . . . ," wrote Christopher Cranch in 1846. "We took our way toward the ruins, stopped to contemplate the old Forum, the Arch of Septimius Severus, the Pillar of Phocas, and all the ruins in that vicinity, —all steeped in the loveliest of moonlights. We passed under the small Arch of Titus, and stood before the Coliseum. For some time we stood, or walked around on the outside, reserving the impression of entering, like something too rare and sacred to be hastily snatched. . . . At last we drew slowly to the centre, and never have I beheld before anything to compare with that scene."[48] If moonlight was romantic even on James's "coarse Hudson," it was much more so in Keats's Italy, where it added further to the veiled timelessness that was part of the spell. Perhaps this was why Hawthorne so much admired George Loring Brown, preferring him, indeed, to Claude, and writing with rare pleasure of "a moonlight picture . . . really magical—the moon shining so brightly that it seemed to throw a light even beyond the limits of the picture. . . . it was a patient, and most successful wooing of a beloved object," which at last rewarded him by "yielding itself wholly."[49]

Was it, perhaps, the removal to timelessness that caused the artists frequently to omit the human figure from their portrayals of the Italian landscape? For human mortality had little place in this dream. The landscape itself sat for its portrait. What figures were included were generally small and so much a part of the landscape, so thoroughly accommodated to the image, that we are not especially aware of their presence. Elihu Vedder once remarked: "It is strange, how, when I paint landscapes, I don't seem to care for the figures; that is, I feel as if I ought to put them in, but don't most of the time."[50]

Claude often used figures as exponents of the myths to which he attached them. The American landscape artists felt no special need to excuse their preoccupation with the landscape through the use of mythological themes. The landscape *was* the myth. Its golden air, as James rightly pointed out, caused subjects to "float by . . . as the fish in the sea may be supposed to float by a merman, who doubtless puts out a hand from time to time to grasp, for curiosity, some particularly iridescent specimen. But he has conceivably not the proper detachment for full appreciation." As James so rightly suggested, there were some artists and writers, and he counted Story among them, for whom Italy was "too much"; and "was it not this too much that constituted precisely, and most characteristically and gracefully, the amusement of the wanton Italy at the expense of her victim?"[51]

Yet, for those who successfully met the challenge of "wanton Italy,"

we might at least conclude, from the works that remain to us, that the lover served his mistress well, responding to her charms with appropriate artistic gestures that fully characterized the depth of his emotion and enthrallment. In Volterra, Cole wrote in his notebook:

I have witnessed some truly glorious sunsets and lovely twilights—one in particular from the western declivity of the mountain, I watched with feelings of singular delight as it faded away. The tone of the landscape was most heavenly; all the great plain was in deep shadow, reposing in an atmosphere whose hues can never be expressed in language; the ordinary terms, "silvery" and "golden," give but a dim notion of it. It was such an atmosphere as one could imagine angelic beings would delight to breathe, and in which they would joy to move. . . . I am not surprised that the Italian masters have painted so admirably as they have; nature in celestial attire was their teacher.[52]

And Christopher Cranch exulted:

I have not seen any place that combines so much a landscape painter can make use of as Tivoli. There is the great ravine with the old picturesque town overlooking it, and its one beautiful relic of classic times, the Sibyl's temple. There are the grottos, the deep, weird chasms, where waterfalls shoot down roaring, as into the mouth of hell, and disappear to the eyes. . . . There are the beautiful views of the Villa of Maecenas and the distant Campagna, with the dome of St. Peter's looming up on the far horizon. There is the Villa d'Este, a wonderful old place, with its fanciful fountains all in ruins, and its magnificent sombre cypresses, the most beautiful I have yet seen [fig. 109].[53]

While Hawthorne wrote of the Val d'Arno:

Now that the moon is on the wane, there is a gentler lustre, but still bright; and it makes the Val d'Arno with its surrounding hills, and its soft mist in the distance, as beautiful a scene as exists anywhere out of heaven. . . . This mist, of which I have so often spoken, sets it beyond the limits of actual sense and makes it ideal; it is as if you were dreaming about the valley—as if the valley itself were dreaming, and met you halfway in your own dream.[54]

What larger realities could have intruded on this dream? Henry Greenough, in his novel *Ernest Carroll*, saw contemporary Italy as "the skeleton of some mighty mastodon, among whose bones jackals, mice, and other vermin were prowling about. The great frame was there, but the life and strength which animated it was departed."[55] Yet contemporary Italy had sufficient energy to be involved in an intense political struggle for unification. What effect could such a struggle have on the American expatriates who were busy dreaming their dream?

We know that Margaret Fuller, a good friend of Mazzini and deeply devoted to the interests of her husband, the Marchese d'Ossoli, involved herself emotionally and practically with contemporary political events.[56] But how many other members of the English-speaking

109. Sanford Gifford, *Tivoli*, 1879
Oil on canvas, 26⅜″ × 50⅜″. The Metropolitan Museum of Art, New York, gift of Robert Gordon

community responded to Italian domestic problems with similar vigor? Cole had written explicitly to Dunlap in 1834, almost two years after his return from Italy, that "what I believe contributes to the enjoyment of being there [in Italy] is the delightful freedom from the common cares and business of life—the vortex of politics and utilitarianism, that is forever whirling at home."[57]

Yet by 1848, when the Storys arrived in Rome, they were just in time for the French siege of the following year. Story was thoughtful enough about the political issues of Italy to mention them in a letter to James Russell Lowell, and Lowell replied on March 10, 1848: ". . . if you mention political changes, Italy has been getting herself born again ever since I can remember, and will have to be delivered by a Caesarian operation after all. Besides, have we not ours?"[58] James, speaking of the "most incoherent birth of the time, the advance of French troops for the restoration of the Pope, the battle waged against the short-lived 'popular government' of Rome by the scarce longer-lived popular government of Paris," notes: "It was at this battle that foreign visitors 'assisted' as in an opera-box. . . . They arrived in time to seat themselves well, as it were, for the drama, to get seated and settled before it begins. . . ."[59]

218

The idea of Italy as spectacle, so removed from the consciousness of the "visitors" that they could never really experience Italy's problems as actual ones, persists. Just as they loved to visit the Pergola Theatre for concerts, to see Ristori at the Cocomero, to watch Molière's *Tartuffe* at the Metastasio, in some ways they saw Italy's revolution as "delightful Revolution . . . which . . . promoted afternoon drives and friendly parleys."[60] As James interprets it, Mrs. Browning especially enjoyed the drama, writing to a friend: " 'The child's play between the Livornese and our Grand Duke provokes a thousand pleasantries. Every now and then a day is fixed for a revolution in Tuscany, but up to the present time a shower has come and put it off.' "[61]

Yet though James observes that "Mrs. Browning thirsted for great events,"[62] Clare Louise Dentler has noted: ". . . Story said . . . to her Italy was a living fire, her interest was centered in the political life of the Italians and in the wrongs they had suffered. For the entire time that she lived here she devoted her heart, brain and pen to the Italian cause. . . . The Italian patriots always found a sympathetic welcome at Casa Guidi and it became their rallying place."[63]

Some Americans also cared enough about Italy's actual problems to help the cause of the Republic where they could. Mrs. Story noted that during the French attack their good friend "Frank Heath went to the Hospital with Margaret and returned so full of interest and sympathy that he at once set on foot a subscription."[64] The Storys themselves assisted when possible. James quotes Story on May 6, 1849: "Went in the evening to the Trinità dei Pellegrini to carry the American subscription for the wounded in the late battle."[65]

George Wynne, in *Early Americans in Rome,* writes of the Republic: "During its short life and while under siege by a French expeditionary force, some determined U.S. residents joined the defenders, nursed the wounded and put their scarce cash into the public purse. Finally, when it was all over and the French in control of the city, American officials furnished passports to the leaders of the revolution to help them reach safe haven. In some cases they smuggled them out personally disguised as members of their household."[66]

Yet he adds, "Lest these remarks give the impression of great numbers, it was only a handful of Americans who were actively committed to the defense of the Roman Republic. But this small group was dedicated to the hilt. Foremost among them was Margaret Fuller. . . . In lesser measure there were the Storys, sculptor Crawford. . . ."[67] Elsewhere he notes, "While some of the American colony acted merely as spectators, others joined the defenders of Rome. We have sure notice of only two, the sculptor Thomas Crawford, and the painter Frederick Mason who helped defend the Porta San Pancrazio. . . . the Rome

daily *Contemporaneo* reported that 268 foreigners had joined the defenders of Rome. . . . It is a logical supposition that among the 268 foreigners figured a number of American artists and students who had thrown in their lot with the city's defenders."[68]

Of them all, despite the natural logic of American partisans of democracy joining a fight for freedom, it seems to have been Margaret Fuller Ossoli who was most realistically engaged. Thus, as correspondent for the New York *Tribune,* she wrote: "It was fearful to see the villas with fragments of rich fresco still clinging to the rafters between the great holes torn by the cannonade. Roses and oleander bloomed amid the ruins. A marble nymph with broken arm looked sadly from her sun-dried fountain. I saw where thirty-seven men were buried beneath one wall. From a barricade protruded a pair of skeleton legs. A dog stared stupidly at the dead soldier uncovered by its digging."[69] With the American Civil War still more than a decade away, she could add: "O men and women of America, spared such a sight as these, what angel do you think has time to listen to your tales of woe?"[70]

After her death, Mazzini wrote: "The poor Margaret Fuller came from the United States with God knows what preconceptions about us . . . but after an hour she became our sister. Her candid mind open to all that was noble glimpsed the love our purpose inspired."[71] Thus he offers, in a way, the key to Fuller's involvement, quite apart from her open and candid mind: she became their sister. And by her love for and probable marriage to the Marchese d'Ossoli, she transferred her sense of actuality from America to Italy, dispensing, as we can see from her observation above, with the dream.

Still, it is probably fair to say that James's interpretation of the American attitude to Italy's problems was generally correct. From the late forties to the late sixties when Italy was experiencing the birth trauma of unification, American visitors indulged their dream of an Italian past. It was not that they were insensitive. When they could, they extended themselves to be helpful, in a human way, to the beleaguered Italians. Nor were they insensitive to the terrible struggles of a divided America around the same time. But dreaming relieved them of the painful necessity of coping with the problems of either place. They were abroad as lovers, not spouses. They could be "heartsick during a walk on the Pincian while the French were coming" from the sight of the destruction of "numbers of the fine trees in Villa Borghese, hewn down, for the construction of defences, to their stumps,"[72] but the suspicion persists that this was only because the intrusion threatened their dream. Real necessity, American necessity, was distanced by an ocean, and by the mythic time which enveloped them.

Reminders of home came, of course, in the morning post. The Americans were interested enough, as Haseltine's daughter suggests, in the political and social events at home to watch the mails with anticipation. When Church visited Rome in 1868 he wrote, on November 4, to his good friend William Osborn: "We Americans in Rome —are of course much exercised about the election which took place yesterday. . . . I can have no doubt about the election of Grant—still —I should like to hear that it is all right."[73] Five days later he wrote again: "The election of Grant is very inspiring. Heaven help our country and bring us safely out of the confusion that at present prevails and make clear the turbid waters by settling the dirty politicians in the profoundest depths of oblivion. My pleasantest thoughts nowadays are when they are about our home on the Hudson and all the surroundings. . . ." In the same letter he noted, "We are almost as comfortable around our table—illuminated by a carcel lamp and warmed by an oak fire—as if we were lighted by petroleum and basked by hickory coals in our own cottage—But—the Tiber is not the Hudson. . . ."[74]

Church arrived in Rome at a time when, he noted on January 23/28, 1869, "Americans are as plentiful here as ants in an anthill—and just about as active—and the amount of stuff they buy is astonishing— copies, new pictures—sculpture—jewelry—mosaic—antiquities—bronzes, etc." He observed that "from the studio building we have represented in Rome—McEntee—Gifford—Thompson—Weir—Hazeltine—Church— six, part of them have no studios, but are here to see and travel. Gifford has just gone to the East."[75] Yet January 1869 was very close to the achievement of Italian unity and to the end of the era of major American expatriation in Italy. The Americans' artistic focus was about to shift to Paris and Munich (though Venice, in another way, continued to hold a spell over such artists as Whistler).

Church's attitude to Rome was a bit atypical. He found Italian scenery pretty and sentimental, and much preferred, given the eastern inclinations so clearly demonstrated at Olana, the barren, parched landscape of Syria, where he had stopped before his Roman visit. To Martin Heade, who was staying in his studio at 51 West Tenth Street, Church observed on October 9, 1868: "I have no comments to make on Rome. I thereby distinguish myself from the crowd who scratch interminable letters about the 'Eternal City' as they delight to call it."[76]

On November 16, he wrote again to Heade:

Keeping house on the Pincian Hill—good cook—buys such admirable meats etc. that I am obliged to pay nearly double what other people do—Still we are very comfortable—Healy is here—T. Buchanan Read—and several other American artists—McEntee and Hazeltine have studios in the same building with me. I have just finished a small Syrian picture for a Bostonian and am

hard at work at a big "Damascus." . . . I paint until 2—then dine—and after—see sights—sketch some and penetrate into the profoundest recesses of the dirtiest old-old master shops. . . . There is no use writing about Rome—The subject is as thread bare as the priests here—[.][77]

Obviously, Church had not fallen victim to James's wanton Italy, as had such genuine expatriates as Brown, Tilton, or Story. An exchange of letters between Story and James Russell Lowell is instructive. Lowell wrote on September 25, 1849: "You talk about my being a man of leisure. Why, besides what other writing I have done, I have for fourteen months contributed a column a-week and for four months a column a fortnight to the 'Anti-Slavery Standard.' . . . You are a man of leisure there in Italy, whose climate makes loafers of us all."[78]

In 1852, Story wrote to Lowell: "Such a summer as we have had I never passed and never believed in before. Sea and mountain breezes all the time, thunder-showers varying with light and shade the Campagna, donkey-rides and rambles numberless—a long, lazy, luxurious *far niente* of a summer. . . . All that I wanted was to have some old friend with me. . . . Every day that I live here I love Italy better and life in America seems less and less satisfactory."[79]

Yet in what, exactly, did this dissatisfaction with America reside? Surely, the American artists did not transplant themselves to Italy simply to experience an endless dolce far niente. In a later letter, from Dresden, Lowell himself admits "a horrible homesickness and—shall I confess it?—longing for Italy." And he continues: "I agree with you as to the wants one feels at home. When I look back and think how much in me might have earlier and kindlier developed if I had been reared here, I feel bitter. But on the other hand, I prize my country-breeding, the recollections of my first eight years, my Hosey Biglow experiences as something real, and I mean to make a poem out of them some day that shall be really American."[80]

Italy, then, offered to the individual the possibility of developing his finest tastes and potentialities. The mistress offered all the refinements of civilization that could help the individual to become his best self. The artist especially had to benefit through such an encounter, for, as Hawthorne observed, "artists . . . lifted by the ideality of their pursuits a little way off the earth" possessed "a property, a gift, a talisman, common to their class, entitling them to partake somewhat more bountifully than other people in the thin delight of moonshine and romance."[81]

The poet Frederick Tuckerman, a cousin of the famous critic, preferred the intellectual aspects of Italy to the commercial and competitive society of America because, again, there was more possibility in this atmosphere for the development of human potential. In Sonnet XXV he wrote:

In my first youth, the feverish thirst for gain
 That in this noble land makes life so chill,
Was tempered to a wiser trust by pain,
 Hope's early blight—a chastening sense of ill;
And I was exiled to a sunny clime,
 Where cloud and flower a softer meaning caught
From graceful forms and holy wrecks of time,
 Appealing all to fond and pensive thought;
Enamored of the Beautiful I grew,
 And at her altar pledged my virgin soul. . . .[82]

Yet Hawthorne, who had mixed feelings about Italy, and especially about Rome, wrote:

It would only be a kind of despair . . . that would ever make me dream of finding a home in Italy; a sense that I had lost my country through absence or incongruity, and that earth is not an abiding-place. I wonder that we Americans love our country at all, it having no limits and no oneness; and when you try to make it a matter of the heart, everything falls away except one's native State; neither can you seize hold of that unless you tear it out of the Union, bleeding and quivering. Yet, unquestionably, we do stand by our national flag as stoutly as any people in the world, and I myself have felt the heart throb at sight of it as sensibly as other men. I think the singularity of our form of government contributes to give us a kind of patriotism, by separating us from other nations more entirely.[83]

That nationalism, or patriotism, ultimately triumphed with the American landscapists who had gone to Italy. Though the sculptors, tied to their marble and to their craftsmen, had practical reasons for immersing themselves in the Italian dream, the landscape painters also had them, on the other side of the ocean. There was an alternative to the landscape of history and association of which Hawthorne had noted so eloquently: "In Italy, whenever man has once hewn a stone, Nature forthwith relinquishes her right to it, and never lays her finger on it again. Age after age finds it bare and naked, in the barren sunshine, and leaves it so."[84]

That alternative was American nature—a nature which symbolized America's sacred destiny. Even Cole, torn perhaps more than any other American between natural and cultivated antiquity, had found it necessary, it will be remembered, to restate his primary allegiance to the Catskills. Such an allegiance was both philosophical and practical. Cole's American paintings were much better received by a public that wanted pictures to remind them of their native land. For most contemporary critics, the *New York Mirror* summed it up: "His Arcadias and other scenes from the imagination, have not that originality and truth-telling force which his native pictures have."[85]

Despite the numbers of patrons who could be counted on in Rome or Florence to buy the artists' landscapes as mementos of the Grand Tour, American taste during the period under discussion generally

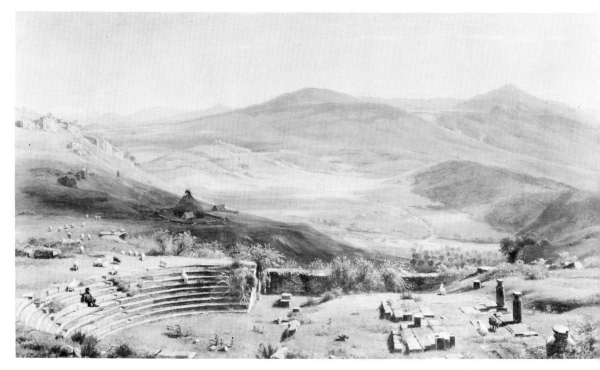

110. Worthington Whittredge, *The Amphitheatre of Tusculum
and View of the Alban Hills*, 1860
Oil on canvas, 24″ × 40″. The Victor Spark Collection

preferred American landscapes. This was partly due to the fact that America was at a critical moment in the shaping of a national identity largely dependent on the landscape for moral and religious as well as social justification.

Hawthorne, writing of Hiram Powers, observed: "It makes a very unsatisfactory life, thus to spend the greater part of it in exile. In such a case we are always deferring the reality of life till a future moment, and, by and by, we have deferred it till there are no future moments; or, if we do go back, we find that life has shifted whatever of reality it had to the country where we deemed ourselves only living temporarily; and so between two stools we come to the ground, and make ourselves a part of one or the other country only by laying our bones in its soil."[86]

The majority of American landscapists who went abroad to dream of Arcadia ultimately laid their bones in American soil. Only a very few succumbed forever to the dream. Worthington Whittredge (fig. 110), returning to America, felt the dislocation of which Hawthorne had spoken and wrote:

It was impossible for me to shut out from my eyes the works of the great landscape painters which I had so recently seen in Europe, while I knew well enough that if I was to succeed I must produce something new and which might claim to be inspired by my home surroundings. I was in despair . . . I hid myself for months in the recesses of the Catskills. But how different was the scene before me from anything I had been looking at for many years! The forest was a mass of decaying logs and tangled brush wood, no peasants to pick up every vestige of fallen sticks to burn in their miserable huts, no well-ordered forests, nothing but the primitive woods with their solemn silence reigning everywhere. I think I can say that I was not the first or by any means the only painter of our country who has returned after a long visit abroad and not encountered the same difficulties in tackling home subjects.[87]

Whittredge was not talking only of a return to a more primitive and less cultivated nature. Behind his comments we may glimpse some necessity to cope with reality, and a responsibility to produce "something new which might claim to be inspired by my home surroundings." How could he provide the national art for which the critics and public clamored?

To take on such responsibilities involved, for the American landscape painter, a return to reality tantamount to a return, once the beguiling affair has abated, to a wife. For Italy, in de Rougemont's terms, was Iseult, and not to be wed: "Iseult is ever a stranger, the very essence of what is strange in woman and of all that is eternally fugitive, vanishing. . . . that which indeed incites to pursuit, and rouses in the heart of a man who has fallen a prey to the myth an avidity for possession so much more delightful than possession itself. She is the woman-from-whom-one-is-parted: to possess her is to lose her."[88]

In one concrete way, however, the American landscape painters did possess Italy, whether for longer or shorter periods of time—in the portraits they painted of the Italian landscape. Through these, they allow us to possess it a hundred years later, and to see their efforts as the epitome of the romantic temperament, its energetic illusions, its emotional idealism, its blind exclusions, its desire for Paradise, its creation of a world unlike the reality they so carefully filtered out of their shared romantic dream—one that has a peculiar poignancy when contrasted with their birthright.

X

America and Europe:
Influence and Affinity

When Worthington Whittredge returned from Europe in 1859 he succinctly posed the problem of the American artist.[1] European models were in his mind's eye; if emulated, they would stamp his landscapes with the imprimatur of the great traditions. But only something "new," inspired by "home surroundings" (fig. 111), would meet his needs and those of his American colleagues: "We are looking and hoping for something distinctive to the art of our country, something which shall receive a new tinge from our peculiar form of Government, from our position on the globe, or something peculiar to our people, to distinguish it from the art of the other nations and to enable us to pronounce without shame the oft repeated phrase, 'American Art.'"[2]

At this crucial moment in the formation of American culture, the art of Europe—of the Western world of which America was a distant but integral part—exerted its authoritative pull. The dilemma was there from the outset. Provincialism was tempted to call on Europe for its artistic credentials. And yet, as Henry James pointed out: "The apple of 'America' is a totally different apple. . . ."[3] The American who had bitten deep into the apple of Europe had to reconcile himself to a different taste.

The ambivalence and insecurity of the provincial jostled the pride and optimism of the blossoming culture. Emerson, typically, tried to turn American "rawness" into an asset: "Let us live in America, too thankful for our want of feudal institutions. Our houses and towns are like mosses and lichens, so slight and new; but youth is a fault of which we shall daily mend. This land too is old as the Flood, and wants no ornament or privilege which nature could bestow. Here stars, here woods, here hills, here animals, here man abound, and the vast tendencies concur of a new order."[4]

The problem was difficult. "Civilizing" the land meant substituting for America's hoary purity something new that, at least from the artist's point of view, was less satisfactory. Emerson's "new order"

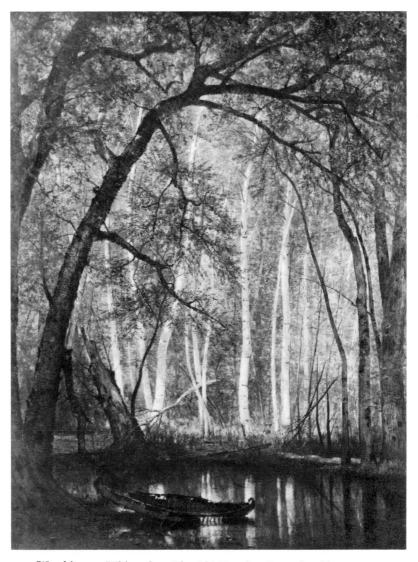

111. Worthington Whittredge, *The Old Hunting Grounds,* 1864
Oil on canvas, 36″ × 27″. Reynolda House, Winston-Salem, North Carolina

would remain new only if it maintained the freshness of American
land and life. Making use of Whittredge's distinction between Amer-
ica's primitive woods and Europe's "well-ordered forests" required
from the artist a subtle balance between Europe's landscape art and
the pragmatic experience of the American land.

To establish American nineteenth-century landscape painting within
the context of Western landscape demands an examination of all these
factors. If Americans were "civilizing" their landscape through the

development of new towns and communities, the landscape painters had an analogous option through recourse to European traditions. First among these were the conventions of Claude, whose pastoral compositions had such an enormous impact on late-eighteenth-century European art, and on the concept of the picturesque. This apt term counts among its many connotations the literal one of seeing nature in terms of other pictures. As Richard Payne Knight put it: ". . . persons, being in the habit of viewing, and receiving pleasure from fine pictures, will naturally feel pleasure in viewing those objects in nature, which have called forth those powers of imitation. . . . The objects recall to the mind the imitations . . . and these again recall to the mind the objects themselves and show them through an improved medium—that of the feeling and discernment of a great artist."[5]

Claude had for both Europeans and Americans the "feeling and discernment of a great artist." At a moment when the subject hierarchy was still important, this sentiment could lift landscape to the level of history painting, transcending Sir Joshua's "mere reality." Given Sir Joshua's importance to late eighteenth and early nineteenth-century artists in America, it is not surprising that the Claudian "stamp" became a major convention. On it could be loaded all the connotations of Ambition, of competition with European culture, that American artists not so secretly harbored. It offered the artists the assurance that they were "framing" the landscape artfully, thus making "art" out of nature, and so were eligible for acceptance by their European confrères. I use the word "framing" deliberately, for the Claudian convention is most easily recognized by the trees that frame the picture's lateral edges, as well as by the dark foreground coulisse, the middle-ground scoop of water, and the distant mountain—a set of motifs endlessly permuted (fig. 112).

Though Gilpin had made the distinction between the "picturesquely beautiful" in Claude and the "picturesquely sublime" in Salvator, only Cole (fig. 113) maintained it, and depending on mood, alternated between Claude and Salvator. His Hudson River colleagues telescoped the beautiful and the sublime into a single convention, still Claude-derived, on which they could ring changes of mood and space. Claude, used "sublimely," stands behind some of Church's most ambitious canvases of the Andes.

Why did the Claudian convention persevere so tenaciously? The ideal, or classical, tradition it so richly represented was strong not only in England but in Germany and Scandinavia in the late eighteenth and early nineteenth centuries. In using this mode, Americans appropriated its Italianate associations, with all the accrued interest of time and myth. They annexed a museum culture they could only experience as visitors. Thus the Claudian mode remained a vital force

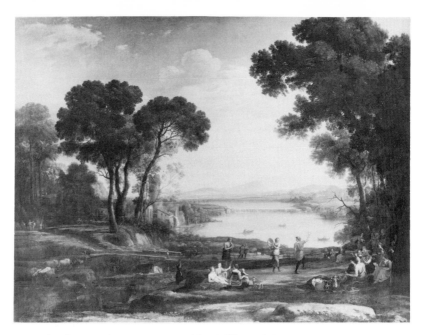

112. Claude Lorrain, *Landscape with a Mill,* c. 1648
Oil on canvas, 58½″ × 78″. Galleria Doria-Pamphili, Rome. Photo courtesy Fratelli Alinari

113. Thomas Cole, *Dream of Arcadia,* 1838
Oil on canvas, 39¼″ × 63⅛″. The Denver Art Museum

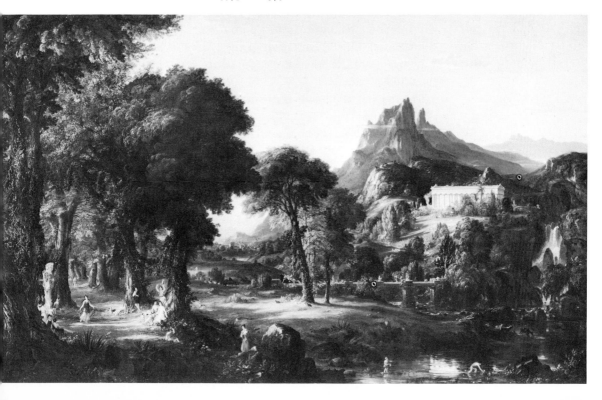

in America long after the so-called classical tradition in European landscape had been modified. Also, the pastoral aspect of the Claudian convention reinforced those myths of America as a new Eden that were so important in the nineteenth century.

Although this American attachment to Claude resembled the European vogue of a little earlier, it had, I feel, a much larger psychic and philosophical investment. Perhaps this is why it appears so frequently in American art as an unquestioned "given." It establishes the necessary philosophical and artistic armature on which the artist could then deposit the fresh observations he derived from the natural world.

These observations, of course, involved space and light. For a group of artists who had found their religion in nature, something in Claude's atmosphere answered a need for an idealized, reverent light. On his first trip to Europe, Cole, visiting London's National Gallery on July 29, 1829, noted of number fourteen, Claude's *Embarkation of the Queen of Sheba,* which along with Turner may have inspired Cole's *Consummation* (see fig. 6) in *Course of Empire:* "The best Claude I have ever seen. The sky and distance of a pearly cool tone may light and assist—the other parts of the picture darker—The clouds are light and beautiful and seem as though they were not painted with brushes but melted into the blue. . . . There are very broad masses of shadow in the picture but all transparent and gradating into the light beautifully. The water in the foreground is exquisitely painted and looks like the purest of water. His touch throughout is mellow melting and appropriate." Cole goes on to say: "The sky and distance are smooth as though they have been pummiced—though here and there you may see where the painter has used his hand."[6]

After another visit to the National Gallery on his second European trip in 1841, Cole noted in his journal (August 24): "The Claudes are still pleasing but Embarkation of the Queen of Sheba is my favourite —the beauty of the atmosphere, the truth, transparency and motion of the water are surprising."[7]

Durand, on the other hand, had mixed feelings about Claude, as might be expected from an artist who could produce not only Claudian-derived compositions such as *Thanatopsis* (Metropolitan Museum of Art, New York) but also some of the most pragmatic examples of realism in American landscape painting. In London on June 22, 1840, he wrote in his journal: "I may now say more emphatically I have seen the Old Masters, several of them undoubtedly fine specimens . . . and first and foremost in my thought is Claude. . . . There are 10 of his works in this collection, some of them esteemed his very best. I may therefore venture to express my first impressions of Claude —On the whole then, if not disappointed, at the least, I must say he does not surpass my expectations . . . I will not express an opinion in

detail until further examination, yet what I have seen of them is worth the passage of the Atlantic."[8]

On July 3, Durand left the National Gallery "resolved to commence a landscape in Oil" and began one "as an attempt at some of the principles presented in the pictures of Claude."[9] Durand then traveled to Italy via Switzerland, Holland, Germany, and Belgium. When he arrived in Florence he wrote to Cole: "It may be hopeless to expect more perfect light and atmosphere than we find in the seaports and, occasionally, other scenes by Claude. Still I have not felt in contemplating them that I was so completely in the presence of Nature, so absorbed by her loveliness and majesty, as not to feel that the portrait of her might be at least, in some important feature, more expressive of character."[10]

En route to Italy, Durand had done a lot of sketching, and he wrote to his wife from Geneva: "I have found an agreeable change from the previous study of pictures to the study of nature, and nature too, in her utmost grandeur, beauty and magnificence."[11] Durand, like Cole, studied and admired Claude, but nature's *presence* made him question, however ambivalently, the need to rely on him.

This questioning is crucial for the American contribution. A strong empiricism shaping original solutions to the landscape problem had always been part of the American sensibility. It could also, perhaps, be part of a basic primitivism that distinguishes so-called provincial art from the art of the mainstream. Each pictorial problem is solved afresh; tradition is built, not by the transfer of pictorial "progress" from one generation to another, like links on a chain, but rather through a commonality of experience gained from the process of beginning anew. Correspondences within this tradition result from starting in the same place—and working through similar problems to similar results. This is American landscape painting's great advantage or, for some, its disadvantage. It is what gives its history an identifying signature.

Direct response to nature involved spontaneous reactions to light and air and meticulous observation of detail—of the clouds, rocks, plants, and trees which filled the sketchbooks of the American landscapists, authenticating with fact their more ambitious and ideal works. As we know, in the Claudian compositions, light and air could represent Tuckerman's "general effect," while particularity of detail met the requirements of "specificity" without which the ideal in America was unacceptable.

While the high-art Claudian stamp was widely utilized, especially within the Hudson River milieu, two other landscape solutions that

also developed were ostensibly realist. In luminism, as we have seen, the ideal radiates from the core of the real in what is now recognized as a more philosophically genuine reconciliation. This and a more purely pragmatic mode, which occurred less frequently but was part of the vanguard development of plein-airisme, are significant American contributions to the Western landscape tradition.

The luminist mode, often considered free from the influence of pictures, may have found its paradigms in the Dutch landscapes ruled inferior by Sir Joshua and devalued by most American critics. James Jackson Jarves was forced to observe in 1869 that ". . . Dutch art is too well-liked and known for me to dwell longer on it. Those whose aesthetics are in sympathy with its mental mediocrity will not desert it for anything I may say."[12]

Though Dutch art did not have the intellectual credentials that would have rendered it acceptable to official criticism, there was, as Jarves indicates, a strong sympathy for it that remains largely unresearched. It was appreciated by the artists themselves and by private individuals who were not, it appears, very vocal. This taste corresponded with a shift of emphasis, around 1850, from the noble ideal of nature to a quieter realism. This realism, though still imbued with the ideal, gave nature more say in the dialogue between nature and art that determined the course of American landscape painting. Evidence of the taste that assisted this conversion is still scanty.

Dutch paintings were included in such private collections as those of Robert Gilmor, Jr., Michael Paff, and Thomas J. Bryan, and were shown in public exhibitions at the American Academy of Fine Arts, the Apollo Gallery, the American Art-Union, and the Boston Athenaeum. The Gilmor collection alone included paintings by van de Velde, van der Neer, van Goyen, and Cuyp, all of which offered prototypes for American marine landscapes. A substantial number of works by Dutch artists were to be seen at the Boston Athenaeum during the years Lane was in Boston, from about 1832 to 1848. The list includes such names as van de Cappelle, Cuyp, van Goyen, Hobbema, Potter, Jacob and Salomon van Ruysdael, and van de Velde. Lane showed intermittently at the Athenaeum from 1841 until his death in 1865, so his contact with the exhibitions in Boston may well have extended beyond his removal to Gloucester in about 1848.[13]

The open lateral edges and straight horizons that distinguish so many land/sea luminist compositions in America—Lane's *Owl's Head, Penobscot Bay, Maine* (see fig. 95); Heade's *Rocks in New England* (M. and M. Karolik Collection, Museum of Fine Arts, Boston); Kensett's *Shrewsbury River, New Jersey* (New-York Historical Society)—find parallels in the quiet compositions of the Dutch. The structural

similarities are clear from a comparison of a drawing by Cuyp, *River Landscape* (fig. 114), with Lane's *Entrance of Somes Sound, from Southwest Harbor, Mount Desert* (fig. 115). Even were the Cuyp a painting, we would find the American form more solid, the light more concrete, the surface harder. Generally, the luminists tend to stress the horizontal axis even more, with less space allocated to skies. Cloud formations in the luminist works are less prominent—cirrus rather than cumulus—if they appear at all. These distinctions are relatively minor when compared to the major similarities. The luminist structural mode, which substitutes the absolutes of an implied geometry for the picturesque undulations of the Claudian type, finds its most obvious parallels in seventeenth-century Holland.

The Dutch mode, like the Claudian, was partly transmitted through eighteenth-century England—to which early-nineteenth-century America looked most naturally for exemplars. The marine tradition founded in England by Willem van de Velde the Younger was continued in the eighteenth century by such English artists as Charles Brooking and Peter Monamy. Their successor, Robert Salmon, was surely one of the agents of transmittal; he worked in Boston between 1828 and 1842, and his works were known to Lane. The structural similarities yielded by a comparison of van Goyen's *Haarlem Sea* (fig. 116) and Lane's *Sunrise Through Mist: Pigeon Cove, Gloucester* (fig. 117) offer such conclusive visual evidence that it is hard to believe they do not result from a direct (Holland) or indirect (Holland via England) cause and effect.

Yet we cannot overlook the mysterious possibilities of affinity. *Webster's New World Dictionary* defines influence as "the power of persons or things to affect others, seen only in its effects."[14] Affinity is defined as a "similarity of structure, as of species or languages, implying common origin."[15] On the one hand—cause and effect; on the other—similarity of structure with the suggestion of a common root. The distinctions between these two are not as clear-cut as we are often led to believe. Sometimes what we call affinity turns out, after additional research, to be influence. But to extend the dialogue between America and Europe beyond influence to affinity joins America even more firmly with Europe as part of the Western world. American artists held some attitudes that shared common philosophical and artistic roots with those of their European contemporaries; other attitudes stemmed more directly from American soil and from the pragmatic encounter with the *look* of their native landscape.

The social similarities between the Dutch republic of the seventeenth century—with its Protestantism, its respect for humble things, its middle-class citizens—and the American republic of the nineteenth

114. Albert Cuyp, *River Landscape,* undated
Black crayon and black and gray wash on paper, 7⅕″ × 12″. Kupferstichkabinett,
Staatliche Museen Preussischer Kulturbesitz, Berlin

century indicate basic affinities that require further study. Art historical affinities reside in a common recourse to so-called "raw" nature, as an alternative to the Claudian formula. In addition, it is possible that "influence" acted not so much by cause and effect as by fortifying a proclivity that already existed. In America, that proclivity clearly related to a more empirical response to the actual experience—and, I suspect, to a pragmatic, even primitive, freshness in the approach to picture-making.

John Neal recognized the early American taste for the picturesque in 1829 when he wrote that in landscape painting the public preferred poetry to prose.[16] Is it possible that the luminist artists finally learned to paint prose rather than poetry by looking at prose painters looking at nature? They may have gained access to a more direct experience of nature by learning *how* to be direct from the conventions of another group of artists. Nature now is not so much seen through pictures (i.e., the picturesque), but rather pictures instruct on how to see nature for itself.

In calling this landscape "prose" in Neal's terms, I do not at all mean that there is no poetry in it. Quite the contrary. The poetry is an implied extension of the prose. The distinction here probably hinges on the degree of artificiality present in the earlier poetry. This is not artful poetry imposed on nature, but nature whose poetry has been delicately floated to the surface.

The question of Dutch influence, open though it may be, is highly important. It may fill in and clarify a vital aspect of the esthetic dialogue between Europe and America. The prose-poetry of luminism may well represent a unique mix of influence and affinity, of pictures and nature, which indeed answered the problem posed by Worthington Whittredge of an art which "might claim to be inspired by my home surroundings."

115. Fitz Hugh Lane, *Entrance of Somes Sound from Southwest Harbor, Mount Desert,* c. 1852
Oil on canvas, 23¾″ × 35¾″. Private collection. Photo courtesy Peabody Museum, Salem, Massachusetts

To be instructed by pictures on *how* to look at nature is a rarely considered art historical question. Though it is a simple and plausible idea, the concept that the American work resulted from a direct recourse to nature challenges some basic art historical theories. Most of us, as we prowl the corridors of artistic genealogies, subscribe to Gombrich's notion of art coming from art. Yet there is a basic danger for the art historian who overlooks the potential power of the natural experience per se. No matter how much we may wish to speak of artistic histories, it is important to remember that quite apart from "art" nature offers its own rich resources to the artist's eye and mind.

In America as elsewhere, this also led to those pragmatic plein-air pursuits which, as developed in France, still dominate the way we see the history of nineteenth-century landscape. The history of plein-airisme in America needs to be written. A sketch for it would include

116. Jan van Goyen, *Haarlem Sea,* 1656
Oil on wood, 15⅞″ × 21⅒″. Städelsches Kunstinstitut und Städtische Galerie, Frankfurt

117. Fitz Hugh Lane, *Sunrise through Mist:*
Pigeon Cove, Gloucester, 1852
Oil on canvas, 24¼″ × 36½″. Shelburne Museum, Vermont

many of the brilliant outdoor studies made by Durand in the early
1850's, which clearly parallel works done slightly later by Courbet;[17]
Bierstadt's studies of clouds and trees; Kensett's scumbled rocks;
Church's hurried atmospheric encounters with erupting volcanoes in
Ecuador; and the plein-air researches of Mount ("The canopy of
heaven is the most perfect paint room for an *artist*")[18] and Homer,
both of whom shared with the French impressionists an admiration
for Chevreul. Mount's comment about plein-air painting—"My best
pictures are those which I painted out of doors"[19]—fortifies Baur's ar-
gument for a native American impressionism[20] that grew also out of
tonal realist or luminist concern with light yet never quite developed
the more abstract color "pulsations" of the French tradition.

Such a study would also consider the history of the "happened-
upon" view. Bearing little resemblance compositionally to the Clau-
dian or Dutch marine modes, this view abandons the emphasis on lat-
eral edges, either framed or unframed, and brings the observer more
immediately into the depicted terrain. After the 1860's such paintings,

237

in which the scene presses the space closer to the picture plane (see fig. 119), were, in an important shift of focus, to change the size relationships of forms to picture edges. Behind such observational statistics lie substantial changes of attitude.

France

How surprising that Courbet's vanguard efforts toward a new landscape realism find parallels and affinities in the nature studies of an "unimaginative" Hudson River landscapist like Durand. Yet no one familiar with the works of both artists can deny the similarities between Courbet's weighty, heavily troweled rocks, as in *The Source of the Loue* (fig. 118) or *The Gour de Conches* (Musée des Beaux-Arts, Besançon), and the rock and tree studies of his American contemporary. In each instance, nature dictates compositional structures that find their own "natural" order; the exigencies of outdoor circumstances foster painterly spontaneity of stroke; and sensational responses to light and air shift the surface away from the smooth, flat closure of the conceptual mode toward the "breathing openness" of a more optical or perceptual mode.

The established logic of the formal canon leads us from Courbet's

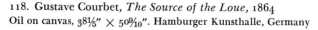

118. Gustave Courbet, *The Source of the Loue,* 1864
Oil on canvas, 38⅕" × 50⁹⁄₁₀". Hamburger Kunsthalle, Germany

work to the rock and tree studies of his fellow countryman, Cézanne; extrapolation of a similar order can be made from the studies of the American Durand, so often stereotyped as a bucolic cow painter. In subject matter, Durand's bucolic landscapes are furnished like those of such Barbizon artists as Rousseau, who, in still another variation on the theme of Dutch influence, shares similar Dutch roots. Yet the weighty economy of Durand's rocks (fig. 119) goes beyond the efforts of the Barbizon men, to link more directly to the later works of none other than Cézanne (fig. 120). This is doubtless due not to Durand's avant-gardism, of which he was totally unconscious, but to his empiricism, which responded, like Cézanne's, to the weight of objects in reality. This pragmatic emphasis on the density and weight of the object in reality is a quality that has distinguished the American tradition since Copley. Along with philosophical determinants, it impeded the development of a "pure" impressionism that would fracture both the object and the picture's surface.

In Courbet's rocks, the painterly skin is always thicker, more sensually compelling than corresponding American surfaces, regardless of their spontaneity. Courbet's rocks are weighty largely because of the heavy paint that depicts them. Durand's have weight because he takes care to cut the volume of the rocks themselves into the pictorial space in which they are set. In this spontaneous American proto-impressionism, which appears not only with Durand, but at the same time in Kensett's studies of rocks and waterfalls, paint surface is never allowed to dominate the depicted scene. For the Barbizon artist Dupré, "Nature is only the pretext. Art is the goal, passing through the individual."[21] This paramount elevation of art and its vehicle, paint, was not possible for the Americans. Durand found it necessary for the artist to keep "in due subordination the more sensuous qualities with which material beauty is invested, thereby constituting his representation the clear exponent of that *intention* by which every earnest spirit enjoys the assurance of our spiritual nature, and scorns the subtlety and logic of positive philosophy."[22] For Durand, nature—which included spiritual nature—was all. With the Barbizon men, painterly means were beginning to dominate the natural model. And positivism was crucial for Courbet. Had he known Durand's metaphysic, it would have been abhorrent to him. Courbet could not paint an angel because he had never seen one. All Durand's rocks and trees were instinct with spirit.

Thus, plein-airisme in France could lead to the erosion of the object, the abstract apotheosis of paint, and ultimately to the autonomy of art. In America, though pragmatic observation of the object in light and air led to some similarities with French plein-airisme, the fundamental respect for the object as a vessel for the ideal had to yield

119. Asher Brown Durand, *Nature Study, Rocks and Trees*, 1853–55(?) Oil on canvas, 21½″ × 17″. The New-York Historical Society

different results. Yet again, it is necessary to point out the affinities. If art historical importance is gauged by who did what when, and what was possible to whom, we must recognize that out of their own empirical relation to nature the Americans reached a point similar to that approached by Courbet, en route to Cézanne. Such intersections are of great art historical interest. That the Americans' spiritual guidelines resulted in a different end product, and thus a different assessment of their position, does not detract from their achievement.

American plein-airisme makes a contribution to Western plein-airisme because it was indigenous, not imported, growing out of a

similar response to objects seen outdoors. It came from a need to draw on the experience of nature, rather than on pictures. And since, interestingly enough, it also drew on a long tradition that insisted on the weightiness of the object in reality, it looked beyond impressionism to the post-impressionism of a Cézanne, a short-circuit that favored the American sensibility.

Extending the concept of affinity further into the century, we are struck by the way in which some of these constants within the American tradition continue to dominate. Though Homer's croquet pic-

120. Paul Cézanne, *Pines and Rocks (Fontainebleau?)*, 1896–99
Oil on canvas, 32" × 25¾". The Museum of Modern Art, New York, Lillie P. Bliss Collection

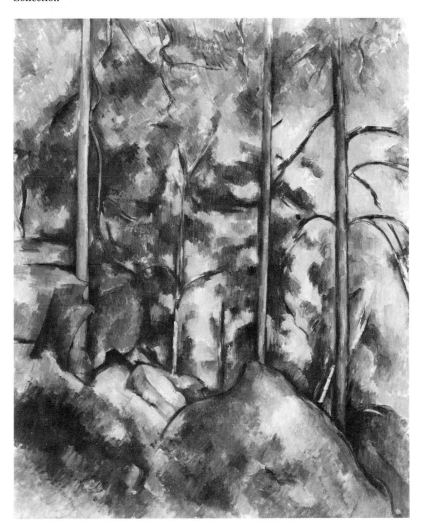

tures of the mid and late 1860's (fig. 121) can be compared with the
early works of Monet,[23] the basic empiricism already cited may ac-
count for his need to preserve the tactile identity of objects. Optical
knowledge, based more exclusively on sensations, never seems to have
satisfied the American sense of "reality." We can justifiably say, I
think, that Homer belongs to a post-Darwinian generation that had
largely abandoned the earlier metaphysical idealism, and that his
matter-of-fact realism is a good deal more in accord philosophically
with Courbet than was Durand's ostensibly objective realism. Yet
more than his European colleagues, Homer maintains the American
appetite not only for the solid identity of each object, but for weighted
space, nourishing a careful correspondence to the three-dimensional
world we live in. All this despite those tendencies toward flatness and
surface that also unite him to the new developments in France.

Homer's art also has resonances, just at this moment, with the
works of the Macchiaioli in Italy—especially with the figures in land-
scape of Silvestro Lega, Cristiano Banti, Giovanni Fattori,[24] and re-

121. Winslow Homer, *The Croquet Match*, c. 1868–69
Oil on board, 9¾″ × 15½″. Hirschl and Adler Galleries, New York

122. Federico Zandomeneghi, *Along the Seine,* 1878
Oil on canvas, 6⅞″ × 11″. Galleria d'Arte Moderna di Palazzo Pitti, Florence

lated artists such as Federico Zandomeneghi. Zandomeneghi's art, in
works like *Along the Seine* (fig. 122) of 1878, has a classic planarism
that relates not only to Homer but to the luminist tradition of which
Homer is sometimes a part.[25] Can we speculate here that the long
classic Italian tradition may unite these Italian works with an Ameri-
can art distinguished by planar and classic elements from the outset?
In the nineteenth century both traditions, for all their involvement
with plein-airisme at the moment I am discussing, have perhaps a
basic provincial tendency toward conceptualism. Removed from a
mainstream that, in Gombrich's terms, is testing other formulae for
"matching" reality, do they not share the similar "look" of good
provincialism?

England

The formulae tested by the mainstream (French art) came to some ex-
tent from England—from the painterly essays of Constable, so impor-
tant to the Barbizon men, and to Delacroix in the 1820's and 1830's.[26]

243

Constable's plein-airisme mimicked the idea of the transitory effect in the fleeting action of paint, the ruggedly tactile surface which could detach itself from nature at the same time that it described it. What the French took from Constable moved them increasingly toward the autonomy of the *means*—of paint itself.

To the Americans, Constable offered less. What effect he had seems tied to his empiricism. Durand especially admired Constable's cloud studies when he saw them at Leslie's in 1840. Citing their "naturalness and beauty of effect,"[27] he was doubtless also impressed by their pragmatic bent. There are some affinities between Constable's objective natural observations and the Americans' studies of trees, rocks, and clouds. As we know, Constable's skies form an interesting link through Luke Howard between the Americans and Goethe.[28] Constable admired Wordsworth, as did the Americans, and paid some lip service to the idea of landscape as scripture.[29] For all this, I cannot help feeling—though further research may not bear this out—that Constable's analytical scientism, and an objectivity quite subjective in its painterliness, removed his methods and results from any strong affinity with or influence on the Americans.

Nonetheless, the English landscape tradition touched the Americans in significant ways. The English eighteenth-century painters fortified the Americans' awareness of both Claude and the Dutch. The lineage of Claudian and Dutch motifs in America can be traced through such eighteenth-century English works as the ideal landscapes of George Lambert and the marine paintings of Samuel Scott and, as suggested earlier, Charles Brooking. In the nineteenth century, both Constable and Turner transformed that lineage into something uniquely their own.[30] We can find transformations of similar significance within the American tradition.

Far more than Constable's, Turner's effect in America can be specifically documented. His art, like Constable's, was a touchstone for the development of French impressionism,[31] and his reconciliation of light and color in a single operation paralleled that of Delacroix.[32] Turner's coloristic concerns also linked him to Goethe, whose *Theory of Colours* he annotated in the 1840's, and which he may have known as early as the 1820's.[33] He responded to Goethe's treatise with at least two paintings, *Light and Colour (Goethe's Theory;* fig. 123) and *Shade and Darkness.*[34] Constable's plein-air empiricism may have helped free the naturalist urges of the Barbizon men; but in the teleological progress toward impressionism, Turner must be given credit for a further adumbration of the autonomy of paint and color. Ironically, the American heir to his suggestive revelations may have been Whistler, who seems not to have liked him.[35] Given the paradoxes of human behav-

123. J. M. W. Turner, *Light and Color (Goethe's Theory)—
the Morning after the Deluge—Moses Writing the Book of Genesis,* 1843
Oil on canvas, 31″ × 31″. Tate Gallery, London.

ior, it is not surprising that Turner's ardent champion, Ruskin, was
blind to Whistler.[36]

At all events, the expatriate Whistler bore little resemblance to the
American landscapists who preceded him. Unlike Ruskin, they had
difficulty accepting Turner's abstraction, though there was just enough
of the ideal in him to appeal to that pole of the American sensibility.
They valued most of all, perhaps, the Turner they knew through the
engravings of the *Liber Studiorum* (fig. 124). Church, whom David
Huntington linked to Turner's "cosmic breadth," seems to have known
him mainly through this channel, and through the eloquent descrip-
tions of Ruskin's *Modern Painters.*[37]

Roger Stein points out that "Americans of 1848 were not on the
whole very concerned with either Turner's painting or the defense of
his reputation—and even Ruskin's writings would not basically alter

124. J. M. W. Turner, *Inverary Pier, Loch Fyne:*
Morning (Liber Studiorum 35), 1811
Etching, aquatint, and mezzotint. British Museum, London

their indifference in this respect."[38] Yet the artists took Ruskin seriously. Even before the publication of *Modern Painters* I in 1843, they had discovered Turner. Allston went so far as to claim that Turner had "no superior of any age" and advised Cole, through a mutual friend, to get a copy of the *Liber Studiorum*. Allston himself did not own a copy, and had not even seen one by 1827, but he noted that "coming from *him,* I know what it must be."[39]

Cole shared Allston's admiration and was obviously influenced by Turner's *Building of Carthage* (as well as by Claude) for the central picture, *Consummation* (see fig. 6), in *Course of Empire*. Perhaps we can talk here of Claude redux. But Cole felt strongly that Turner's later works were "the strangest things imaginable . . . as far as respects colour (colour independent of truth of representation), they are splendid; but as the Greeks have said, The most brilliant composition

of colours is nothing better than a gaudy show, dazzling the eye for a moment, but passing afterward disregarded. To this colouring let the painter add the solid beauties of design and sentiment, and he will convert an empty amusement of the eye into an elegant entertainment of the Fancy."[40]

Insofar as Turner's art was poetic rather than analytic, his evanescent abstraction could to some extent be accommodated by an American taste that had already accepted Allston's reveries. Yet Turner's "artificiality" collided with an American bias against mannerism that had also afflicted Cole, a much less serious transgressor. The American insistence on the solid integrity of form looked askance at Turner's filmy dissolutions.

Despite this, he had his American heirs. Durand, having first found him "factitious and artificial" (during that same 1840 visit to Europe when he encountered Constable's works), later claimed, as we have seen, that Turner's skies "approached nearer to the representation of the infinity of Nature than all that have gone before him."[41] Cropsey too, in the cloud essay of 1855, praised Turner's skies.[42] How influential had Ruskin's words been by then?

Ruskin himself received copies of Turner's paintings as votive gifts from artists: among them the American John Henry Hill, who copied Turner in 1864 and 1865 (fig. 125).[43] Sanford Gifford, who admired Ruskin early on, was torn between a distaste for Turner's indefiniteness and an admiration for his light, color, and imagination. When Gifford's good friend Thomas Hotchkiss saw Ruskin's Turners in 1860, he especially admired the watercolors, which he found "more quiet and united in idea and less ambitious." Hotchkiss specifically referred to the "delicacy, breadth and unity" of the Turners, as well as to the color. Though on this visit to London shortly after his arrival in Europe Hotchkiss saw "several pictures by William Holman Hunt and Rosetti [sic] and several landscapes by young men of whom I have never heard which are fine," he felt that "except Turner our painters have done more in landscape than the English." For Hotchkiss, Turner was "to my feeling the greatest of all painters."[44]

The American artists who traveled abroad after the mid-century, studying and copying Turner's paintings, and especially the watercolors (which offered different lessons from the engravings of the *Liber Studiorum*), were distinguished, like Hotchkiss, for their delicate painterly handling of light. William Trost Richards, who early on (1854) cited the influence of Cole and Turner in "the purposes and principles of landscape expression," returned to Turner throughout his career. In 1878, he was still "trying to digest anew the Turners and the Sir Joshua Reynolds, and the Claudes."[45]

Since Turner's rivalry with Claude was so much at the root of some

125. John Henry Hill, *Coblentz after Turner*, c. 1864
Watercolor on paper, 2�5⁄16″ × 3⅝″. Private collection

of his work, one wonders how much the Claudian element in Turner augmented the American concern with him. The Turner influence came a little too late perhaps to feed the Claudian obsession. By the mid-century he had more to offer the Americans than a simple fortification of Claudian sublimity. He offered a more rhetorically painterly sublime, which seems to have struck its strongest affinity with Frederic E. Church. Affinity here seems at least as important as influence. Turner and Church genuinely shared a sense of the older sublime that drew them to such awesome subjects as volcanoes. Niagara, which brought Church such renown, seemed to Turner, who never visited America, the greatest wonder in nature.[46] These fascinations attest also to their mutual concern with contemporary science, and with the new awareness of nature's "unity." Yet the greatest resemblance between them was, I think, their enveloping, all-consuming light.

That light, which prompted critics of both to allude to primeval beginnings, was, however, similar *and* different. Like the French to whom he was to mean so much, Turner's light was initially and pre-

dominantly paint. The "substance" of paint (the means) comprised his light, was equivalent to it, and somehow managed to be both Apocalypse and paint at the same time. With Church, the Apocalypse came first. Though he left his "labor trail"[47] on the surface of the canvas, paint never displaced spirit. Beside Turner he emerges, for all the dazzling brilliance of his atmosphere, as a devout American artist who still put nature (and God) before art (see fig. 25). His exact crystalline foregrounds often belie the controlled painterliness of his atmospheric distances. He managed to have it both ways—as Jarves said, to "idealize in composition, and to materialize in execution."[48] Turner's vivid *skin* of paint found a more genuine parallel in Ryder at the end of the century than in any of the mid-century landscapists.

Yet they were frequently compared with him. The *London Art Journal* for October 1859 claimed that "the mantle of our greatest painter" (Turner) had fallen on Church "more than any other."[49] James Hamilton, who until his trip to London in 1854 was affected primarily, as far as we can tell, by Turner's engravings,[50] afterwards absorbed some of Turner's feeling for paint. Like Thomas Moran, who learned so much from him, Hamilton was often called the American Turner. Moran, like Church, indulged too much in specific detail to deserve the title, yet his interest in Turner was life-long. He studied Turner in the *Liber Studiorum*, first copied his paintings in 1861, and frequently doused his own works with a golden sauce that may well have derived from Turner.[51] Yet never, with any of these Americans, does paint become what it clearly was for Turner, the primary life substance of the painting. As to affinity of intent, Church was perhaps closest: in his light, as in Turner's, shines both Revelation and Creation.

Yet even the most painterly Americans at mid-century could not absorb Turner's emphasis on the means of art, any more than they could produce French-type impressionism. Art could never mean more to them than God's world. As acolytes of nature, they were always more discreet about how they disintegrated that world and, even in the midst of dazzling atmosphere, they tried to preserve its fundamental semblance in as much recognizable detail as was feasible. Detail clarified and formulated the vessel in which God's spirit was stored—Emerson's fact as "the end and issue of spirit." Perhaps this is why we can find more obvious similarities to the Americans in a later generation of English artists, their pre-Raphaelite contemporaries of the 1850's and 1860's.

The polished surfaces and the industrious respect for the minutiae of nature have affinities with American landscapes, particularly in the intricate studies of vegetation. The Pre-Raphaelites were involved in a kind of morality of the difficult. As Henry James put it: "When the English realists 'went in,' as the phrase is, for hard truth and stern

fact, an irresistible instinct of righteousness caused them to try and purchase forgiveness for their infidelity to the old more or less moral properties and conventionalities by an exquisite, patient, virtuous manipulation—by being above all things laborious."[52] The Americans seem to have made such industry an even more direct votive gesture, serving nature-as-Deity in laborious dedication. They were more concerned with revealing a morality in nature itself (Emerson's "thought which is . . . good").[53] One senses that the Pre-Raphaelite Brotherhood was more concerned with the moral qualities of art and artist. Laborious art-making endowed the artist and his products with moral superiority. This underlines the selflessness with which American artists regarded even the process of artistic labor. The ends to which they were committed did not reflect the artist's own moral glory, but God's moral glory as revealed in nature.

At this moment, of course, Ruskin's influence was extensive on both sides of the Atlantic. Stein points out that in America "the Pre-Raphaelites were usually associated with Ruskin's name after the publication of his pamphlet in 1851, but the reverse was not necessarily the case."[54] The American painters seem to have taken from Ruskin certain pragmatic advice that suited their journeyman sensibilities. They already spoke his moral and spiritual language even more eloquently than his British confrères. He served them best when he verbally articulated that language for them.[55]

The term Pre-Raphaelite, often rather broadly used in American criticism at mid-century, always implied careful detail. Tuckerman writes of Kensett,

In some of his pictures the dense growth of trees on a rocky ledge, with the dripping stones and mouldy lichens, are rendered with the literal minuteness of one of the old Flemish painters. It is on this account that Kensett enjoys an exceptional reputation among the extreme advocates of the Pre-Raphaelite school, who praise him while ignoring the claims of other American landscape-artists. But this fidelity to detail is but a single element of his success. His best pictures exhibit a rare purity of feeling, an accuracy and delicacy, and especially a harmonious treatment, perfectly adapted to the subject.[56]

Tuckerman had hit on an important difference between the PRB and the Americans. The PRB seems to have taken literally Ruskin's injunction to paint as many ideas into a picture as possible.[57] Their works differed from the Americans in their horror vacui, their Victorian clutter. Despite their passion to clarify detail, the Americans —especially the luminists—avoided this. They often stressed effect as much as detail, and ordered their space with an intrinsic classicism that made for smooth transitions in an unencumbered pictorial terrain. The PRB also rarely achieved the gleaming luminosity that halates American landscape.

126. John Brett, *Morants Court in May,* 1864
Oil on canvas, 17½" × 27½". Collection Mr. and Mrs. Allen Staley

Despite this, there are some rather striking affinities. John Brett's *Massa, Bay of Naples* (fig. 128), with its calm water and sun-dappled hills, has something of the quality of Gifford's *Mount Hayes* (fig. 127). Brett too, occasionally makes use of the "weighted" space so familiar in the American tradition, as in *Morants Court in May* (1864; fig. 126). The horizontal extension of Brett's *The British Channel Seen from the Dorsetshire Cliffs* (1871; fig. 129) obviously compares to American luminism; it also relates to Friedrich's studies of Rügen (fig. 130). Dyce's *Pegwell Bay, Kent—a Recollection of October 5, 1858* (fig. 131) also offers a striking comparison with luminism in the handling of the water and rocks.

Yet the divergent moral premises counter the formal similarities. More than with the Americans, science seems to have outweighed sentiment for some members of the PRB. Though William Michael Rossetti found Courbet's brusque realism wanting, claiming he had only a "half grasp of realism,"[58] and though Rossetti was concerned, as Allen Staley noted, with "the sentiment of things as well as their ap-

251

127. Sanford Gifford, *Mount Hayes*, undated
Oil on canvas, 30½″ × 54″. The Vose Galleries, Boston

128. John Brett, *Massa, Bay of Naples*, 1873
Oil on canvas, 25⅛″ × 40⅛″. Indianapolis Museum of Art

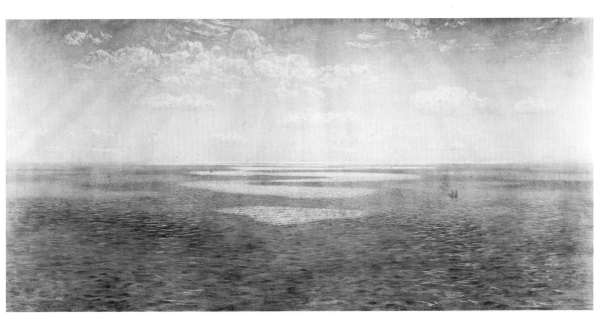

129. John Brett, *The British Channel*
Seen from the Dorsetshire Cliffs, 1871
Oil on canvas, 41¾″ × 83¾″. The Tate Gallery, London

130. Caspar David Friedrich, *Shore with Rising Moon*, c. 1835–37
Pencil and sepia on paper, 9″ × 13⁹⁄₁₀″. Kupferstich-Kabinett, Staatliche Kunst-sammlungen, Dresden

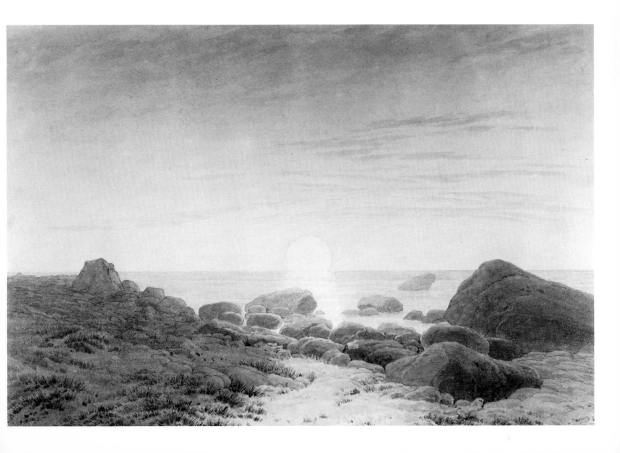

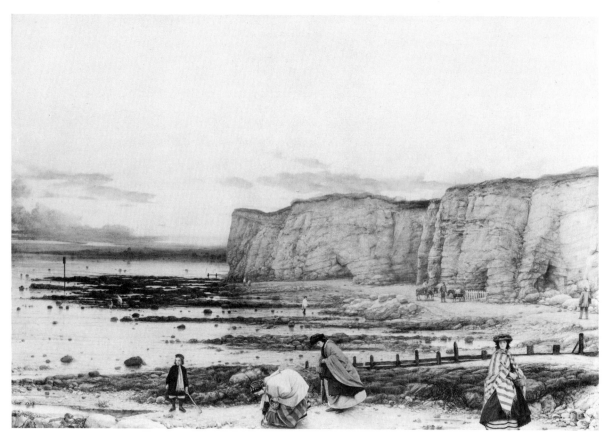

131. William Dyce, *Pegwell Bay, Kent—*
A Recollection of October 5th, 1858, c. 1860
Oil on canvas, 24½″ × 34½″. The Tate Gallery, London

pearance,"[59] sentiment may have been less important for the PRB than it was for the Americans. Ruskin, who was greatly admired by Brett, liked Brett's *early* work, but eventually faulted him for "absence of sentiment." Brett's *Val d'Aosta* (private collection) was not "in the strong, essential meaning of the word, a noble picture. It has a strange fault, considering the school to which it belongs—it seems to me wholly emotionless. I cannot find from it that the painter loved, or feared, anything in all that wonderful piece of the world. There seems to me to be no awe of the mountains there—no real love of the chestnuts or the vines. . . ."[60] "Sentiment," "love," or if necessary "awe" would elevate landscape painting to the "nobility" Ruskin valued. That nobility was also prized by the Americans, who served him better in spirit than some of his own countrymen. Though Brett may be an extreme example within the PRB circle, his splendidly anti-romantic comment "Sentiment in landscape is chiefly dependent on meterology"[61] empha-

254

sized cool science in a way that distinguished it from the more overt idealism of the Americans. For affinities here, we have to look elsewhere, to the Germans and to the Scandinavians.

Germany and Scandinavia

When considering American and German landscape painting, scholars usually stress the Düsseldorf influence, especially in the 1850's and 60's.[62] Whittredge, Haseltine, Bierstadt, James MacDougal Hart all studied in Düsseldorf. Direct connections between their works and their German "masters" can certainly be cited. Some of Whittredge's works resemble those of his painting companion Carl Lessing, whose studio was a gathering place for Americans in Düsseldorf.[63] Whittredge, like Haseltine and Bierstadt, also admired the rather inaccessible Andreas Achenbach.[64]

But the Düsseldorf influence has always seemed to me a bit overstressed. Though Lane, in faraway Gloucester, knew what the Düsseldorf school was doing,[65] it is misleading to assume that American landscapists needed Düsseldorf, or for that matter Biedermeier,[66] to encourage their fixation on detail. Emphasis on detail was part of the American esthetic long before the Düsseldorf influence.

There are more striking affinities with the Dresden circle of Caspar David Friedrich—Germans and Scandinavians whose attitudes to nature and to picture-making in many ways paralleled those of the Americans. Friedrich is surely the single European landscapist whose sensibility most closely matches that of the Americans. Some of his quiet sea pictures (see fig. 130) coincide with works by Lane and Heade; his lone trees, mists, and sky studies are echoed in Bierstadt (figs. 132, 133); his allegorical landscapes relate to Cole (fig. 134); his ice pictures, such as *The Polar Sea* (fig. 135), to Bradford (fig. 136) and Haseltine (fig. 137); his sailing boats to Allston and Lane (figs. 138, 139). Since Düsseldorf (Bierstadt was born nearby) owed some artistic debts to Dresden, we can naturally cite similarities between the Düsseldorf-trained artists Bierstadt and Haseltine and the earlier Friedrich. But influence here seems very far from the point. Friedrich's affinity with the Americans is as much philosophical as formal. When his art is placed beside theirs, common attitudes to the world and to picture-making create a striking "resemblance."

Unexpectedly, he shares their primitivism. If we fail to recognize Friedrich's primitive "root" we cannot really understand his art, let alone his affinities with the Americans. By primitivism, I mean a strong tendency to the linear and the flatly planar, an abstractness which maintains (even more than the American works) the mat quality of paint, a frequent recourse to overall emphasis of parts, and an inherent bias toward draftsmanship, toward "colored drawings" rather

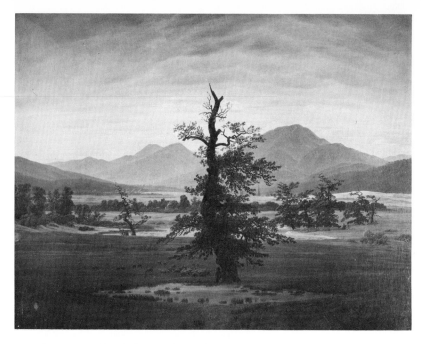

132. Caspar David Friedrich, *The Solitary Tree*
(*Village Landscape in the Morning Light*), c. 1822
Oil on canvas, 21½″ × 28″. Nationalgalerie, Staatliche Museen Preussischer Kultur-
besitz, Berlin

133. Albert Bierstadt, *Ascutney Mountain, Vermont,*
from Claremont, New Hampshire, 1862
Oil on canvas, 40⅒″ × 70½″. Fruitlands Museum, Harvard, Massachusetts

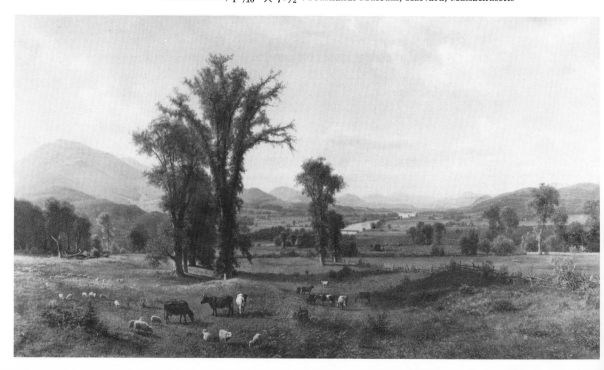

134. Caspar David Friedrich, *Skeletons in the Stalactite Cave*, c. 1834
Pencil and sepia on paper, 7⅕″ × 10⅖″. Hamburger Kunsthalle, Germany

135. Caspar David Friedrich, *The Polar Sea*, c. 1824
Oil on canvas, 37⁷⁄₁₀″ × 49½″. Hamburger Kuntshalle, Germany

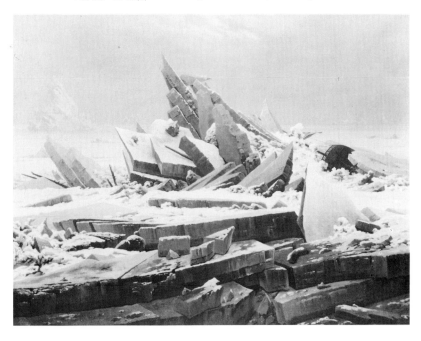

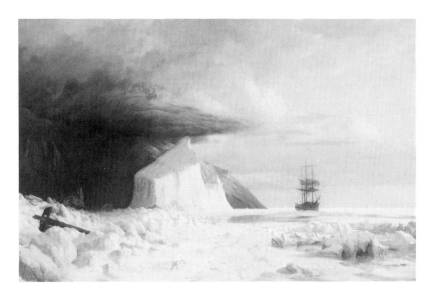

136. William Bradford, *An Arctic Summer, Boring Through the Pack Ice in Melville Bay*, 1871
Oil on canvas, 51¾″ × 78″. Private collection. Photo courtesy Metropolitan Museum of Art, New York

137. William S. Haseltine, *Rocks at Nahant*, 1864
Oil on canvas, 21″ × 39″. Private collection

138. Fitz Hugh Lane, *Study for Brace's Rock, Eastern Point,* 1863
Oil on paperboard, 5¼″ × 8½″. Private collection

139. Caspar David Friedrich, *Mist,* 1807
Oil on canvas, 13½″ × 20³⁄₁₀″. Kunsthistorisches Museum, Neue Galerie, Vienna

than paintings. The primitivism is also revealed in small gaucheries, often in abortive attempts to dissolve linear boundaries in atmosphere. The careful enclosure of image by line has little to do with the sensual and optical, but much to do with "idea." The Americans' ideational root came out of a strong folk or "primitive" tradition, which tempered the sophisticated academic line throughout the nineteenth century.

Friedrich gives scant but provocative evidence of his connection to a similar tradition. His earliest works before he attended the Copenhagen Academy are devotional texts (fig. 140) adorned with linear bird creatures reminiscent of American fractur drawings, or perhaps of Scandinavian folk art. It is rarely stressed that Greifswald, where Friedrich was born, remained a part of Sweden until 1815, when it was ceded to Prussia.[67] Also, Suzanne Latt Epstein has noted that the Copenhagen Academy, where Friedrich studied from 1794 to 1798, had strong connections to the craft and folk arts.[68]

There are also obvious formal similarities between the works of such Danish artists as Christen Købke and Christoffer Wilhelm Eckersberg and those of the Americans—similarities that underline the significance of Friedrich's Scandinavian origin and training. Købke's *Frederiksborg Castle* (fig. 141) is dominated by mirror-smooth reflections that recall luminist seascapes or such luminist genre-landscapes as Mount's *Eel Spearing at Setauket* (fig. 142). His *Lakeside near Dosseringen* (1838; fig. 143) looks forward, in its geometric simplicity,

141. Christen Købke, *Fredriksborg Castle,* 1835
Oil on canvas, 26⁹⁄₁₀″ × 39⁴⁄₁₀″. The Hirschsprung Collection, Copenhagen

smooth surface, and handling of light, to Eakins's *Biglin Brothers Turning the Stake* (1873; fig. 144). Eckersberg's *View from Trekroner* (fig. 145) again has the simplicity of Eakins, or some of the quiet geometry of Homer. His *Section of Nyholm* (fig. 146) relates to Lane in structure, theme, handling of detail, light, and even time, as do others of his sea pictures. His cloud studies clearly echo similar studies by Bierstadt.[69]

Many questions pose themselves here. How much are these affinities due to similar attitudes toward "picture-making"? It has long seemed to me that the similarities between Scandinavian and American art in the nineteenth century are rooted in the importance of each country's vigorous folk art. The conceptual focus and impersonal hand of a strong folk tradition runs parallel to, and tempers, the more sophisticated tradition, in both America and Scandinavia. The sophisticated tradition is further conditioned by the strong neoclassical controls de-

261

142. William Sidney Mount, *Eel Spearing at Setauket*, 1845
Oil on canvas, 29″ × 39″. New York State Historical Association, Cooperstown

143. Christen Købke, *Lakeside near Dosseringen*, 1838
Oil on canvas, 20⁷⁄₁₀″ × 28¹⁄₁₀″. Statens Museum for Kunst, Copenhagen

144. Thomas Eakins, *Biglin Brothers Turning the Stake*, 1873
Oil on canvas, 40¼″ × 60¼″. Cleveland Museum of Art, Hinman B. Hurlbut
Collection

veloped by the academies here and abroad (compare Abildgaard in
Denmark, Allston and West in America and England).

Friedrich's linearity has been considered a result of his neoclassic
training with Abildgaard in Copenhagen. But that neoclassicism may
have been tempered by the Scandinavian folk tradition. If so, we have
a similar situation, formally, to that which nourished the Americans.
Friedrich's methodology was sometimes strikingly similar to that of
the Americans. Like the luminists he most resembles, he relied strongly
on measure, numbering off areas in his drawings, using rulers to con-
trol his horizons, compasses to insure the circularity of his moons, and
probably the camera lucida or obscura to render landscape contours.
Knowledge and measure directed his effects more than optical sensa-
tions. Yet like the luminists, he converted a conceptual concern that
is largely technical (picture-making) into a conceptual philosophy (or
vice versa). His pursuit of the inner image, shared with the folk artist,

145. C. W. Eckersberg, *View from Trekroner*, 1836
Oil on canvas, 8⅖″ × 11⁹⁄₁₀″ The Hirschsprung Collection, Copenhagen

146. C. W. Eckersberg, *Section of Nyholm*, 1826
Oil on canvas, 7⅕″ × 11⁷⁄₁₀″. The Hirschsprung Collection, Copenhagen

becomes a philosophical voyage toward an inner knowledge of reality, such as we encounter with the luminist Lane and the visionary Cole.

"Close your bodily eye," wrote Friedrich, "so that you may see your picture first with the spiritual eye. Then bring to the light of day that which you have seen in the darkness, so that it may react upon others from the outside inwards."[70] This stress on interior process was not too far from Cole's separation of optical reality from inner reality. Cole used the winnowing processes of memory and time: ". . . you never succeed in painting scenes, however beautiful, immediately on returning from them . . . I must wait for time to draw a veil over the common details, the unessential parts, which shall leave the great features, whether the beautiful or the sublime, dominant in the mind."[71] Cole always tried to get "the objects of nature, sky, rocks, trees, etc. as strongly impressed on my mind as possible, and by looking intently on an object for twenty minutes I can go to my room and paint it with much more truth than I could if I employed several hours on the spot."[72] This insistence on Mind, aspiring toward the Ideal, touched on Friedrich.

For Cole, this ideal was a kind of Reynoldsian Platonism achieved through memory; for Lane it was something held in memory. On one occasion at least, it was the memory of a picture seen in a dream: "The dream was very vivid and on awakening I retained it in memory for a long time. The effect was so beautiful in the dream that I determined to attempt its reproduction, and this picture is the result. The drawing is very correct, but the effect falls far short of what I saw, and it would be impossible to convey to canvas such gorgeous and brilliant coloring as was presented to me. This picture, however, will give to the beholder some faint idea of the ideal."[73]

For Lane, as for Cole and Friedrich, the ideal also had strong spiritual overtones. Friedrich maintained: "You should keep sacred every pure impulse of your mind; you should keep sacred every pious sentiment; because that is art in us! In an inspired hour she will appear in a clear form, and this form will be your picture!"[74] In Friedrich and Cole, "pious sentiment" received more overt allegorical service than in Lane. Anyone familiar with Cole's *Voyage of Life* will recognize the philosophical and symbolic similarities to Friedrich's *Times of Year*. A text on the latter, by Friedrich's close friend, G. H. von Schubert, opens with the purity of childhood: "We awake among flowers by the clear source of life, where the eternal sky is mirrored in its virgin purity."[75] In Cole's painting of *Childhood* (see fig. 11) for *Voyage of Life,* the "rosy light of the morning, the luxuriant flowers and plants" are, in Cole's own description, "emblems of the joyousness of early life."[76] Friedrich's protagonist is carried along the river until

"the inner striving has grown weary on the last part of the path which was full of rocks and crags . . . on this side of the river a place of rest is found beneath the cross which rises peacefully above the cliffs. At last the mind understands that the abode of that longing which has guided us so far, is not here on earth. Speed on then, river, down your way! Where your waves flow into the infinite sea on a far distant shore we have heard of a last place of rest."[77]

In Cole's *Manhood* (see fig. 13), Friedrich's "rocks and crags" are "bare, impending precipices" that "rise in the lurid light. The swollen stream rushes furiously down a dark ravine. . . ."[78] In *Old Age* (see fig. 14), Cole's voyager "looks upward to an opening in the clouds, from whence a glorious light bursts forth; and angels are seen descending the cloudy steps, as if to welcome him to the Haven of Immortal Life."[79] More than Cole's verbal broadside, the painting *Old Age* underscores the similarity to Friedrich's concept. After the turbulence of *Manhood,* the quiet horizontal calm of the river has become Cole's equivalent to Friedrich's "last place of rest."

Cole tried to raise landscape to the level of history painting—while lamenting that the public would never understand the philosophy behind his paintings. Friedrich sought an allegorical landscape that would incorporate his most "pious sentiment." One of the most sensitive writers of the Dresden circle, Ludwig Tieck, recognized Friedrich's intention when he wrote: ". . . He tries to introduce allegory and symbolism in light and shadow, living and dead nature, snow and water, and also in the living figures. Indeed, by means of a definite clarity in his ideas and a purposefulness of his imagination, he attempts to lift landscape above history and legend. . . ."[80]

In this deliberate symbolism, Friedrich goes further than the Americans; only Cole's philosophical series begin to offer parallels. For the Americans by and large, nature was by definition already Christian and spiritual: it was, by a priori understanding, read and interpreted as a biblical text. The insertion of a cross on the mountain was rarely necessary (figs. 147, 148). Indeed, the Americans would have agreed with Emerson that "mysticism consists in the mistake of an accidental and individual symbol for an universal one."[81] The difference between Friedrich and the Americans lies in the *specific* allegorical meaning attached by Friedrich to the landscape, a meaning compounded by a deliberate theatricality of presentation. The Friedrich literature makes much of the way in which certain aspects of nature are elevated to symbols.[82] Mountains, for example, are said to stand for the divine. But with the Americans, mountains *are* the divine. The once-removed nature of symbolism is thereby short-circuited.

The Americans have clear affinities with the Germans in their erasure of ego, entry into the infinite, and search for a universal quietism—

147. Caspar David Friedrich, *The Cross in the Mountains*, 1808
Oil on canvas, 44⁹⁄₁₀″ × 43½₀″. Staatliche Kunstsammlungen, Dresden

Emerson's "serene, inviolable order." As Emerson's library lists elo-
quently testify,[83] the American transcendentalists were exposed early
to German philosophy. How much they were directly influenced by
German ideas, which also arrived via Coleridge and Carlyle, and how
much these ideas fortified their own inclinations, as Stanley Vogel
suggests, is still a matter of conjecture.[84] However, the philosophical
connections between Goethe's "The works of nature are ever a freshly
uttered word of God," which Emerson quoted in his journal, and
Emerson's own "The noblest ministry of nature is to stand as the ap-
parition of God"[85] clearly underlie some of the formal similarities be-
tween the paintings. Indeed, the philosophical parallels, crucial to the
affinity between Friedrich and the Americans, are legion. The textual
evidence indicates an extraordinary number of congruent ideas, par-
ticularly between Emerson, who can now be seen as the unofficial

148. Frederic Edwin Church, *Blue Mountains, Jamaica*, c. 1865
Oil on canvas, 10⅝" × 17¾". Olana Historic Site, New York Department of Parks

spokesman for the American landscapists,[86] and Carus, Friedrich's friend, biographer, and theoretical spokesman. Emerson's famous passage in *Nature*—"I become a transparent eyeball; I am nothing; I see all; the currents of the Universal Being circulate through me; I am part or parcel of God"[87]—has direct affinities with Carus. Carus's man senses the "immense magnificence of nature, feels his own insignificance, and feeling himself to be in God, enters into this infinity and abandons his individual existence . . . his surrender is gain rather than loss. What otherwise only the mind's eye sees, here becomes almost literally visible: the oneness in the infinity of the universe."[88] Carus sounds the transcendental and luminist concern with quietism when he speaks of the feeling of "quiet devotion within you; you lose yourself in boundless space; your whole being undergoes a quiet refining and cleansing; your ego vanishes; you are nothing; God is all."[89]

The formal differences can also be traced back to certain philosophical roots. Though Schelling's *Naturphilosophie* surely had its effect on the development of an American nature attitude, his stress on "pure ideas" again cues our understanding of the difference between Fried-

rich and the Americans. Schelling suggested that the artist "must . . . withdraw himself from the product [actual nature], from the creature, but only in order to raise himself to the creative energy and to seize them spiritually. Thus he ascends into the realm of pure ideas; he forsakes the creature, to regain it with thousandfold interest, and in this sense to return to nature."[90]

Schelling's withdrawal "into the realm of pure ideas" incorporated the ideal and the real (i.e., his *actual*) in a way that differed somewhat from the Americans' practice. Like Emerson, he emphasized that truth and beauty were not opposed to, but of a piece with, the actual. But the Americans did not withdraw as completely from the actual into pure idea; they did not abandon the details of the material shell to reach "above form" for "essence, the universal, the look and expression of the indwelling spirit of nature."[91] Translated into formal terms, they did not paint as *abstractly* as Friedrich.

With Friedrich, we never lose the mat sense of the painted surface. Paint, remaining paint, keeps the forms essentially abstract—and thus ideational. The object identity that is such a potent aspect of American expression (especially in the luminist art to which he is most directly linked) is totally absent.

The Americans' respect for fact in no way hindered them from discovering within it the same spirit of nature that Schelling sought. They fully recognized that "each material thing" had its "celestial side" (Emerson).[92] But the way in which they adhered to a versimilitude of the object's surface is one of their most dramatic differences from Friedrich. In nineteenth-century America, idea could best be reached through penetration of its material enclosure. In this way, the artist's sensibility could reveal, in Ruskinian terms, the inner and outer, or "moral and material," truth.[93]

Following Schelling, Friedrich reached above form for its essence, abandoning the sensual details of the material object. In so doing, he also relinquished the brilliant light that glistens on the surface of American luminist landscapes.[94] That radiant glow is not paralleled by Friedrich's surfaces. His light effects, usually controlled in a carefully modulated middle distance, exist as color rather than as transparency (fig. 149). His mat surfaces parallel the serenity but not the crystallinity of luminism. Spirit in Friedrich's art is achieved through a surface generalization that stresses the abstract and symbolic role of form. As Schelling put it, "This spirit of nature, working at the core of things, and speaking through form and shape as by symbols only, the artist must follow with emulation; and only so far as he seizes this with vital imitation has he himself produced anything genuine."[95] In a painting by Lane, on the other hand, the inner spirit announces itself more vehemently through a brilliance deliberately heightened to

149. Caspar David Friedrich, *View of a Harbor*, c. 1815
Oil on canvas, 35⅒″ × 27⅞₁₀″. Staatliche Schlösser und Gärten, Potsdam-Sanssouci

pierce the outer husk of material detail (fig. 150; color). As Emerson had it: "There is no object so foul that intense light will not make beautiful."[96] For Friedrich then, spirit is abstract. For the luminists, spirit is light. Though for both, the material world represented something higher, the more conscious emphasis on symbolism in the German work enters an arena of allegorical iconography rarely touched by the Americans.[97]

The subjective nature of this iconography further separates it from the American works. In American and German transcendental phi-

losophy and art there is a strong emphasis on the elimination of ego. But, despite his even surfaces, Friedrich introduces ego once again. He does this by stressing a symbolic iconography which imposes his own "meaning" on the face of nature, and by insisting on the artist's "feeling" as a guiding "law."[98] Friedrich tells his students: "Respect the voice of nature in yourselves."[99] He sees "the heart" as the "only true source of art"[100] and suggests that "a painter should not merely paint what he sees in front of him, he ought to paint what he sees within himself."[101] He respects subjective originality: "Whatever one may say about X's paintings, and however much they may resemble Y's, they originated in him and are his own."[102] Allston's concept of originality, and to some extent Cole's, would support this. But, in deferring to nature, American, especially luminist, art eschewed the obvious interjection of feeling (what Friedrich called "heart"). The artist's primary function was to act as a *medium* between the real and the ideal. So at the core of the American service to the real, there is often an impersonality that becomes personal *only* in its end result. This occurs when the artist, through elimination of ego, reconciles the self with the Emersonian universal spirit.

For all the similarity, then, between the mystical annihilation of the self by German nineteenth-century idealism and the abolition of ego in American transcendental philosophy and painting, for all the parallels between Emerson's Oversoul and Carus's Divine Being in nature, there is a crucial distinction in the attitude to the ego. The German maintains a situation in which the ego is both affirmed and banished. As we saw earlier (see Chapter VIII), Worringer was sensitive to this when he noted that mysticism itself contained "a peculiar state of discord": "born of individualism, it immediately preaches against its own origin."[103] The Germans remain for him the *"conditio sine qua non* of Gothic. They introduce among self-confident peoples that germ of sensuous uncertainty and spiritual distractedness from which the transcendental pathos of Gothic then surges so irrepressibly upwards."[104]

The German ego, even when striving for mystical annihilation, is somehow self-consciously present, witnessing its own tragic and human origins. Though both the American transcendentalists and the German idealists were steeped in oriental mysticism, the American ego, in Emersonian terms, was perhaps based more strongly in oriental self-lessness, in what Worringer has called a "human self-consciousness so small" and a "metaphysical submissiveness so great."[105] The American transcendentalists, affected, like their German counterparts, by mystics such as Boehme and Eckhart (as well as by the German idealists themselves) might indeed have added a still more potent dose of something akin to oriental mysticism to the American mix.

Of Emerson and the Orient, Arthur Christy notes:

It might be questioned whether Emerson was not largely influenced by Eckhart or at least that part of Western mysticism which is represented by Eckhart and Boehme. Western mysticism emphatically did influence Emerson. But it also paved the way to Hinduism, making him receptive to it, for when a thinker has reached the neti, neti stage he is above many of the frontiers and divisive boundaries of human thought. Occidental or Oriental, he feels that his limited powers cannot compass the transcendental vastness of God, yet he is humanly impelled to describe him in his own small way. The pictures he forms of the sublime, inscrutable source of the universe are necessarily inadequate. This he knows. He knows too that personality implies a distinction of the self and the not-self, and hence is inapplicable to the Being which includes and embraces all that is.[106]

The American transcendental painter approached oriental anonymity more by the retreat of the ego behind the *thing* than the German idealist, whose art became, in the twentieth century, the expressionist exaltation of the tragic self. Somehow this was attached not just to American pragmatism (always less dramatic than the German) but to an American need to equate thing and Deity without symbolic intervention. When in German art symbol intervened, feeling and subjectivity could as well. Thus one may say that in America there was a more complete elimination of ego. Expressionism in America has always been, in my view, imported. Whether traditional Puritan repression was a factor in erasing demonstrable feeling in paint is a question that might be considered. Friedrich's transcendentalism had its root in Worringer's Gothic man, for whom "everything becomes weird and fantastic"; Lane's transcendentalism related to the Puritan-Unitarian-Realist palate that Whicher identified in Emerson before he scented the "indescribable brew called modern philosophy."[107]

Clearly, American painters arrived at the American art of landscape and founded Emerson's "new order" out of an amalgam of elements only hinted at in the foregoing chapter. What emerges, I hope, is our sense of the landscape art of this period as an integral part of its moment, and of the art of the Western world. American landscape art is attuned philosophically as well as art historically to the nature attitudes of the West. The concurrent ideas of German idealism and American transcendentalism, the concepts of the ideal and the picturesque, the empirical experience itself, all find their influences, parallels, and affinities.

Out of a common debt to Claude and the Dutch the nineteenth century developed a new relation to nature that nourished the greatest efflorescence of landscape painting in the history of art. The Americans participated in the great landscape adventure with an art that grew out of its singular relation to American nature, to the artistic

traditions of Europe, and to its own developing traditions. Beside the pragmatism of Constable, Courbet, and Barbizon we can place the plein–air efforts of Durand and the Hudson River men. Beside the audacious poetry of Turner, the atmospheric effects of Church. Beside the mystic universalism of Friedrich, the luminism of Lane and the allegories of Cole. Yet, in the final analysis, what emerged was precisely what Whittredge was looking for: "something distinctive to the art of our country."

That "something" raised nature above art or ego, and subsumed self in spirit. Where the French had stressed means, the Americans stressed ends; where the Germans injected feeling, the Americans distilled it to a more impersonal essence. Nowhere in Europe was a similar emphasis placed on the "weight" of reality, an American constant that was rarely relinquished. Idea often predominated over eye in the confrontation with nature, and with the artistic conventions representing nature. Often, too, the ideational base slid quickly onto an ideal plane, frequently classicized, in luminist art especially, so that time, opened out into transitory flux by mainstream proto-impressionism, was locked into an eternal present. Empirical observation, which in France added a new positivism to existence, in America largely gave credibility to an experience that was recognizable and true at the same time that it stressed spirit.

The truths of light and atmosphere that absorbed American artists quickly served a concept of nature as God, turning landscape paintings into proto-icons. American landscape was dominated by this concept, which went further than the European philosophies that helped generate it. As with other areas of American art, the perfect solution was one that reconciled the real and the ideal, the tangible and the ephemeral, that infused the inviolate "stuff" of God's world with Godhead. Thus, the American painters were able to make of their "natural antiquity" a "new order" in landscape painting, which was one answer to the difficult resolution of the problem of nature and culture.

Notes

I *Introduction: The Nationalist Garden and the Holy Book*

1. Quoted in Leo Marx, *The Machine in the Garden* (New York: Oxford University Press, 1964), p. 210.
2. Perry Miller, "Nature and the National Ego," in *Errand into the Wilderness* (New York: Harper & Row, 1964), p. 211.
3. Ibid., p. 204.
4. Henry Nash Smith, *Virgin Land* (New York: Random House–Knopf, 1950); see Book 3.
5. R. W. B. Lewis, *The American Adam* (Chicago: University of Chicago Press, Phoenix Books, 1958).
6. See Marx, op. cit.
7. Thomas Cole, "Essay on American Scenery" (1835), in John McCoubrey, ed., *American Art, 1700–1960*, Sources and Documents in the History of Art Series (Englewood Cliffs, N.J.: Prentice-Hall, 1965), p. 102.
8. Quoted in Louis L. Noble, *The Course of Empire, Voyage of Life and Other Pictures of Thomas Cole, N.A.* (New York: Cornish, Lamport & Co., 1853), pp. 58–59.
9. Quoted in Miller, op. cit., pp. 205–6.
10. Quoted in Lewis, op. cit., p. 59.
11. Ibid., p. 61.
12. Ralph Waldo Emerson, *The Selected Writings of Ralph Waldo Emerson*, ed. Brooks Atkinson (New York: Random House, Modern Library, 1950), pp. 34, 285–86.
13. "The Over-Soul," ibid., p. 269.
14. James Jackson Jarves, *The Art-Idea* (Hurd and Houghton, 1864; reprint, ed. Benjamin Rowland, Jr., Cambridge: Harvard University Press, Belknap Press, 1960), p. 86.
15. Asher B. Durand, undated ms., Durand papers, New York Public Library.
16. Asher B. Durand, "Letters on Landscape Painting," Letter II, *Crayon* 1 (Jan. 17, 1855):34; also in McCoubrey, op. cit., p. 111.
17. Durand, "Letters," Letter III, *Crayon* 1 (Jan. 31, 1855):66.
18. Thomas Cole, "Thoughts and Occurrences," undated entry, c. 1842, New York State Library, Albany; photostat, New-York Historical Society; microfilm, Archives of American Art.
19. Cole, "Essay on American Scenery," p. 109.
20. *New York Mirror* 14, no. 17 (Oct. 22, 1856):135.
21. Henry T. Tuckerman, *Book of the Artists* (1867; New York: James F. Carr, 1966), p. 531.
22. Emerson, *Nature*, in *Selected Writings*, pp. 23–24.
23. *Crayon* 1 (1855):81.
24. *Southern Literary Messenger* 10 (1844):112.
25. Tuckerman, op. cit., p. 512.
26. Durand, Letter II, p. 34; in McCoubrey, op. cit., p. 112.
27. William Sidney Mount, quoted in John I. H. Baur, "Trends in American Painting," introduction to *M. & M. Karolik Collection of American Paintings,*

1815–1865, Museum of Fine Arts, Boston (Cambridge, Mass.: Harvard University Press, 1949), p. xxvi.

28. Quoted in Lorenz Eitner, *Neoclassicism and Romanticism, 1750–1850,* Sources and Documents in the History of Art Series (Englewood Cliffs, N.J.: Prentice-Hall, 1970), 2:26.

29. Quoted in Miller, op. cit., p. 210.

30. Quoted in Perry Miller, *The Life of the Mind in America from the Revolution to the Civil War* (New York: Harcourt, Brace & World, 1965), p. 57.

31. Ibid., p. 11.

32. Ibid., p. 13.

33. Quoted in Russel Blaine Nye, *The Cultural Life of the New Nation, 1776–1830* (New York: Harper Torchbooks, 1960); p. 219 from *Democracy in America,* ed. Phillips Bradley (New York, 1948), 1:303–4.

II *Grand Opera and the Still Small Voice*

1. Walt Whitman, preface to *Leaves of Grass,* in *The Portable Walt Whitman,* selected and introduced by Mark Van Doren (New York: Viking Press, 1945), p. 46.

2. Henry David Thoreau, *Selected Journals,* ed. Carl Bode (New York: Signet Classics, 1967), p. 50.

3. D. H. Lawrence, *Studies in Classic American Literature* (Garden City, N.Y.: Doubleday Anchor, 1951), p. 64.

4. John Francis McDermott, *The Lost Panoramas of the Mississippi* (Chicago: University of Chicago Press, 1958), p. 133.

5. Although recent studies (both published and unpublished) have begun to deal more intensively with the problem of the panorama (see Lee Parry, "Landscape Theatre in America," *Art in America,* Nov.–Dec. 1971, pp. 52–61, and *The River: Images of the Mississippi, Design Quarterly* 101/102 [Minneapolis: Walker Art Center, 1976]), progress in panorama research is badly hampered by the scarcity of extant visual material. Nonetheless, one of the most fertile areas for investigation would still seem to be the relation of the panorama format to the scale and shape of easel pictures in America.

6. Jarves, *The Art-Idea,* p. 205.

7. Tuckerman, *Book of the Artists,* p. 395.

8. Ibid., pp. 371, 375. See also below, p. 73.

9. Ibid., p. 375.

10. Ibid., p. 389.

11. Jarves, op. cit., p. 190.

12. Ibid., p. 191.

13. Ibid., p. 205.

14. Quoted in McDermott, op. cit., p. 137.

15. Tuckerman, op. cit., pp. 382–83.

16. See also ibid., p. 389.

17. Ibid., p. 372.

18. Jarves, op cit., pp. 205–6.

19. Frederick Jackson Turner, *Frontier and Section* (Englewood Cliffs, N.J.: Prentice-Hall, 1961), p. 39.

20. Ibid., p. 38.

21. Ibid.

III *Sound and Silence: Changing Concepts of the Sublime*

1. Samuel H. Monk, *The Sublime* (1935; Ann Arbor: University of Michigan Press, Ann Arbor Paperbacks, 1960).

2. See Edmund Burke, *A Philosophical Enquiry into the Origin of Our Ideas of the Sublime and Beautiful* (1757). Ernest Tuveson has stressed the importance of the divine in the "natural sublime" of the seventeenth century. But it is significant for my hypothesis that Deity here is associated with vastness of space, and that "the sublime of nature" is characterized as "an aesthetic which set up as supreme criteria the qualities of immensity, unlimitedness, and awe." See Ernest Tuveson, "Space, Deity and the 'Natural Sublime,'" *Modern Language Quarterly* 12, no. 1 (March 1951):32.

3. Quoted in Monk, op. cit., p. 220.

4. Hugh Blair, *Lectures on Rhetoric and Belles Lettres* (1783), quoted in ibid., p. 121.

5. Ibid., p. 17.

6. Riobamba Diary (1857), Olana.

7. Tuckerman, *Book of the Artists*, pp. 382–83, quoting a London critic.

8. Ibid., p. 378.

9. In McCoubrey, *American Art, 1700–1960*, p. 103.

10. Ibid., p. 110.

11. Durand, "Letters on Landscape Painting," Letter II, *Crayon* 1 (Jan. 17, 1855): 34; also in McCoubrey, op. cit., p. 111.

12. Ibid.

13. Emerson, "The Over-Soul," in *Selected Writings*, p. 269.

14. McCoubrey, op. cit., p. 104.

15. Ibid., pp. 104–5.

16. Raymond Bernard Blakney, ed., *Meister Eckhart: A Modern Translation* (New York: Harper and Row, 1941), p. 97.

17. Tuckerman, op. cit., p. 512.

18. McCoubrey, op. cit., p. 103.

19. Henry David Thoreau, *Walden* (New York: New American Library, 1942), p. 128.

20. Ibid., p.129.

21. Ibid., p. 128.

22. Emerson, *Nature*, in *Selected Writings*, p. 18.

23. Blakney, op. cit., p. 167.

24. Durand, "Letters," Letter VI, *Crayon* 1 (April 4, 1855):210.

25. McCoubrey, op. cit., p. 107.

26. See Wilhelm Worringer, *Form in Gothic*, ed. Herbert Read (New York: Schocken Books, 1964).

27. Emerson, *Nature*, in *Selected Writings*, p. 19.

28. "The Over-Soul," ibid., p. 263.

29. Blakney, op. cit., p. 159.

30. See for example "Studying from Nature," *Crayon* 1 (June 6, 1855):354, where the artist is admonished, "But this one thing ever remember, that before Nature you are to lose sight of yourself, and seek reverently for truth, neither being captious as to what its qualities may be, or considering whether your manner of telling it may be the most dexterous and draughtsmanlike. It is not of the least consequence whether *you* appear in your studies or no—it is of the highest importance that they should be true." See also William Sidney Mount: "A painter should lose sight of himself when painting from nature—if he loves her—if a painter loves nature he will not think of himself—she will give him variety and raise him from insipidity to grandeur" (journal, undated entry following entry of November 9, 1846, Suffolk Museum and Carriage House, Stony Brook, L.I.) And of course, see Emerson's famous "transparent eyeball" statement in *Nature* (*Selected Writings*, p. 6).

IV *The Geological Timetable: Rocks*

1. Thomas Cole, "Essay on American Scenery," in McCoubrey, op. cit., p. 102.

2. Jarves, *The Art-Idea*, pp. 40–42.

3. Russel Blaine Nye, *The Cultural Life of the New Nation, 1776–1830* (New York: Harper Torchbooks, 1963), p. 60.

4. Ibid., p. 68.

5. Miller, *The Life of the Mind*, p. 286.

6. Ibid., pp. 279, 278.

7. Mircea Eliade, *Myth and Reality*, trans. Willard R. Trask (New York: Harper Torchbooks, 1968), p. 6.

8. Jarves, op. cit., p. 192.

9. Tuckerman, *Book of the Artists*, pp. 371–72.

10. Ibid., p. 380.

11. Jarves, op. cit., p. 40: "Science, apart from its material mission, by which it seconds art and descends to be a servant of man, has still a nobler purpose, and talks face to face with spirit, disclosing its knowledge direct to mind itself."

12. See for example Nye, op. cit., p. 96, where Emerson's awareness of flux is pinpointed as the arrival of "the new science."

13. The organic awareness of pre-Darwinian science went back not only to the late eighteenth century, but, if we wish to pursue it, to the Greeks. See especially Henry Fairfield Osborn, *From the Greeks to Darwin* (New York: Macmillan, 1913; the 1894 edition is in Church's library at Olana), who finds the germs of evolution in Aristotle, p. 57.

14. Edward Hitchcock, *Elementary Geology* (New York: Dayton and Newman, 1842), p. 279.

15. Loren Eiseley, *Darwin's Century* (Garden City, N.Y.: Doubleday Anchor, 1961), p. 46.

16. Ibid., pp. 45, 100, 120, 136.

17. Arthur O. Lovejoy, "The Argument for Organic Evolution before *The Origin of Species*," *Popular Science Monthly* 75 (July–Dec. 1909):549.

18. Charles Coulston Gillispie, *Genesis and Geology* (Cambridge: Harvard University Press, 1951), p. 301 n. 6.

19. See Eiseley, op. cit., pp. 66–67; see also Gertrude Himmelfarb, *Darwin and the Darwinian Revolution* (Garden City, N.Y.: Doubleday Anchor, 1962), pp. 83ff.

20. Eiseley, op. cit., p. 71. (I quote Eiseley's interpretation here.)

21. Quoted in ibid., p. 72.

22. See glossary, in ibid., p. 353, for extended definitions.

23. Ibid., p. 66.

24. Gillispie, op. cit., p. 96.

25. Ibid.

26. Quoted in ibid., p. 3.

27. See A. Hunter Dupree, *Asa Gray* (New York: Atheneum, 1968), p. 137; see also Nye, op. cit., pp. 61–62, who cites *Natural Theology* as "one of the most widely used of all college texts of the time" and notes that "as late as 1885 the Reverend Thomas Gallaudet's *Youth's Book of Natural Theology* (1832), a children's adaptation of Paley, was still popular." Perry Miller, in *The Life of the Mind*, p. 276, notes: "Bishop Paley's *Natural Theology* . . . was reprinted endlessly in America, used as the standard text in the colleges, and assiduously conned by the self-educated."

28. Quoted in Gillispie, op. cit., pp. 36–37; Eiseley, op. cit., p. 178, notes: "Darwin had been a diligent student of Paley's *Natural Theology*. . . ."

29. Thomas Cole, "Thoughts and Occurrences," undated entry of c. 1842, New York State Library, Albany; photostat, New-York Historical Society; microfilm, Archives of American Art. Quoted in Louis L. Noble, *The Course of Empire*,

Voyage of Life and Other Pictures of Thomas Cole, N.A. (New York: Cornish, Lamport & Co., 1853), p. 335, with some changes.

30. John Dewey, "Darwin's Influence upon Philosophy," *Popular Science Monthly* 75 (July–Dec. 1909):94, 92.

31. Gillispie, op. cit., p. 225.

32. See Arthur O. Lovejoy, *The Great Chain of Being: A Study of the History of an Idea* (New York: Harper Torchbooks, 1965).

33. Eiseley, op. cit., p. 10.

34. Ibid., p. 8.

35. Church's library at Olana and Cropsey's at Hastings-on-Hudson are the most useful at present, but hopefully with more research our knowledge of the landscape artists' libraries will expand.

36. Eiseley, op. cit., remarks: "Lyell must be accorded the secure distinction, not alone of altering the course of geological thought, but of having been the single greatest influence in the life of Charles Darwin" (p. 98); and "Darwin read the first edition of the *Principles of Geology* while on the voyage of the *Beagle* and became Lyell's devoted admirer upon his return" (pp. 99–100). See also Gillispie, op. cit., p. 131. Cropsey's shelves at Hastings-on-Hudson contain Lyell's *A Manual of Elementary Geology* (1852) and *Principles of Geology* (1853), as well as Gideon Algernon Mantell's *Thoughts on a Pebble, or a First Lesson in Geology* (1849).

37. Quoted in Bentley Glass, Owsei Temkin, and William L. Straus, Jr., eds. *Forerunners of Darwin* (Baltimore: Johns Hopkins Press, 1968), p. 260.

38. See Virginia E. Lewis, *Russell Smith* (Pittsburgh: University of Pittsburgh Press, 1956), pp. 82, 131.

39. See Gillispie, op. cit., p. 225, who notes: "No one rejected mutability more uncompromisingly than Lyell at the time when he himself was the chief object of clerical attack."

40. Sir Charles Lyell, *Lectures on Geology Delivered at the Broadway Tabernacle in the City of New York* (1840) (New York: Greeley and McElrath, 1843), pp. 1, 16–17.

41. *The Dial: A Magazine for Literature, Philosophy, and Religion* (1840–44; reprint ed., New York: Russell and Russell, 1961), 3:133 (July 1842). Identification of Emerson as the author is in George Willis Cooke, *An Historical and Biographical Introduction to Accompany the "Dial"* (New York: Russell and Russell, 1961), 2:205.

42. See Walter Harding, ed., *Emerson's Library* (Charlottesville: University of Virginia Press, 1967), p. 177.

43. Stephen E. Whicher, *Freedom and Fate: An Inner Life of Ralph Waldo Emerson* (Philadelphia: University of Pennsylvania Press, 1953), pp. 145–46.

44. Hitchcock, op. cit., pp. 275–76.

45. Thomas Cole, "Sicilian Scenery and Antiquities," *Knickerbocker* 23, no. 2 (Feb. 1844):109.

46. List of some books in Cole's library. Cole papers, The Detroit Institute of Arts; microfilm, Archives of American Art.

47. Copy of *Literary World* in Cole papers, pp. 255ff; microfilm, Archives of American Art.

48. Cole to Silliman, Nov. 11, 1839, Gratz Collection, Historical Society of Pennsylvania, Philadelphia; microfilm, Archives of American Art. Silliman to Cole, Nov. 15, 1839, New York State Library, Albany; photostat, New-York Historical Society; microfilm, Archives of American Art. I am grateful to Katherine Manthorne, who offered a report on Silliman in my graduate seminar at Columbia University, for these references.

49. Dupree, op. cit., p. 26.

50. Nye, op. cit., p. 61.

51. "The Relation between Geology and Landscape Painting," *Crayon* 6 (1859): 255–56.

52. See Eiseley, op. cit., p. 105: "Lyell . . . possessed in 1830 all of the basic information necessary to have arrived at Darwin's hypothesis but did not."

53. Harding, op. cit., p. 54.

54. See Lovejoy, "Argument for Organic Evolution," p. 546 especially.

55. See Dupree, op. cit., p. 148, and Eiseley, op. cit., p. 133.

56. Ralph Waldo Emerson, *The Letters of Ralph Waldo Emerson,* ed. Ralph L. Rusk, 6 vols. (New York: Columbia University Press, 1966), 3:283.

57. Ibid., p. 290.

58. *The Journals of Ralph Waldo Emerson,* ed. Edward W. Emerson and Waldo Emerson Forbes, 10 vols. (Boston: Houghton Mifflin, 1909–14), vol. 7 (1845–46), pp. 69–70.

59. Ibid., p. 53.

60. Whicher, op. cit., p. 144.

61. Ibid., pp. 165, 141.

62. *Journals of Ralph Waldo Emerson,* ed. Emerson and Forbes, 7:51–52.

63. Harding, op. cit., pp. 207, 135. See also William H. Gilman [and others], eds., *The Journals & Miscellaneous Notebooks of Ralph Waldo Emerson,* 14 vols. (Cambridge: Harvard University Press, Belknap Press, 1960–78), vol. 13, ed. Ralph H. Orth and Alfred R. Ferguson, where Emerson noted in his journal [Journal DO] for 1852, 3, or 4, "I see beforehand that I shall not believe in the Geologies" (p. 51), and for 1856(?), "The Bible will not be ended until the Creation is" (p. 54).

64. Harding lists no work by Darwin in Emerson's personal library. Emerson did take *The Origin of Species* out of the Concord Free Library on June 9, 1877. See "Emerson's Use of the Concord Library" in Kenneth Walter Cameron, *Emerson and Thoreau as Readers, American Transcendental Quarterly* 18, pt. 3 (Spring 1973):69.

65. Emerson, *Letters,* 5:194–95. Rusk observes (p. 195 n. 41): "Emerson, who had been for many years an interested spectator of the march of science and a student of earlier speculations on evolution, must have been deeply stirred by Darwin's great book." Rusk adds, however: "Agassiz, with his unswerving disbelief in the theory of evolution, must have loomed large on the horizon." Rusk's extended footnote catalogues a few other mentions of Darwin by Emerson, and suggests that in such works as *Conduct of Life* (1860) and *Letters and Social Aims* (1875), "Emerson definitely shows his allegiance to the general notion of evolution." However, Emerson deals so rarely with Darwin in his voluminous letters and journals that it is hard for me to believe he had any real understanding of Darwin's significance and potential impact. One small indication of his efforts to reconcile Darwinism with his spiritual beliefs reads a bit like a theosophical tract, and is titled "Consolation for readers of Darwin": "Why is Man the head of Creation the power of all, but because his education has been so longaeval & immense? he has taken all the degrees; he began in the beginning, & has passed through radiate, articulate mollusk vertebrate, through all the forms to the mammal, & now holds in essence the virtues or powers of all, though in him, all the exaggeration of each subdued <into harmony & their> through the antagonism of their opposites, and is at last the harmony, the flower & top of all their being,—their honored representative. . . . Many individuals have taken their master's degree prematurely, & will yet have mortifications & perhaps drop into one of the lower classes for a time." (Undated journal, PH Philosophy, Emerson papers, Houghton Library, Harvard University, p. 10. Quoted by permission of the Houghton Library and the Ralph Waldo Emerson Memorial Association.) I am indebted to the noted Emerson scholar Eleanor Tilton for this reference.

66. Emerson read T. H. Huxley's *Lectures on Comparative Anatomy, Lay Sermons,* and *Man's Place in Nature.* I am grateful to Eleanor Tilton for this information, and generally for her kind assistance on the difficult problem of Emerson's relation to Darwin.

67. Lidian Emerson to Edward Waldo Emerson, Jan. 18, 1864. My thanks to Eleanor Tilton for making this information available to me. (Ms. Tilton has reminded me, however, that Emerson and his wife often disagreed.)

68. As late as 1872, Emerson wrote to Lidian Emerson (Jan. 9): "I called on Professor Baird, the ornithologist, who had come to me the day before, & had a valuable conversation with him on the present aspects of science, Darwin, Agassiz, &c." (*Letters*, 6:195).

69. See Edward Lurie, *Louis Agassiz: A Life in Science* (Chicago: University of Chicago Press, 1960), p. 200.

70. Dupree, op. cit., p. 248.

71. Ibid., p. 227.

72. Ibid., p. 229.

73. Edward Waldo Emerson, *The Early Years of the Saturday Club, 1855–1870* (Boston and New York: Houghton Mifflin, 1918), p. 19.

74. Ibid., p. 9. Emerson thought Agassiz might be too busy: "Agassiz again I suppose quite too full already of society."

75. Ibid., pp. 19, 206; see M. A. de Wolfe Howe, ed., *Later Years of the Saturday Club, 1870–1920* (Boston and New York: Houghton Mifflin, 1927), p. 67. See also Dupree, op. cit., p. 353.

76. Quoted in E. W. Emerson, *Early Years*, p. 31.

77. Ibid., p. 44.

78. Quoted in ibid., pp. 23–24.

79. Quoted in ibid., pp. 131, 171–72.

80. Quoted in ibid., p. 172.

81. See Harding, op. cit., p. 6.

82. Ibid., pp. 143–44, where vol. 2, pt. 2; vol. 3; and vol. 4, pt. 1 of *Cosmos*, a 4-vol. set translated by Mrs. E. Sabine, are listed as wanting (London: Longman, Brown, Green, and Longmans [etc.], 1847–[5-?]).

83. *Journals of Ralph Waldo Emerson*, ed. Emerson and Forbes, 7:100.

84. Much of Church's library is still intact at Olana and can be studied there.

85. I am grateful to Alan Dages, of Olana, to Richard Slavin, formerly of Olana, and to David Huntington for assistance with the problems of Church's library.

86. Alexander von Humboldt, *Cosmos*, trans. E. C. Otté, 2 vols. (New York: Harper & Brothers, 1850), 1:23.

87. Ibid.

88. Ibid., p. 25.

89. Ibid., 2:93.

90. Ibid., p. 94.

91. Ibid., p. 95.

92. Ibid., p. 98.

93. Ibid., 1:24.

94. Ibid., 2:94–95.

95. Ibid., 1:231.

96. An extensive collection of photographs owned by Church and used as research tools for specific details and sites still exists at Olana. See also, for a brief consideration of this problem, Elizabeth Lindquist-Cock, "Frederic Church's Stereographic Vision," *Art in America*, Sept.–Oct. 1973, pp. 70–75.

97. Humboldt, op. cit., 2:98.

98. Ibid.

99. Ibid.

100. See Alan Moorehead, *Darwin and the Beagle* (New York: Harper & Row, 1969), pp. 38–39. Lyell's second volume reached Darwin at Montevideo (p. 86). Vol. 3 reached him in Valparaiso when he arrived on July 22, 1834 (p. 153).

101. Quoted in ibid., p. 57.

102. Typescript, Olana. Original, Bayard Taylor papers, Regional Archives, Cornell University Library, Ithaca, N.Y.

103. See David C. Huntington, *The Landscapes of Frederic Edwin Church* (New York: Braziller, 1966), pp. 51–52.

104. Moorehead, op. cit., pp. 178–79.

105. Baranquilla Diary (1853), Olana; my translation from the Spanish.

106. Riobamba Diary (1857), Olana.

107. Ibid.

108. Louis L. Noble, *The Heart of the Andes,* broadside (New York, 1859), p. 4. In Church papers, Olana.

109. Humboldt, op. cit., 1:47.

110. Noble, *Heart of the Andes,* pp. 4–5.

111. Ms., Olana. In Noble's *After Icebergs with a Painter: A Summer Voyage to Labrador and Around Newfoundland* (New York: Appleton & Co., 1861), p. 65, our sense of Church's preoccupation with the Andes is reinforced: "To venture a geological remark: All these coast highlands correspond with the summits of the Alleghanies, and with those regions of the Cordilleras, C—— tells me, which are just below the snow-line. From the sea-line up to the peak, they correspond with our mountains above the upper belt of woods. Their icy pinnacles and eternal snows are floating below in the form of icebergs. Imagine all the mid-mountain region in the deep and you have the Andes here."

112. Humboldt, op. cit., 1:48.

113. Emerson, "The Over-Soul," in *Selected Writings,* p. 271.

114. Cunningham Geikie, *Hours with the Bible or The Scriptures in the Light of Modern Discovery and Knowledge* (New York: James Pott and Co., 1888), 1:49. Church's library at Olana included John Tyndall, *The Forms of Water in Clouds and Rivers, Ice and Glaciers* (New York: Appleton, 1872), and *Heat Considered as a Mode of Motion: Being a Course of 12 Lectures Delivered at the Royal Institute of Great Britain in 1862* (New York: Appleton, 1863); Dr. Eugene Lomell, *The Nature of Light with a General Account of Physical Optics* (New York: Appleton, 1876); M. E. Chevreul, *The Laws of Contrast of Colour: And Their Application to the Arts,* Bohn ed. (London, 1859); Ogden N. Rood, *Modern Chromatics with Application to Art and Industry* (New York: Appleton, 1879).

115. William M. Bryant, *Philosophy of Landscape Painting* (St. Louis, 1882), with an inscription to Church; p. 83.

116. Alfred Russel Wallace, *Natural Selection and Tropical Nature* (London and New York: Macmillan, 1891), p. 474.

117. Louis Figuier, *The World Before the Deluge* (London: Chapman and Hal, 1865), p. 7.

118. John Fiske, *The Idea of God As Affected by Modern Knowledge* (Boston and New York: Houghton Mifflin, 1892), pp. 156, 158, 163. Church's library, Olana.

119. Huntington, op. cit., p. 45.

120. *Pre-Raphaelitism* (1851), in *The Art Criticism of John Ruskin,* ed. Robert L. Herbert (Garden City, N.Y.: Doubleday Anchor, 1964), p. 34.

121. *The Eagle's Nest* (1872), in ibid., pp. 28–29. Ruskin's attitude to Darwin needs more research. Like many of his attitudes, it supported a number of ambiguities, and in the same text he suggested that perhaps he was implying the fallacy of Darwinism "more positively than is justifiable in the present state of our knowledge."

V *The Meteorological Vision: Clouds*

1. Ralph Waldo Emerson, *Emerson: A Modern Anthology,* ed. Alfred Kazin and Daniel Aaron (Boston: Houghton Mifflin, 1958), p. 39 (from his journals); Henry David Thoreau, *The Journal of Henry D. Thoreau,* ed. Bradford Torrey and Francis H. Allen, 14 vols. in 2 (New York: Dover, 1962), 1:319 (Jan. 7, 1852).

2. Jasper F. Cropsey, "Up Among the Clouds," *Crayon* 2 (August 8, 1855):79–80.

3. *Crayon* 2 (July 11, 1855):26.

4. Kurt Badt, *John Constable's Clouds*, trans. Stanley Godman (London: Routledge & Kegan Paul, 1950), p. 51.

5. Ibid., pp. 8, 17.

6. Quoted in ibid., p. 50: "I return the book you lent me so long ago. My observations on clouds and skies are on scraps and bits of paper, and I have never yet put them together so as to form a lecture, which I shall do, and probably deliver at Hampstead next summer. . . . If you want anything more about atmosphere, and I can help you, write to me. Forster's is the best book; he is far from right, still he has the merit of breaking much ground." The first chapter of Forster's book is called "Of Mr. Howard's Theory of the Origin and Modifications of Clouds."

7. Louis Hawes, "Constable's Sky Sketches," *Journal of the Warburg and Courtauld Institutes* 32 (1969):344–64. Hawes stresses the history of Constable's cloud observations prior to the early 1820's and also reminds us of his knowledge of theoretical treatises such as those of De Piles, Gilpin, Taylor, and Richter (see especially pp. 360ff). He notes, p. 346n, "There is considerable likelihood that Constable acquired a general acquaintance with Howard's classifications, if only indirectly, a good eight or ten years or more before commencing his Hampstead studies. Even so, his work throughout this time and later shows no sign that any such awareness had a decisive effect on his approach to sky sketching."

8. Badt, op. cit., p. 17 n. 1: "Ueber die Modificationen der Wolken, von Lucas Howard, Esq.," *Annalen der Physik* 21 (1815):137–59, published and translated into German from a French text by Professor L. W. Gilbert of Halle. Goethe started a correspondence with Howard and requested autobiographical notes, which he received in 1822 (Badt, p. 16).

9. Ibid., p. 9.

10. Ibid., pp. 12–13.

11. Ibid., pp. 10–15.

12. For a good consideration of Goethe's scientific contributions, see Willy Hartner, "Goethe and the Natural Sciences," in *Goethe: A Collection of Critical Essays*, ed. Victor Lange (Englewood Cliffs, N.J.: Prentice-Hall, Spectrum, 1968), pp. 145–60.

13. Badt, op. cit., pp. 18–19.

14. Ibid., pp. 26–27. Badt (p. 28) suggests that Goethe did not share this view of art as the "crown of science."

15. Ibid., p. 34.

16. Ibid., pp. 35ff. Badt (p. 37) isolates specifically a cloud study done by Dahl in Naples in 1821 and writes (pp. 38–39): "The young Blechen visited Dahl in 1823 in his Dresden studio and had the opportunity of examining Dahl's nature studies closely for three months. The cloud studies which Dahl had painted shortly before in Italy must have been amongst them."

17. Ibid., p. 25.

18. Cropsey, op. cit., p. 79.

19. William Dunlap, *A History of the Rise and Progress of the Arts of Design in the United States* (1834; New York: Dover, 1969), vol. 2, pt. 2, p. 363.

20. See below, pp. 244, 296 n. 29.

21. See John Durand, *The Life and Times of Asher B. Durand* (New York: Scribner's, 1894), p. 151. Durand observed that "notes on the backs" stated "the hour of the day, direction of the wind, and kind of weather."

22. Ibid., pp. 150–51.

23. Ibid., p. 151.

24. *Crayon* 2 (July 11, 1855):26.

25. Cropsey, op. cit., p. 79.

26. Ibid.

27. Ibid.

28. Ibid., p. 80.

29. Nathan Reingold, ed., *Science in Nineteenth Century America: A Documentary History* (New York: Hill and Wang, 1964), p. 129.

30. See Robert Taft, *Artists and Illustrators of the Old West, 1850–1900* (New York: Scribner's, 1953), pp. 254–55. Some sources, including Taft, list only twelve volumes, but vol. 12 was issued in two parts.

31. Vols. 1, 3, 4, 5, 6, 7, 8, 10.

32. See n. 114, p. 282.

33. Records at Olana indicate that Church owned the following copies of Ruskin's *Modern Painters* (London: Smith, Elder & Co., 1851–60): vol. 1, pts. 1–2, *Of General Principles and of Truth*, 5th ed.; vol. 2, pt. 3, *Of the Imaginative and Theoretic Faculties*, 4th ed.; vol. 3, pt. 4, *Of Many Things*; vol. 4, pt. 5, *Of Mountain Beauty*; vol. 5, pt. 6, *Of Leaf Beauty*, pt. 7, *Of Cloud Beauty*, pts. 8–9, *Of Ideas of Relation*. On a visit to Olana I was able to examine only two volumes on the shelves: vol. 3, pt. 4, and vol. 4, pt. 5. I am grateful to Alan Dages, Historic Site Manager of Olana, for assistance with this reference.

34. A Graduate of Oxford [John Ruskin], *Modern Painters* I (1843; New York: Wiley and Son, 1868), p. 213.

35. Ibid., p. 221.

36. Ibid., pp. 223–24.

37. Ibid., p. 236.

38. Ibid., p. 243.

39. Ibid., p. 249. In the same reference (to Loch Coriskin) he observes: "When rain falls on a mountain composed chiefly of barren rocks, their surfaces, being violently heated by the sun, whose most intense warmth always precedes rain, occasion sudden and violent evaporation, actually converting the first shower into steam. Consequently, upon all such hills, on the commencement of rain, white volumes of vapor are instantaneously and universally formed, which rise, are absorbed by the atmosphere, and again descend in rain. . . ."

40. Quoted in Robert L. Herbert, ed., *The Art Criticism of John Ruskin* (Garden City, N.Y.: Doubleday, 1964), pp. 26–27.

41. John Ruskin, *Modern Painters* III (1856; New York: Wiley and Son, 1868), pp. 312–13.

42. For information about the cloud drawings of Alvan Fisher in the collection of the Museum of Fine Arts, Boston, I am indebted to Fred Adelson.

43. Notebook (1825), The Detroit Institute of Arts; microfilm, Archives of American Art.

44. Ibid.

45. Ibid.

46. See Cropsey papers, microfilm, Archives of American Art.

47. See especially the drawings in the collection of the Cooper-Hewitt Museum of Design, New York.

48. Riobamba Diary (1857), Olana.

49. Notebook (1827), The Detroit Institute of Arts; microfilm, Archives of American Art.

50. See *International Cloud Atlas* (Paris: World Meteorological Organization, 1956), vols. 1, 2.

51. Ruskin, *Modern Painters* I, pp. 231–32.

52. Badt, op. cit., p. 20.

VI *The Organic Foreground: Plants*

1. From Horace Smith's "Hymn to the Flowers," written by Asa Gray in his sister's album; quoted in A. Hunter Dupree, *Asa Gray* (New York: Atheneum, 1968), p. 46.

2. Tuckerman, *Book of the Artists,* p. 243.

3. "Flowers," *Godey's Lady's Book* 40 (Jan. 1850):13.

4. Ibid.

5. Mark Catesby, preface to *Natural History of Carolina, Florida and the Bahama Islands* (1731–43); quoted in Martina R. Norelli, *American Wildlife Painting* (New York: Watson-Guptill, 1975), p. 61.

6. Ibid.

7. See Dupree, op. cit., pp. 67ff, and Russel Blaine Nye, *Society and Culture in America, 1830–1860* (New York: Harper & Row, 1974), p. 245 n. 17. Had they both gone, they would have encountered Titian Ramsay Peale, who was a member of the expedition.

8. Ralph L. Rusk, *The Life of Ralph Waldo Emerson* (New York: Columbia University Press, 1949), p. 187.

9. Quoted in M. H. Abrams, *The Mirror and the Lamp* (New York: Oxford University Press, 1953), pp. 173–74. See also Coleridge on genius: "Hence there is in genius itself an unconscious activity; nay, that is the genius in the man of genius" (ibid., p. 222).

10. See Washington Allston, *Lectures on Art—Poems* (1850; New York: Da Capo Press, 1972), p. 80: "We shall therefore assume as a fact, the eternal and insuperable difference between Art and Nature."

11. *The Statesman's Manual*, in *The Portable Coleridge*, ed. I. A. Richards (New York: Viking, 1950), p. 393.

12. Emerson, *Selected Writings*, p. 7.

13. Quoted in Abrams, op. cit., p. 171.

14. *Journal of Henry D. Thoreau*, 1:714 (April 8, 1854).

15. Quoted in Abrams, op. cit., p. 171.

16. *Journal of Henry D. Thoreau*, 1:627 (Aug. 23, 1853).

17. See Rusk, op. cit., p. 143.

18. Hector St. Jean de Crèvecoeur, *Letters from an American Farmer* (1782), quoted in John Conron, *The American Landscape* (New York, London, and Toronto: Oxford University Press, 1974), p. 133.

19. Abrams, op. cit., p. 218.

20. Ibid., p. 219.

21. Quoted in ibid., pp. 219–20, from Herder's *Von Deutscher Art und Kunst* (1773). As Abrams points out (p. 371 n. 93), the full development of such ideas is to be found in Herder's *Ideen zur einer Philosophie der Geschichte der Menschheit* (1784–91). According to Harvard College Library records, Emerson borrowed Herder's *Outlines of History of Men* (1800 ed.) on Feb. 1, 1829. The records of the Boston Athenaeum indicate that he borrowed vol. 1 of Herder's *Outlines of a Philosophy of Man* on May 3, 1831, and returned it on May 6. On August 1, 1831, he borrowed vols. 1 and 2 and returned them on August 26. See Stanley M. Vogel, *German Literary Influences on the American Transcendentalists* (New Haven: Yale University Press, 1955), pp. 181, 177.

22. Quoted in Abrams, op. cit., p. 220.

23. Emerson, "Nature," in *Selected Writings*, p. 16.

24. Vogel, op. cit., p. 88. Vogel notes: "By 1836 Emerson had read most of his fifty-five volume set of Goethe's works printed at Stuttgart and Tübingen, and in spite of adverse criticisms of Goethe, he conceded in his journal that every one of his own writings had been taken from the whole of nature, and bore the name of Goethe" (p. 90, and n. 9).

25. Quoted in Rudolf Steiner, introduction to Johann Wolfgang von Goethe, *The Metamorphosis of Plants* (Bio-Dynamic Farming and Gardening Association, 1974), p. 13.

26. Quoted in ibid., p. 11.

27. Johann Wolfgang von Goethe, *Letters from Goethe*, trans. M. von Herzfeld and C. Melvil Sym (Edinburgh: at the University Press, 1957), p. 192.

28. Agnes Arber, "Goethe's Botany," *Chronica Botanica* 10, no. 2 (Summer 1946): 80–81.

29. Ibid., p. 81.

30. Ibid.

31. Thomas Cole, "Thoughts and Occurrences," undated entry c. 1842, New York State Library, Albany; microfilm, Archives of American Art. Quoted in Noble, *Course of Empire*, p. 335, with some changes. See also, for a theory that touches on Goethe's Platonism in the *Metamorphosis*, Willy Hartner, "Goethe and the Natural Sciences," in *Goethe: A Collection of Critical Essays*, ed. Victor Lange (Englewood Cliffs, N.J.: Prentice-Hall, 1968), pp. 151–52. Hartner notes: "All the attempts which have been made to derive Goethe's ideas of the *type* which is the carrying idea of his natural philosophy altogether from Plato's *idea* have failed, and had to fail. . . . Goethe's types are immanent in nature, they are derived from and exist only within experience. But it seems justifiable to assume that Plato's doctrine of ideas stimulated Goethe and led him to adapt the Platonic concept to his own way of thinking."

32. Quoted in Abrams, op. cit., pp. 207, 206.

33. Cole, "Thoughts and Occurrences," c. 1842.

34. Ibid., entry dated July 22, 1838. Quoted in Noble, *Course of Empire*, pp. 266–67, with some small changes.

35. See Barbara Novak, *American Painting of the Nineteenth Century* (New York: Praeger, 1969), p. 134.

36. Steiner, op. cit., p. 17.

37. To Frau von Stein, July 9, 1786, quoted in ibid., p. 13.

38. Henry David Thoreau, *Selected Journals*, ed. Carl Bode (New York: Signet Classics, 1967), p. 71 (Sept. 29, 1843).

39. Emerson, *Modern Anthology*, p. 131.

40. Vogel, op. cit., p. 85.

41. Ibid., p. 103.

42. Thoreau, *Selected Journals*, p. 180 (May 15, 1853).

43. *Thomas Cole's Poetry*, ed. Marshall B. Tymn (York, Pa.: Liberty Cap Books, 1972), p. 133. Ms., New York State Library, Albany; microfilm, Archives of American Art.

44. "Written in Autumn" (Oct. 1837), *Thomas Cole's Poetry*, p. 90.

45. Ibid., p. 127.

46. Ibid., p. 90 (last two lines of "Written in Autumn").

47. See "Childhood," in *Catalogue of Pictures by Thomas Cole, A.N.A. The Voyage of Life . . .* Now exhibiting in the Rooms of the National Academy, Corner of Broadway and Leonard Street, open from 9 AM until 10 PM. Broadside, unpaged, in Cole papers; microfilm, Archives of American Art. See also Noble, *Course of Empire*, p. 287.

48. Peter Bermingham, *Jasper F. Cropsey, 1823–1900: A Retrospective View of America's Painter of Autumn*, exhibition catalogue (College Park: University of Maryland, 1968), p. 45.

49. Ibid., p. 5.

50. Noble, *Course of Empire*, pp. 292–93.

51. *Journal of Henry D. Thoreau*, 2:1439 (March 8, 1859).

52. Ms., Feb. 26, 1843, New York State Library, Albany; microfilm, Archives of American Art. Noble, *Course of Empire*, p. 342, changes this.

53. Noble, *Course of Empire*, p. 310.

54. *Selected Journals*, p. 166 (July 18, 1852).

55. Ibid., p. 180 (May 17, 1853).

56. Theodore Stebbins, *The Life and Works of Martin Johnson Heade* (New Haven and London: Yale University Press, 1975), p. 148.

57. *Hawthorne's Short Stories*, ed. Newton Arvin (New York: Vintage Books, 1960), p. 184.

58. Ibid., pp. 207–8.

59. *Selected Journals*, pp. 220–21 (Oct. 23, 1855).

60. Asa Gray, *Natural Science and Religion: Two Lectures Delivered to the Theological School of Yale College* (New York: Scribner's, 1880), p. 12.

61. Emerson, *Nature,* in *Selected Writings,* p. 36.

62. Quoted in Tony Tanner, *The Reign of Wonder* (London: Cambridge University Press, 1965), p. 48.

63. *Selected Journals,* p. 105 (Jan. 7, 1851).

64. *Journal of Henry D. Thoreau,* 2:1439 (March 8, 1859).

65. Ibid., p. 1438 (March 7, 1859).

66. *The Eagle's Nest,* in *The Art Criticism of John Ruskin,* p. 26.

67. *Journal of Henry D. Thoreau,* 2:1687 (Sept. 22, 1860).

68. Ibid., 1:246 (Aug. 19, 1851).

69. Ibid., p. 304 (Nov. 15, 1851).

70. Ibid., p. 351 (Feb. 17, 1852).

71. Ibid., pp. 194–95 (May 20, 1851).

72. Arber, op. cit., p. 77.

73. *Journal of Henry D. Thoreau,* 1:195 (May 20, 1851).

74. Ibid., 2:1694 (Oct. 13, 1860).

75. Ibid., pp. 1091–92 (Dec. 4, 1856).

76. Cropsey's library, Hastings-on-Hudson.

77. Church's library, Olana. Though Church knew Agassiz, interestingly, only Elizabeth Agassiz's *Louis Agassiz: His Life and Correspondence* (1885) is presently at Olana.

78. Robert Hunt, *The Poetry of Science* (London: 1854), p. xiii.

79. Both Church and Cole gathered and saved flowers. A herbarium comprised mostly of ferns, compiled by either Church or Mrs. Church, is in the collection at Olana. Another herbarium, also at Olana, includes on a single page "Flowers gathered by Thomas Cole—artist—from a crevice in the upper part of the Leaning Tower of Pisa, from Petrarch's garden at Vaucluse, from Vaucluse, crocus from the Borghese grounds Rome, from the Alps." Another page gathered by Cole includes a "blue violet, last flower found on the top of Mt. Etna, a flower from the Colisseum [*sic*] gathered in March, Alpine moss, from the interior of the Temple of Segesta, Sicily, Alpine moss, orange flower from the Benedictine Convent, Catania Italy."

80. Notebook, The Detroit Institute of Arts; microfilm, Archives of American Art. In the same notebook, Cole pressed an acanthus leaf and other plants.

81. An undated note from Ruskin to Cropsey at 2 Kensington Gate, Kensington (postmark illegible) reads: ". . . Wednesday at two o'clock if that hour is convenient to you—Denmark hill is about an hours journey from Kensington, over Vauxhall bridge, & by Camberwell." Cropsey papers; microfilm, Archives of American Art.

82. Notebook, Cropsey papers; microfilm, Archives of American Art.

83. Humboldt, *Cosmos,* 1:24.

84. Ibid., p. 47.

85. *Watson's Weekly Art Journal,* March 3, 1866, quoted in Gordon Hendricks, *Albert Bierstadt: Painter of the American West* (New York: Harry N. Abrams, 1973), p. 160.

86. Edward Lurie, *Louis Agassiz: A Life in Science* (Chicago: University of Chicago Press, 1960), p. 307.

87. Dupree, op. cit., p. 53.

88. Ibid., p. 54.

89. Ibid., p. 135.

90. Ibid., p. 143.

91. Ibid., p. 145. See *North American Review* 62 (1846):465–506.

92. Dupree, op. cit., p. 206.

93. Letter of March 26, 1861, ibid., pp. 211–12.

94. Ibid., pp. 222–23. Dupree remarks here on Thoreau's awareness of Gray's work,

noting the passage from Gray on roots referred to above (pp. 115, 116) in Thoreau's journal (May 20, 1851), but finds that Thoreau "read into it a symbolism which changed the matter-of-fact scientific prose beyond recognition. . . . The discrepancy between these two ways of looking at the same phenomenon is the measure of the great gap between transcendentalism and Gray's empiricism."

95. Ibid., p. 226.

96. Ibid., p. 232.

97. Lurie, op. cit., pp. 50–51.

98. Ibid., p. 89.

99. Ibid., pp. 51–52.

100. See Robert G. McIntyre, *Martin Johnson Heade* (New York: Pantheon Press, 1948), pp. 11–13, who says that Heade accompanied Fletcher to Brazil in 1863 and 1864. McIntyre also notes (p. 13): ". . . Agassiz' praise of Heade's hummingbirds is proof of the scientific worth of his paintings." Because of a conflict in dates in late 1863, Stebbins (op. cit., p. 85) doubts that Fletcher and Heade actually traveled together, but credits Fletcher with suggesting that Heade go to Brazil.

101. Quoted in Linda Ferber, "William Trost Richards (1833–1905): American Landscape and Marine Painter" (Ph.D. diss. written under the author's direction, Columbia University, 1978), p. 111.

102. Noble, *After Icebergs*, p. 6. Agassiz seems to have turned up during the initial part of the voyage, but did not accompany Noble and Church all the way to the Arctic.

103. Letter of April 27, 1862, quoted in Hendricks, op. cit., pp. 108–9.

104. Agassiz to Bierstadt, quoted courtesy of Henry Francis du Pont Winterthur Museum, Joseph Downs Manuscript Collection, Winterthur, Delaware.

105. Ibid.

106. *Journal of Henry D. Thoreau,* 2:1127 (March 20, 1857).

107. Ibid., p. 1344 (Aug. 23, 1858).

108. See Dupree, op. cit., p. 225. See also Nathan Reingold, ed., *Science in Nineteenth Century America: A Documentary History* (New York: Hill and Wang, 1964), p. 181.

109. Dupree, op. cit., p. 151.

110. William James Stillman, *The Autobiography of a Journalist,* 2 vols. (Boston and New York: Houghton Mifflin, 1901), 1:259–60.

111. Dupree, op. cit., p. 258. Gray had noted this in a footnote to his *Botanical Memoirs,* published on April 25, 1859, several weeks before he spoke at the Cambridge Scientific Club.

112. Stillman, op. cit., p. 261.

113. Once begun, the contest between Agassiz and Gray was short-lived. By 1864, despite Agassiz's rigorous popular lecturing and publications, many American scientists, and even his own students, had begun to reject him. It took at least another decade for the tide to shift substantially. The end of the "era of Agassiz," however, roughly coincided with the end of the great era of American landscape painting, punctuated by the Civil War. The ideas and attitudes embodied in the paintings endured in the works of the Hudson River artists and luminists of Church's generation who continued to make some occasional fine landscapes after this time. As Church's library indicates, efforts to reconcile Darwinism and religion reached well into the latter part of the nineteenth century. But the demise of Agassiz and the advent of Darwin signaled, as nothing else could, the approaching demise of landscape painting as a major form of spiritual expression in America.

VII *The Primal Vision: Expeditions*

1. Tuckerman, *Book of the Artists*, p. 389.
2. Ibid., pp. 370–71.
3. *Cosmopolitan Art Journal* (Sept. 1859):183.
4. George Catlin, *Letters and Notes on the Manners, Customs and Conditions of the North American Indians* (1844; New York: Dover, 1973), 1:4.
5. Robert Taft, *Artists and Illustrators of the Old West, 1850–1900* (New York: Scribner's, 1953), remains one of the best sources for this material. See especially, for the Kerns, the notes on pp. 257–64. See also an excellent catalogue by Larry Curry, *The American West* (New York: Viking Press and Los Angeles County Museum of Art, 1972).
6. E. G. Beckwith, "Report of Exploration for a Route for the Pacific Railroad, by Capt. J. W. Gunnison, Topographical Engineers, near the 38th and 39th Parallels of North Latitude, from the Mouth of the Kansas River, to the Sevier Lake, in the Great Basin," *Reports of Explorations and Surveys to Ascertain the Most Practicable and Economic Route for a Railroad from the Mississippi River to the Pacific Ocean* (Washington, D.C.: War Department, 1855), 2:127 (Appendix B, "Explanations of Maps and Illustrations"). See also p. 126.
7. Heinrich Baldwin Möllhausen, *Diary of a Journey from the Mississippi to the Coasts of the Pacific*, trans. Mrs. Percy Sinnett (1858; New York and London: Johnson Reprint Co., 1969), 1:264–66.
8. See Taft, op. cit., p. 5. See also Howard Mumford Jones, *O Strange New World* (New York: Viking, 1968), pp. 378–79.
9. See Nancy Dustin Wall Moure, "Five Eastern Artists Out West," *American Art Journal* 5, no. 2 (Nov. 1973):15–16.
10. See Gordon Hendricks, "The First Three Western Journeys of Albert Bierstadt," *Art Bulletin* 46 (Sept. 1964):333–65. See also Elizabeth Lindquist-Cock, "Stereoscopic Photography and the Western Paintings of Albert Bierstadt," *Art Quarterly* 33 (Winter 1970):361–78.
11. See William H. Goetzmann, *Exploration and Empire: The Explorer and the Scientist in the Winning of the American West* (New York: Vintage Books, 1972), for a masterly consideration of the big surveys as well as details of the earlier explorations. See also *National Parks and the American Landscape*, exhibition catalogue (Washington, D.C.: Smithsonian Institution Press, 1972).
12. Thurman Wilkins, *Thomas Moran: Artist of the Mountains* (Norman: University of Oklahoma Press, 1966), pp. 59ff.
13. Moure, op. cit., p. 27.
14. Ibid., pp. 17, 20, 21.
15. Ibid., pp. 21–22.
16. Worthington Whittredge, *The Autobiography of Worthington Whittredge, 1820–1910*, ed. John I. H. Baur, *Brooklyn Museum Journal* (1942):60.
17. See *Era of Exploration: The Rise of Landscape Photography in the American West, 1860–1885*, exhibition catalogue, texts by Weston J. Naef, James N. Wood, and Therese Thau Heyman (Albright-Knox Gallery and Metropolitan Museum of Art, 1975), for a superb collection of photography by all these photographers except Gardner. For Gardner's work, see Robert Sobieszek, *Alex Gardner's Photographs along the 35th Parallel* (Rochester and New York: George Eastman House, 1971).
18. Quoted in Roderick Nash, *Wilderness and the American Mind* (New Haven: Yale University Press, 1967), p. 73.
19. Alexis de Tocqueville, *Journey to America*, trans. George Lawrence and ed. J. P. Mayer (Garden City, N.Y.: Doubleday Anchor, 1971), p. 354.
20. Whittredge, op. cit., p. 46.
21. Hendricks, op. cit., p. 337; from a letter written from the Rocky Mountains, dated July 10, 1859, printed in *Crayon* 6 (Sept. 1859):287.

22. Tocqueville, op. cit., p. 399.

23. Thomas Cole, "Essay on American Scenery" (1835), in McCoubrey, *American Art, 1700–1960*, p. 108.

24. Tocqueville, op. cit., p. 383.

25. Washington Irving, *A Tour on the Prairies* (1835; New York: Pantheon, 1967), p. 188.

26. Francis Parkman, *The Oregon Trail* (1849; New York: Signet, 1950), pp. 56, 206.

27. Whittredge, op. cit., p. 45.

28. James Fenimore Cooper, *The Deerslayer*, in *The Leatherstocking Saga*, ed. Allan Nevins (New York: Modern Library, 1966), p. 63.

29. Tocqueville, op. cit., p. 398.

30. Cole, op. cit., p. 104.

31. *Journal of Henry D. Thoreau*, 1:34 (entry of Dec. 15, 1838).

32. Möllhausen, op. cit., p. 278.

33. Ibid.

34. Irving, op. cit., p. 36.

35. Clarence King, *Mountaineering in the Sierra Nevada* (1871; New York: W. W. Norton & Co., 1935), p. 99.

36. Fitz Hugh Ludlow, *The Heart of the Continent* (1870; New York: AMS Press Reprint, 1971), p. 434. (Ludlow comments also here that "the other two vaguely divided orders of gentlemen and sages were sightseeing . . . or hunting specimens of all kinds—*Agassizing*, so to speak.")

37. King, op. cit., p. 99.

38. Ludlow, op. cit., pp. 431–32.

39. Whittredge, op. cit., p. 56.

40. Ibid.

41. Ibid., p. 47.

42. Henry D. Thoreau, *Walden* (1854; New York: Mentor, 1942), pp. 91, 96.

43. Walt Whitman, *Leaves of Grass*, in *The Portable Walt Whitman*, ed. Mark Van Doren (New York: Viking Press, 1945), p. 314.

44. Walt Whitman, *Specimen Days* (1882; Boston: David R. Godine, 1971), p. 90.

45. Ibid., p. 92.

46. Ibid., p. 94.

47. Ibid., p. 91.

48. Ibid., p. 95.

49. Lewis, *The American Adam*, p. 51.

50. James Fenimore Cooper, *The Pioneers*, in *The Leatherstocking Saga*, p. 688.

VIII *Man's Traces—Axe, Train, Figure*

1. *Thomas Cole's Poetry*, p. 103.

2. *Evidence Concerning Projected Railway Across the Sierra Nevada Mountains from Pacific Tide Waters in California, and the Resources, Promises and Action of Companies Organized to Construct the Same* (Carson City: Nevada Legislature, 1865), p. 86.

3. See Thoreau, *Walden*, pp. 32–33, and *Selected Journals*, pp. 220–21.

4. See Marx, *The Machine in the Garden*, and Smith, *Virgin Land*.

5. The first painting of the *Course of Empire* series, *The Savage State*, also refers back to Salvator, so that the earlier *Expulsion* may be seen as incorporating Garden and wilderness, Claude and Salvator, in preparation for their distinct separation in the series that followed.

6. Cole, "Essay on American Scenery," in McCoubrey, *American Art, 1700–1900*, p. 102.

7. Quoted in Hans Huth, *Nature and the American: Three Centuries of Chang-*

ing Attitudes (Berkeley and Los Angeles: University of California Press, 1957), p. 16.

8. Andrew Jackson Downing, *A Treatise on the Theory and Practice of Landscape Gardening* (New York: Funk and Wagnalls, 1967; facsimile edition of 1859 publication), p. 18.

9. Tocqueville, *Journey to America*, pp. 372, 399.

10. Cooper, *The Pioneers*, in *The Leatherstocking Saga*, pp. 662–63.

11. Roderick Nash, *Wilderness and the American Mind* (New Haven: Yale University Press, 1967), pp. 44, 69.

12. Tocqueville, op. cit., p. 399.

13. Quoted in Miller, "Nature and the National Ego," in *Errand into the Wilderness*, p. 205.

14. *Thomas Cole's Poetry*, pp. 68, 106.

15. "The March of Time," ibid., p. 165.

16. Ibid.

17. "Essay on American Scenery," p. 100.

18. "The Lament of the Forest," *Thomas Cole's Poetry*, p. 109.

19. Noble, *The Course of Empire*, pp. 217–18.

20. Tocqueville, op. cit., p. 354.

21. Ibid., p. 399.

22. Emerson, "The Over-Soul," in *Selected Writings*, p. 285.

23. *Journal of Henry D. Thoreau*, 1:89 (Sept. 5, 1841).

24. Ibid., p. 84 (Aug. 1, 1841).

25. Poem XLIII, in *Poems by Emily Dickinson*, ed. Martha Dickinson Bianchi and Alfred Leete Hampson (Boston: Little, Brown & Co., 1952), p. 22.

26. Marx, op. cit., p. 180.

27. Miller, op. cit., p. 208.

28. Quoted in Marx, op. cit., pp. 195, 160.

29. Quoted in Miller, *The Life of the Mind in America*, p. 305.

30. Ibid., p. 304.

31. Marx, op. cit., p. 238.

32. Emerson, *Selected Writings*, p. 612.

33. Quoted in Marx, op. cit., p. 263.

34. Quoted in ibid., p. 250.

35. Quoted in ibid., p. 13.

36. See Lloyd Goodrich, *Thomas Eakins: His Life and Work* (New York: Whitney Museum of American Art, 1933), p. 21.

37. Kenneth Maddox, "Intruder into Eden: Iconographic Significance of the Train in Nineteenth-Century American Landscape" (Ph.D. diss. in progress, Columbia University, written under the author's direction).

38. Marx, op. cit., p. 222.

39. Nicolai Cikovsky, Jr., "George Inness and the Hudson River School: *The Lackawanna Valley*," *American Art Journal* 2, no. 2 (Fall 1970):52.

40. Ibid., p. 57.

41. Maddox, op. cit.

42. See Cikovsky, op. cit., p. 50. Cikovsky publishes a photo of the site taken about four years later, indicating that some, if not all, of the stumps were already present. But the stump motiff tends to be rare in Inness's work. Most of his views escape the scars of desecration, returning to a dreamy pastoral ideal and to the "time-ravaged" picturesque tree.

43. Quoted in *Life in America*, exhibition catalogue (New York: The Metropolitan Museum of Art, 1939), p. 160.

44. Woodcut from drawing by Porte Crayon (D. H. Strother) in *Harper's New Monthly Magazine* 19 (1859):1, reproduced in Huth, *Nature and the American*, p. 85.

45. See Hendricks, *Albert Bierstadt*, p. 205.

46. See Moure, "Five Eastern Artists Out West," pp. 15ff.

47. Whitman, *Specimen Days*, p. 89.

48. Barbara Novak, "Landscape Permuted: From Painting to Photography," *Artforum*, Oct. 1975, pp. 40–45; and see *Era of Exploration*.

49. See Marx, op. cit., p. 238, referring to Emerson's attitude. I am quoting Marx here.

50. Wilhelm Worringer, *Form in Gothic*, ed. Herbert Read (New York: Schocken Books, 1972), p. 179.

51. Quoted in Quentin Anderson, *The Imperial Self* (New York: Vintage Books, 1971), p. 11.

52. See Brian O'Doherty, *American Masters: The Voice and the Myth* (New York: Random House, 1973), pp. 159–60. In a study of Rothko, O'Doherty speculates convincingly on the nature of the immobile figure: "Surely this figure represents mind—mind separated from nature so that, in the epitome of the Romantic idea, it may be reabsorbed and interfused with it." Later, he makes a distinction between "the transcendental watcher" and "the tragic spectator," antagonistic to each other and yet forced to coincide in what he feels is Rothko's idea of the figure. The implication is that *we* become the figure in Rothko's work, without the interposition of a surrogate. Similarly, O'Doherty traces the modernist sense of the medium—paint itself—to "the artist representing himself painting at his easel before the view. . . . Toward the end of the [nineteenth] century that figure—the artist—disappears into the medium, is replaced by touch and color and process. The figure representing mind also disappears. Its remnants of idealism join with the medium to fill the void caused by its departure, and thus initiate the proper history of modernism, rehearsing Romanticism in terms suitably transposed."

53. *North American Review* 81 (1855):223.

54. *Emerson: A Modern Anthology*, p. 147.

55. Ibid., pp. 143–44.

56. Ibid., p. 117.

57. See below, p. 268.

58. *Selected Journals*, pp. 33, 34 (Aug. 13, 1838).

59. *Democratic Vistas*, in *Portable Walt Whitman*, p. 457.

60. Quoted in Stanley Bank, *American Romanticism* (New York: Capricorn Books, 1969), p. 293. See also Hyatt H. Waggoner, *American Poets from the Puritans to the Present* (New York: Dell, 1970), p. 5. Waggoner speaks of a dark strain which "was a submerged minor note in nineteenth-century American poetry. Here and there we find it just under the surface. Now and then it breaks into the open and becomes dominant, as it does in a very special sort of way in Poe and Melville and in many of the poems of Emily Dickinson. But to find it most powerfully and meaningfully expressed we must go outside the poetry, to the fiction—to Hawthorne, Melville, and the late work of James. Earlier, in the verse of the eighteenth-century Enlightenment, it was hardly present at all.
 But it was present when American poetry began, with the Puritans."

61. Herman Melville, *Moby Dick* (New York: Harper & Row, 1966), pp. 140–41.

62. Bank, op. cit., p. 14.

63. "Song of the Broad-Axe," from *Leaves of Grass*, in *Portable Walt Whitman*, pp. 186–90.

64. *Passage to India*, in ibid., p. 343.

65. *Democratic Vistas*, in ibid., p. 460.

66. Preface to *Leaves of Grass*, in ibid., pp. 37–38.

67. *Democratic Vistas*, in ibid., p. 457.

IX *Arcady Revisited: Americans in Italy*

1. William Wetmore Story, *Roba di Roma*, 2 vols. (Boston and New York: Houghton Mifflin, 1896), 1:5.
2. Henry James, *William Wetmore Story and His Friends* (2 vols., 1903; 2 vols. in 1, New York: Da Capo Press, 1969), 2:4.
3. Ibid.
4. Ibid., 1:27–28.
5. Denis de Rougemont, *Love in the Western World* (New York: Doubleday Anchor, 1959), p. 41.
6. Ibid., p. 42.
7. Quoted in James, op. cit., 2:50.
8. Nathaniel Hawthorne, *The Marble Faun* (New York: Dell, 1960), p. 28.
9. De Rougemont, op. cit., p. 23.
10. James, op. cit., 2:209.
11. Ibid., pp. 209–10.
12. Henry James, *Roderick Hudson* (Middlesex, Eng.: Penguin, 1969), p. 225.
13. James, *William Wetmore Story*, 2:131.
14. Henry James, *Stories of Writers and Artists*, ed. F. O. Matthiessen (New York: New Directions, n.d.), p. 21.
15. Ibid.
16. James, *William Wetmore Story*, 1:296.
17. Thomas Cole, "Essay on American Scenery," in McCoubrey, *American Art, 1700–1960*, p. 108.
18. Noble, *Course of Empire*, pp. 153–54.
19. James Jackson Jarves, *Art-Hints* (New York: Harper & Bros., 1855), pp. 13–14.
20. Story, op. cit., 1:7.
21. Nathaniel Hawthorne, *Passages from the French and Italian Note-Books* (1858–59), vol. 10, *The Works of Nathaniel Hawthorne* (Boston & Cambridge: Houghton Mifflin, 1888), pp. 89–90.
22. *A Handbook of Rome and Its Environs*, Part II of *The Handbook for Travellers in Central Italy* (London: John Murray, 1858), p. 243.
23. Story, op. cit., p. 5.
24. Hawthorne, *Note-books*, p. 58.
25. James, *William Wetmore Story*, 2:134, quoting *Roba di Roma*.
26. George Stillman Hillard, *Six Months in Italy*, 2 vols. (Boston: Ticknor & Read, 1853), 1:204.
27. James, *William Wetmore Story*, 2:134.
28. Ibid., 1:347.
29. Quoted in Nathalia Wright, *American Novelists in Italy* (Philadelphia: University of Pennsylvania Press, 1965), p. 46.
30. Helen Haseltine Plowden, *William Stanley Haseltine* (London: Frederick Muller, 1947), p. 54.
31. *Harriet Hosmer: Letters and Memories*, ed. Cornelia Carr (New York: Moffat, Yard, and Co., 1912), p. 40.
32. Ibid., p. 31.
33. Plowden, op. cit., p. 54.
34. George Wynne, *Early Americans in Rome* (Rome: Dapco, 1966), p. 65.
35. Quoted in ibid., p. 50.
36. The dates and addresses offered here were compiled from the following sources: Mme. Ricss, "Résidences romaines des principaux écrivains anglais et américains," typescript in Keats Library, Keats House, Rome; Murray's *Handbook of Rome* (1858); James E. Freeman, *Gatherings from an Artist's Portfolio in Rome* (Boston, 1883); Plowden, op. cit.; Wynne, op. cit.; guest register of the Caffè Greco from 1845 on; Clara Louise Dentler, *Famous Foreigners in Florence, 1400–1900* (Florence: Marzocco, 1964); Joshua C. Taylor, *William Page*

(Chicago: University of Chicago Press, 1957); Hosmer, op. cit.; William Gerdts, *The White Marmorean Flock*, exhibition catalogue, Vassar Art Gallery, Pough-keepsie, N.Y., April 4–20, 1972. This information is still very sparse and some-times contradictory. For example, Mme. Ricss lists 43 Via Bocca di Leone as the nineteenth-century address of the Hotel d'Inghilterra (now no. 14). Joshua Taylor (p. 124) locates the Brownings and Pages in private apartments at no. 43. Hosmer (p. 48) numbers the Brownings' address as 42, and says they occupied the third floor. I am indebted to Octavia Hughes for the information about Kensett's address, and to Donald Reynolds for allowing me to consult an un-published ms., "Artistic Life in the American and English Colonies in Florence, 1825–61."

37. Quoted in Wright, op. cit., p. 46.

38. Quoted in E. P. Richardson and Otto Wittman, Jr., *Travelers in Arcadia* (De-troit and Toledo: Detroit Institute of Arts, Toledo Museum of Art, 1951), p. 13.

39. Susan A. Hutchinson, "Old Letters in the Avery Collection of Artist's Letters in the Brooklyn Museum," *Brooklyn Museum Quarterly* 2 (July 1915):287. I am grateful to Linda Ferber for this reference.

40. Ibid.

41. Hosmer, op. cit., p. 42.

42. Plowden, op. cit., p. 54.

43. Hosmer, op. cit., pp. 108–9.

44. Leonora Cranch Scott, *The Life and Letters of Christopher Pearse Cranch* (Boston and New York: Houghton Mifflin, 1917), p. 105.

45. Noble, op. cit., p. 333.

46. James, *William Wetmore Story*, 1:171.

47. Ibid., p. 158.

48. Quoted in Scott, op. cit., p. 105.

49. Hawthorne, *Note-Books*, p. 170.

50. Elihu Vedder, *The Digressions of V* (Boston and New York: Houghton Mifflin, 1910), p. 156.

51. James, *William Wetmore Story*, 2:225, 226.

52. Quoted in Richardson and Wittman, op. cit., pp. 28–29. Cole's delight in the smallest bits of nature can be seen in the two pages of a herbarium in Church's library at Olana; see above, p. 287 n. 79.

53. Quoted in Scott, op. cit., p. 120.

54. Hawthorne, *Note-Books*, p. 425.

55. Quoted in Wright, op. cit., p. 81.

56. See Van Wyck Brooks, *The Dream of Arcadia* (New York: Dutton, 1958), chap. 9, for a fine account of Margaret Fuller in Italy. See also Joseph Jay Deiss, *The Roman Years of Margaret Fuller* (New York: Thomas Y. Crowell, 1969).

57. William Dunlap, *History of the Rise and Progress of the Arts of Design in the United States* (1834; New York: Dover, 1969), vol. 2, pt. 2, p. 364.

58. Quoted in James, *William Wetmore Story*, 1:103.

59. Ibid., pp. 107–8.

60. Ibid., p. 119.

61. Quoted in ibid.

62. Ibid.

63. Dentler, op. cit., p. 31.

64. Quoted in James, *William Wetmore Story*, 1:136.

65. Ibid., p. 157.

66. Wynne, op. cit., p. 105.

67. Ibid.

68. Ibid., p. 116. See also Brooks, op. cit., p. 111, who indicates that Horatio Greenough and Jarves cared deeply about Italian independence.

69. Quoted in Wynne, op. cit., p. 124.

70. Ibid.

71. Ibid., p. 125.

72. James, *William Wetmore Story*, 1:139.
73. Church to Osborn, Nov. 4, 1868, typescript, Church-Osborn correspondence, Olana.
74. Church to Osborn, Nov. 9, 1868, typescript, Church-Osborn correspondence, Olana.
75. Church to Osborn, Jan. 23/28, 1869, typescript, Church-Osborn correspondence, Olana.
76. Church to Heade, Oct. 9, 1868, Church-Heade correspondence, microfilm, Archives of American Art.
77. Church to Heade, Nov. 16, 1868, Church-Heade correspondence, microfilm, Archives of American Art.
78. Quoted in James, *William Wetmore Story*, 1:179.
79. Quoted in ibid., pp. 249, 253.
80. Quoted in ibid., pp. 314–15.
81. Hawthorne, *Marble Faun*, p. 152.
82. Quoted in Wright, op. cit., p. 53.
83. Hawthorne, *Note-Books*, pp. 456–57.
84. Hawthorne, *Marble Faun*, p. 161.
85. *New York Mirror* 15, no. 49 (June 2, 1838):390.
86. Hawthorne, *Note-Books*, p. 432.
87. See *Autobiography of Worthington Whittredge*, p. 42.
88. De Rougemont, op. cit., pp. 294–95.

X *America and Europe: Influence and Affinity*

1. Whittredge, *Autobiography*, p. 42.
2. Ibid., p. 40.
3. James, *William Wetmore Story*, 1:296.
4. Emerson, *Modern Anthology*, p. 59.
5. Richard Payne Knight, *Analytical Inquiry into the Principles of Taste* (London, 1805), pp. 152–53.
6. Cole, journals, entry of July 29, 1829; ms., New York State Library, Albany; photostats, New-York Historical Society; microfilm, Archives of American Art.
7. Ibid., entry of Aug. 24, 1841.
8. Durand, journal, entry of June 22, 1840, Asher B. Durand papers, New York Public Library.
9. Ibid., July 3, 1840.
10. Quoted in John Durand, *Asher B. Durand*, p. 160.
11. Asher B. Durand papers, New York Public Library.
12. James Jackson Jarves, *Art-Thoughts: The Experiences and Observations of an American Amateur in Europe* (New York: Hurd & Houghton, 1869), p. 182.
13. For an extended study of this problem, see Lois Engelson, "The Influence of Dutch Landscape Painting on the American Landscape Tradition" (Master's essay, Columbia University, 1966, written under the author's direction).
14. *Webster's New World Dictionary*, college ed. (Cleveland and New York: World Publishing Co., 1960), s.v. "influence" (2a).
15. Ibid., s.v. "affinity" (3).
16. See Harold E. Dickson (ed.), *Observations on American Art: Selections from the Writings of John Neal (1793–1876)*, Pennsylvania State College Studies no. 12 (State College: The Pennsylvania State College, 1943), p. 46.
17. See Barbara Novak, "Asher B. Durand and European Art," *Art Journal* 21, no. 4 (Summer 1962):250–54.
18. William Sidney Mount, ms., Dec. 29, 1848, Suffolk Museum and Carriage House, Stony Brook, L.I.
19. Ibid.
20. John I. H. Baur, "Trends in American Painting," introduction to *M. & M.*

Karolik Collection of American Paintings, 1815–1865, Museum of Fine Arts, Boston (Cambridge: Harvard University Press, 1949), p. iv: "The main line of development towards impressionism grew . . . directly out of the strict realist tradition and was for many years modified by it. It was thus a slow evolution rather than an abrupt change in vision. It was also predominantly a native development, for it owed little to European influences."

21. Robert L. Herbert, *Barbizon Revisited* (Boston: Museum of Fine Arts, 1962), p. 30.
22. Asher B. Durand, "Letters," Letter IV, *Crayon* 1 (Feb. 14, 1855):98.
23. See Novak, *American Painting of the Nineteenth Century,* pp. 167–69.
24. See Norma F. Broude, "The Macchiaioli: Academicism and Modernism in Nineteenth Century Italian Painting" (Ph.D. diss., Columbia University, 1967).
25. Zandomeneghi's art by 1878 had already been touched by Parisian painting. He arrived in Paris in 1874 and was followed there by his friend, the Macchiaioli supporter and critic Diego Martelli, in the year he painted *Along the Seine.* There are many connections also between his paintings of the sixties and Homer. See Mia Cinotti, *Zandomeneghi* (Milan: Bramante Editrice, Busto Arsizio, 1960).
26. Herbert, op. cit., pp. 17–18.
27. John Durand, *Asher B. Durand,* p. 151.
28. See Chapter V, p. 80.
29. See Kenneth Clark, *Landscape into Art* (New York: Scribner's, 1950), pp. 78ff, for a consideration of parallels between Constable's attitudes and those of Wordsworth. See also Giuseppe Gatt, *Constable* (London: Thames and Hudson, 1968), p. 12, who quotes Constable's 1819 letter to his wife: "Everything seems full of blossom of some kind and at every step I take, and on whatever object I turn my eyes, that sublime expression of the Scriptures, 'I am the resurrection and the life,' seems as if uttered near me." See also Lorenz Eitner, *Neoclassicism and Romanticism, 1750–1850* (Englewood Cliffs, N.J.: Prentice-Hall, 1970), 2:68.
30. There are many references in Constable's letters to both Claude and the Dutch. See C. R. Leslie, *Memoirs of the Life of John Constable* (London: Phaidon, 1951), pp. 81–83 (letter of Aug. 4, 1821, to John Fisher): ". . . There is some hope of the Academy's getting a Claude from Mr. Angerstein's, the large and magnificent marine picture, one of the most perfect in the world; should that be the case, though I can ill afford it, I will make a copy of the same size. . . . The very doing it will almost bring me into communion with Claude himself." A subsequent letter of Sept. 20, 1821, indicates the Claude did not come that year: ". . . it would have been madness for me to have meddled with it this season. . . . The beautiful Ruysdael, 'The Windmill' which we admired, is at the Gallery. I trust I shall be able to procure a memorandum of it. . . ."
31. See John Gage, *Color in Turner: Poetry and Truth* (New York: Praeger, 1969), pp. 189ff. See also Fritz Novotny, *Painting and Sculpture in Europe 1780 to 1880,* The Pelican History of Art (Baltimore: Penguin, 1960), p. 91, referring to Delacroix's 1825 trip to London with Bonington.
32. *The Journal of Eugène Delacroix,* ed. Hubert Wellington, trans. Lucy Norton (London: Phaidon, 1951), p. 137 (entry of Sept. 29, 1850): "The two conceptions that Mme. Cavé was describing to me, that of colour as *colour* and of light as *light,* must be reconciled in one operation."
33. Gage, op. cit., pp. 184–85.
34. Ibid., p. 185. Gage notes that Turner's pictorial response to Goethe may have been a criticism of his theories, but states, "I believe it was not a criticism of the basis of Goethe's account of the genesis of colours from light and darkness, by substituting their Newtonian origin in light alone, but an attempt to restore the equality of light and darkness as values in art and nature, which Turner felt Goethe had unduly neglected."
35. Ibid., p. 189. "Whistler had, surprisingly perhaps, very little respect for Turner,

as he did not, he thought, meet either the simply natural or the decorative requirements of landscape art."

36. See James M. Whistler, *The Gentle Art of Making Enemies* (London and New York: William Heinemann, 1890), pp. 1–34, for Whistler's account of the famous Whistler-Ruskin case. See also, for a useful reprise, Hesketh Pearson, *The Man Whistler* (New York: Harper & Bros., 1952), pp. 106ff.

37. See Huntington, *Church*, pp. 19, 45. Rhoma Phillips, in an unpublished paper on Turner's influence on American artists and in a Ph.D. dissertation in progress (Columbia University, written under the author's direction), stresses the importance of Turner's influence through engravings. I am grateful to Ms. Phillips for emphasizing this for me through her research.

38. Roger B. Stein, *John Ruskin and Aesthetic Thought in America, 1840–1900* (Cambridge: Harvard University Press, 1967), p. 2.

39. Letter to H. Pickering, Nov. 23, 1827; quoted in Jared B. Flagg, *The Life and Letters of Washington Allston* (1892; New York: Da Capo Press, 1969), pp. 203–4.

40. Quoted in Noble, *Course of Empire*, p. 121, from a letter of March 1, 1830. C. R. Leslie had already written similarly to Allston, as early as August 18, 1823. See Flagg, op. cit., p. 177: "Turner, in all his last pictures, seems to have entirely lost sight of the 'modesty of nature.' The coloring of his 'Bay of Baiae,' in the present Exhibition, would have been less objectionable perhaps in Howard's 'Solar System'; but as applied to a real scene, although splendid and harmonious, it is nevertheless a lie from beginning to end." This attitude, however, did not prevent Allston from suggesting that Cole acquire the *Liber Studiorum*.

41. John Durand, op. cit., pp. 150, 151n.

42. See p. 86, above. Cropsey also owned copies of *The Rivers of France from Drawings by J. M. W. Turner, R. A.* (London, 1837) and *Turner and Girtin's Picturesque Views, Sixty Years Since* (London, 1854); in Cropsey library, Hastings-on-Hudson.

43. Ruskin wrote to Hill on March 14 (1879?): "The copy of Turner is excellent, and you had better now work from nature and your own mind only. . . . I am going to take you at your kindly spoken word and keep this Turner copy a little while" (ms., private collection; information courtesy of Joan Washburn). On March 26, 1879, Ruskin wrote to Hill again: "I am obliged to you for your kind little present of the copy from Turner which will be useful to me in my schools" (*Drawings & Watercolors, John William Hill, John Henry Hill*, unpaged exhibition brochure, Nov. 3–27, 1976, Washburn Gallery, New York).

44. Barbara Novak O'Doherty, "Thomas H. Hotchkiss: An American in Italy," *Art Quarterly* 29, no. 1 (Spring 1966):6–7. See also *Sanford Robinson Gifford*, exhibition catalogue, text by Nikolai Cikovsky, Jr. (The University of Texas Art Museum, 1970), pp. 14–16.

45. Linda Ferber, *William Trost Richards: American Landscape and Marine Painter, 1833–1905*, exhibition catalogue (New York: Brooklyn Museum, 1973), pp. 15, 33.

46. See Gage, op. cit., p. 121. J. J. E. Mayall, a young American photographer, was visited in his London studio by Turner in 1847: "He wished me to copy my views of Niagara—then a novelty in London—and enquired of me about the effect of the rainbow spanning the great falls. I was fortunate in having seized one of these fleeting shadows when I was there, and I showed it to him. He wished to buy the plate. . . . He told me he should like to see Niagara, as it was the greatest wonder in Nature; he never tired of my description of it." Turner's interest in Niagara's rainbow tallies nicely with Church's mastery of the rainbow, and with Tuckerman's well-known anecdote about Ruskin and Church's *Niagara*. A typescript of a letter from Church to his friend William Osborn, written in Rome on Nov. 30, 1868 (in the collection at Olana), reads in part: "I am not only in demand to cure men but pictures also. Some time

since Healy asked me to show him how to paint a rainbow which he wished to introduce into a large picture of Lincoln, Grant, Sherman and Porter—a few days later a Mr. Welsch, a German-American artist, begged me to show him how to paint a rainbow for a waterfall that he was painting and also a Mr. Richards came in for instructions in rainbows. I gave them all my best prismatic touches and retired as I supposed with my best bow. . . ."

47. Jarves, *The Art-Idea,* p. 205.

48. Ibid., p. 191.

49. Quoted in Huntington, *Church,* p. 1.

50. See Arlene Jacobowitz, *James Hamilton, 1819–1878: American Marine Painter,* exhibition catalogue (New York: Brooklyn Museum, 1966), p. 23, which stresses the early influence of the engravings.

51. See Thurman Wilkins, *Thomas Moran: Artist of the Mountains* (Norman: University of Oklahoma Press, 1966), pp. 24, 37.

52. Quoted in Allen Staley, *The Pre-Raphaelite Landscape* (London: Oxford University Press, 1973), p. 182.

53. Emerson, "Art," in *Selected Writings,* p. 305.

54. Stein, op. cit., p. 102.

55. To approach the Ruskin problem is to approach a writer whose ideas are as changeable as emotions—who presents us with a strange inversion of ideas and feelings: constant feelings and changeable ideas. Francis G. Townsend, in his seminal Ruskinian study *Ruskin and the Landscape Feeling* (Urbana: University of Illinois Press, 1951), said it succinctly: "*Modern Painters* is so poorly organized that even an intelligent reader finds it almost impossible to follow the argument. It contains so many pronouncements on so many topics that it provides every adverse critic with ample ammunition. It is so full of contradictions that it is superfluous to point them out . . ." (p. 3). And, "It is not surprising that *Modern Painters* is one of the worst organized books ever to earn the name of literature, nor that a careful reading of it by an intelligent reader leads to confusion rather than enlightenment as to the author's opinions" (p. 1).

Why then should we even bother to consider Ruskin? Because the jumble of *Modern Painters* presumably managed to reach the painterly intelligences of American artists, and affect them as no other critical enterprise ever had. Almost every biography of an American nineteenth-century landscapist alludes somewhere to a catalytic encounter with *Modern Painters.* Whittredge, op. cit., p. 55, says: "The study of nature proved to be too strong meat for all the babes to digest. They never got beyond a literal transcript. Ruskin, in his Modern Painters, just out then and in every landscape painter's hand, had told these tyros nothing could be too literal in the way of studies, and many of them believed Ruskin." We are frequently assured, in addition, that the tone of the influential *Crayon* was pre-eminently Ruskinian, and this is backed up by William Stillman's comment (*Autogiography of a Journalist,* 1:222–23): "My friends came to the conclusion that it would be a good and useful thing that I should start an art journal. I had read with enthusiasm 'Modern Painters,' and absorbed the views of Ruskin in large draughts. . . . The art-loving public was full of Ruskinian enthusiasm, and what strength I had shown was in that vein. . . . I was an enthusiast, fired with the idea of an apostolate of art, largely vicarious and due to Ruskin, who was then my prophet, and whose religion, as mine, was nature."

Recent studies, such as Roger B. Stein's invaluable *John Ruskin and Aesthetic Thought in America, 1840–1900,* have gone so far as to place on Ruskin's doorstep the responsibility for certain key ideas that are central to the development of nineteenth-century art in America. We have an obligation, therefore, to evaluate as best we can how the artists could have benefited by reading *Modern Painters,* what sense they could have made of Ruskin's pontifical theorizing, what "tips" they could have gotten from reams of practical advice, how Ruskin's

ideas related to, or affected, the development of landscape painting in theory and practice in mid-century America.

Stein, in his brilliant study, has done more than any other scholar to amplify the long-term suspicion that Ruskin did indeed have an important effect on American mid-century art. But at the heart of Stein's thesis is the idea, to my mind questionable, that the dilemma of the real and the ideal was a "Ruskin-ian" one (see especially p. 116). Stein suggests that this dilemma, along with an emphasis on God and nature, was exported by Ruskin to America, where the seeds, planted in receptive soil, yielded a peculiarly American fruit. In all fairness, Stein is moved to admit that "at times I have inadvertently argued the case for my subject too strongly" (p. ix). He has also noted that "the ideas of the best American landscape painters of the period—Durand, Kensett and others—sprang from the American Wordsworthian tradition, quite independent of the Brotherhood. They read Ruskin later, and he corroborated and rein-forced already existing ideas rather than showing them a new path" (p. 103).

Stein's reference to corroboration and reinforcement is very apt. Ruskin's popularity in America stemmed not so much from what he offered that was new, as from what he "corroborated and reinforced." In many ways, America was a far more fertile ground for Ruskinian ideas than England could ever be. As *The Crayon* pointed out in its very first year of publication (vol. I (1855), p. 76): "Between Ruskin and most of the English literary papers there is open hostility and fairness of judgment is quite out of the question."

No such hostility existed in America. Indeed, it could be said that in America Ruskin found his most receptive and appreciative audience. This is not, how-ever, because he showed them anything new. But he may well have been in a position to reveal them to themselves. The concern with the real as a vehicle for the ideal, the reverence for nature as God, the respect for a scientism of observation, were all part of a developing American landscape esthetic when *Modern Painters* arrived on the scene. But Ruskin could verbalize for a new generation attitudes that had rarely received such "word-painting." He could, in fact, offer to the art world an intellectual spokesman and mentor who could bring, with all the credentials of his European origin, "the word" on how to paint nature. That word, laden with technical and practical observations, also emphasized the "conceptive" faculties of thought, prescribing a blend of seeing and knowing that coincided beautifully with the American propensity for the conceptual, and quickly coalesced with the American feeling for what Ruskin called "the Divine mind . . . visible in its full energy of operation on every lowly bank and smouldering stone . . ." (*Modern Painters* I, p. 320).

56. Tuckerman, *Book of the Artists*, p. 511.
57. Ruskin, *Modern Painters* I, p. 12.
58. Quoted in Staley, op. cit., p. 181.
59. Quoted in ibid.
60. Quoted in ibid., pp. 132, 131.
61. Quoted in ibid., p. 136. Further, Phillip Hamerton, the painter and critic, wrote: ". . . our ardour was not really and fundamentally artistic, though we believed it to be so. It came much more from a scientific motive than from any purely artistic feeling, and was a part—though we were not ourselves aware of it—of that great scientific exploration of the realms of nature which this age has carried so much farther than any of its predecessors" (quoted in ibid., p. 174).
62. See *The Düsseldorf Academy and the Americans,* exhibition catalogue (Atlanta: The High Museum of Art, 1972), especially the essay by Donelson F. Hoopes, for a good consideration of the problem. There has not yet been a similar scholarly focus on the parallels between the Americans and the Dresden group. See, for a preliminary study of the Dresden problem, Suzanne Latt Epstein, "The Relationship of the American Luminists to Caspar David Friedrich"

(Master's essay written under the author's direction, Columbia University, 1964).

63. *Düsseldorf*, p. 27.

64. Ibid. Achenbach seems to have discouraged formal study with him. See also Whittredge, op. cit., p. 26.

65. John Wilmerding, *Fitz Hugh Lane* (New York: Praeger, 1971), p. 51, quotes a letter from Lane's friend Joseph L. Stevens: "Lane was frequently in Boston. . . . The coming of the Dusseldorf Gallery to Boston was an event to fix itself in one's memory for all time. What talks of all these things Lane and I had in his studio and by my fireside!"

66. See Novotny, op. cit., p. 110ff, for a consideration of Biedermeier painting. On p. 117, Novotny isolates the Danish art of Købke as Biedermeier.

67. *Caspar David Friedrich, 1774–1840: Romantic Landscape Painting in Dresden*, exhibition catalogue (London: Tate Gallery, 1972), p. 110.

68. Epstein, op. cit., pp. 5–6, notes that the Academy curriculum from 1754 on included courses in draughtsmanship for handicraft apprentices.

69. Scandinavian artists more directly within the Friedrich-Dresden circle who warrant comparison with the American landscapists would include the Norwegians Johann Christian Claussen Dahl (1788–1857) and Thomas Fearnley (1802–42).

70. Quoted in *Friedrich* (Tate), pp. 14, 103.

71. Quoted in *Karolik Collection*, pp. 191–92.

72. Letter to person unknown, undated; ms., New York State Library, Albany; microfilm, Archives of American Art.

73. Quoted in Wilmerding, op. cit., p. 79.

74. Elizabeth Gilmore Holt, ed., *From the Classicists to the Impressionists: A Documentary History of Art* (Garden City: Doubleday Anchor, 1966), 3:85.

75. Quoted in *Friedrich* (Tate), p. 105.

76. Noble, *Course of Empire*, p. 287. See also broadside for *Voyage of Life*, Cole papers, New York State Library, Albany; microfilm, Archives of American Art.

77. Quoted in *Friedrich* (Tate), p. 106.

78. Noble, op. cit., p. 288.

79. Ibid., p. 289.

80. Quoted in *Friedrich* (Tate), p. 106.

81. Emerson, *Modern Anthology*, p. 153.

82. See *Friedrich* (Tate), which seems to me to have exaggerated this out of bounds. Though Friedrich's work *was* clearly more deliberately and overtly symbolic than that of the Americans, the catalogue notes, by Helmut Börsch-Supan, carry the concept of Friedrich's symbolism to an extreme.

83. See especially Stanley Vogel, *German Literary Influences on the American Transcendentalists* (New Haven: Yale University Press, 1955), pp. 172ff.

84. Vogel, p. 103, notes: "I side with those persons who believe that much in Emerson's thought and philosophy which may appear German is merely Yankee."

85. Quoted in ibid.

86. The point should be made that Emerson's comments on nature and God are verbalizations of ideas and feelings made manifest in the landscape paintings. Though some amount of influence through essays and lectures can be cited, it is clearly Emerson's parallel sentiments that make him the spokesman for the painters, rather than any direct cause-and-effect relationship. Emerson himself seems hardly to have been much interested in American landscape paintings. A visit to his home in Concord indicates that his taste ran to prints of Italian Renaissance paintings.

87. Emerson, *Selected Writings*, p. 6.

88. Eitner, op. cit., 2:48.

89. Quoted in Holt, op. cit., p. 90.

90. Quoted in Eitner, op. cit., 2:46, 47.

91. Quoted in ibid., p. 47.

92. Emerson, *Modern Anthology*, p. 135.

93. Ruskin, *Modern Painters* I, p. 21.

94. A key distinction between American luminist and European landscape is precisely that glow—which yields up an almost palpable, shining light radiating from the smooth picture surface.

95. Quoted in Eitner, op. cit., 2:47.

96. Emerson, *Modern Anthology*, p. 26.

97. Cole's allegories and some of Cropsey's early works are the most obvious American examples. These, however, tended also to be more explicitly narrative than German symbolism, and ultimately less intrinsically symbolic.

98. Quoted in Eitner, op. cit., 2:54: "The artist's feeling is his law. Pure sensibility can never be unnatural; it is always in harmony with nature."

99. Ibid.

100. Ibid.

101. Ibid., p. 55.

102. Ibid., p. 54.

103. Wilhelm Worringer, *Form in Gothic*, ed. Herbert Read (New York: Schocken, 1964), p. 179.

104. Ibid., p. 180.

105. Ibid., p. 35.

106. Arthur Christy, *The Orient in American Transcendentalism* (New York: Columbia University Press, 1932), pp. 84–85.

107. Whicher, *Freedom and Fate*, p. 17: "Take a quantity of Kant; add unequal parts of Goethe, Schiller, Herder, Jacobi, Schleiermacher, Fichte, Schelling, Oken, and a pinch of Hegel; stir in, as Emerson did, a generous amount of Swedenborg; strain through Mme. de Stael, Sampson Reed, Oegger, Coleridge, Carlyle, Wordsworth, Cousin, Jouffroy, Constant; spill half and season with Plato—and you have something resembling the indescribable brew called modern philosophy whose aroma Emerson began to detect in his corner of the world in the 1820's, and for which his Puritan-Unitarian-Realist palate slowly but decisively acquired a taste."

Selected Bibliography

Additional sources may be found in the notes.

Contemporary Manuscripts

The most useful manuscript material can be found in the Archives of American Art, Washington, D.C. For this book, I utilized the microfilms in the New York office of the Archives. I consulted especially:

The Thomas Cole papers. There are also photostatic copies in the collection of the New-York Historical Society. Most of the originals are in the collection of the New York State Library, Albany. Others are in The Detroit Institute of Arts.

The Cropsey papers. Originals at Hastings-on-Hudson, New York.

The Church-Heade correspondence. Originals in Archives of American Art, Washington, D.C.

I also consulted:

The Church letters from South America at the Henry Francis DuPont Winterthur Museum, Winterthur, Delaware.

Church's South American diaries, letters, papers, and library at Olana.

Cropsey's library at Hastings-on-Hudson.

The Asher B. Durand papers at the New York Public Library.

The John Durand papers at the New York Public Library.

The William Sidney Mount papers at the Suffolk Museum and Carriage House, Stony Brook, Long Island. Microfilm in the New York Public Library.

Publications

Abrams, M. H. *The Mirror and the Lamp*. New York: Oxford University Press, 1953.

Allston, Washington. *Lectures on Art—Poems*. 1850. Reprint. New York: Da Capo Press, 1972.

Anderson, Quentin. *The Imperial Self*. New York: Vintage Books, 1971.

Arber, Agnes. "Goethe's Botany." *Chronica Botanica* 10, no. 2 (Summer 1946).

Badt, Kurt. *John Constable's Clouds*. Translated by Stanley Godman. London: Routledge & Kegan Paul, 1950.

Bermingham, Peter. *Jasper F. Cropsey, 1823–1900: A Retrospective View of America's Painter of Autumn*. Exhibition catalogue. College Park: University of Maryland, 1968.

Blakney, Raymond Bernard, ed. *Meister Eckhart: A Modern Translation*. New York: Harper & Row, 1941.

Brooks, Van Wyck. *The Dream of Arcadia*. New York: Dutton, 1958.

Burke, Edmund. *A Philosophical Enquiry into the Origin of Our Ideas of the Sublime and Beautiful.* London, 1757.

Catlin, George. *Letters and Notes on the Manners, Customs and Conditions of the North American Indians.* 1844. Reprint (2 vols.). New York: Dover, 1973.

Christy, Arthur. *The Orient in American Transcendentalism.* New York: Columbia University Press, 1932.

Cikovsky, Nicolai, Jr. "George Inness and the Hudson River School: *The Lackawanna Valley.*" *American Art Journal* 2, no. 2 (Fall 1970):36–57.

Clark, Kenneth. *Landscape into Art.* New York: Scribner's, 1950.

Cole, Thomas. *Thomas Cole's Poetry.* Edited by Marshall B. Tymn. York, Pa.: Liberty Cap Books, 1972.

Conron, John. *The American Landscape: A Critical Anthology of Prose and Poetry.* New York, London, and Toronto: Oxford University Press, 1974.

Cooper, James Fenimore. *The Leatherstocking Saga.* Edited by Allan Nevins. New York: Modern Library, 1966.

Crayon, The: A Journal Devoted to the Graphic Arts, and the Literature Related to Them. Vols. 1–8. 1855–61.

Curry, Larry. *The American West.* Exhibition catalogue. New York: Viking Press and Los Angeles County Museum of Art, 1972.

Darwin, Charles. *The Autobiography of Charles Darwin, 1809–1882.* Edited by Nora Barlow. New York: W. W. Norton, 1969.

————. *The Darwin Reader.* Edited by Marston Bates and Philip S. Humphrey. New York: Scribner's, 1956.

————. *The Origin of Species.* Edited by J. W. Burrow. Middlesex: Penguin, 1970.

————. *The Voyage of the Beagle.* Edited by Leonard Engel. Garden City, N.Y.: Doubleday Anchor, 1962.

Dewey, John. "Darwin's Influence upon Philosophy." *Popular Science Monthly* 75 (July–Dec. 1909): 90–98.

Dial, The: A Magazine for Literature, Philosophy and Religion. 1840–44. Reprint (4 vols.). New York: Russell and Russell, 1961.

Dunlap, William. *A History of the Rise and Progress of the Arts of Design in the United States.* 2 vols. 1834. Reprint (2 vols. in 3), edited by Rita Weiss, introduction by J. T. Flexner. New York: Dover, 1969.

Dupree, A. Hunter. *Asa Gray.* New York: Atheneum, 1968.

Durand, John. *The Life and Times of Asher B. Durand.* New York: Scribner's, 1894.

Düsseldorf Academy and the Americans, The. Exhibition catalogue. Texts by Donelson F. Hoopes, Gudmund Vigtel, and Wend von Kalnein. Atlanta: High Museum of Art, 1972.

Eiseley, Loren. *Darwin's Century.* Garden City, N.Y.: Doubleday Anchor, 1961.

Eitner, Lorenz. *Neoclassicism and Romanticism, 1750–1850.* 2 vols. Sources and Documents in the History of Art Series. Englewood Cliffs, N.J.: Prentice-Hall, 1970.

Emerson, Edward Waldo. *The Early Years of the Saturday Club, 1855–1870.* Boston and New York: Houghton Mifflin, 1918.

Emerson, Ralph Waldo. *Emerson: A Modern Anthology.* Edited by Alfred Kazin and Daniel Aaron. Boston: Houghton Mifflin, 1958.

————. *The Journals & Miscellaneous Notebooks of Ralph Waldo Emerson.* Edited by William H. Gilman [and others]. 14 vols. Cambridge: Harvard University Press, Belknap Press, 1960–78.

————. *The Journals of Ralph Waldo Emerson.* Edited by Edward Waldo Emerson and Waldo Emerson Forbes. 10 vols. Boston: Houghton Mifflin, 1909–14.

————. *The Letters of Ralph Waldo Emerson.* Edited by Ralph L. Rusk. 6 vols. New York: Columbia University Press, 1966.

————. *The Selected Writings of Ralph Waldo Emerson.* Edited by Brooks Atkinson. New York: Modern Library, 1950.

Era of Exploration: The Rise of Landscape Photography in the American West, 1860–1885. Exhibition catalogue. Texts by Weston J. Naef, James N. Wood,

and Therese Thau Heyman. Albright-Knox Gallery and Metropolitan Museum of Art, 1975.

Ferber, Linda. *William Trost Richards: American Landscape and Marine Painter, 1833–1905.* Exhibition catalogue. New York: Brooklyn Museum, 1973.

Fiske, John. *The Idea of God as Affected by Modern Knowledge.* Boston and New York: Houghton Mifflin, 1892.

Flagg, Jared B. *The Life and Letters of Washington Allston.* 1892. Reprint. New York: Da Capo Press, 1969.

Friedrich, Caspar David, 1774–1840. Exhibition catalogue. Texts by Werner Hoffmann and Siegmar Holsten. Hamburger Kunsthalle, Munich: Prestel-Verlag, 1974.

Friedrich, Caspar David, 1774–1840: Romantic Landscape Painting in Dresden. Exhibition catalogue. Texts by William Vaughan, Hans Joachim Neidhardt, and Helmut Börsch-Supan. London: Tate Gallery, 1972.

Gage, John. *Color in Turner: Poetry and Truth.* New York: Praeger, 1969.

Gifford, Sanford Robinson. Exhibition catalogue. Text by Nikolai Cikovsky, Jr. The University of Texas Art Museum, 1970.

Gillispie, Charles Coulston. *Genesis and Geology.* Cambridge: Harvard University Press, 1951.

Glass, Bentley; Temkin, Owsei; and Straus, William L., Jr., eds. *Forerunners of Darwin.* Baltimore: The Johns Hopkins Press, 1968.

Goethe, Johann Wolfgang von. *Letters from Goethe.* Translated by M. von Herzfeld and C. Melvil Sym. Edinburgh: at the University Press, 1957.

———. *The Metamorphosis of Plants.* Introduction by Rudolf Steiner. Bio-Dynamic Farming & Gardening Association, 1974.

Goetzmann, William H. *Exploration & Empire: The Explorer and the Scientist in the Winning of the American West.* New York: Vintage Books, 1972.

Gombrich, E. H. *Art and Illusion: A Study in the Psychology of Pictorial Representation.* New York: Pantheon, 1960.

Harding, Walter, ed. *Emerson's Library.* Charlottesville: University of Virginia Press, 1967.

Hawthorne, Nathaniel. *Hawthorne's Short Stories.* Edited by Newton Arvin. New York: Vintage Books, 1960.

———. *The Marble Faun.* New York: Dell, 1960.

———. *Passages from the French and Italian Note-Books* (1858–59). *The Works of Nathaniel Hawthorne,* vol. 10. Boston and Cambridge: Houghton Mifflin, 1888.

Hendricks, Gordon. *Albert Bierstadt: Painter of the American West.* New York: Harry N. Abrams, 1973.

Herbert, Robert L. *Barbizon Revisited.* Exhibition catalogue. Boston: Museum of Fine Arts, 1962.

Hillard, George Stillman. *Six Months in Italy.* 2 vols. Boston: Ticknor and Read, 1853.

Himmelfarb, Gertrude. *Darwin and the Darwinian Revolution.* Garden City, N.Y.: Doubleday Anchor, 1962.

Hitchcock, Edward. *Elementary Geology.* New York: Dayton & Newman, 1842.

Hosmer, Harriet. *Harriet Hosmer: Letters and Memories.* Edited by Cornelia Carr. New York: Moffat, Yard & Co., 1912.

Howe, M. A. de Wolfe, ed. *Later Years of the Saturday Club, 1870–1920.* Boston and New York: Houghton Mifflin, 1927.

Humboldt, Alexander von. *Cosmos.* Translated by E. C. Otté. 2 vols. New York: Harper & Bros., 1850.

Huntington, David C. *The Landscapes of Frederic Edwin Church.* New York: Braziller, 1966.

Huth, Hans. *Nature and the American: Three Centuries of Changing Attitudes.* Berkeley and Los Angeles: University of California Press, 1957.

Irving, Washington. *A Tour on the Prairies*. 1835. Reprint. New York: Pantheon, 1967.

Jacobowitz, Arlene. *James Hamilton, 1819–1878: American Marine Painter*. New York: Brooklyn Museum, 1966.

James, Henry. *Roderick Hudson*. Middlesex, Eng.: Penguin, 1969.

———. *William Wetmore Story and His Friends*. 2 vols. 1903. Reprint (2 vols. in 1). New York: Da Capo Press, 1969.

Jarves, James Jackson. *Art-Hints*. New York: Harper & Bros., 1855.

———. *The Art-Idea*. New York: Hurd and Houghton, 1864. Reprint, edited by Benjamin Rowland, Jr. Cambridge: Harvard University Press, Belknap Press, 1960.

———. *Art-Thoughts: The Experiences and Observations of an American Amateur in Europe*. New York: Hurd and Houghton, 1869.

Jones, Howard Mumford. *O Strange New World*. New York: Viking, 1968.

Karolik, M. & M., Collection of American Paintings, 1815–1865, Museum of Fine Arts, Boston. Cambridge: Harvard University Press, 1949.

King, Clarence. *Mountaineering in the Sierra Nevada*. 1871. Reprint. New York: W. W. Norton & Co., 1935.

Lange, Victor, ed. *Goethe: A Collection of Critical Essays*. Englewood Cliffs, N.J.: Prentice-Hall, 1968.

Lawrence, D. H. *Studies in Classic American Literature*. Garden City, N.Y.: Doubleday Anchor, 1951.

Leslie, C. R. *Memoirs of the Life of John Constable*. London: Phaidon, 1951.

Lewis, R. W. B. *The American Adam*. Chicago: University of Chicago Press, Phoenix Books, 1958.

Lindquist-Cock, Elizabeth. "Frederic Church's Stereographic Vision." *Art in America*, Sept.–Oct. 1973, pp. 70–75.

Lovejoy, Arthur O. "The Argument for Organic Evolution before *The Origin of Species*." *Popular Science Monthly* 75 (July–Dec. 1909):499–514, 537–49.

———. *The Great Chain of Being: A Study of the History of an Idea*. New York: Harper Torchbooks, 1965.

Ludlow, Fitz Hugh. *The Heart of the Continent*. New York: Hurd and Houghton, 1870. Reprint. New York: AMS Press, 1971.

Lurie, Edward. *Louis Agassiz: A Life in Science*. Chicago: University of Chicago Press, 1960.

Lyell, Sir Charles. *Lectures on Geology Delivered at the Broadway Tabernacle in the City of New York*. 1840. New York: Greeley & McElrath, 1843.

McCoubrey, John, ed. *American Art, 1700–1960*. Sources and Documents in the History of Art Series. Englewood Cliffs, N.J.: Prentice-Hall, 1965.

Marx, Leo. *The Machine in the Garden*. New York: Oxford University Press, 1964.

Miller, Perry. *Errand into the Wilderness*. New York: Harper & Row, 1964.

———. *The Life of the Mind in America, from the Revolution to the Civil War*. New York: Harcourt, Brace & World, 1965.

Möllhausen, Heinrich Baldwin. *Diary of a Journey from the Mississippi to the Coasts of the Pacific*. 1858. Reprint (2 vols.). New York and London: Johnson Reprint Co., 1969.

Monk, Samuel H. *The Sublime*. 1935. Ann Arbor: University of Michigan Press, Ann Arbor Paperbacks, 1960.

Moorehead, Alan. *Darwin and the Beagle*. New York: Harper & Row, 1969.

Moure, Nancy Dustin Wall. "Five Eastern Artists Out West." *American Art Journal* 5, no. 2 (November 1973):15–31.

Nash, Roderick. *Wilderness and the American Mind*. New Haven: Yale University Press, 1967.

National Parks and the American Landscape. Exhibition catalogue. Texts by William H. Truettner and Robin Bolton-Smith. National Collection of Fine Arts. Washington, D.C.: Smithsonian Institution Press, 1972.

Natural Paradise, The: Painting in America, 1800–1950. Exhibition catalogue.

Edited by Kynaston McShine. Essays by Barbara Novak, Robert Rosenblum, and John Wilmerding. New York: Museum of Modern Art, 1976.

Noble, Louis L. *After Icebergs with a Painter: A Summer Voyage to Labrador and Around Newfoundland.* New York: Appleton and Co., 1861.

——. *The Course of Empire, Voyage of Life and Other Pictures of Thomas Cole, N.A.* New York: Cornish, Lamport and Co., 1853. Reprint, edited by Elliot S. Vessell. Cambridge: Harvard University Press, 1964.

——. *The Heart of the Andes.* Broadside. New York, 1859.

Novak, Barbara. *American Painting of the Nineteenth Century.* New York: Praeger, 1969.

Novotny, Fritz. *Painting and Sculpture in Europe, 1780 to 1880.* Pelican History of Art. Baltimore: Penguin, 1960.

Nye, Russel Blaine. *The Cultural Life of the New Nation, 1776–1830.* New York: Harper Torchbooks, 1960.

——. *Society and Culture in America, 1830–1860.* New York: Harper & Row, 1974.

Parkman, Francis. *The Oregon Trail.* 1849. Reprint. New York: Signet, 1950.

Plowden, Helen Haseltine. *William Stanley Haseltine.* London: Frederick Muller, 1947.

Reingold, Nathan, ed. *Science in Nineteenth Century America: A Documentary History.* New York: Hill and Wang, 1964.

Reports of Explorations and Surveys to Ascertain the Most Practicable and Economic Route for a Railroad from the Mississippi River to the Pacific Ocean. 13 vols. Washington, D.C.: War Department, 1855–61.

Richardson, E. P., and Wittman, Otto, Jr. *Travellers in Arcadia.* Exhibition catalogue. Detroit and Toledo: Detroit Institute of Arts, Toledo Museum of Art, 1951.

Rosenblum, Robert. *Modern Painting and the Northern Romantic Tradition: Friedrich to Rothko.* New York: Harper & Row, 1975.

Ruskin, John. *The Art Criticism of John Ruskin.* Edited by Robert L. Herbert. Garden City, N.Y.: Doubleday Anchor, 1964.

——. *Modern Painters.* 5 vols. New York: John Wiley & Son, 1868.

Scott, Leonora Cranch. *The Life and Letters of Christopher Pearse Cranch.* Boston and New York: Houghton Mifflin, 1917.

Smith, Henry Nash. *Virgin Land.* New York: Random House–Knopf, 1950.

Staley, Allen. *The Pre-Raphaelite Landscape.* London: Oxford University Press, 1973.

Stebbins, Theodore. *The Life and Works of Martin Johnson Heade.* New Haven and London: Yale University Press, 1975.

Stein, Roger B. *John Ruskin and Aesthetic Thought in America, 1840–1900.* Cambridge: Harvard University Press, 1967.

Stillman, William J. *The Autobiography of a Journalist.* 2 vols. Boston and New York: Houghton Mifflin, 1901.

Story, William Wetmore. *Roba di Roma.* 2 vols. Boston and New York: Houghton Mifflin, 1896.

Taft, Robert. *Artists and Illustrators of the Old West, 1850–1900.* New York: Scribner's, 1953.

Taylor, Joshua C. *William Page.* Chicago: University of Chicago Press, 1957.

Thoreau, Henry David. *The Journal of Henry D. Thoreau.* Edited by Bradford Torrey and Francis H. Allen. 2 vols. New York: Dover, 1962.

——. *Selected Journals of Henry David Thoreau.* Edited by Carl Bode. New York: Signet, 1967.

——. *Walden.* New York: Mentor, 1942.

Tocqueville, Alexis de. *Journey to America.* Translated by George Lawrence and edited by J. P. Mayer. Garden City, N.Y.: Doubleday, 1971.

Townsend, Francis G. *Ruskin and the Landscape Feeling.* Urbana: University of Illinois Press, 1951.

Tuckerman, Henry T. *Book of the Artists.* 1867. Reprint. New York: James F. Carr, 1966.

Turner, Frederick Jackson. *Frontier and Section*. Englewood Cliffs, N.J.: Prentice-Hall, 1961.

Vedder, Elihu. *The Digressions of V*. Boston and New York: Houghton Mifflin, 1910.

Vogel, Stanley M. *German Literary Influences on the American Transcendentalists*. New Haven: Yale University Press, 1955.

Waggoner, Hyatt H. *American Poets from the Puritans to the Present*. New York: Dell, 1970.

Whicher, Stephen E. *Freedom and Fate: An Inner Life of Ralph Waldo Emerson*. Philadelphia: University of Pennsylvania Press, 1953.

Whistler, James M. *The Gentle Art of Making Enemies*. London and New York: William Heinemann, 1890.

Whitman, Walt. *The Portable Walt Whitman*. Selected and introduced by Mark Van Doren. New York: Viking Press, 1945.

———. *Specimen Days*. 1882. Boston: David R. Godine, 1971.

Whittredge, Worthington. *The Autobiography of Worthington Whittredge, 1820–1910*. Edited by John I. H. Baur. *Brooklyn Museum Journal* (1942).

Wilkins, Thurman. *Thomas Moran: Artist of the Mountains*. Norman: University of Oklahoma Press, 1966.

Wilmerding, John. *Fitz Hugh Lane*. New York: Praeger, 1971.

———. *A History of American Marine Painting*. Salem, Mass.: Peabody Museum of Salem, 1968.

Wölfflin, Heinrich. *Principles of Art History*. New York: Dover, 1932.

Worringer, Wilhelm. *Form in Gothic*. Edited by Herbert Read. New York: Schocken Books, 1964.

Wynne, George. *Early Americans in Rome*. Rome: Dapco, 1966.

Illustrations

Figures 1, 10, 19, 28, 48, 51, 52, and 150 appear in the color insert following p. 116.

Index

Page numbers in italics indicate illustrations.